Preface

Writing a book like this is impossible without the support of others. We were happily surprised by all the enthusiastic reactions of the product designers we approached. They offered interesting insights into their domain as well as relevant drawings and sketches. Sometimes you could already get a sense of the final design in their preliminary sketches. We feel privileged to be able to show their studio work in context. Our thanks also go to the photographers who allowed us to use their pictures.

The environment of the Faculty of Industrial Design in Delft and that of The Utrecht School of Arts enabled and stimulated us in this enterprise. Many thanks to Yvonne van den Herik, who worked with us during the first stages of this book. Her contribution to our research strengthened the context of this publication.

Our private environment, of course, had to cope with our "sorry, no time" due to this ever-demanding book. We are glad to have finished it, and will make it up to you.

Koos Eissen and Roselien Steur
www.sketching.nl

Koos Eissen and Roselien Steur both teach design drawing techniques. He is an associate professor at the Delft University of Technology (TU Delft) and responsible for the freehand drawing classes at the Faculty of Industrial Design Engineering, while she is a professional 3D sound-related sculptor and teaches part-time at the Faculty of Visual Art and Design, Utrecht School of the Arts.

Table of Contents

Preface 3

Introduction 7

Chapter 1

Side view sketches 9

Sketching in side view provides an easy 3D suggestion of a product. Drawing this way is generally experienced as easier than perspective drawing. A redesign of a domestic handheld mixer explains the drawing approach basics of sketching in side view, step-by-step.

Introduction 9
Getting started 10
 Adidas AG 14
Light and shading 16
 npk industrial design bv 18
Details 20
 Ford Motor Company 21
 SMOOL Designstudio 22
Drop shadows 24
Displays 25
 WeLL Design 26

Chapter 2

Perspective drawing 27

Basic perspective rules are needed to start drawing in perspective, but these rules can also be regarded as a tool to influence visual information. Separate aspects of perspective and their impact in drawing are shown.

Introduction 27
Scale 28
Perspective convergence 29
Distortion 30
Foreshortening 32
 Well Design 34
Viewpoint 36
 BMW Group 38
Eye-level perspective 42
Extreme perspective 43
 DAF Trucks NV 44

FLEX/theINNOVATIONLAB 44
DAF Trucks NV 48
Aerial perspective 50
 Guerrilla Games 52

Chapter 3

Simplifying shape 55

Learning how to analyze helps you to simplify complex situations into understandable simple steps. An effective analysis results in an effective drawing. Complex and simple drawings are compared for an effective approach to drawing. Major players are block shapes, ellipses, cylinder and planes. The following chapters are ordered accordingly.

Introduction 55
Analyzing 56
The drawing approach 59
 WAACS 66

Chapter 4

Elementary geometrical shapes 67

In addition to perspective, shading is used to create depth. The immediate spatial impact of a drawing is largely determined by its contrast in shading, and with that the choice of light direction. The influence of light on simple geometric shapes is explained, as they form the basis of most drawings.

Introduction 67
Block shapes 67
Cylinders, spheres and cones 74
 Audi AG 80

Chapter 5

Special attention for ellipses 81

A lot of people 'automatically' start drawing an object by first drawing a block. In a lot of situations, however, a cylinder or ellipse can be the most appropriate starting point of a drawing. In this approach, the ellipse plays a major role, to which other shapes are related.

sketching

drawing techniques for product designers

koos eissen and roselien steur

BIS

BIS Publishers
Building 'Het Sieraad'
Postjesweg 1
1057 DT Amsterdam
T (+)31(0)20-515 0230
F (+)31(0)20-515 0239
www.bispublishers.nl
bis@bispublishers.nl

ISBN 978 906 369 171 4

B/SPUBLISHERS

Introduction	81
Vertical (upright) cylinders	83
studioMOM	86
Ford Motor Company	88
Horizontal cylinders	92
Shape combinations	96
Springtime	98
Joining cylinders	100
WAACS	102
Tubes with curvature	104
VanBerlo Strategy + Design	106
WAACS	108

Chapter 6

Rounding 109

Nearly every industrial product has rounding. On closer inspection, their shape can be regarded as a combination of parts of cylinders, spheres and blocks. There are only a few basic roundings – with endless variations, however. Understanding their structure will enable you to draw effectively, based on estimation.

Introduction	109
Singular rounding	110
Jan Melis	114
Pilots Product Design	116
Multiple rounding	118
MMID	120
IAC Group	124
Staring at the surface	129
SPARK Design Engineering	131
Estimating	132

Chapter 7

Cross sections 133

Cross sections can curve a surface, and help 'read' unpredictable shapes. They can also be of use when 'building' an object or determining shape transitions. In some cases, objects are not drawn starting with a volume, but with a plane.

Introduction	133
Remy & Veenhuizen ontwerpers	134
Curving a surface	136

Cross-secting spheres	138
npk industrial design bv	140
Drawing curved shapes	142
SPARK Design Engineering	144
Estimating	146
Audi AG	148
Dre Wapenaar	150

Chapter 8

Ideation 153

For most designers, sketching by hand is preferable for the first (intuitive) design steps. Others prefer to 'sketch' in 3D. Sketching is not an isolated phase; it 'mixes in' with other ideation and presentation methods, like modelling or computer rendering. Various examples are shown of how sketching is used in ideation.

Introduction	153
Atelier Satyendra Pakhalé	154
Tjep.	157
Studio Job	158
Fabrique	163
studioMOM	164
Springtime	166
Ford Motor Company	168
SMOOL Designstudio	170
IAC Group	172
SEAT	173
Pininfarina S.p.A.	174
Feiz Design Studio	176
Khodi Feiz	178

Chapter 9

Explanatory drawings 179

Drawings can be used to 'explain' product information to others. Communicating the integration of technical parts of a product to engineering, for example, or the working of a product to the end user. Over time, the communication of technical information has resulted in specific kinds of drawings; like the Exploded View or the Instruction Manual.

Introduction	179
Richard Hutten Studio	180

Exploded views	182
MMID	184
IAC Group	186
SEAT	187
Cut-away	188
Ghosting	189
FLEX/theINNOVATIONLAB	190
Instructional drawings	191
FLEX/theINNOVATIONLAB	194
DAF Trucks NV	196

Chapter 10

Surface and textures 197

A drawing of a product will become more realistic if its material properties, such as transparency, gloss or structure, can be seen. The intention is not to draw photo-realistically, but to gain insight in effects and properties, so that material can be 'suggested'. Drawings can be made more 'presentable', and decisions in the design process can be taken based upon them.

Introduction	197
Pininfarina S.p.A.	198
Reflections	201
Guidelines for reflections	202
Glossy	204
Mat	205
SPARK Design Engineering	206
Springtime	207
Jan Hoekstra Industrial Design Services	208
Chromium	210
WAACS	212
BMW Group	213
Glass	214
Textures and graphics	217
Van der Veer Designers	218

Chapter 11

Emitting light 221

A special kind of drawing situation occurs when an object is emitting light. Bright light and also soft light such as backlights or LEDs are discussed.

Introduction	221
Marcel Wanders Studio	222
Emitting bright light	224
FLEX/theINNOVATIONLAB	226
Pilots Product Design	227
Emitting soft light	229
Studio Jan Melis	231
Studio Jacob de Baan	233

Chapter 12

Context 235

Products are related to people, interfaces, interaction, and ergonomics. Some products are indistinct when seen without their context, especially for people outside the branch or design field, like marketers or sponsors. People or surroundings can simply place a product in its context or even show the real-life implications of a product and at the same time give scale.

Introduction	235
Pilots Product Design	236
VanBerlo Strategy + Design	237
User context	235
Well Design	239
Blending in part of an object	240
Combining pictures and drawing	242
Hands	244
People	246
Van der Veer Designers	248
VanBerlo Strategy + Design	250
Bibliography	252
Credits	253

Introduction

Are designers still making drawings by hand? Isn't it more advanced to use a computer in this computer era? Some may think sketching is a disappearing skill, but if you ever enter a design studio, you will find out differently. Studios still make sketches and drawings by hand – and in most cases, quite a lot of them. They are an integral part of the decision-making process, used in the early stages of design, in brainstorming sessions, in the phase of research and exploring concepts, and in presentation. Drawing has proved itself, next to verbal explanation, to be a powerful tool for communicating not only with fellow designers, engineers or model makers but also with clients, contractors and public offices.

Our purpose in writing this book about drawing and sketching is to show the incredible power of sketches in the designing process. Skills matter, but even in a quick thumbnail sketch, some designers can already reveal what the final result could be.

We set out to analyze the significance of sketching and drawing in design studios. By visiting them with a questionnaire, we got an interesting overview of the use of these skills in industrial and other design practice in the Netherlands. In analyzing design sketches, there is no such thing as a 'good' or a 'bad' drawing without knowing what its purpose or context has been. A better question to ask is whether a drawing is effective or not. A very photorealistic drawing at the start of a design process can be 'beautiful' but also inefficient. Drawing is like language; choosing an exploded view or a side view to communicate information with an engineer is effective because such drawing conventions are part of an engineer's visual language.

In this book, we have displayed the sketches in relation to the design process or to the final result, together with an explanation of the context. These design projects can also be regarded as presentations of the studios themselves. This gives an interesting overview of various sketching methods and usages within different design environments. It affords a glimpse into the world of exploring, choosing and communicating, and will show the importance of drawing.

We invited both industrial designers and '3D designers' (who approach design as applied art) to participate in this book. The role of drawings

IT'S A VACUUMCLEANER...! A MIXER..? A CAR? NO.... A TOASTER ... UHHH.... A PAPERCLIP MACHINE..? HMM..... A ROBOT, A STARFIGHTER, A TRASHCAN...A COFFEE MACHINE, A... AH HIGH-POWERED, FULL AUTOMATIC, SELFSUSTAINABLE LAWN MOWER

NO... NO... GUESS AGAIN ...NO ...NO...

is different everywhere; so are drawing styles. It is therefore interesting to focus on these differences – and, of course, also on the similarities. A drawing can express a vision, suggest a possible solution, generate ideas, visualize a thought process, or be used as a way to 'think on paper'. Which sketch has had a big impact on the design process? And how does that sketch relate to the final product?

A number of books have been written about drawing techniques. Most of them contain a few prescriptions on how to make drawings, explaining the rules of perspective and the use of drawing materials and showing the results in drawings. To gain a better understanding, we wanted to reverse the process: rather than writing prescriptions and showing results, instead challenging readers to be active, looking for information within the work of the studios, learning from them and finding explanations.

This is why we have placed the sketches of the design studios between the related drawing items and instructions. This also means that the book is more of a reference guide rather than a drawing course, and is primarily aimed at students of design schools and universities.

We intend to give more depth to the question of 'why'; there should always be a reason for a drawing and how it is drawn, a goal to aim at. Learning how to draw is very similar to learning how to write. One person may have nicer handwriting than another, but the writing of both of them should be legible. The better story is not always written in the best handwriting. Drawing skills can be improved and will surely result in an effective way of drawing; but the power of reason will prevail.

The purpose of making a drawing has changed over time, as has the content of a visualization. Computer rendering initially pushed hand sketching towards the start of the design process, only to be used in initial ideation, brainstorming, etc. Now that the use of the computer has settled in, and the benefits and disadvantages are clearer, it is time to re-evaluate.

Time is an issue. Things have to speed up, and it is more important to visualize effectively. In a lot of cases, a quick suggestive sketch is preferable to a more time-consuming rendering. A rendering can look very definite and unchangeable, which is not appropriate, for example, when a studio is still conferring with its client about design directions and possibilities. There are ways to take a first brainstorming sketch and upgrade it to a more presentable drawing. This saves even more time, and inspires you to react intuitively to (or in) your sketch while you are drawing, whereas a rendering offers no possibility for reaction until after it is finished.

In a competitive world, a design has to 'stand out'. Pitches are aimed at people from outside the design field, such as marketers or sponsors. A verbal presentation may not always be included, so the imagery should be catchy, inspiring and powerful. This has required innovative ways of looking at visual communication.

A related tendency is to communicate a design or idea by placing it in an understandable context, intelligible to a total outsider. This can result in scenario-like or context-driven images, communicating the design's impact on real life, its 'feel' or 'emotion'. Freehand drawings can be expressive.

All of the above are reasons why a lot of studios have reconsidered the use of drawing done by hand, causing freehand drawing to gain renewed attention – both as a method on its own and, more especially, mixed with digital media, utilizing the advantages of both worlds. In this book, we have regarded freehand drawings done on paper as equivalent to freehand drawings made with graphic software in combination with a drawing tablet and a digital pen or airbrush, for the drawing methods are very similar. Instead of focusing on what marker to use or which airbrush is the best tool, we prefer to discuss colour in general. We have approached drawing aspects and techniques in a universal way, applicable to various media.

Furthermore, with this book we present an overview of design in the Netherlands. It is a collection of different design attitudes, revealing some of their secrets and showing unique design drawings that would normally stay within the walls of the studios – drawings using the power of freehand sketching.

Koos Eissen and Roselien Steur
May 2007

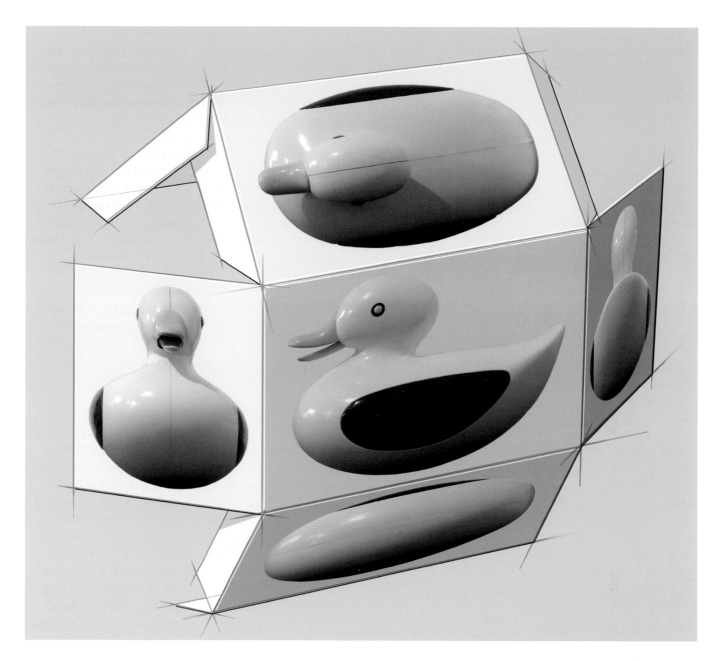

Side view sketches

A side, or isometric, view is a theoretical represen-
tation of an object. Its historic background can be
found in engineering, where technical information
about shape is presented in side views and cross
sections. A commonly used documentation is the
American projection method, in which various views
are arranged in a specific way. The most characteristic
one, the side view, is placed in the centre, with the
top view above it, the left view at its left, etc. In a lot
of cases, a sketch of the side view will be sufficient to
basically suggest a product idea.

Sketching in side view offers an easy way to draw a
three-dimensional representation of a product, as
side view drawing is generally considered easier to
do than perspective drawing. So using side views in
ideation is a way to speed up your sketches. A lot of
designers prefer to draw in side view, especially in the
early stages of a design, as sketching in perspective
can sometimes hinder spontaneous and unguided
thoughts.

Getting started

An underlay has several advantages for getting started. It speeds up the drawing process and gives a realistic sense of proportion, volume and size. When redesigning a handheld domestic food mixer, using a photo of an existing product, a 1:1 scale is most convenient because you can actually compare hand size and grip. Ergonomics and a realistic appearance can thus be integrated easily. By drawing archetypal mixer tools, the design proposal gains legibility and scale.

A line drawing leaves room for many interpretations, so shading is added to express volume. Choosing an appropriate light direction (coming from the top left, slightly away from you and going towards the object) makes volumes and shape transitions recognizable. When adding volume and colour to a line drawing, decisions about the look and feel have to be taken immediately. Clearly, shading is of paramount importance. Knowledge about light and shading will be a key issue throughout this book.

In a brainstorming session you don't immediately evaluate the results. It's important to just keep your freedom and stay open-minded about ideas, looking for other visual stimuli that offer new challenges.

A contour in side view can represent various 3D forms.

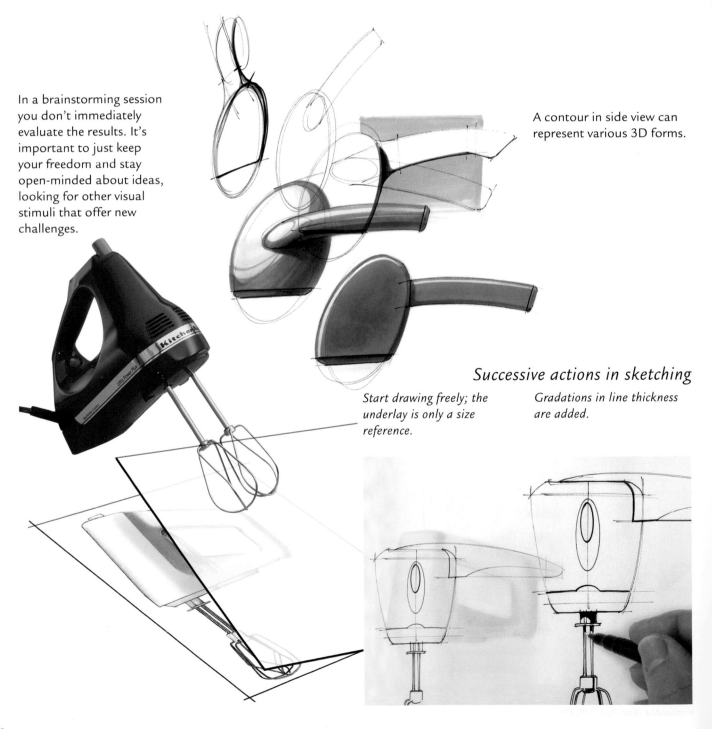

Successive actions in sketching

Start drawing freely; the underlay is only a size reference.

Gradations in line thickness are added.

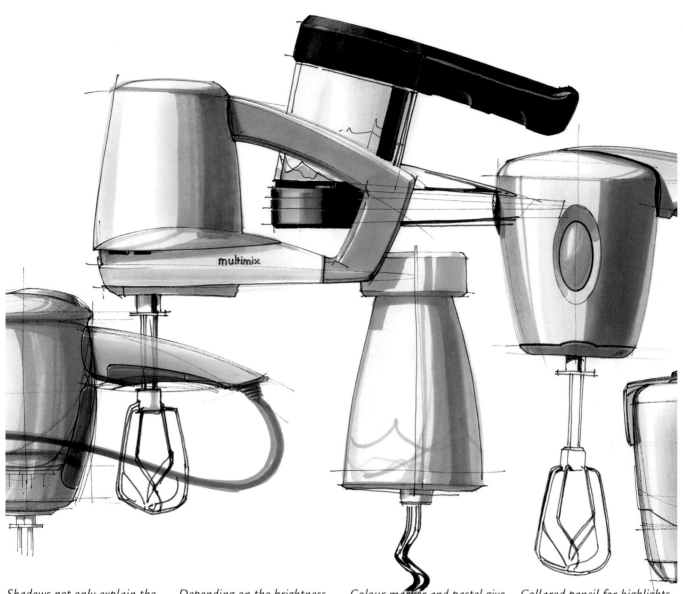

Shadows not only explain the forms that cause them, but also the forms upon which they are cast.

Depending on the brightness of the colour, a lighter or darker gray marker is chosen to darken it.

Colour marker and pastel give the suggestion of colour.

Collared pencil for highlights and details finishes the drawing.

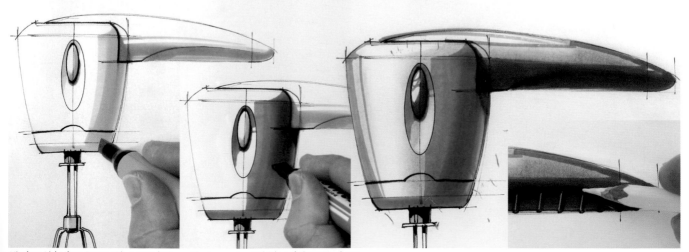

KitchenAid Ultra Power Plus Handmixer. Photography: Whirlpool Corporationv

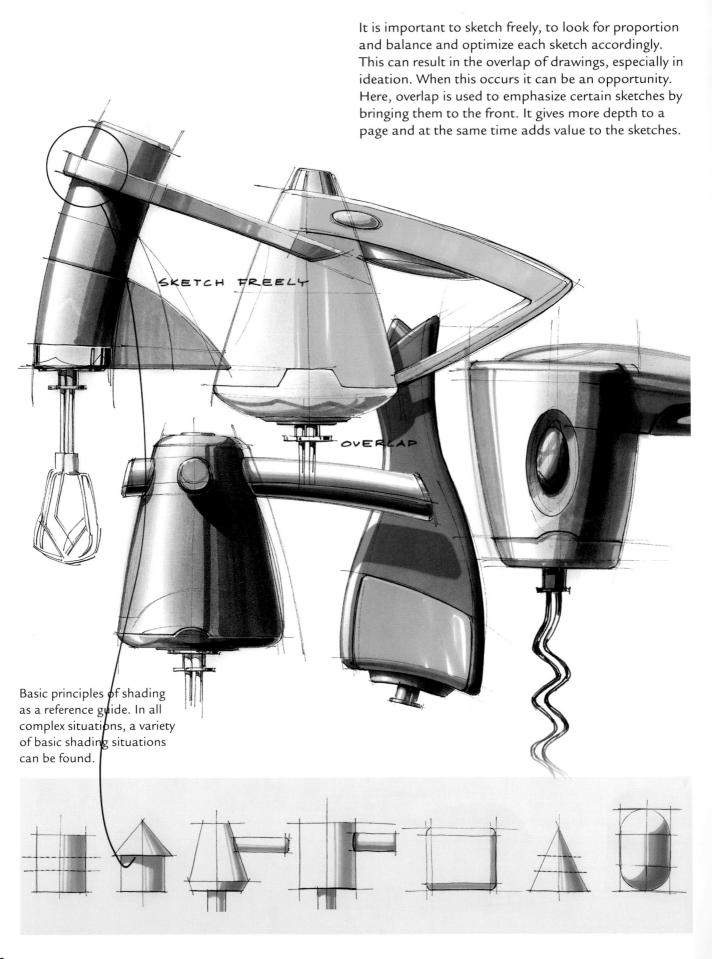

It is important to sketch freely, to look for proportion and balance and optimize each sketch accordingly. This can result in the overlap of drawings, especially in ideation. When this occurs it can be an opportunity. Here, overlap is used to emphasize certain sketches by bringing them to the front. It gives more depth to a page and at the same time adds value to the sketches.

SKETCH FREELY

OVERLAP

Basic principles of shading as a reference guide. In all complex situations, a variety of basic shading situations can be found.

Especially when using an underlay – in which case all sketches become more or less equal in size – overlap can add more variety to a page. It is generally considered more dynamic than separate sketches.

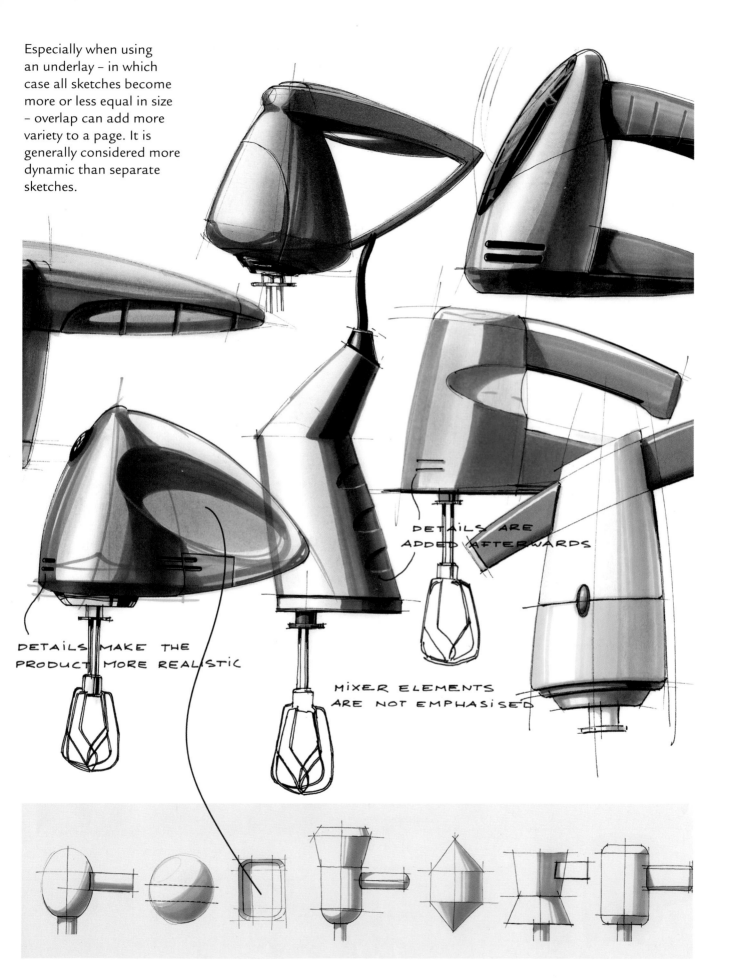

DETAILS ARE ADDED AFTERWARDS

DETAILS MAKE THE PRODUCT MORE REALISTIC

MIXER ELEMENTS ARE NOT EMPHASISED

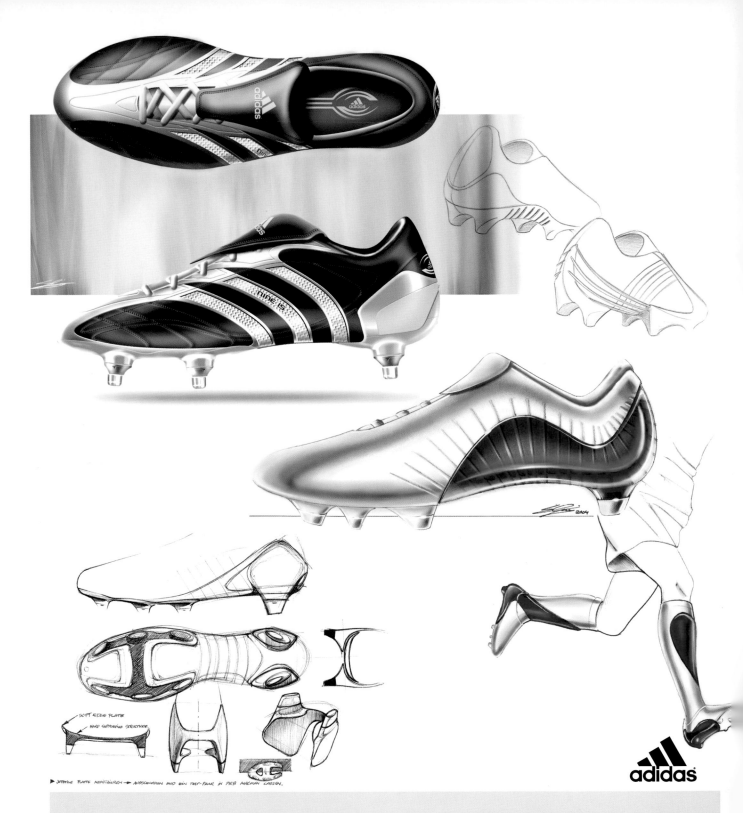

Side views are often used in Footwear Design because shoes are commonly displayed this way in a store to catch the consumer's eye. The drawings shown here cover the initial design process, from concept sketches to final renderings. Drawings are not only used to explore design solutions or to represent a product realistically; their emotional aspect is also very important. They serve to get people excited about a project within the company. Some are also presented to athletes and consumers for feedback.

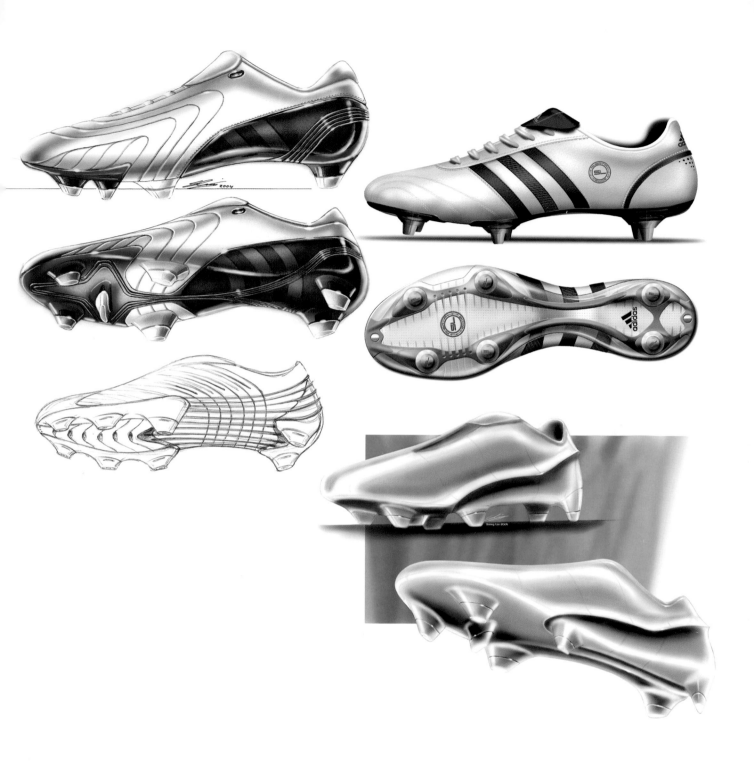

Adidas AG, Germany – Sonny Lim

Many Footwear Designers at Adidas are trained as Industrial Designers. However, there are also quite a number of Transportation and Media designers. The drawing styles are different for every designer, and everyone uses a mixture of techniques. This creates a great cross-functional environment for exchanging visualization and sketching techniques.

The blue and red Football boots were drawn by hand, using blue pencil, markers, fineliners and a Pantone marker airbrush. The drawings were scanned in and the highlights added in Photoshop. The computer renderings were entirely done in Photoshop and Painter, although a hand sketch was still often used as an underlay to get the proper silhouette. Logos and other details, like stitches, were drawn in Illustrator and again imported into Photoshop.

Light and shading

Just like in photography, choosing the most informative viewpoint and a suitable light direction is essential in creating an optimal 3D illusion. By adding tonal values (light and shading), one can express volume. A cylinder should look round, a flat surface flat. Analyzing objects and light conditions is very helpful in understanding the relations between shapes and shadings, and offers basic information suggesting the volumes and combinations needed for creating depth in a two-dimensional sketch. Some products, like clock radios, microwave ovens, and washing machines, clearly have a side that is most informative. In other cases, one has to decide which viewpoint contains the most of a product's (shape) characteristics.

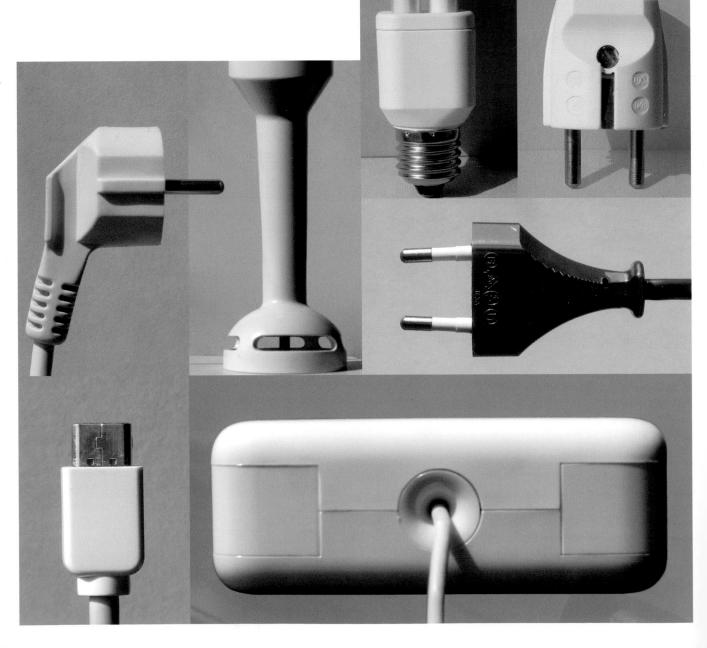

Choosing an angle of light steeper than 45°, coming from a direction slightly away from you and going towards the object, not only results in a clearer distinction between the two shaded (and highlighted) sides, but also in a more distinctive cast shadow.

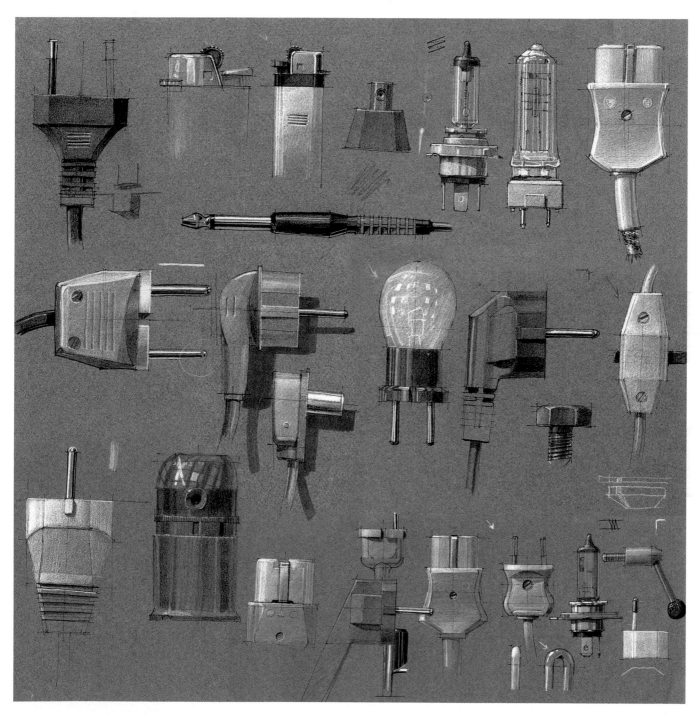

Using collared paper instead of white is an attractive alternative for monochrome sketches. Taking the colour of the paper as the midtone, white colour pencil can be added for the lighter tones and highlights, and black colour pencil for the darker areas.

Drawing from nature, in other words, translating reality on paper, is a useful exercise in creating shading effects. This stimulates you to make a 'visual library of shading situations' and will in time enable you to apply shading without having to think about it.

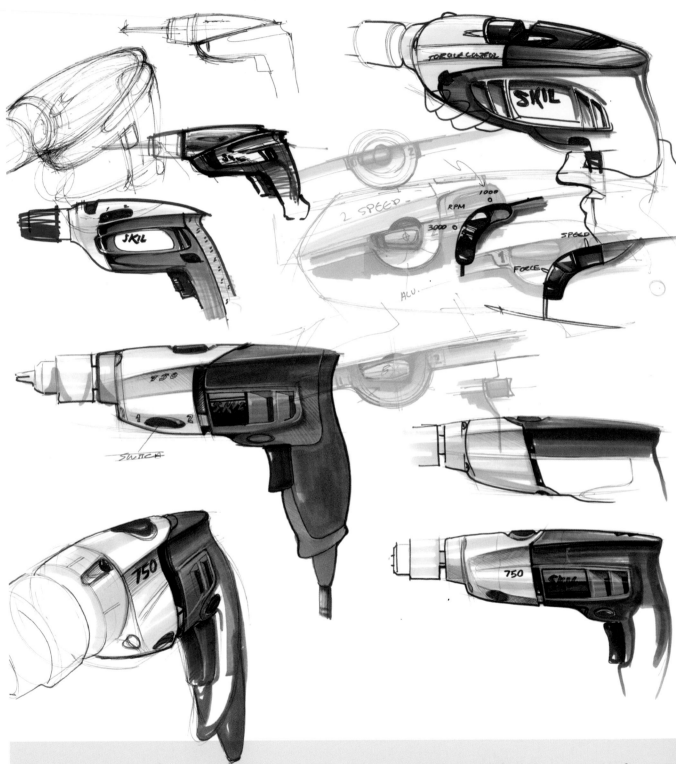

Different designers worked together on this project. Visual language and handwriting should be compatible. In addition to drawings, 1:1 models were made to carry out specific ergonomic studies.

These models then served as a starting point for more elaborated drawings. Although most drawings are in side view, three-dimensional approaches are also necessary to determine shape transitions and connections that would otherwise stay hidden.

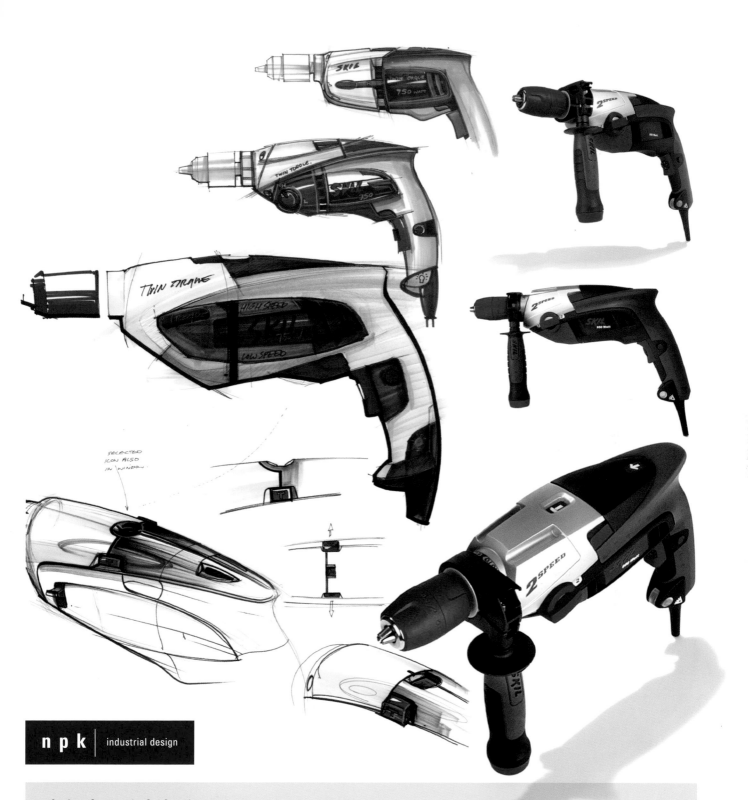

npk industrial design

This Two Speed Impact Drill for Skill (2006) is the start of a new product line that focuses on ergonomics and styling. In this shape strategy, strong lines and soft grips were applied in accordance with the Skill corporate identity. Npk developed the housing, mock-ups and product graphics.

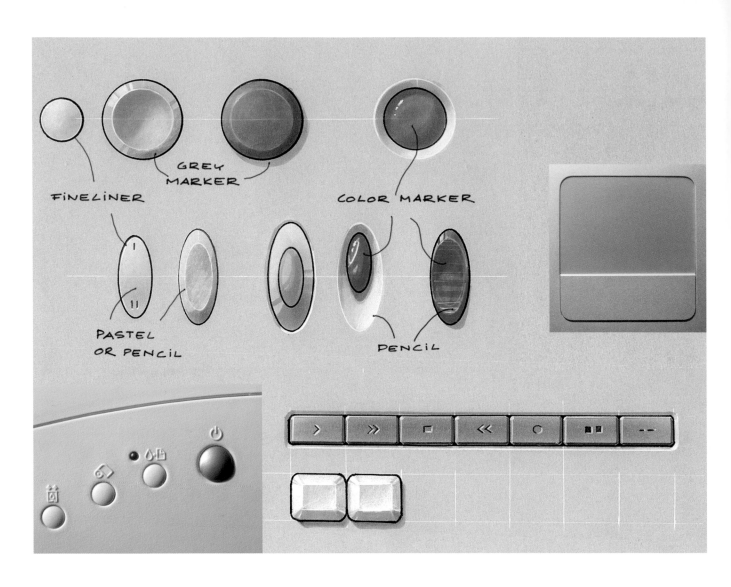

FINELINER

GREY MARKER

COLOR MARKER

PASTEL OR PENCIL

PENCIL

Details

Adding some details to a sketch can give it a far more realistic appearance. Details can also indicate the overall size of an object. Studying pictures of product details will reveal the basic principles of shading.

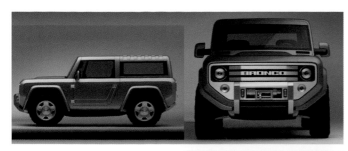

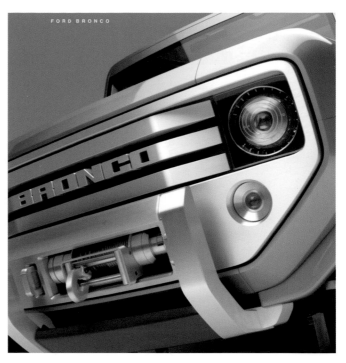

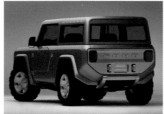

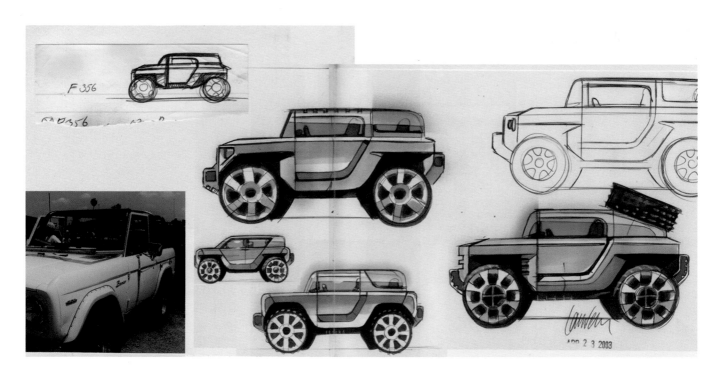

Ford USA – Laurens van den Acker

Sketches drawn in side view give the first impression and basic layout of the SUV. The car's appearance should convey advanced simplicity and power. Every detail added must underline these aspects. With a complex shape such as a car, early sketches in side view speed up the design process and visualize a clear statement about the design.

The Ford Bronco SUV concept of 2004 was inspired by its predecessor, the famous 1965 original Bronco (designed under engineer Paul Axelrad). Simplicity and economy were the main issues, translated in flat glass, simple bumpers and a box-section ladder frame. It turned out to be a popular off-roader. In the 2004 Bronco concept, Ford re-explored this authentic spirit, but added advanced powertrain technologies.

Chief designer: Joe Baker. Photography: Ford Motor Company, USA

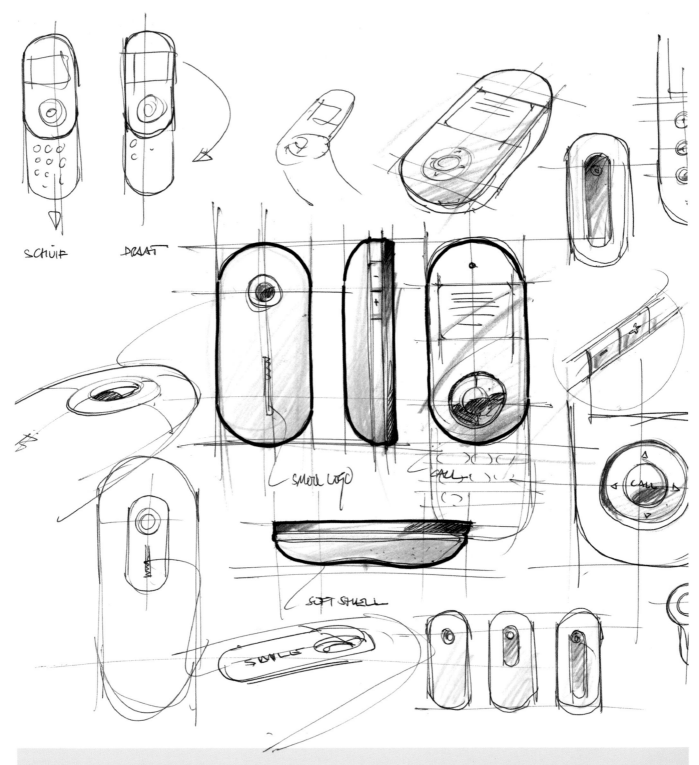

SCHUIF DRAAT

SMOOL LOGO

CALL

SOFT SHELL

SMOOL

SMOOL Designstudio

For designer Robert Bronwasser, handmade sketches are the basis of each design. Sketching stimulates creativity and offers a very quick way to explore design possibilities, study proportions and try out details. By varying the sketches in size, viewpoint, perspective and colour, the design opportunities become clearer. Sketching and designing in side view requires imagination and knowledge of how to visualize in 3D.

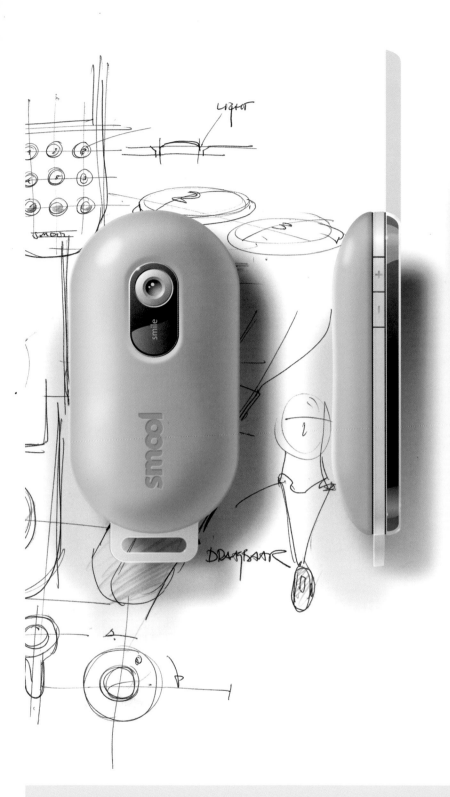

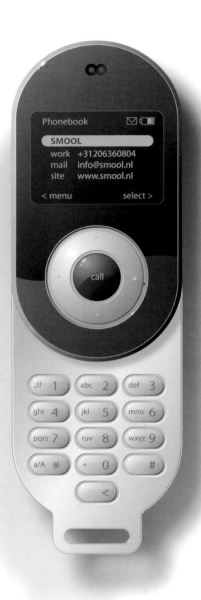

smool

For a period of time, SMOOL Designstudio advertised in the leading Dutch design magazine *Items* with a redesign of an existing product. With these recognizable designs, Robert Bronwasser showed his vision of today's design by applying his own design idiom. The final and detailed side views are made with Adobe Illustrator. *Items/2*, 2006

Drop shadows

Cast shadow can be needed for other reasons than expressing depth. In this case it is used to suggest the transparency of parts of the coffee machine. This shadow is simplified; the contour of the product is the outline of this 'drop shadow', which is cast on an imaginary surface behind the product. It is far easier to manage than constructing a perspectively correct one.

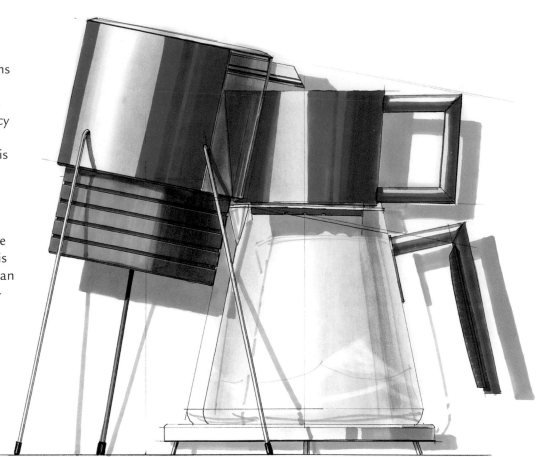

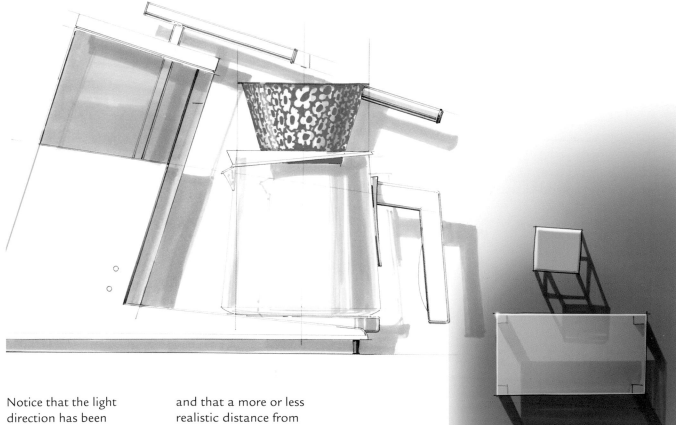

Notice that the light direction has been chosen for an effect of optimal transparency and that a more or less realistic distance from the background surface is suggested.

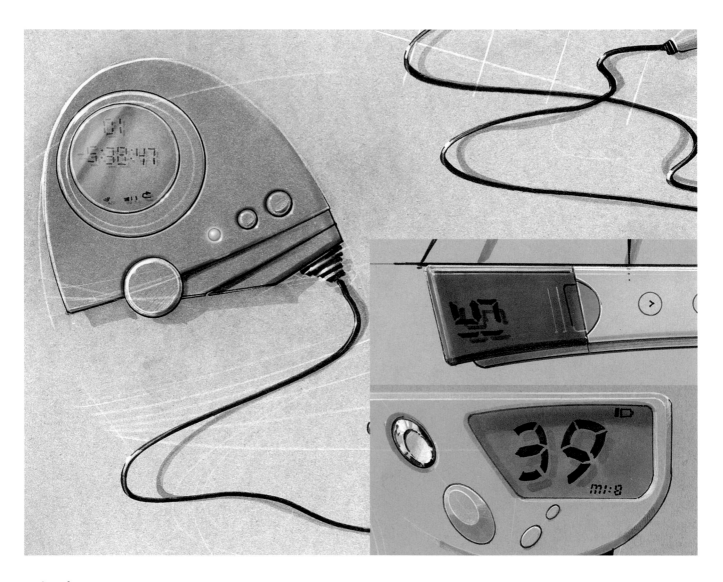

Displays

Displays are details commonly seen in products. To suggest them, we draw the characters in the display and add some depth through cast shadow. Reflections can be added afterwards with white chalk.

In most cases, the difference in transparency is more important than the exact location of the reflections that cause it.

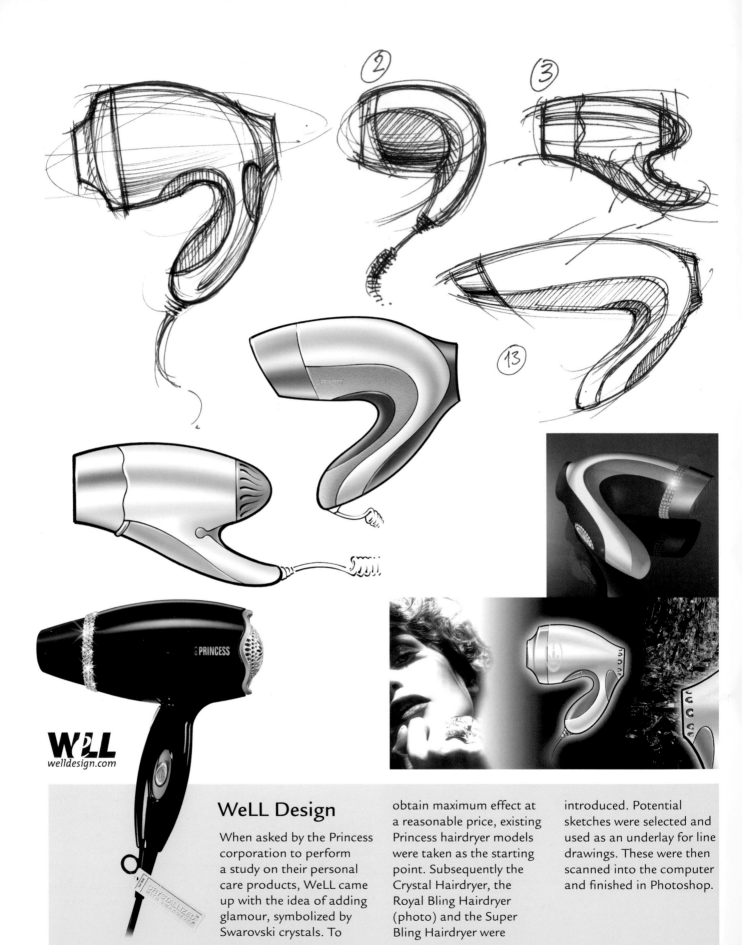

WeLL Design

When asked by the Princess corporation to perform a study on their personal care products, WeLL came up with the idea of adding glamour, symbolized by Swarovski crystals. To obtain maximum effect at a reasonable price, existing Princess hairdryer models were taken as the starting point. Subsequently the Crystal Hairdryer, the Royal Bling Hairdryer (photo) and the Super Bling Hairdryer were introduced. Potential sketches were selected and used as an underlay for line drawings. These were then scanned into the computer and finished in Photoshop.

Designers: Gianni Orsini and Mathis Heller. Product Photography: Princess

Perspective drawing

Knowledge of basic perspective rules is of course needed to start drawing in perspective. But the same object can be presented in various ways; a sketch can communicate information about the shape of a product as clearly as possible. A sketch can also be used to emphasize an object as being tiny or big and impressive. The visual information conveyed by sketching is highly influenced by the choice of viewpoint, scale elements and use of perspective rules. Managing these effects allows various suggestions of reality.

Scale

Scale is a very influential factor. Human size is regarded as the standard in scale elements. Everything can be related to human size and perception. Something above the horizon, for example, is above normal eye-level, and must be bigger than human height (if perceived while standing). Another way to estimate size, or scale an object, is to compare it with familiar surrounding objects. These 'scale elements' can make something look relatively small or big. Cats, people, hands or matches represent a predictable size, so they can explain the size of a product next to them. The clothespins at the right, for example, scale down the size of the kit.

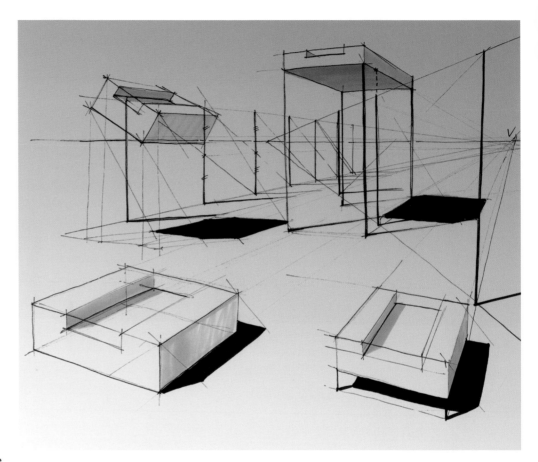

Scale is always related to what we know and what we sense by comparison.

A remarkable visual effect, the third vanishing point (of the vertical lines), can be seen in pictures of buildings. The buildings seem to be falling backwards. It is more difficult to see this effect in real life, for our minds correct our perception – vertical shapes are supposed to be perceived as vertical. Taking this effect into account, vertical lines are generally kept vertical in drawings. However, introducing the third vanishing point or slightly curved lines can give more dramatic expression to a drawing.

Perspective convergence

The apparent size of an object is also influenced by the amount of convergence. In the top right picture of the first aid kit, the use of too much convergence causes a misrepresentation of its size; it appears to be huge. When less convergence is used, the object tends to look more natural.

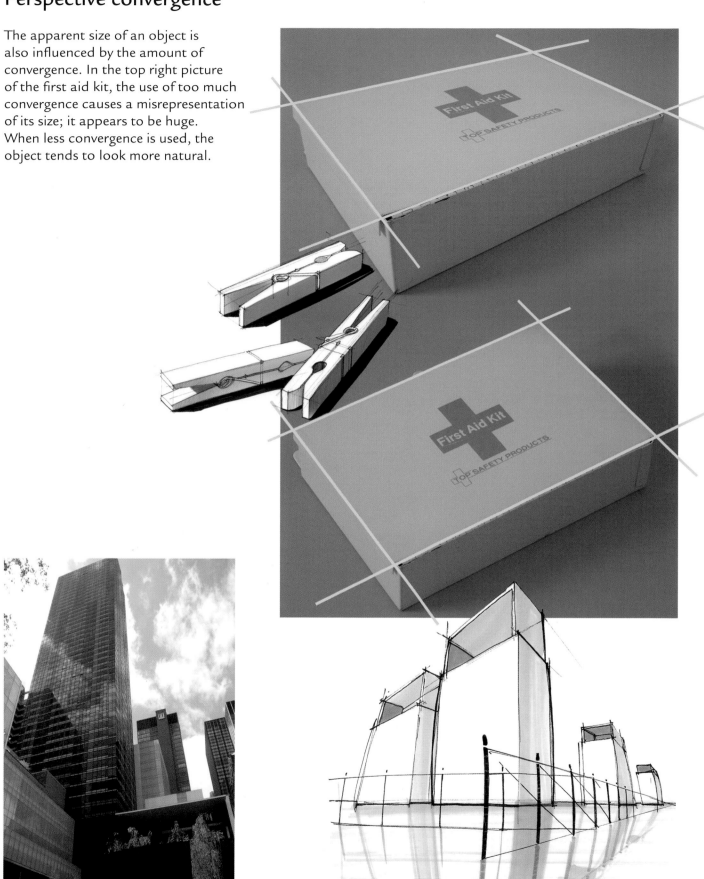

Distortion

The amount of convergence is influenced by its relative distance from the observer; the closer we get to an object, the more convergence is seen. It is important to find a balance between viewpoint and the amount of perspective convergence.

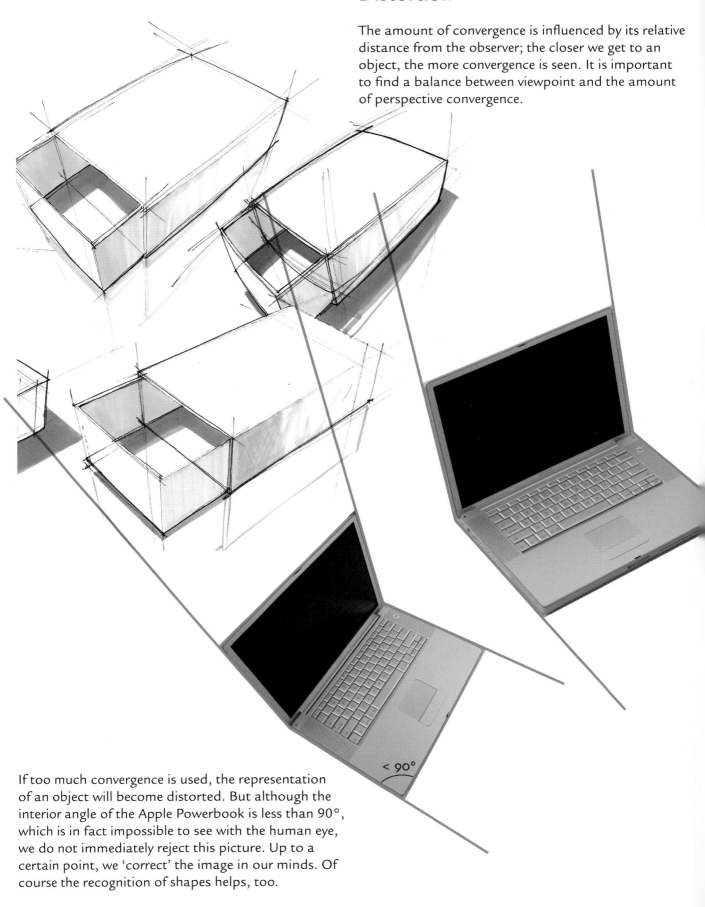

If too much convergence is used, the representation of an object will become distorted. But although the interior angle of the Apple Powerbook is less than 90°, which is in fact impossible to see with the human eye, we do not immediately reject this picture. Up to a certain point, we 'correct' the image in our minds. Of course the recognition of shapes helps, too.

< 90°

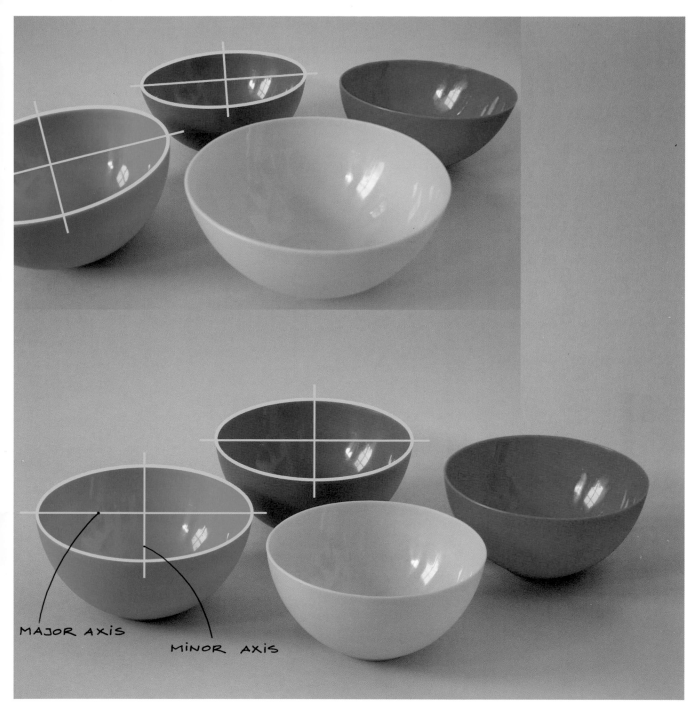

MAJOR AXIS

MINOR AXIS

The distortion of the above ellipses is also the result of too much convergence. Even the horizontal surface on which the bowls are standing seems to curve. Distortion can also be seen in the huge difference in size between the green and pink bowls.
A circle in perspective is represented by an ellipse, which is a mathematical shape.

The major and minor axes are an aid for its shape and orientation. On a horizontal surface, the long axes are drawn horizontally.

Foreshortening

When looking perpendicular at a surface, the relative dimensions of that surface stay intact. If surfaces are angled away, foreshortening effects can be perceived.

Focusing on the distance between the red lines, size a is smaller than b, as its surface is more angled away. As a result, size b appears bigger although it is further away.

Detail, Functional Bathroom Tiles – Arnout Visser, Erik Jan Kwakkel and Peter vd Jagt

Functional Kitchen Tiles – Arnout Visser,
Erik Jan Kwakkel and Peter vd Jagt

At each orientation, the tiles' dimensions are seen
as different in size, but perceived as equal in size.
Different viewpoints show that a higher point of
view makes a surface less foreshortened. A circle in
perspective then looks rounder.

These plates are
flattened due to
their distance
from the observer.

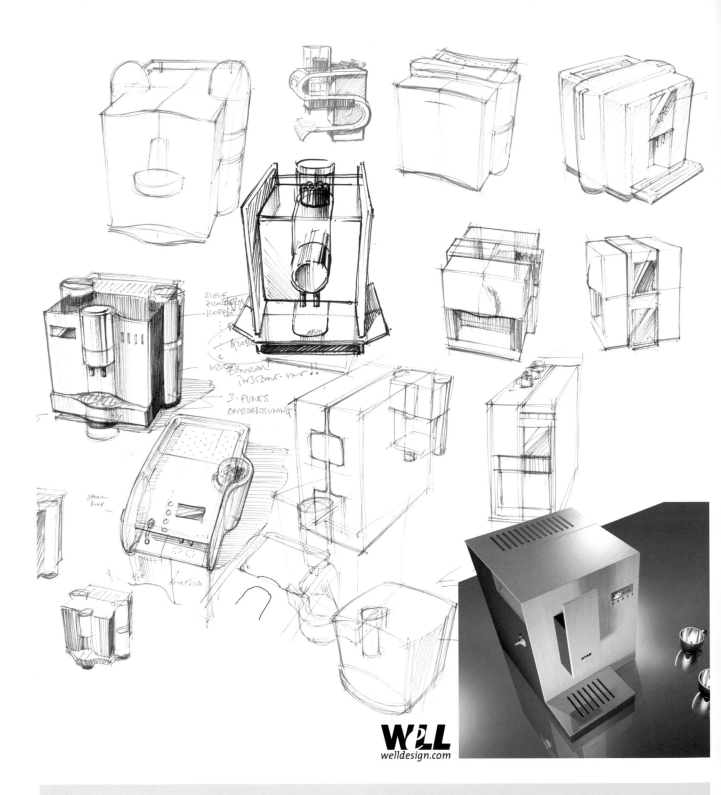

WeLL
welldesign.com

WeLL Design

For Etna Vending Technologies, a series of fully automatic espresso machines was developed by designers Gianni Orsini and Mathis Heller. After a thorough strategic analysis of the market, the conceptual phase was carried out in competition with two other major Dutch design studios. The aim was a more luxurious design than dozens of other machines at the same price level.

Another challenge was to come up with designs that would suit their own brand and two unspecified global brands. Finally, it should be possible to fit three different structural components within the same housing design.

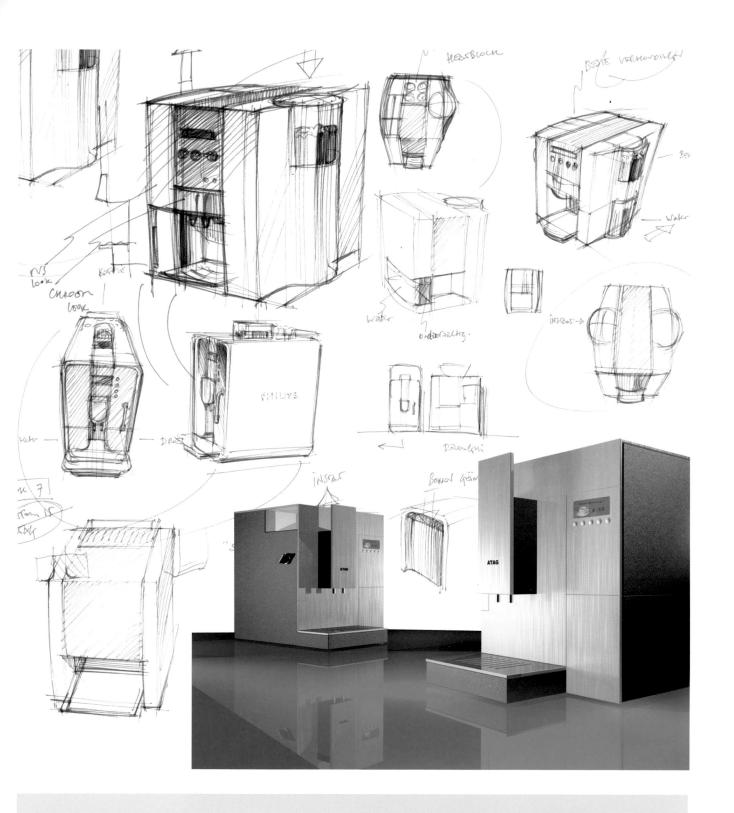

Numerous sketches were made to explore and visualize product ideas, not only to generate a flow of ideas, but also to be able to discuss them later or be stimulated to react to them with another drawing. Emphasizing potential ideas in sketches also maps the design process.

Viewpoint

Finding the best angle of view for a complete and informative representation of an object is sometimes difficult. One can look at an object from different heights, and from different directions. The choice of viewpoint causes certain parts and details to be hidden or revealed.

Objects usually have a side view that is most informative. In general, a drawing will be more characteristic (and informative) when this side view is only slightly foreshortened.

The more foreshortened a surface is, the less information it can display.

A design proposal usually needs more than one drawing to give enough information.

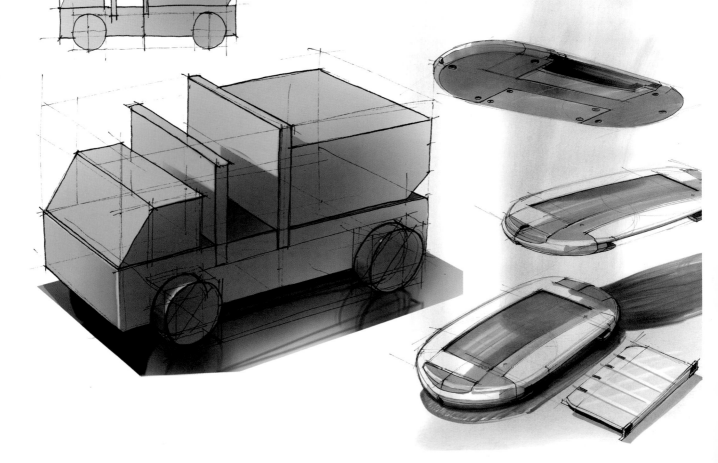

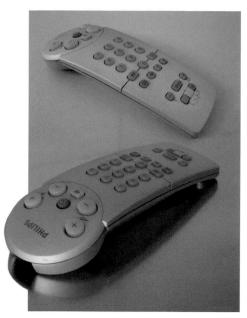

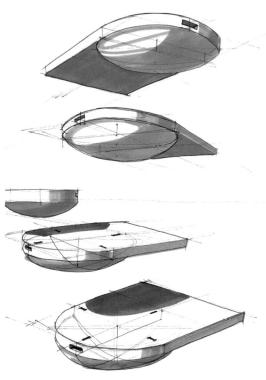

Look at the differences in visual information about the remote control. Both the overall curved shape and the details are more emphasized in the bottom picture. A relatively high viewpoint will normally be more adequate for exploring shapes, because it creates an efficient and informative overview. Choosing a viewpoint that resembles the user's point of view, also enables the viewer to relate to the object.

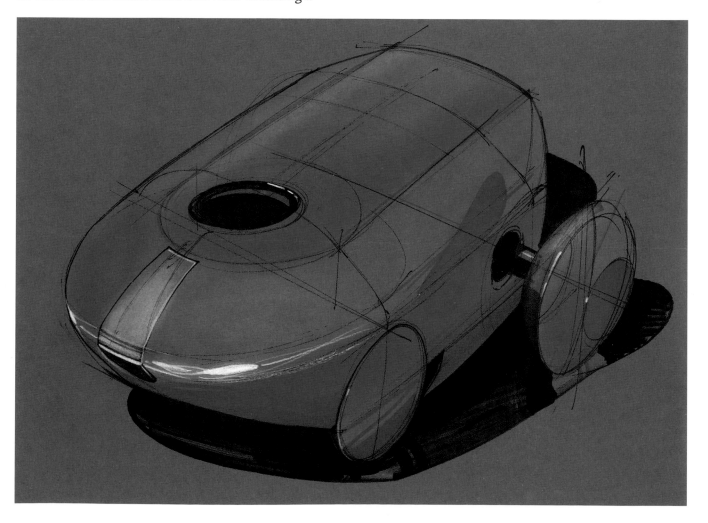

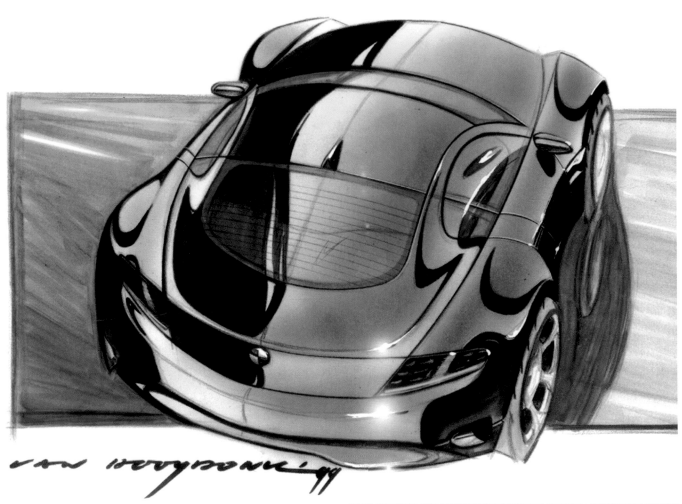

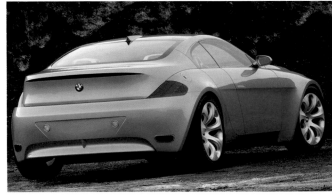

BMW Group, Germany – Adriaan van Hooydonk

This sketch for the BMW-Z9 concept car is drawn from an interesting angle. The choice of viewpoint highly influences the feeling of the vehicle, adding power. This viewpoint best shows the influence of the wheel arches in relation to the body of the car.

Actually, every aspect of this drawing is aimed at achieving this feeling, by using strong lines and the effect of highly polished surfaces. The sleek look of the BMW Z9, a show car sport coupé, hints at future automotive design.

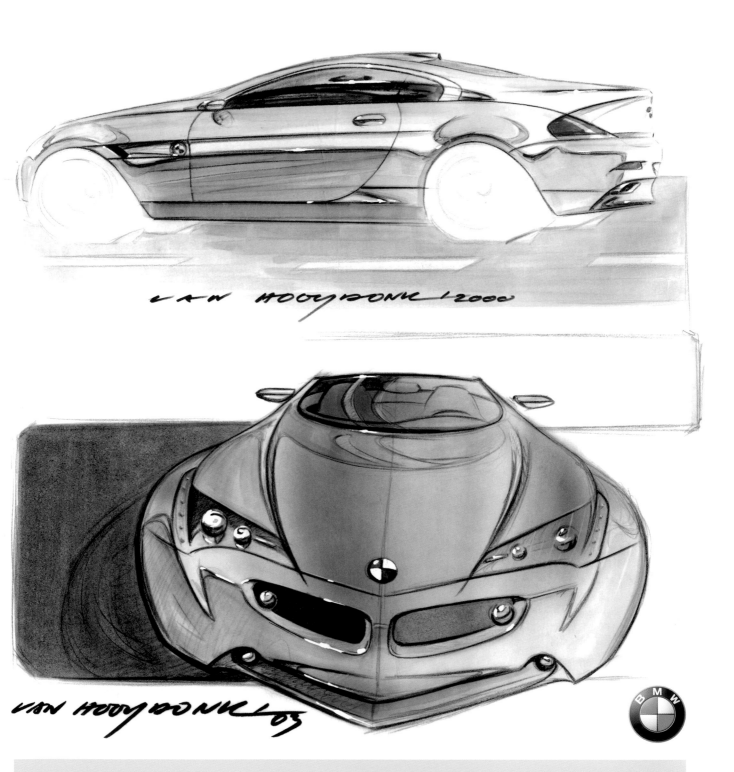

Besides the lightweight construction, the interior design shows an interesting new philosophy about audio communication and driving comfort.

Two sketches by Adriaan van Hooydonk showing different angles of view: a sketch of the BMW 6-series and an impression of a Roadster. Both sketches are made by starting with a pencil, adding marker and, in the case of the drawing below, pastel on both sides of Vellum.

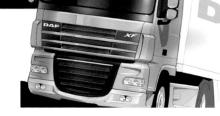

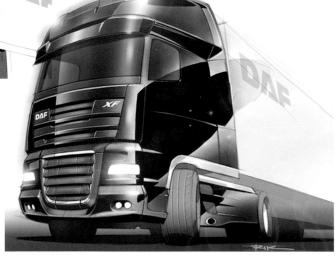

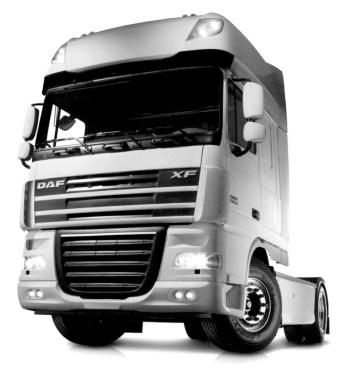

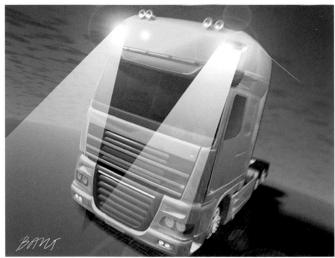

DAF Trucks NV

DAF Trucks is part of PACCAR, a leading company in the transportation industry. The DAF Design Center is located in Eindhoven, the Netherlands, and is responsible for the design of all DAF Trucks.

In 2006, DAF launched its new flagship, the XF105, and was awarded as 'International Truck of the year 2007'.

Comparing the actual DAF XF105 to the drawings shows a remarkable coherence in feel and character. In each drawing, viewpoint and perspective are carefully chosen for a specific reason. An extreme low angle of vision provides an even more dramatic feeling of the impressive length of this long-range truck. A tilted drawing can give a more dynamic sensation. Extreme perspective can produce effects such as these and can also emphasize particular details, such as rooftop lights.

Designers: Bart van Lotringen, Rik de Reuver

In the case of these handhelds, a very high viewpoint is recognizable, as it resembles the user's point of view. The drawings are started with the top surface, which now has almost no perspective convergence. That also makes it easier to paste graphics or add details such as knobs, as this surface is almost in side view.

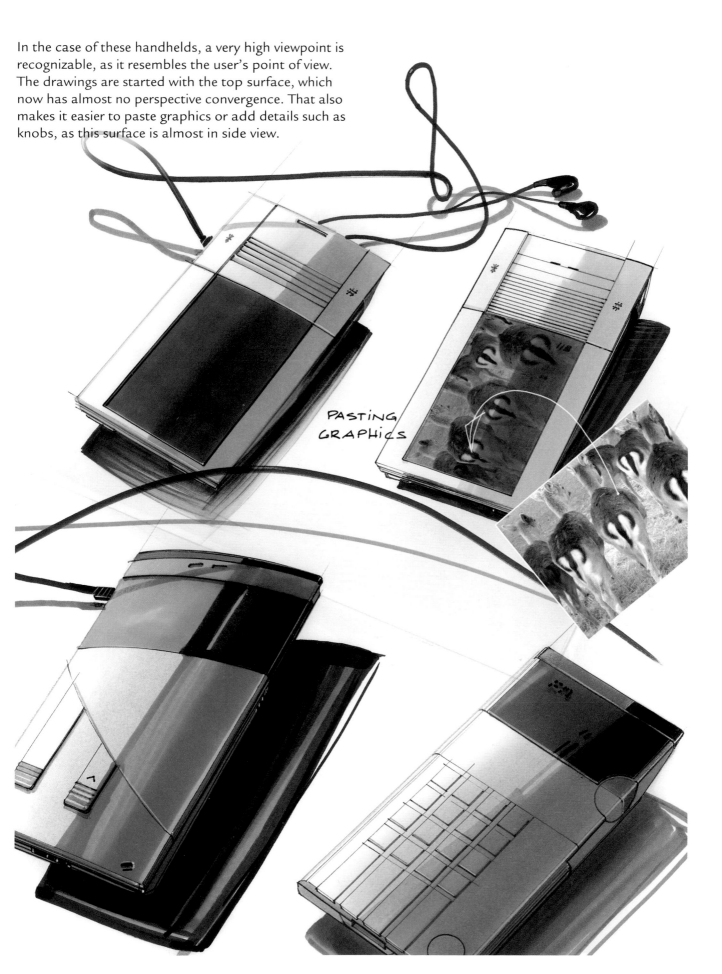

PASTING GRAPHICS

Eye-level perspective

Whereas bird's-eye perspective can create an overview and enriches shape information, eye-level perspective suggests human-related size. Of course, one can directly sketch in eye-level perspective with the aid of the horizon. But it can also be easily derived from a drawing in bird's-eye perspective. A surface is drawn at eye-level, intersecting the object. Lines above this surface will be above the horizon. All vertical lengths stay intact, as does their horizontal position, e.g. the width of the drawing; lines are only rearranged vertically.

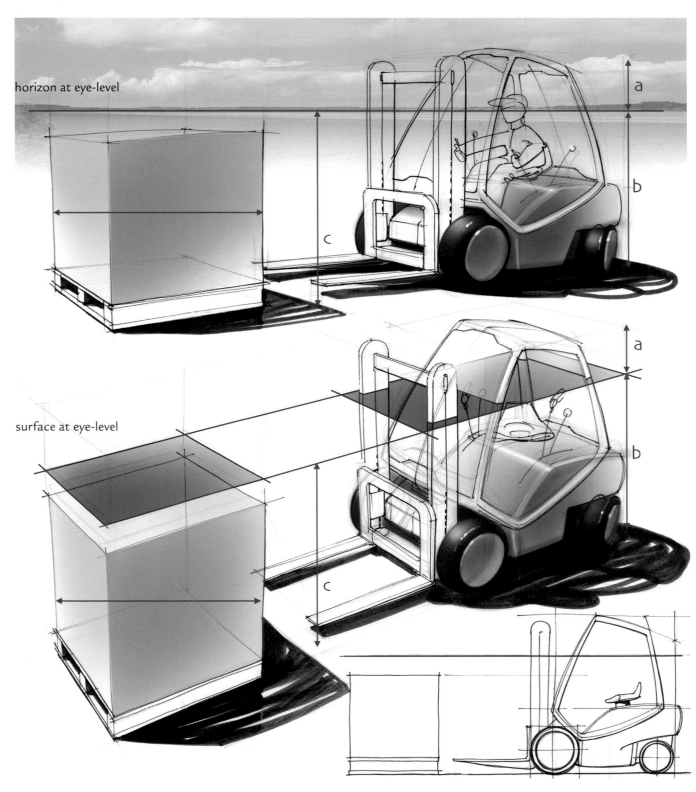

horizon at eye-level

surface at eye-level

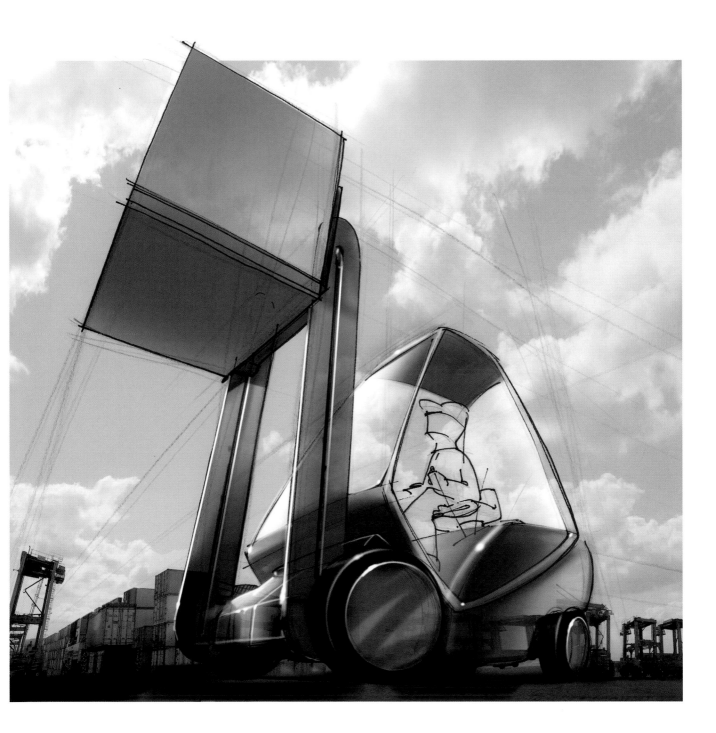

Extreme perspective

This perspective consists of an unusual viewpoint together with an exaggeration of perspective. A very low standpoint, where the surface of the ground equals the horizon (frog-eye perspective), can make the object appear impressive. A third vanishing point, that of vertical lines, is introduced together with a lot of convergence.

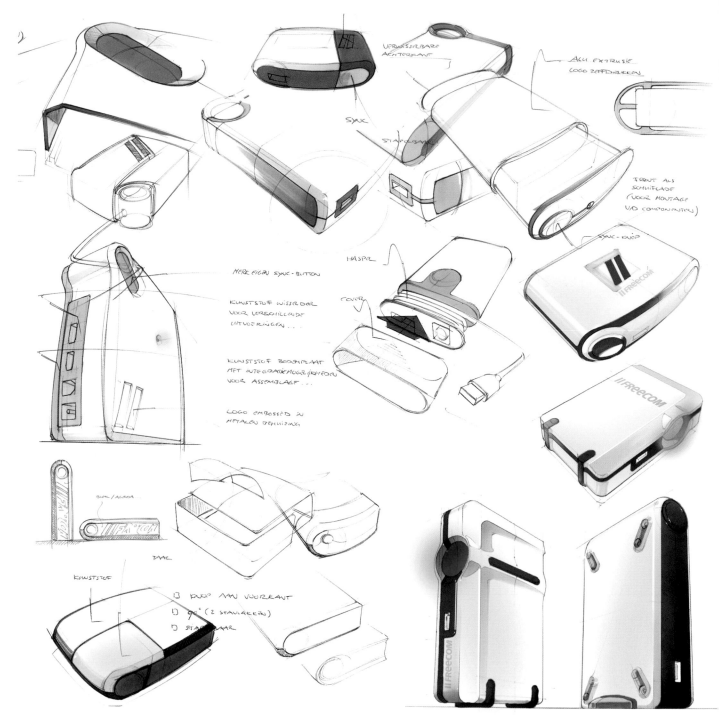

FLEX/the INNOVATIONLAB®

Portable hard disk for Freecom, 2004. The product
has a clear identity, and serves as a design flagship for
the entire Freecom product range. The use of extreme
viewpoints and the accent on material reflection
and light effects creates a clear idea of the design
concepts.

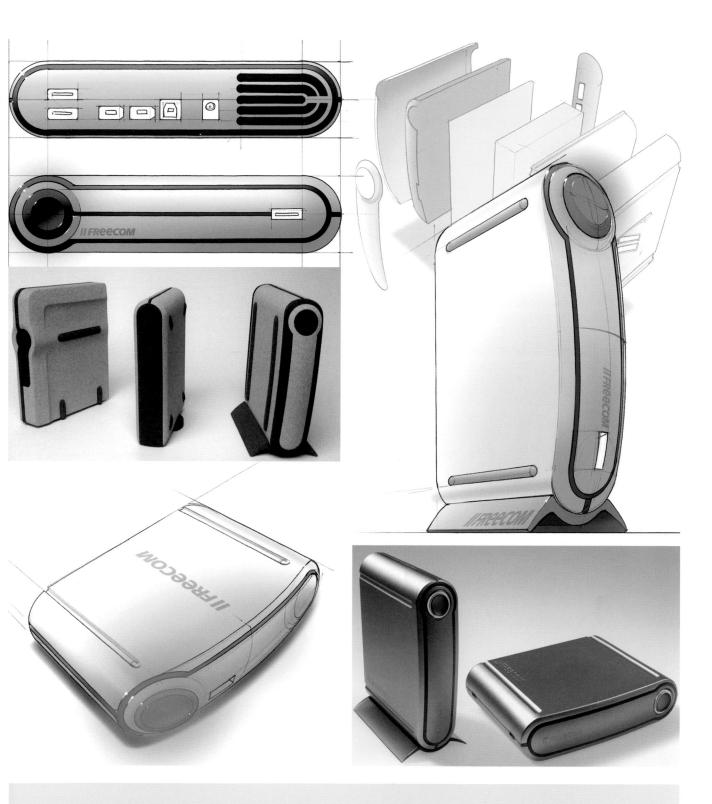

In the first instance, sketches were used to explore the possibilities of a new design language for Freecom. The next step was to define three different concepts and to communicate the look & feel of the products.

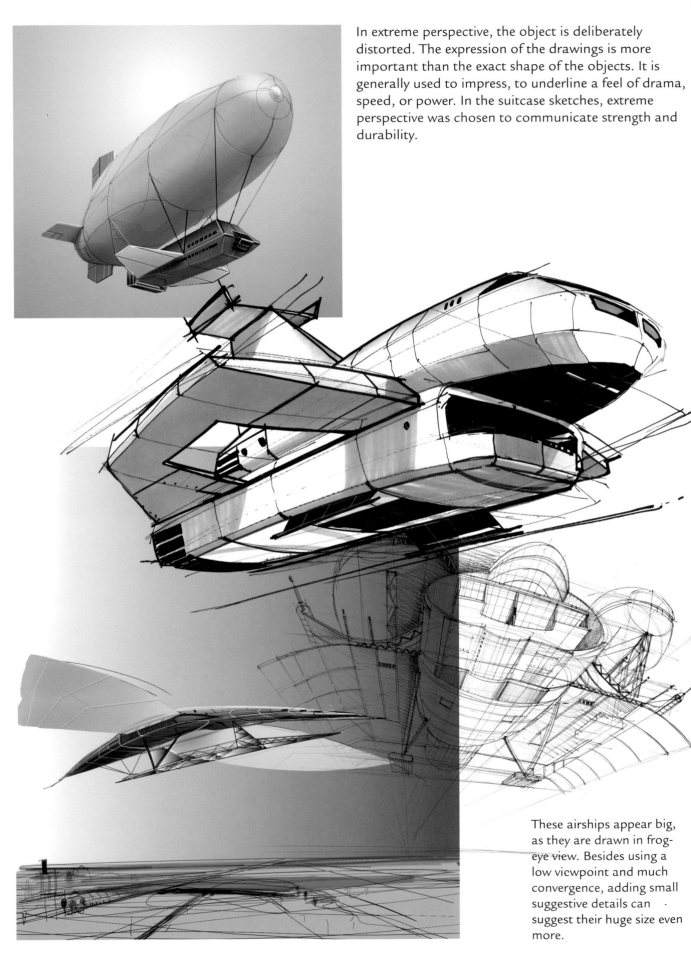

In extreme perspective, the object is deliberately distorted. The expression of the drawings is more important than the exact shape of the objects. It is generally used to impress, to underline a feel of drama, speed, or power. In the suitcase sketches, extreme perspective was chosen to communicate strength and durability.

These airships appear big, as they are drawn in frog-eye view. Besides using a low viewpoint and much convergence, adding small suggestive details can suggest their huge size even more.

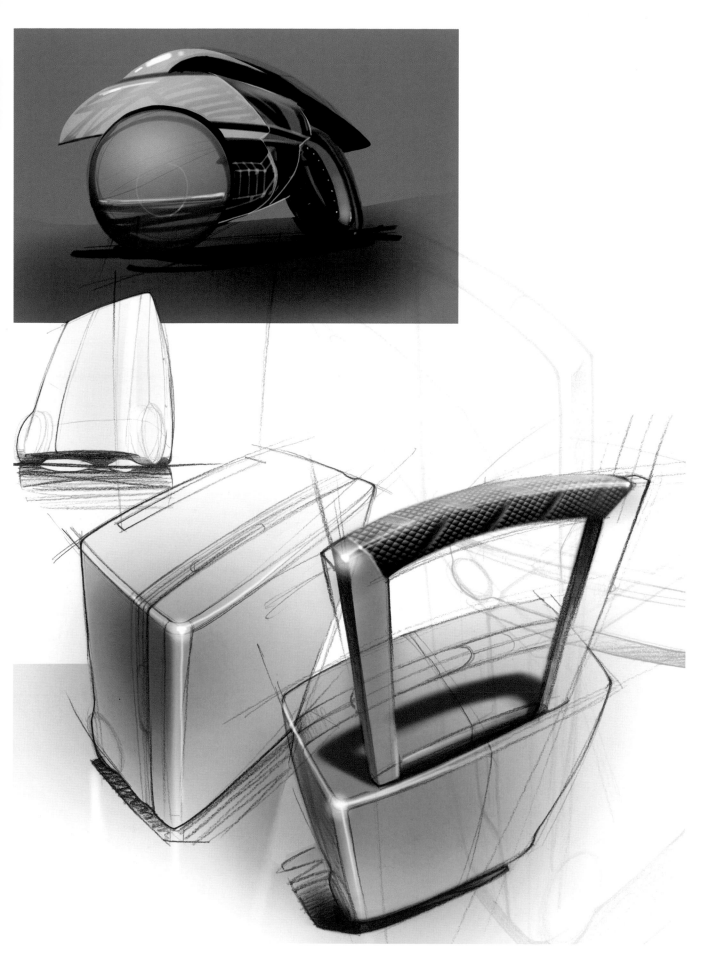

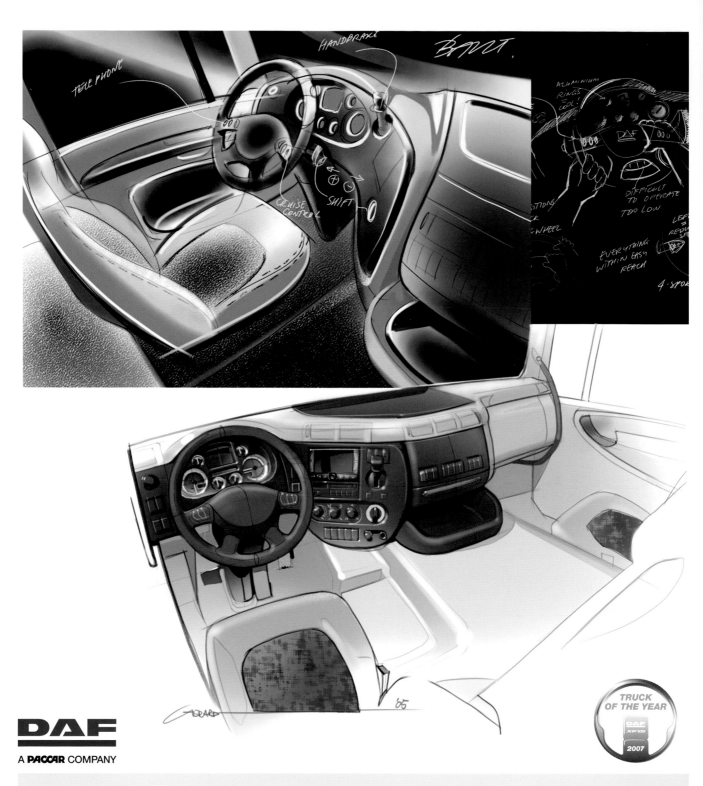

The sketch includes handwritten annotations: TELEPHONE, HANDBRAKE, CRUISE CONTROL, SHIFT, ALUMINIUM RINGS COOL!, DIFFICULT TO OPERATE TOO LOW, EVERYTHING WITHIN EASY REACH, 4-SPOKE

DAF Trucks NV

DAF XF105 / CF / LF Truck interior, 2006. In drawing interiors, choosing an appropriate viewpoint is crucial. To give an overview of the interior and at the same time create a feeling of being inside a truck, the perspective is sometimes exaggerated.

Designers: Bart van Lotringen, Rik de Reuver, Gerard Baten

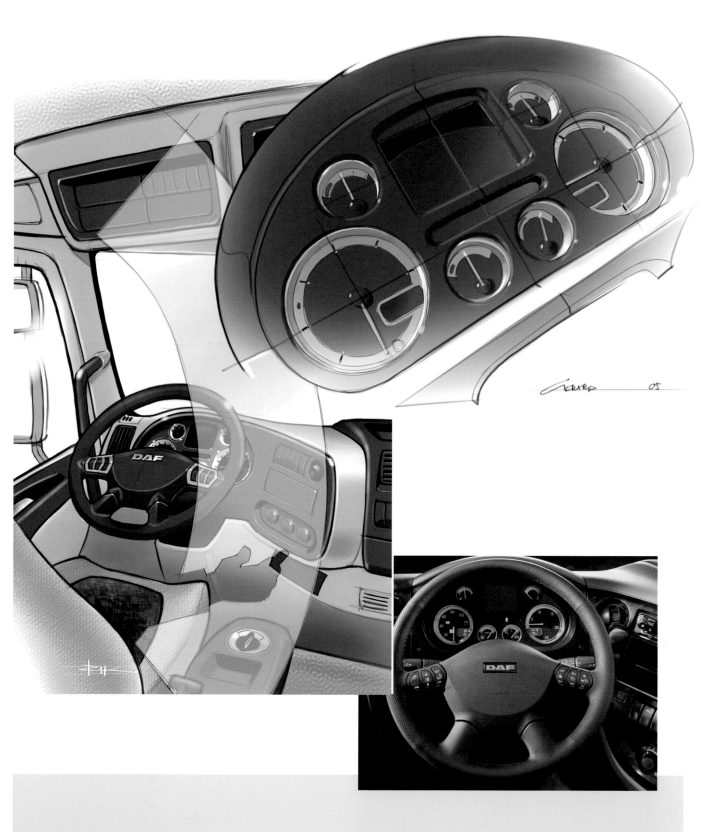

A viewpoint is chosen from, or near to, the driver's position. Here, exploratory sketches of the position of the control panel and handles were necessary in order to examine the layout of the cockpit itself. The resulting details were drawn separately and

emphasize the precision look of the instrument panel. A transparent circle visualizes the driver's reach. Pictures taken afterwards are used to analyze the design process, so as to learn from it and look for new challenges.

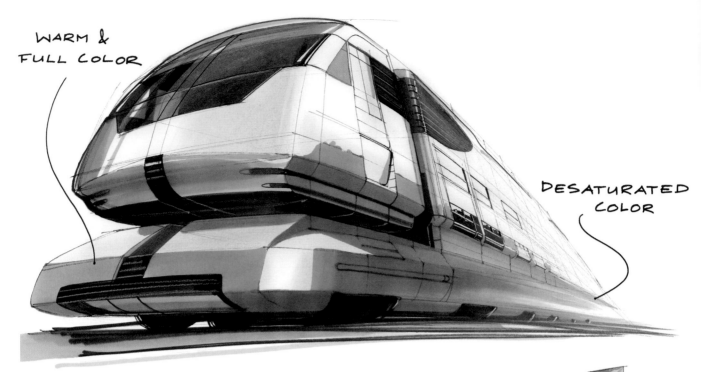

WARM & FULL COLOR

DESATURATED COLOR

Aerial perspective

In order to suggest depth, colour values are important. Nearby objects are seen as having more contrast and more saturated colours. As the distance of an object increases, its colour and shading will be perceived with less contrast and less saturation. Eventually, objects will appear bluish. As a result, rich and warm colours are generally perceived as being closer than cool colours. Objects with much contrast tend to appear closer than objects with little contrast.

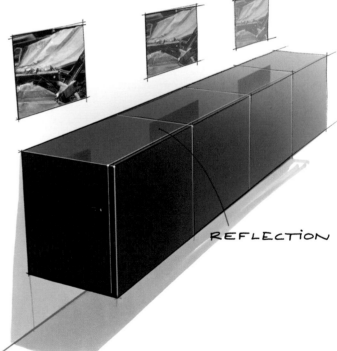

REFLECTION

When drawing large products, the phenomenon known as aerial perspective can emphasize their size. But a feeling of depth can also be added in a drawing of smaller objects. Letting an object 'fade out' towards the back can be a combination of several effects, resembling aerial perspective but also the 'out of focus' effect seen in photography. At the same time, light reflections on shiny surfaces also cause a whitening of the object towards the back.

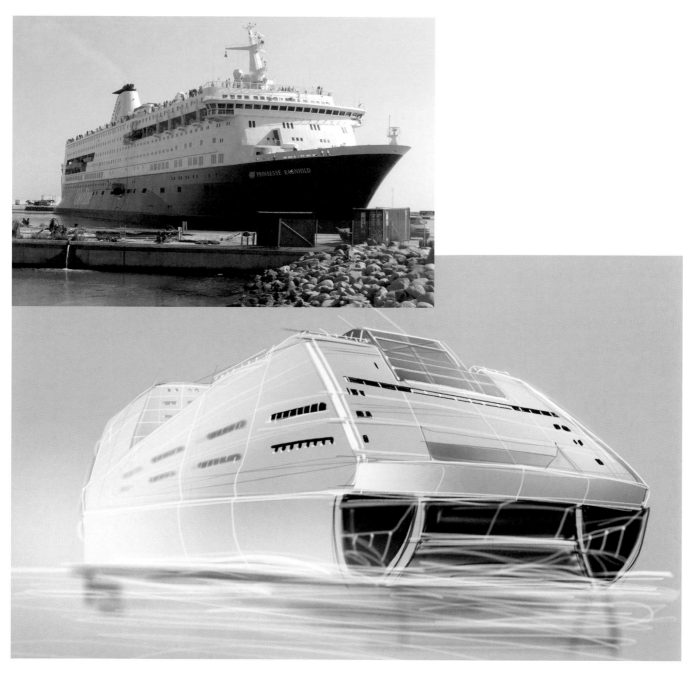

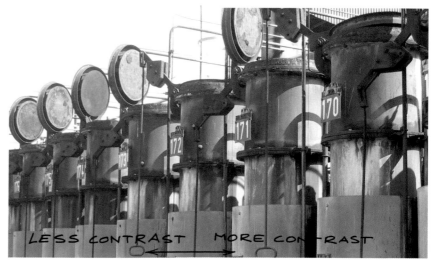

LESS CONTRAST ◄————► MORE CONTRAST

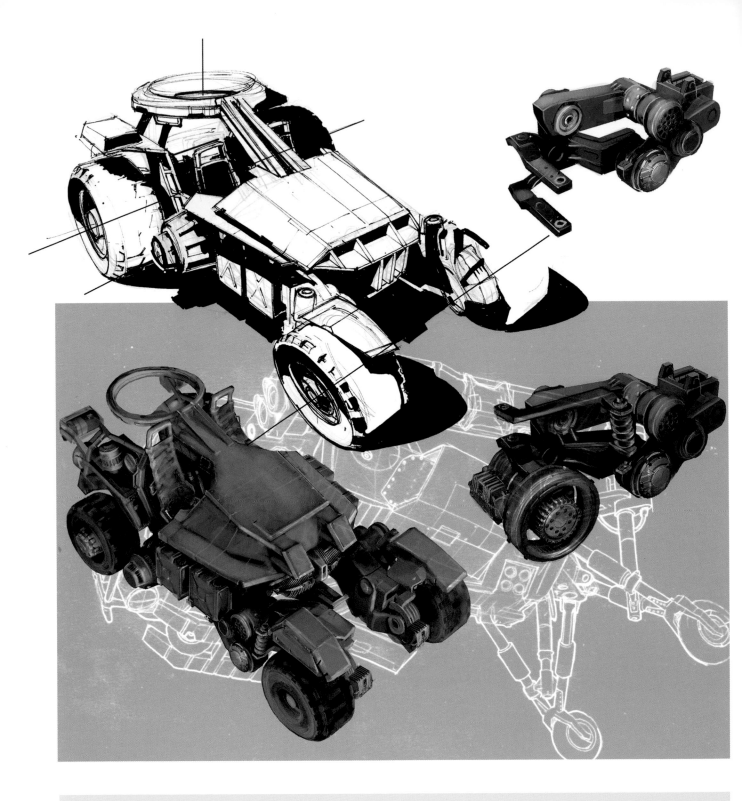

Guerrilla Games

This young but rapidly expanding studio has a growing reputation as one of Europe's leading game developers. As a result of its successful release of *Killzone*, the company was acquired by Sony Computer Entertainment in 2005. Guerrilla produces its games in-house and designs them from the ground up. Its relatively large concept art department designs and visualizes the different surroundings, characters and vehicles in its games. In comparison to other game studios, Guerrilla puts extra effort into creating concepts that have functional credibility. Because of the virtual nature of the games, it is not necessary

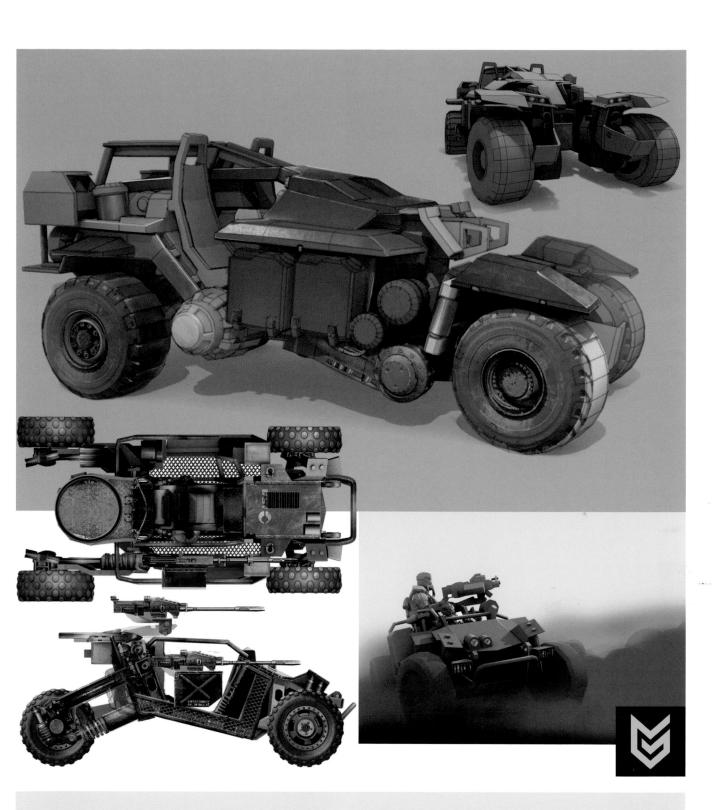

for these concepts to be fully functional but simply to provide that impression, adding to immersion in the overall game environment. These pages show examples of concept work created for the trailer of *Killzone2*, Guerrilla's game for Sony's Playstation 3. Although the end products of the gaming industry are computer-generated realities, a large amount of the visuals in their development is drawn by hand – not only in the early stages of preproduction, but also later on in the design process, where shape optimizing and detailing, for example digital sketching techniques, are applied.

Designers: Roland IJzermans and Miguel Angel Martínez

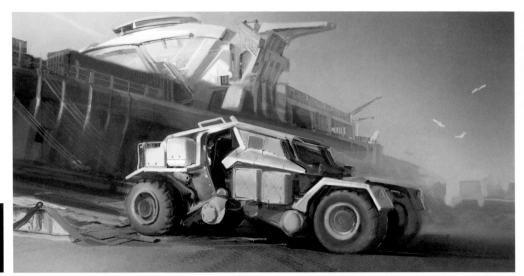

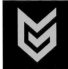

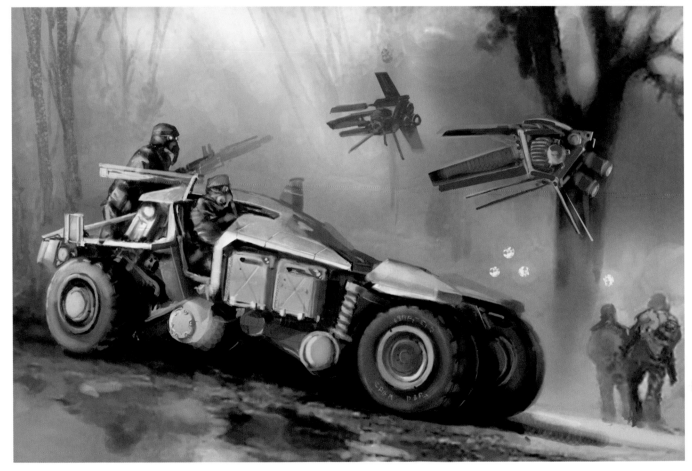

One of the gaming industry's goals is to render with a minimum amount of memory use but with a maximum suggestion of realism. Before making the final in-game models, visuals like the ones above are used to find the optimal utilization of textures. These drawings are digitally painted, using 3D models and photos as reference. They are utilized to show both the design and its placement within the game environment. Based on these types of paintings, concepts are evaluated as to whether or not they fit the overall mood and style of the game.

The use of exaggerated aerial perspective can also be seen in the previous drawings. In the gaming industry, aerial perspective is regarded as a tool.

It creates more depth and realism, and requires less computer memory for rendering.

Simplifying shape

Being able to effectively draw complex shapes has to do with the ability to simplify. When drawing a shape, understanding the underlying structure of a product's physical appearance is as important as learning about perspective.

Drawing decisions are closely related to the ability to destructuralize, which is also a common approach in design, embedded in various design methods and tactics. Learning to see or analyze helps you to simplify complex situations into understandable,

straightforward steps. Every product can be structurally analyzed: What is its basic shape or shapes, how are parts connected and what are the relevant details? Making a plan by deciding what is essential and what is not shows you how to start, what to do next and how to finish a drawing. This analysis defines your drawing approach. An effective analysis results in an effective drawing. In this chapter, complex and simple drawings are compared to emphasize this effective approach to drawing.

Analyzing

Having an effective plan will greatly simplify and speed up the drawing process. Finding efficient ways to make a simple representation of a complex shape by analyzing its shape and characteristics can be a helpful exercise. Spatial effects in general can be taken into consideration in the same way, for various reasons.

A simplified surrounding, for example, can emphasize a sketch, as seen above. It can also add more depth, or influence overall aspects of the layout, such as contrast or composition.

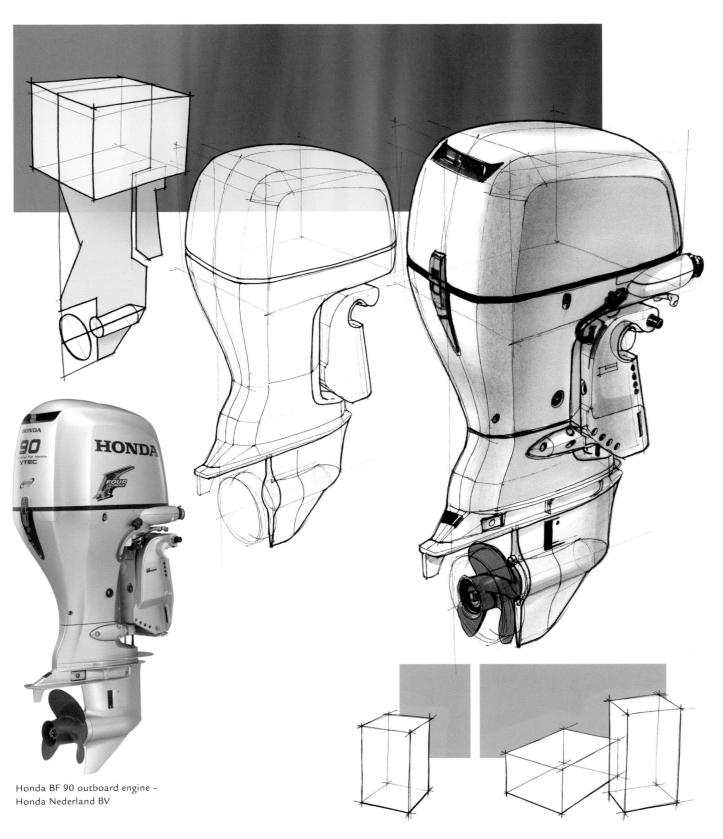

Honda BF 90 outboard engine –
Honda Nederland BV

The basic shape of this Honda outboard engine can
be simplified as a block shape and a vertical plane or
surface. The cover is wrapped around the hardware
like a glove. The shape transitions are smooth and
gradual. You can see these transitions better if the
added details and graphics are left out.

The rectangular background
here is based upon the
principle of overlap. It
adds more depth to the
drawing by representing
a further distance away

and causes the sketches to
stand out more, especially
when a cool or desaturated
colour is used. In this case,
it is also a way to group
sketches together.

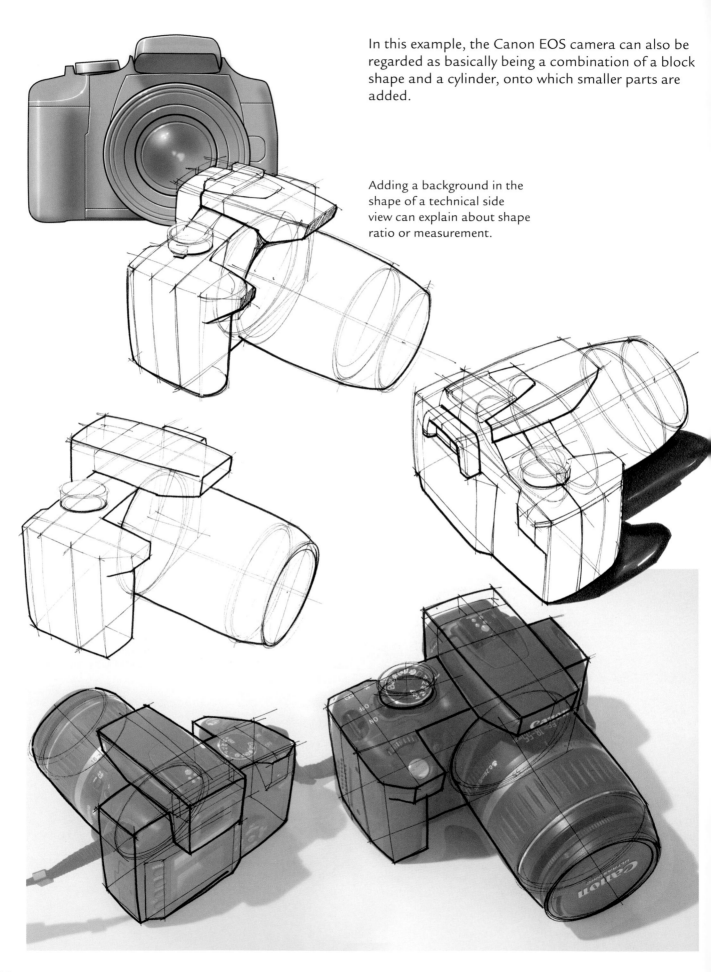

In this example, the Canon EOS camera can also be regarded as basically being a combination of a block shape and a cylinder, onto which smaller parts are added.

Adding a background in the shape of a technical side view can explain about shape ratio or measurement.

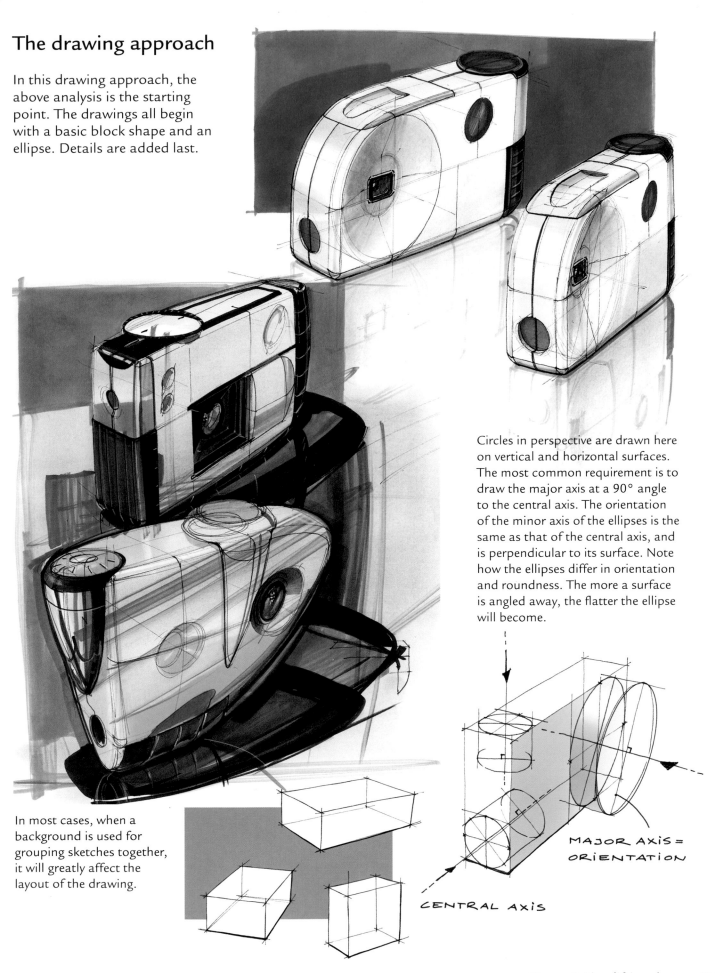

The drawing approach

In this drawing approach, the above analysis is the starting point. The drawings all begin with a basic block shape and an ellipse. Details are added last.

Circles in perspective are drawn here on vertical and horizontal surfaces. The most common requirement is to draw the major axis at a 90° angle to the central axis. The orientation of the minor axis of the ellipses is the same as that of the central axis, and is perpendicular to its surface. Note how the ellipses differ in orientation and roundness. The more a surface is angled away, the flatter the ellipse will become.

In most cases, when a background is used for grouping sketches together, it will greatly affect the layout of the drawing.

MAJOR AXIS = ORIENTATION

CENTRAL AXIS

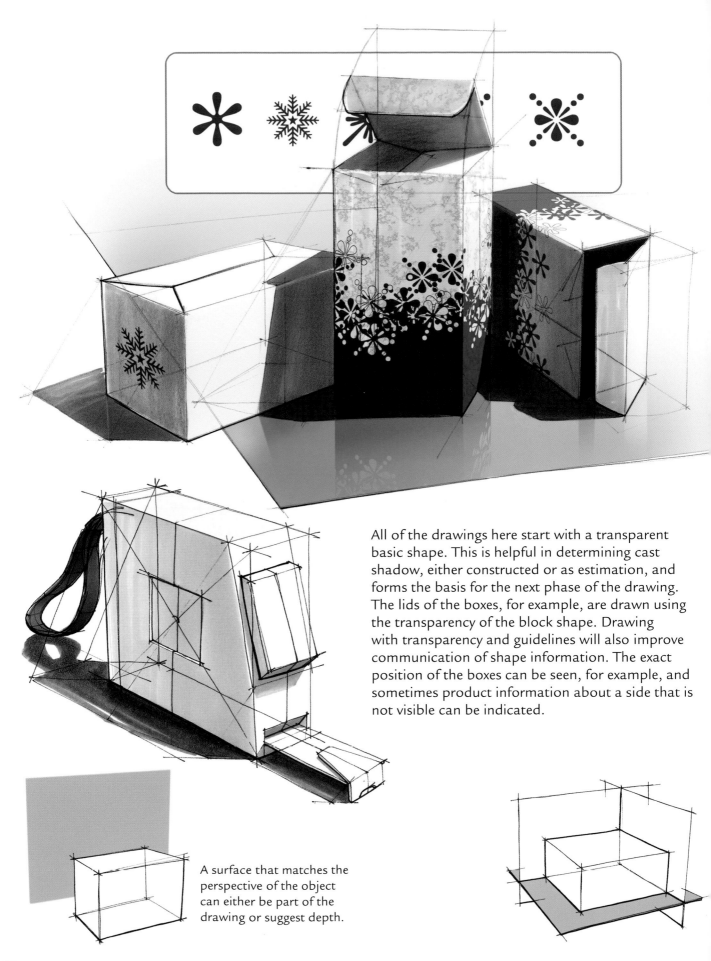

All of the drawings here start with a transparent basic shape. This is helpful in determining cast shadow, either constructed or as estimation, and forms the basis for the next phase of the drawing. The lids of the boxes, for example, are drawn using the transparency of the block shape. Drawing with transparency and guidelines will also improve communication of shape information. The exact position of the boxes can be seen, for example, and sometimes product information about a side that is not visible can be indicated.

A surface that matches the perspective of the object can either be part of the drawing or suggest depth.

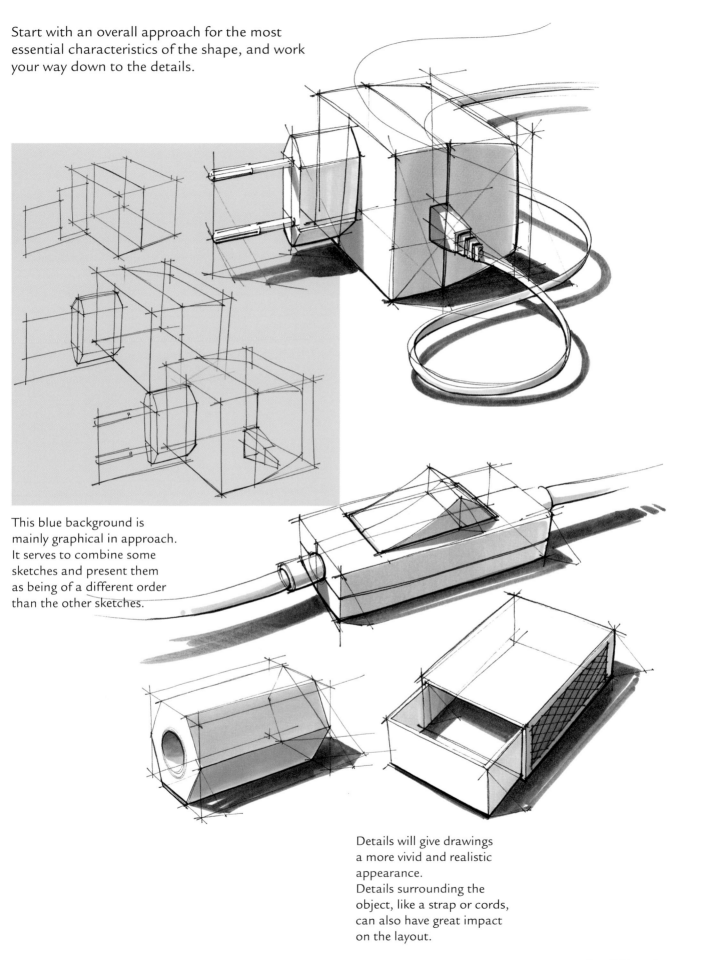

Start with an overall approach for the most
essential characteristics of the shape, and work
your way down to the details.

This blue background is
mainly graphical in approach.
It serves to combine some
sketches and present them
as being of a different order
than the other sketches.

Details will give drawings
a more vivid and realistic
appearance.
Details surrounding the
object, like a strap or cords,
can also have great impact
on the layout.

Guidelines used to 'construct' a shape will also
be helpful to the 'reader' of your drawing, as they
provide extra visual information about shape.

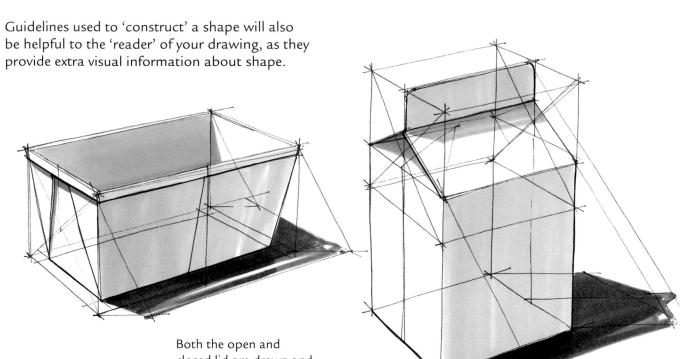

A tangent to the curve at
this location determines the
perpendicular direction, its
thickness.

Both the open and
closed lid are drawn and
connected with a curve. An
appropriate position for the
cover can be chosen along
this path.

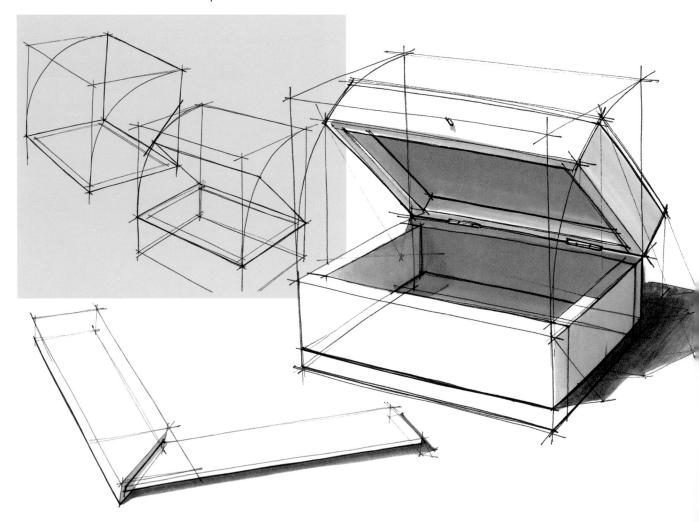

The drawing of a marker refill bottle was started
by sketching a block shape and tilting the front
end. The angle grinder was started by drawing a
horizontally positioned cylinder and attaching a
block shape to it. Two cylindrical parts were added.
Adding rounding and detail finished the drawing.

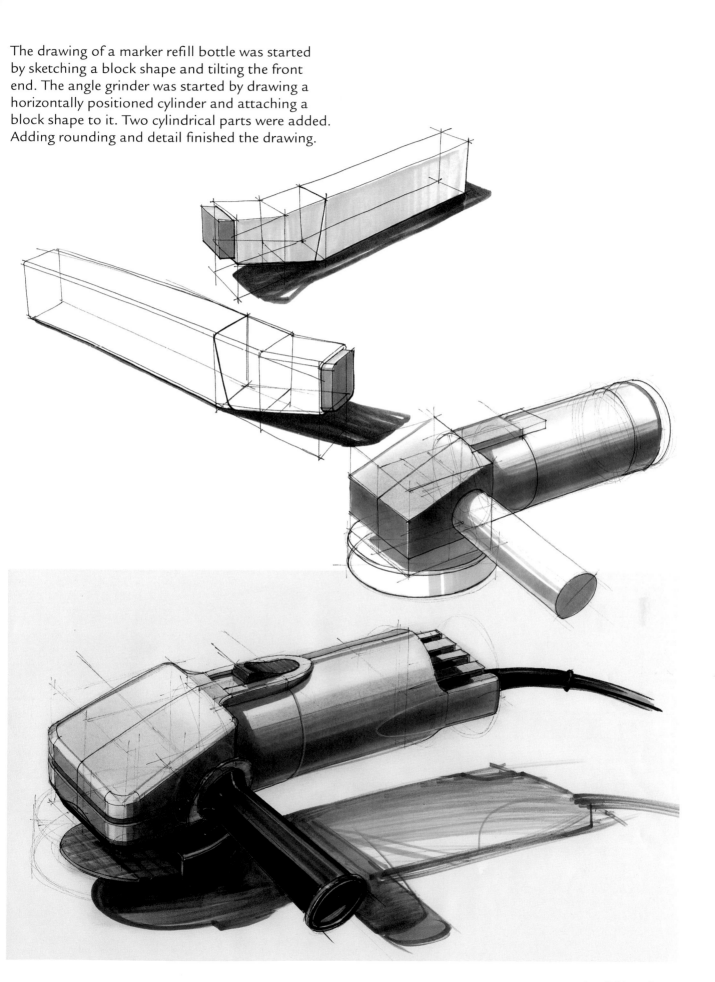

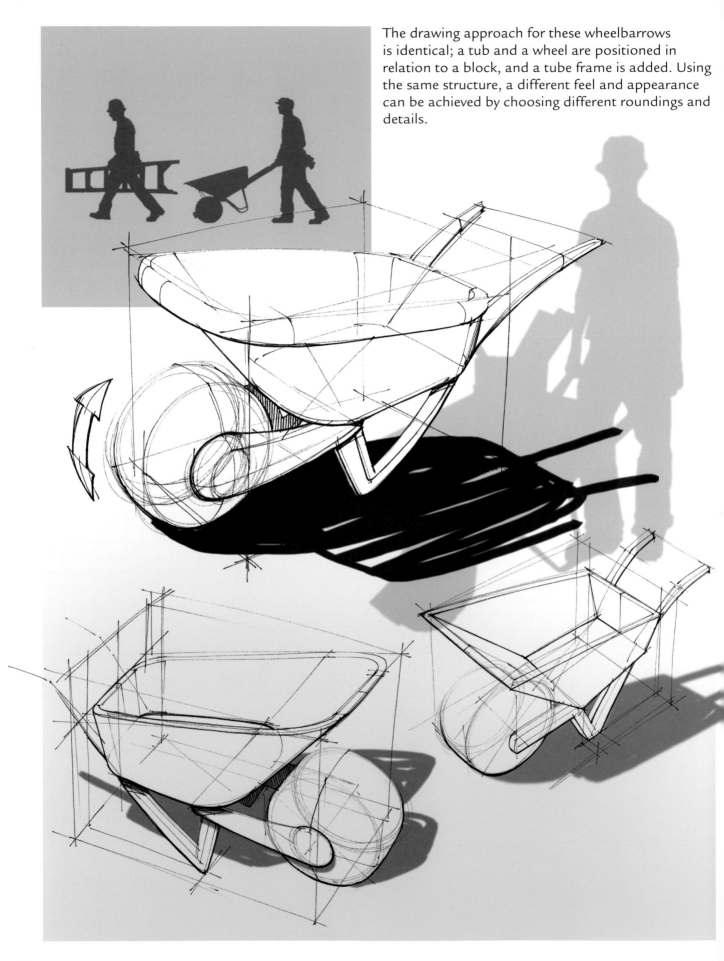

The drawing approach for these wheelbarrows is identical; a tub and a wheel are positioned in relation to a block, and a tube frame is added. Using the same structure, a different feel and appearance can be achieved by choosing different roundings and details.

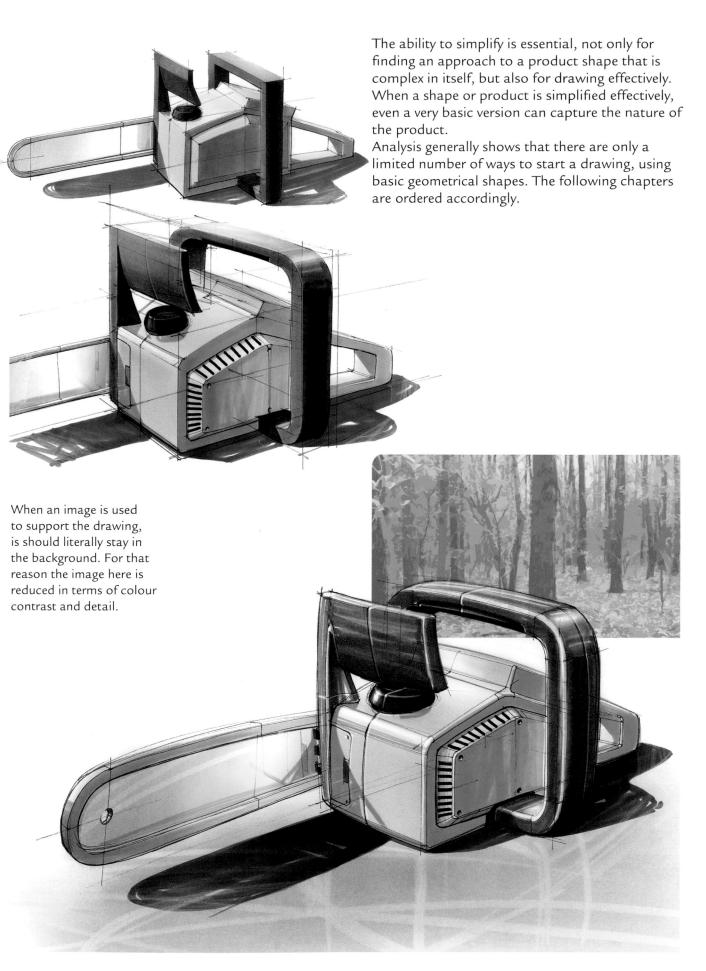

The ability to simplify is essential, not only for finding an approach to a product shape that is complex in itself, but also for drawing effectively. When a shape or product is simplified effectively, even a very basic version can capture the nature of the product.

Analysis generally shows that there are only a limited number of ways to start a drawing, using basic geometrical shapes. The following chapters are ordered accordingly.

When an image is used to support the drawing, is should literally stay in the background. For that reason the image here is reduced in terms of colour contrast and detail.

WAACS – Screen Sketching Foil

Column by Joost Alferink
for Vrij Nederland, 2006

ROL MET
TRANSPARANTE
SCHETS FOLIE

ZUIGNAPPEN VOOR
BEVESTIGING VAN DE HOUDER
AAN HET SCHERM

New products in our surroundings always produce a reaction. Nowadays every office desk sports a flat screen. Whereas once a chunky monitor did the job, now liquid crystals race around! Apart from obvious plusses like taking up less space and reduced flickering, this development has other advantages. More and more often in our studio, we see two people drawing on the flat screen with a pen or pencil during the design process, rapidly reworking details in life-size computer visualizations of new products. And then we have to go to work with aggressive cleansing agents in order to remove traces of ink and graphite from the screen. Obviously the screens are not designed with this in mind, so it is time for an alternative – screen sketching foil! A protective role of transparent foil lies in a holder behind the screen. A layer of foil always hangs over the screen, ready for use. We have even discussed the possibility of turning the information on the foil directly into digital information. The inclination to draw by hand only strengthens the contrast between analogue and digital – and in this age dominated by zeros and ones, we are more and more in need of this!

FOLIESNYDER

OOK HANDIG
VOOR BY DE LAPTOP!

2006

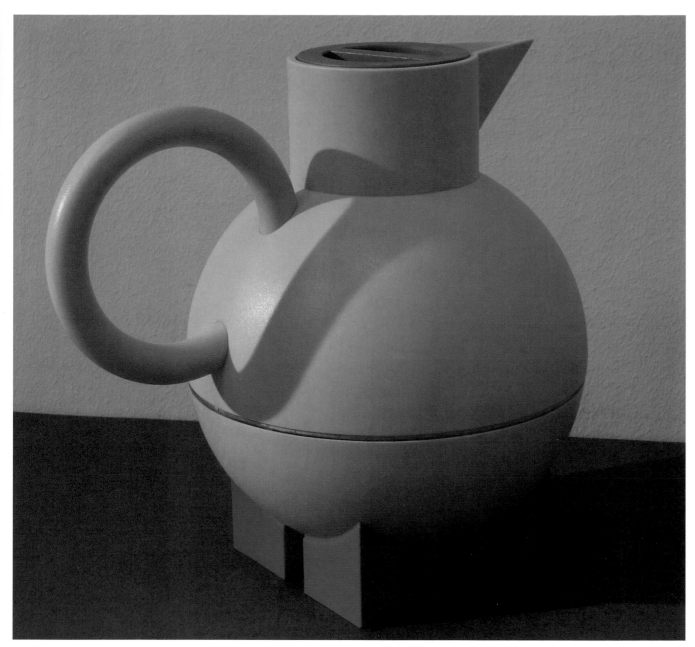

Elementary shapes and shading

The immediate spatial impact of a drawing is largely determined by its shading (related to the incidence of light), as shading is used to create depth. Cast shadows can emphasize an object's shape, and can clarify the position of the product and its parts in relation to a surface or plane. Shading might look difficult, but just as most objects can be reduced to combinations of elementary geometrical shapes, so can shading. In general, a block, cylinder and sphere are the basic starting volumes.

Michael Graves – Euclid thermos jug for Alessi, 1993-2001

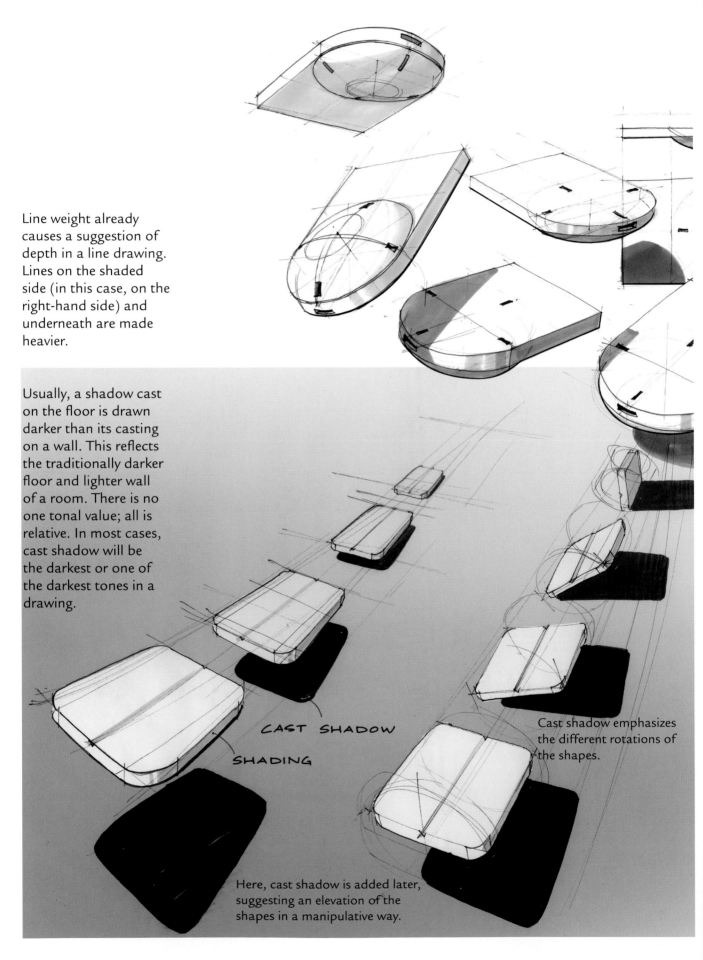

Line weight already causes a suggestion of depth in a line drawing. Lines on the shaded side (in this case, on the right-hand side) and underneath are made heavier.

Usually, a shadow cast on the floor is drawn darker than its casting on a wall. This reflects the traditionally darker floor and lighter wall of a room. There is no one tonal value; all is relative. In most cases, cast shadow will be the darkest or one of the darkest tones in a drawing.

CAST SHADOW

SHADING

Cast shadow emphasizes the different rotations of the shapes.

Here, cast shadow is added later, suggesting an elevation of the shapes in a manipulative way.

Block shapes

The light direction is chosen to create the appropriate contrast and size of shadows. Every basic shape has a characteristic cast shadow. A cast shadow should be large enough to emphasize the shape of an object. It should support the object, and not be so large as to disturb the layout of the drawing.

Detail, Functional Bathroom Tiles – Arnout Visser, Erik Jan Kwakkel and Peter vd Jagt

The cast shadow of an object can be found using two guidelines: the angle and direction of light. The latter is a projection of the light's angle.

ANGLE OF LIGHT

LIGHT DIRECTION

A shaded surface appears darker if it is angled more away from the light source. So under the influence of light, an object will be a different shade of colour on each of its visible sides. One side is represented by 'full colour' and has the highest saturation. The shaded side is darker and less saturated, mixed towards black, and the top surface contains more white and is brighter than the full-colour side.

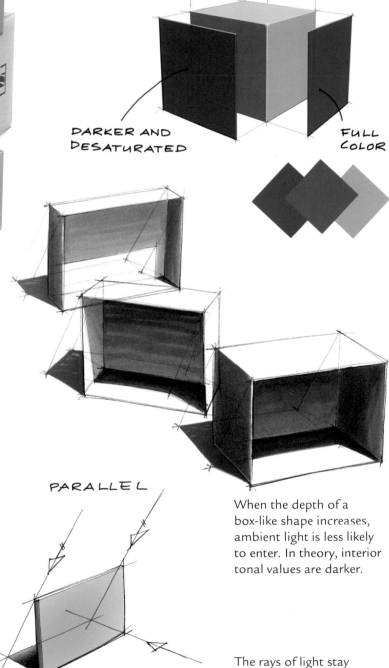

BRIGHTEST

DARKER AND DESATURATED

FULL COLOR

Sunlight (parallel rays of light) is a preferable source of light in drawings, for it creates predictable and reliable cast shadows. Lamplight creates shadows that differ in shape, depending on the position of the light source.

PARALLEL

CONVERGENT

When the depth of a box-like shape increases, ambient light is less likely to enter. In theory, interior tonal values are darker.

The rays of light stay parallel throughout the drawing. The projected light direction slightly converges.

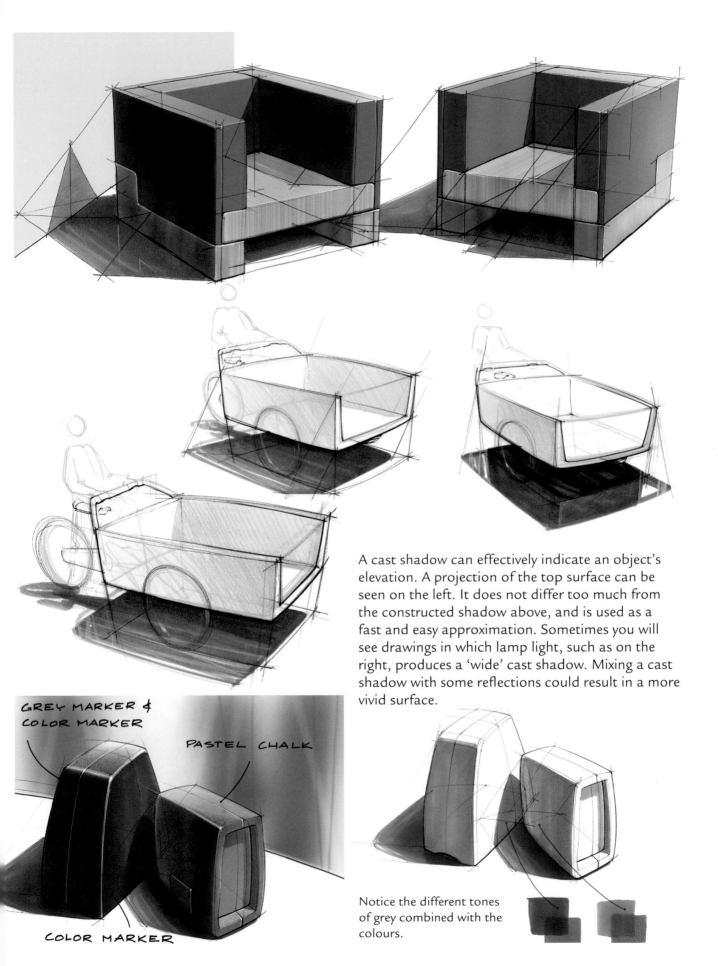

A cast shadow can effectively indicate an object's elevation. A projection of the top surface can be seen on the left. It does not differ too much from the constructed shadow above, and is used as a fast and easy approximation. Sometimes you will see drawings in which lamp light, such as on the right, produces a 'wide' cast shadow. Mixing a cast shadow with some reflections could result in a more vivid surface.

GREY MARKER & COLOR MARKER

PASTEL CHALK

COLOR MARKER

Notice the different tones of grey combined with the colours.

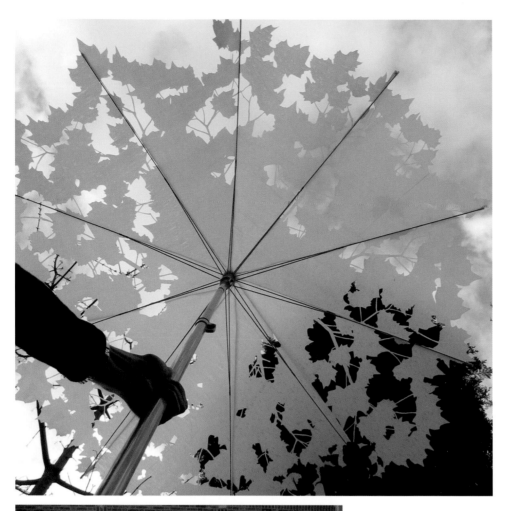

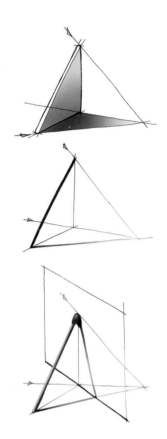

In these three sketches, a similarity can be seen in the drawing approach to shading.

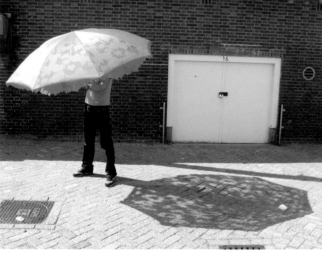

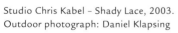

Studio Chris Kabel – Shady Lace, 2003.
Outdoor photograph: Daniel Klapsing

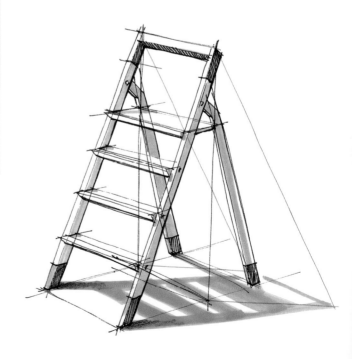

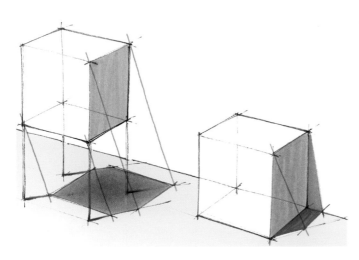

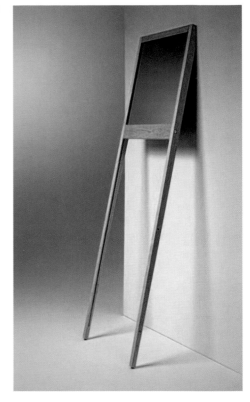

Hugo Timmermans
– Leaning Mirror,
Photography:
Marcel Loermans

Ambient light is not a light source in itself, but reflected light. Due to the influence of ambient light, cast shadows fade out as they get further away from the object. These gradients in shading often make a visual impression more realistic. The open character of the cast shadow on the floor emphasizes the open structure of the objects.

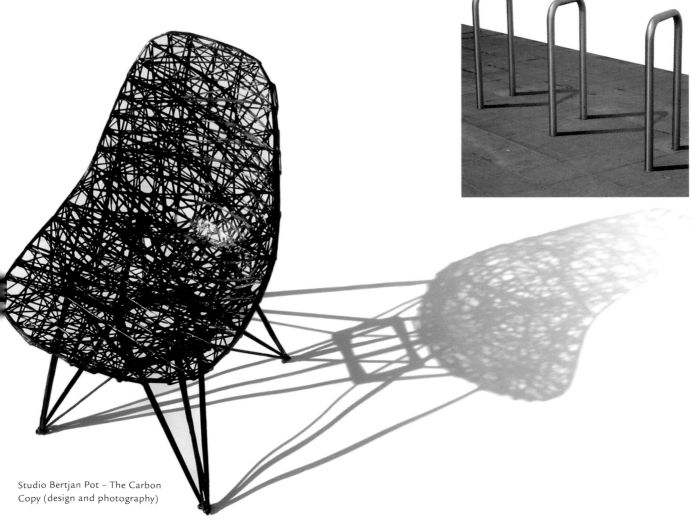

Studio Bertjan Pot – The Carbon Copy (design and photography)

Cylinders, spheres and cones

The navigation buoys here can be regarded as a combination of cylinders, cones and spheres. Analyzing and simplifying can be done in the same way as with block shapes.

The abrupt changes in shading are remarkable; an upright cone will be more lit than a cylinder, and thus has a larger lighted area. Cast shadows, again, can show differences in depth.

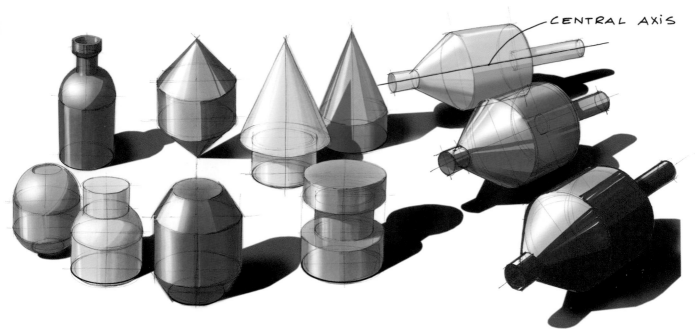

A drawing of a cylindrical shape starts with choosing the central axis. The orientation of the ellipses, the major axes, will be perpendicular to this central line. The direction of the central axis of a horizontal cylinder also influences the rounding of the ellipses. Finally, tangents to the ellipses complete the shape.

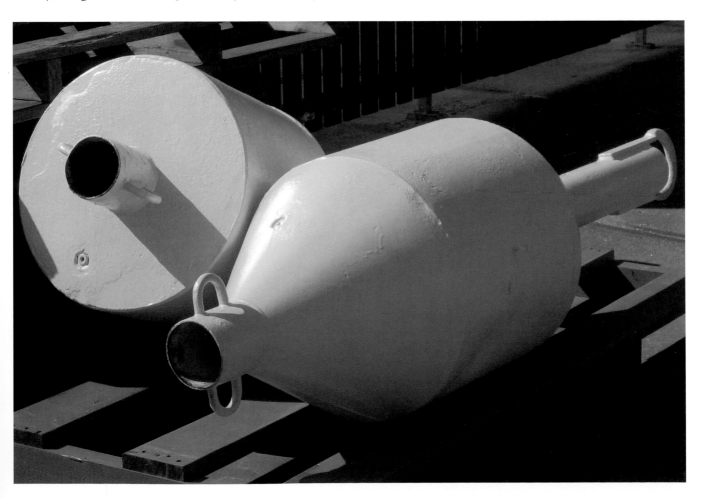

The cast shadow of a cylinder is determined by a projection of its top surface. Due to perspective, the roundness of this ellipse differs only slightly from that of the bottom ellipse of the cylinder. The cast shadow of the skittle is constructed using horizontal cross sections at strategic places, marking the transitions in width. Due to perspective, these ellipses become flatter upwards. When they are projected on the ground surface and connected, the result is a cast shadow. Ambient light causes the darkest area of shading to appear not at the contour, but just inside it.

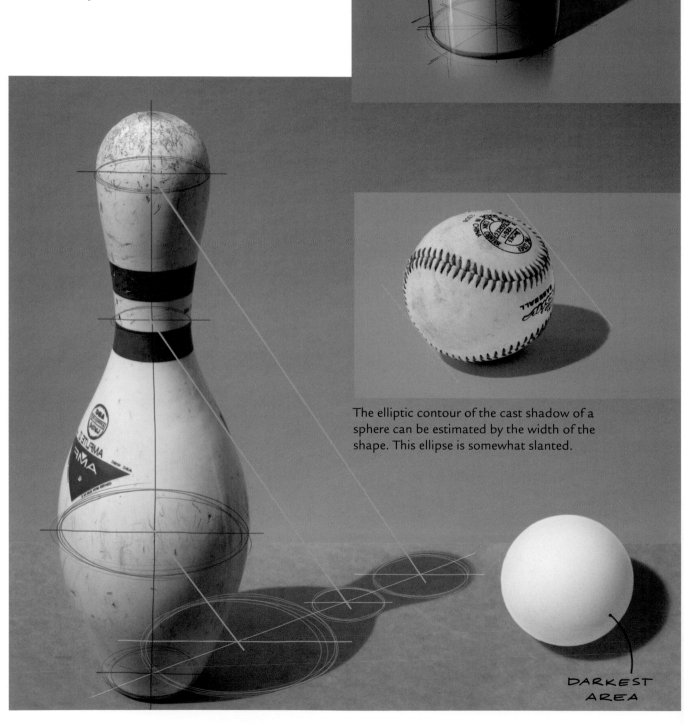

The elliptic contour of the cast shadow of a sphere can be estimated by the width of the shape. This ellipse is somewhat slanted.

DARKEST AREA

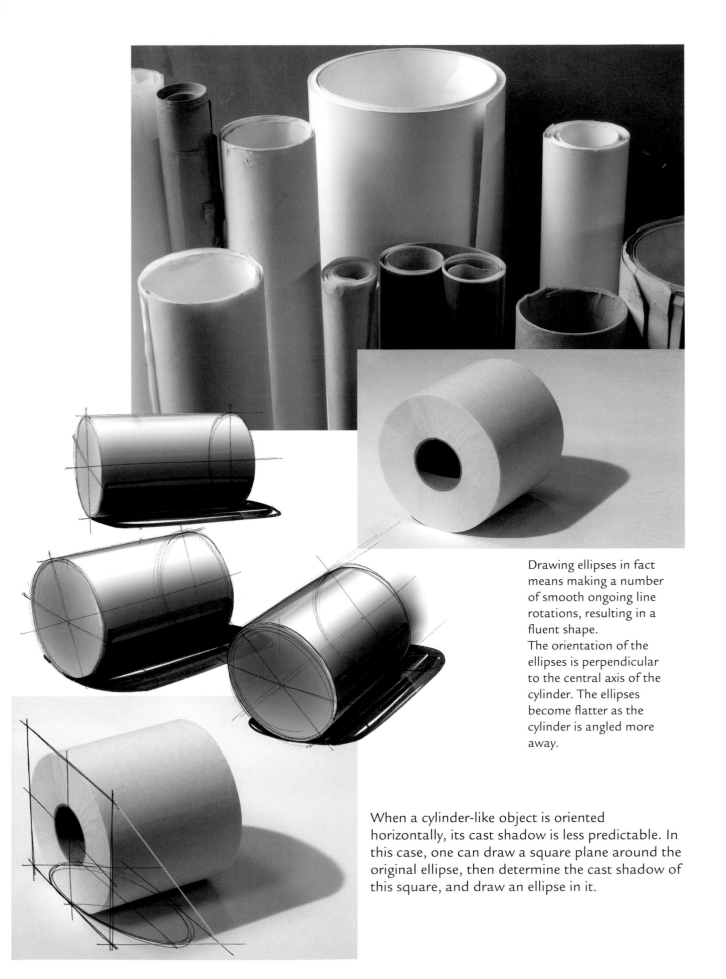

Drawing ellipses in fact means making a number of smooth ongoing line rotations, resulting in a fluent shape.
The orientation of the ellipses is perpendicular to the central axis of the cylinder. The ellipses become flatter as the cylinder is angled more away.

When a cylinder-like object is oriented horizontally, its cast shadow is less predictable. In this case, one can draw a square plane around the original ellipse, then determine the cast shadow of this square, and draw an ellipse in it.

Instead of combining straight cylindrical and
conical parts, a slightly curved contour can make
quite a difference in the appearance of an object.
This relatively simple approach can be an exciting
exploration. A search for unconventional shapes can
quickly have a surprising outcome.

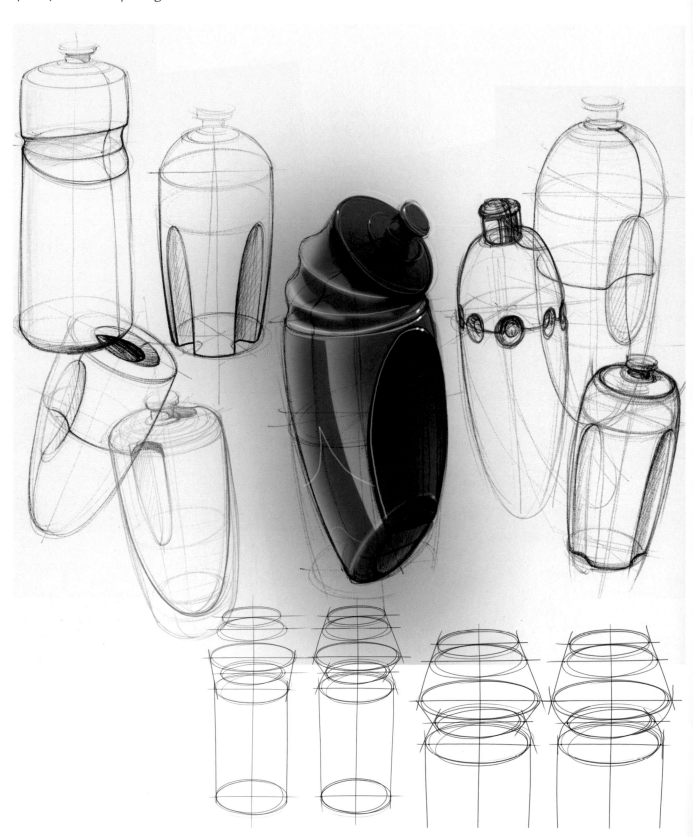

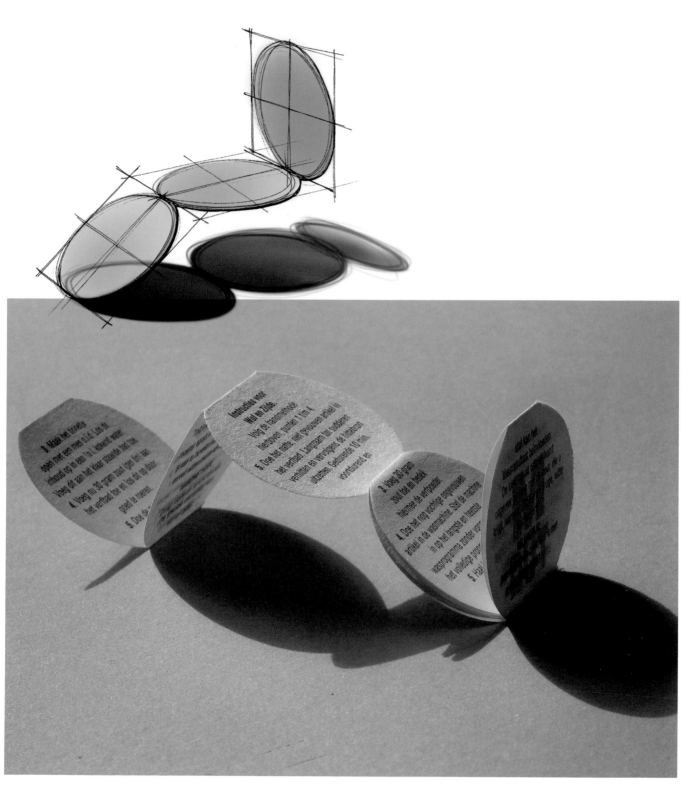

The basic principles in this chapter should be regarded as background knowledge for estimating. Eventually it will not be hard to guess the cast shadow of, for example, tilted perspective circles by sketching various connected ellipses that are also slightly angled.

Estimating cast shadow is more related to effective sketching then constructing cast shadows.

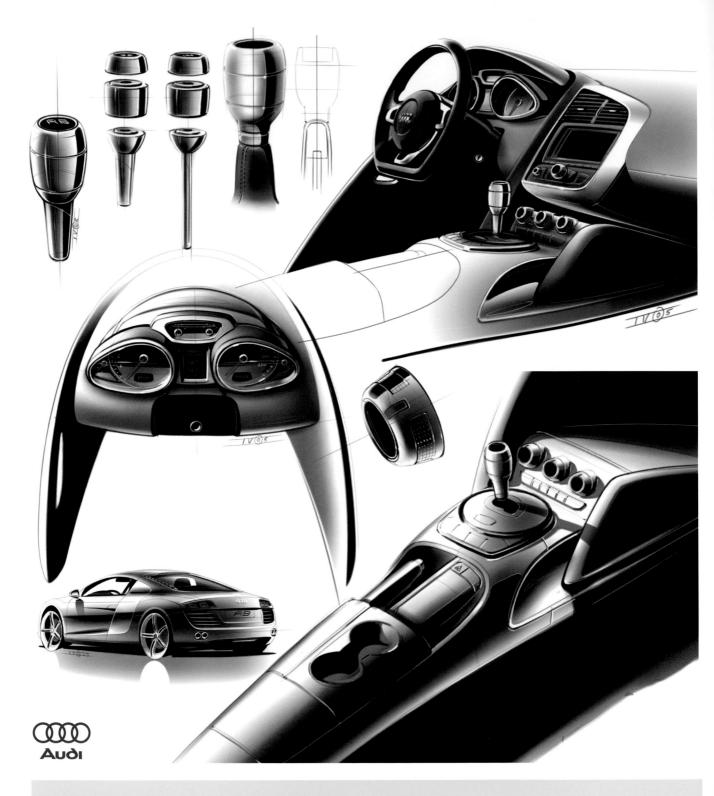

Audi AG, Germany – Ivo van Hulten

Interior design of the Audi R8 (Paris Motor Show 2006).
The sketches of the user interfaces were done directly with a tablet and Painter software. The basic lines and ellipses were sketched in with a small airbrush. Hard reflections and dark shadows were added in the second stage. A big airbrush was used for the soft reflections and soft shadows; they give the sketch its atmosphere and feeling of material. In the final stage, highlights and colours completed the drawing. The shape of the controls and the gear shaft segments in exploded view are shown separately, to explore and appreciate the design possibilities.

Chief designer: Walter de'Silva

Special attention for ellipses

Although it may seem obvious to generally start a drawing with a block shape, in a lot of situations a cylinder or ellipse can be the most appropriate starting point. In this approach, the ellipse plays a major role, to which other shapes are related.

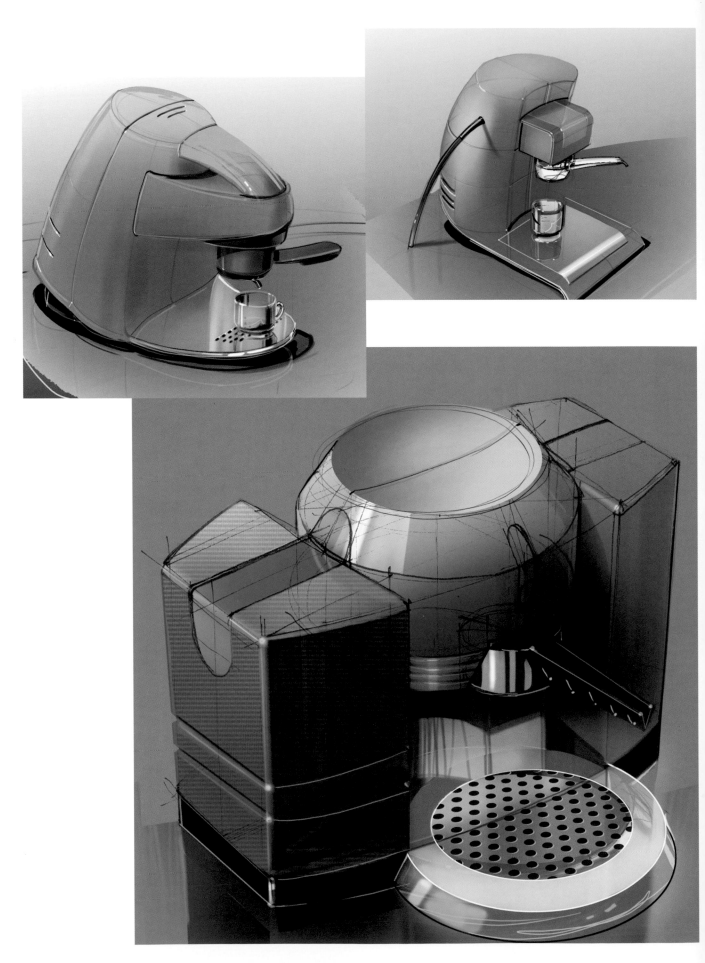

Vertical (upright) cylinders

The orientation of the added block shape is drawn by an axial line through the centre of the top ellipse. With only slight differences in orientation and thickness of the blocks, a variety of shapes can be made.

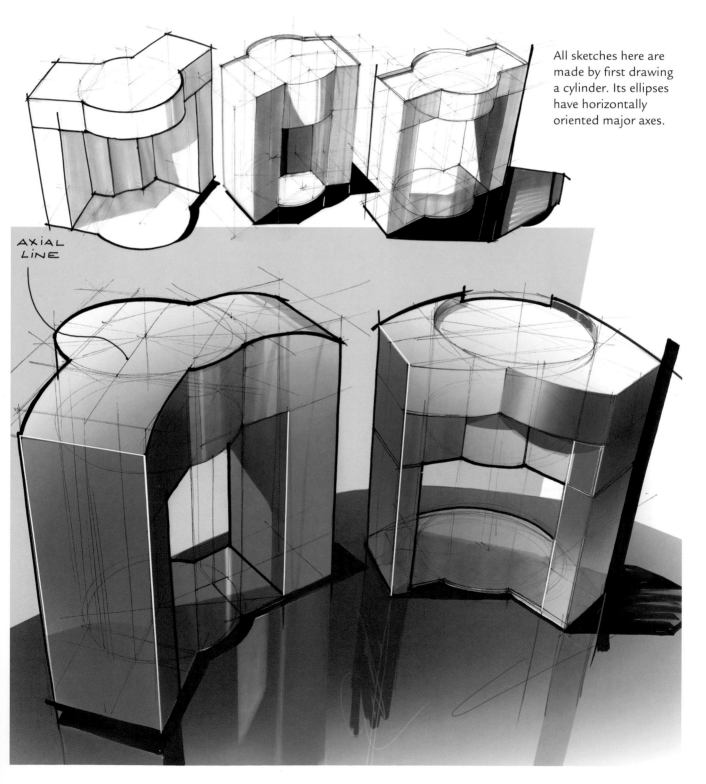

All sketches here are made by first drawing a cylinder. Its ellipses have horizontally oriented major axes.

AXIAL LINE

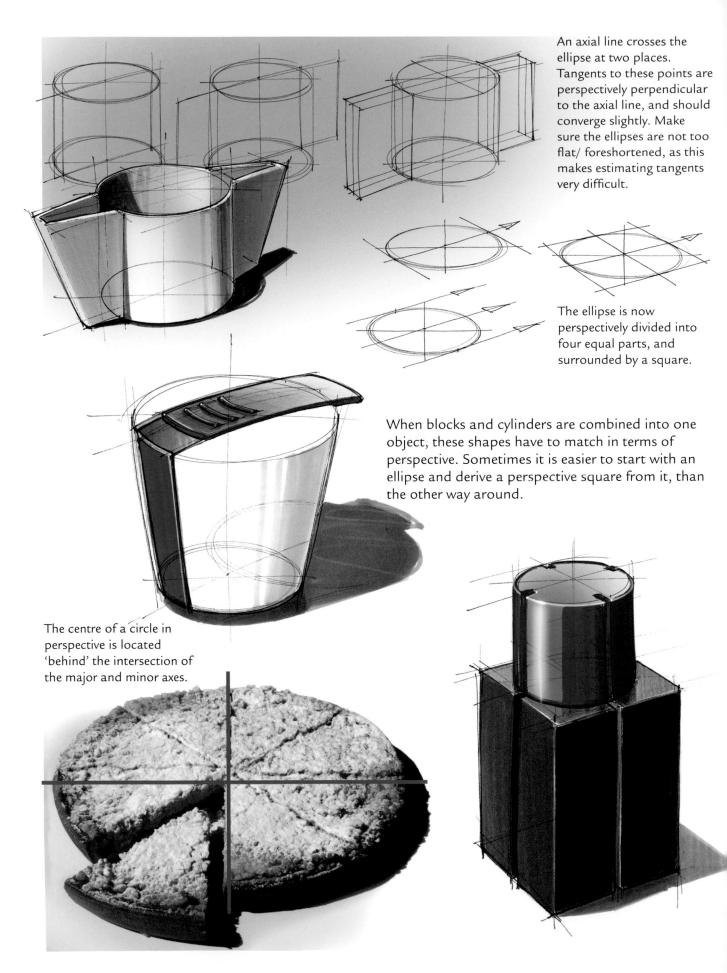

An axial line crosses the ellipse at two places. Tangents to these points are perspectively perpendicular to the axial line, and should converge slightly. Make sure the ellipses are not too flat/ foreshortened, as this makes estimating tangents very difficult.

The ellipse is now perspectively divided into four equal parts, and surrounded by a square.

When blocks and cylinders are combined into one object, these shapes have to match in terms of perspective. Sometimes it is easier to start with an ellipse and derive a perspective square from it, than the other way around.

The centre of a circle in perspective is located 'behind' the intersection of the major and minor axes.

Choosing the direction in which an ellipse is cross-sected, is done independently of the major and minor axes of the ellipse. These axes remain horizontal and vertical. Each direction of the axial line results in different tangents.

In each sketch, the object is rotated differently, for each shape may have a preferable angle of view.

Mix and Measure by Jan Hoekstra Industrial Design Services for Royal VKB, 2005. This design allows you to both mix and measure in the same bowl.

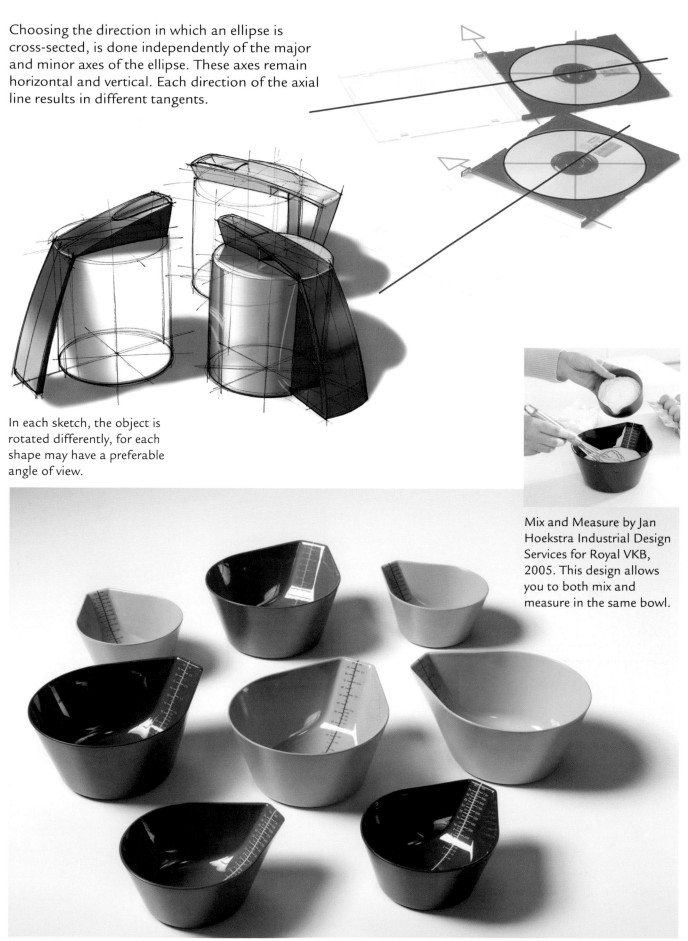

Photography: Marcel Loermans

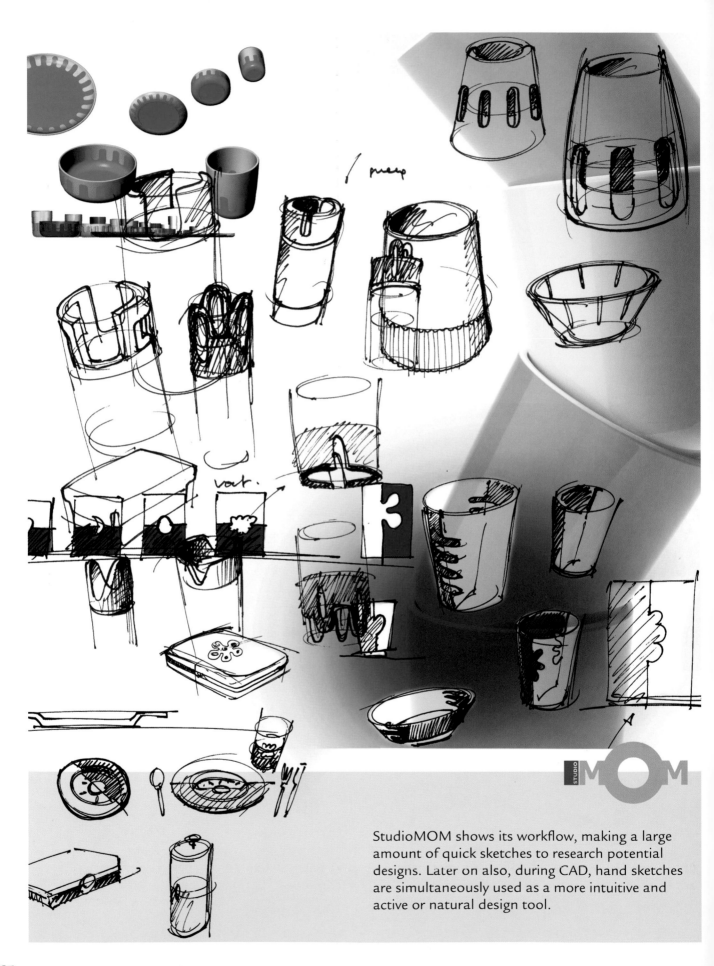

StudioMOM shows its workflow, making a large amount of quick sketches to research potential designs. Later on also, during CAD, hand sketches are simultaneously used as a more intuitive and active or natural design tool.

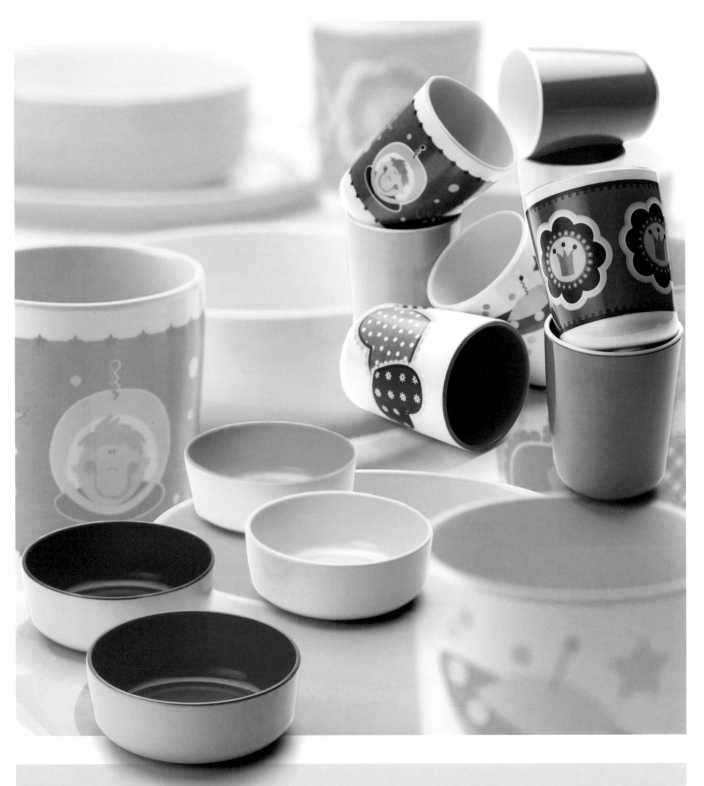

studioMOM

This melamine dinnerware is designed for Widget (2006), an international supplier of quality home accessories.
The basic elements are bright colours, clear shapes and a playful, durable look. Because the collection is designed 'for every age', different themes are explored during idea development.
The collection consists of plates, bowls and cups and will be extended with newly designed accessories for serving and drinking, such as salad cutlery, a serving tray and jug.

Designers: studioMOM, Alfred van Elk and Mars Holwerda. Photography: Widget

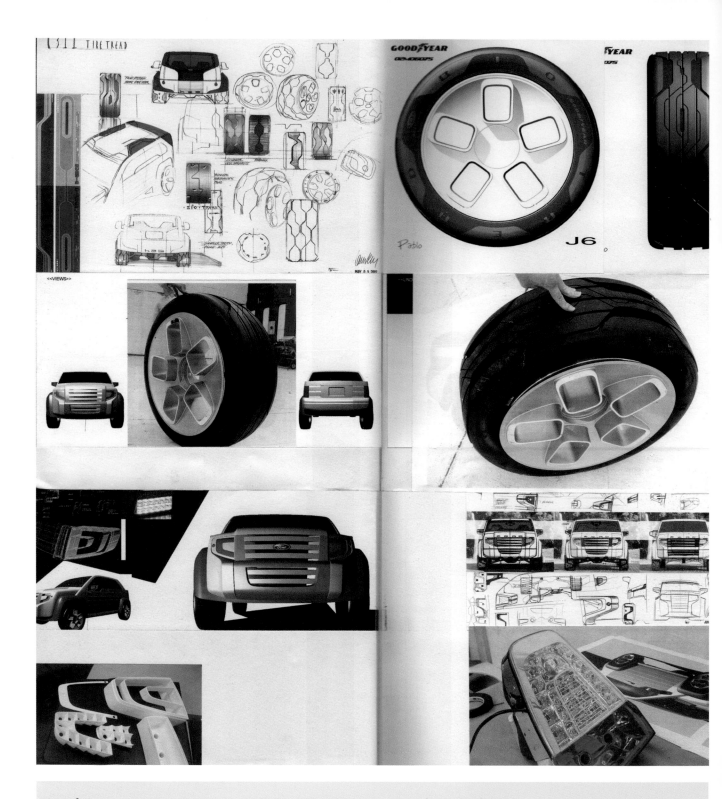

Ford Motor Company, USA – Laurens van den Acker

With the general design of the Model U (2003), there was an opportunity to develop a new profile with Goodyear tires. It completed the concept and added to a more 'racetrack' appearance.

As seen here, the designer prefers to keep a log of the design process. Design decisions can then later be put into context and related to the end result.

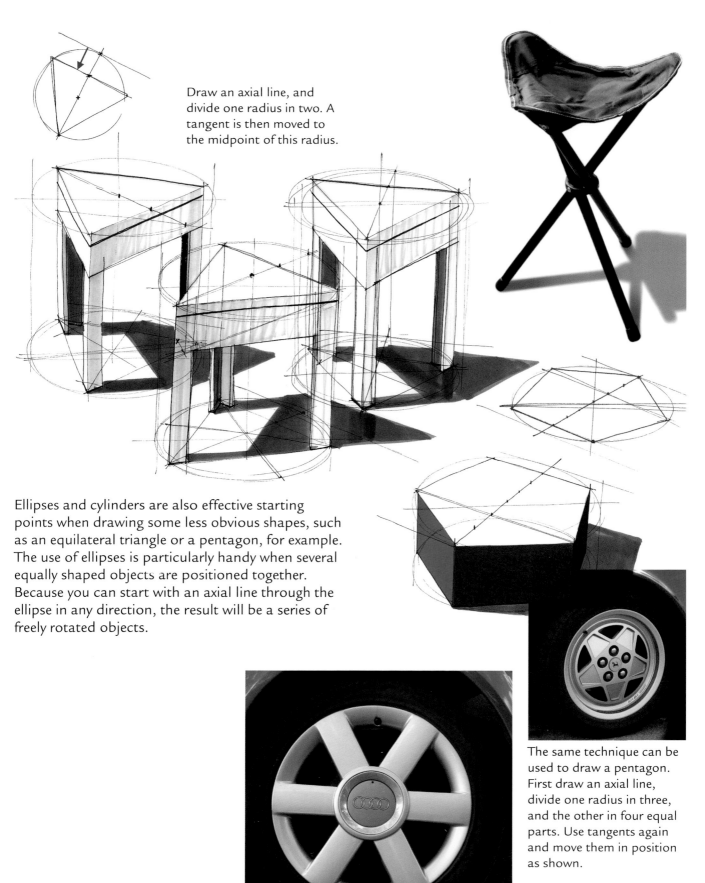

Draw an axial line, and divide one radius in two. A tangent is then moved to the midpoint of this radius.

Ellipses and cylinders are also effective starting points when drawing some less obvious shapes, such as an equilateral triangle or a pentagon, for example. The use of ellipses is particularly handy when several equally shaped objects are positioned together. Because you can start with an axial line through the ellipse in any direction, the result will be a series of freely rotated objects.

The same technique can be used to draw a pentagon. First draw an axial line, divide one radius in three, and the other in four equal parts. Use tangents again and move them in position as shown.

When further dividing the triangle, a hexagon is created.

Two of a kind, by Studio Frederik Roije, is a double ring made of porcelain. In breaking the ring an engagement with each other will exist, 2004.

Dutchtub, by Floris Schoonderbeek, is a 'new way of outdoor bathing'. It requires no electricity, plumbing or hot water. After it is filled, the water is heated by natural fire. Dutchtub has been selected for the Dutch Design Awards 2004.

Photography: Dutchtub USA. Product photography: Steven van Kooijk

A combination of two or more cylindrical or
conical parts can best be drawn by multiplying
the first cylinder or cone in the chosen direction
of perspective. A storage box for lenses can
have such a shape, with two compartments
connected to each other.

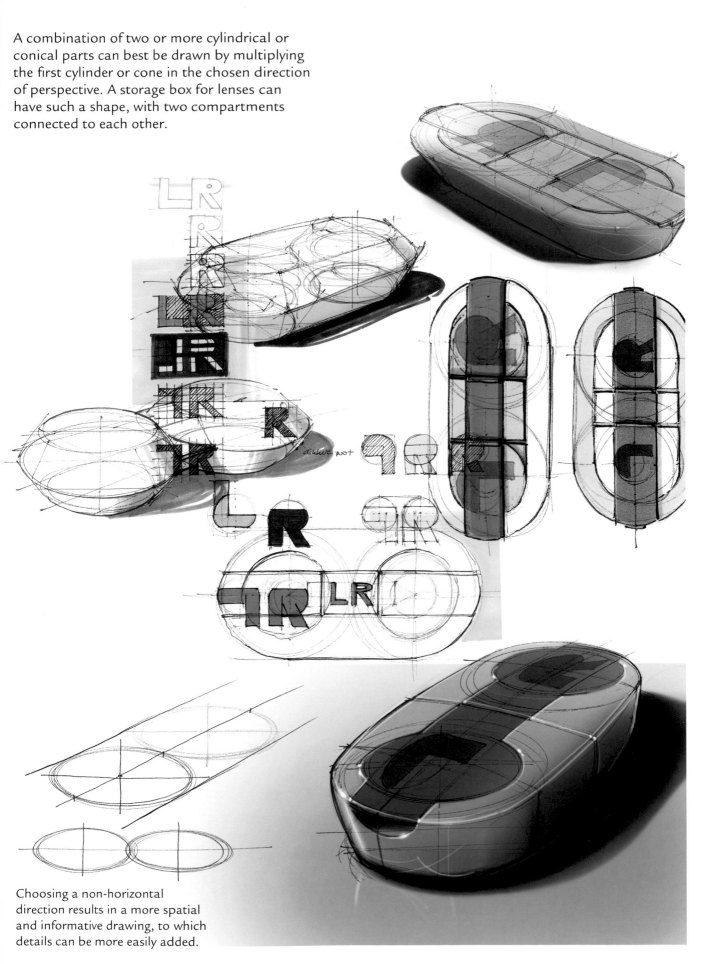

Choosing a non-horizontal
direction results in a more spatial
and informative drawing, to which
details can be more easily added.

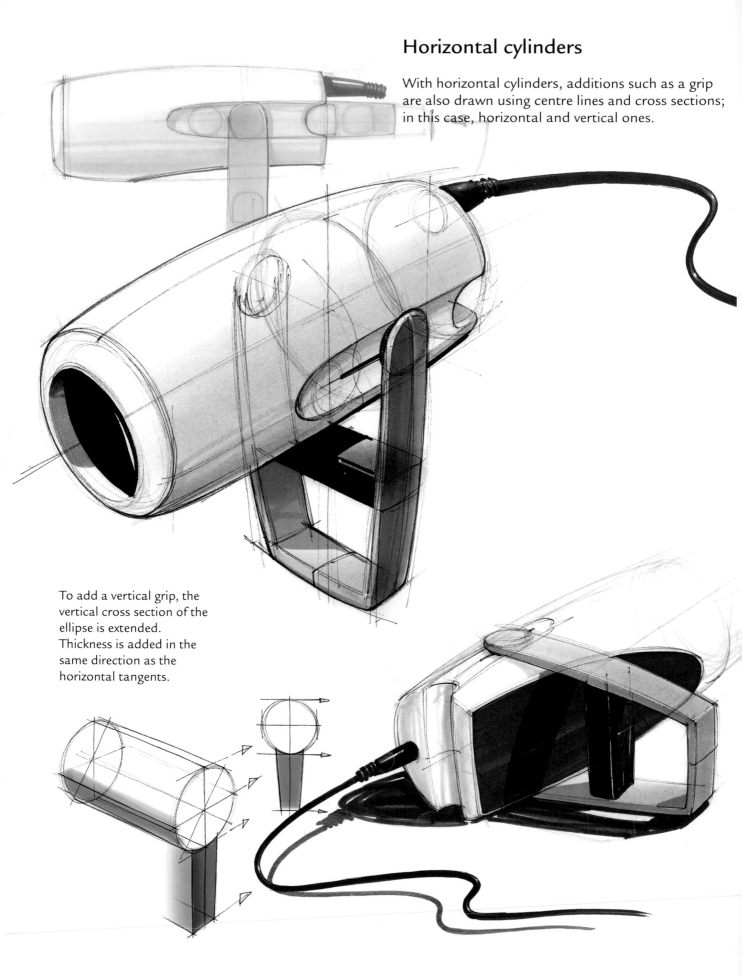

Horizontal cylinders

With horizontal cylinders, additions such as a grip are also drawn using centre lines and cross sections; in this case, horizontal and vertical ones.

To add a vertical grip, the vertical cross section of the ellipse is extended. Thickness is added in the same direction as the horizontal tangents.

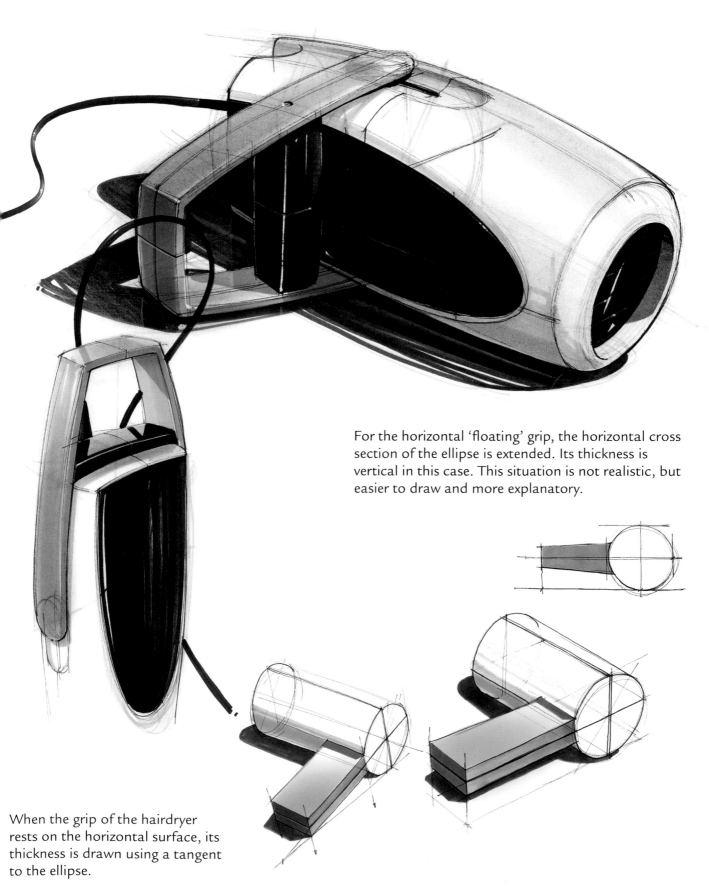

For the horizontal 'floating' grip, the horizontal cross section of the ellipse is extended. Its thickness is vertical in this case. This situation is not realistic, but easier to draw and more explanatory.

When the grip of the hairdryer rests on the horizontal surface, its thickness is drawn using a tangent to the ellipse.

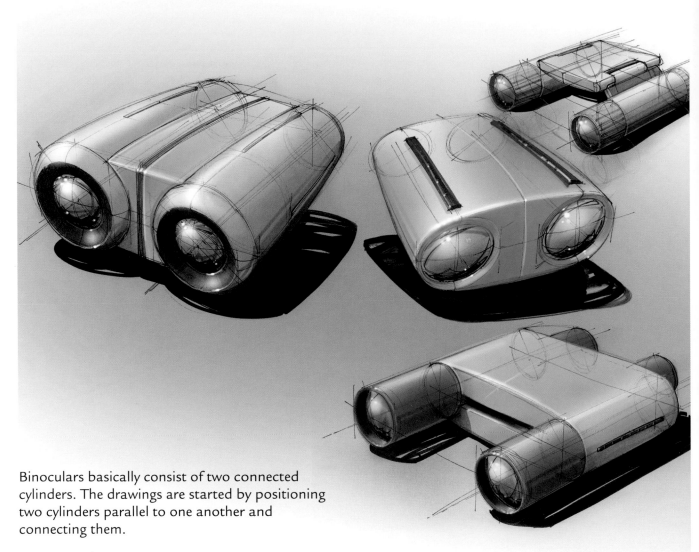

Binoculars basically consist of two connected cylinders. The drawings are started by positioning two cylinders parallel to one another and connecting them.

The orientation and roundness of the first ellipse greatly influences the position of the second cylinder.

Using the nearest ellipse as a starting point, perspectively horizontal guidelines can be positioned.
The next cylinder is centred within these lines.

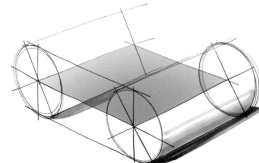

A horizontal surface can also be used to locate the final ellipse.

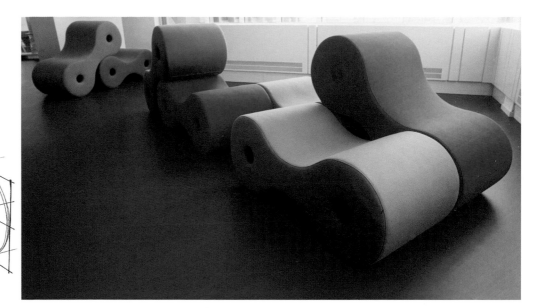

Bench, part of the interior of VROM canteen in The Hague by Remy & Veenhuizen ontwerpers, 2002.

The centre of a circle is located 'behind' the intersection of its axes. A vertical line through this point will show the top and bottom of the ellipse. Tangents through the top and bottom of the ellipse should converge slightly. The horizontal cross section has vertical tangents at both ends.

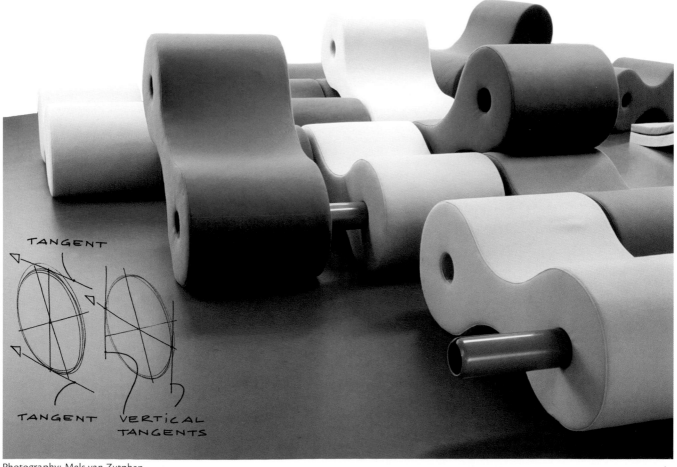

Photography: Mels van Zutphen

Shape combinations

When shapes are basically a combination of cylinders with different orientations, the drawing strategy is the same as before: start with ellipses and cylinders, and then make a connection between them. Choosing the roundness of the ellipses is crucial here; the various cross sections, perpendicular or otherwise, should match in terms of perspective.

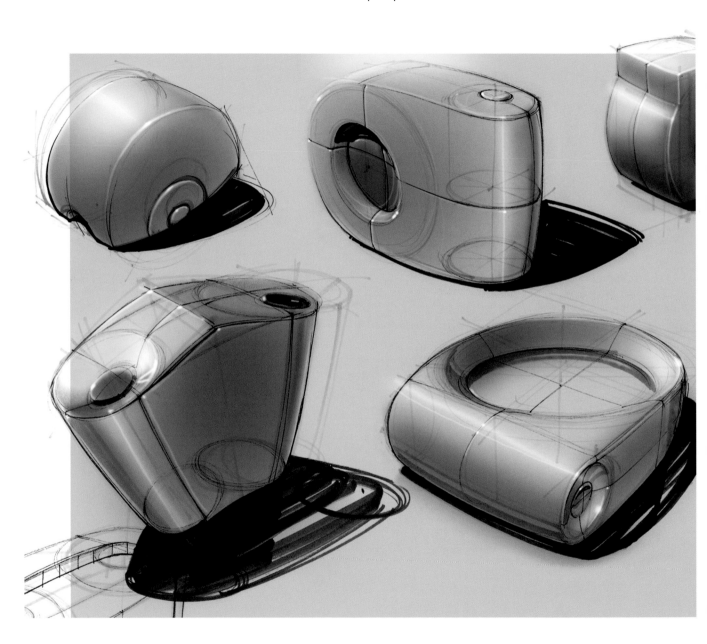

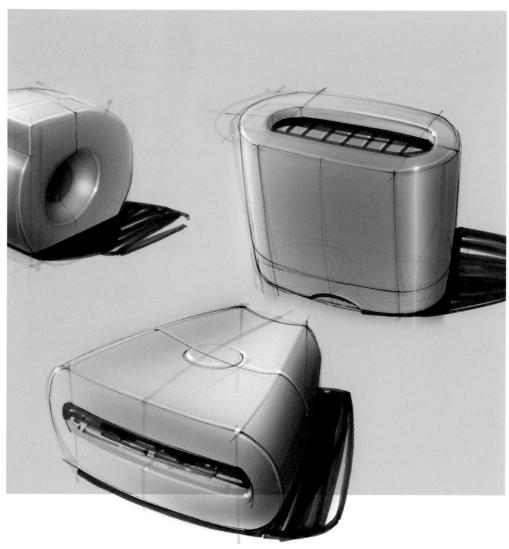

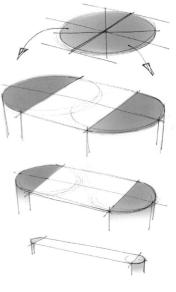

Notice how the ellipse is cut into two equal halves, and then moved apart in a perpendicular direction.

When a shape is more block-like than cylinder-like, it's more obvious to start the drawing with a block, and add parts of cylinders later, so-called 'rounding'.

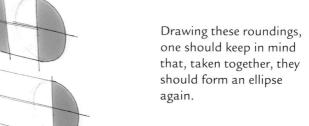

Drawing these roundings, one should keep in mind that, taken together, they should form an ellipse again.

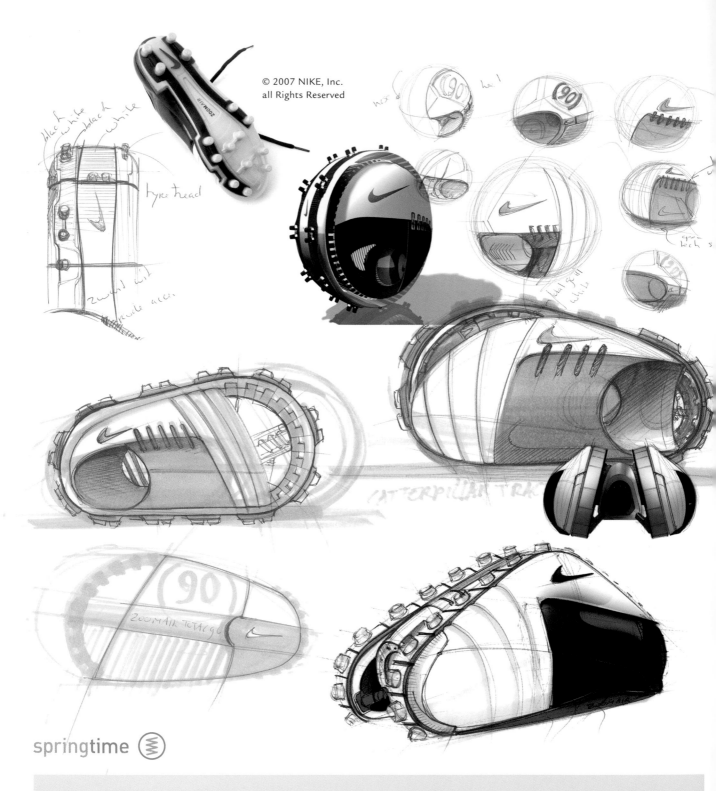

springtime ⊜

Springtime

For the UPGRADE! Football Campaign for Nike
EMEA 2005, Wieden+Kennedy's Amsterdam office
created a campaign showcasing the benefits of
Nike football products. Springtime designed 5
futuristic machines representing five core Nike
football products to illustrate the campaign. This
is one of them. An interaction between sketching
and rendering can be seen here. In this process,
sketches were made over rough 3D renderings and
screenshots, exploring details and questioning
decisions made earlier in the 3D modelling.

Designer: Michiel Knoppert, Computer rendering: Michiel van Iperen, Photography: Paul D. Scott

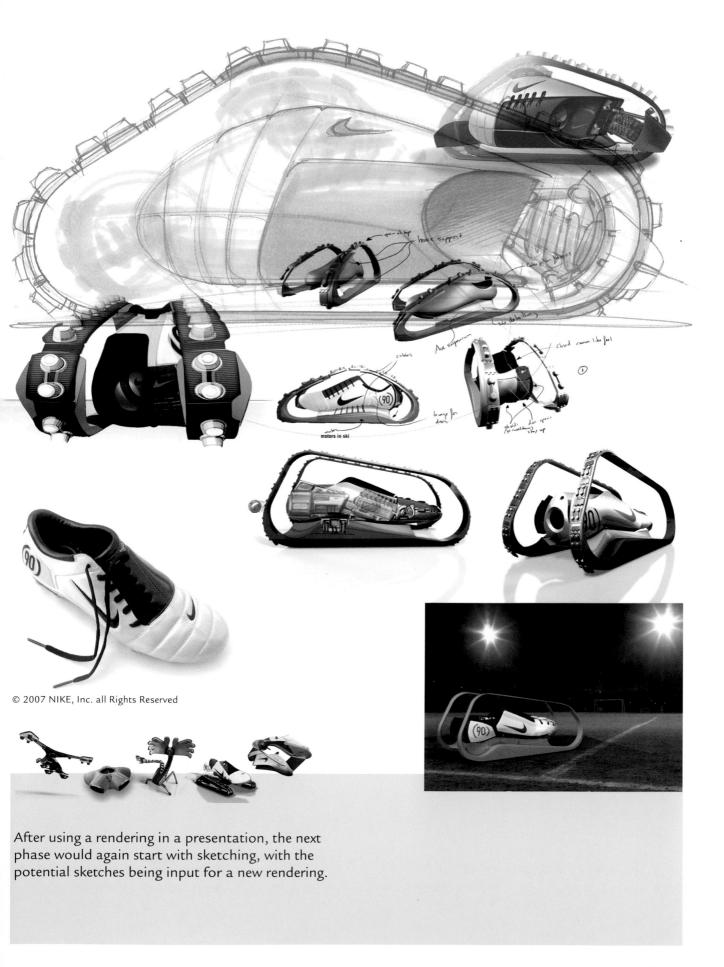

After using a rendering in a presentation, the next phase would again start with sketching, with the potential sketches being input for a new rendering.

Joining cylinders

Another well-known combination of shapes seen in a lot of products is a joining of cylindrical shapes. Ellipses and cross sections are used to determine the connections between them.

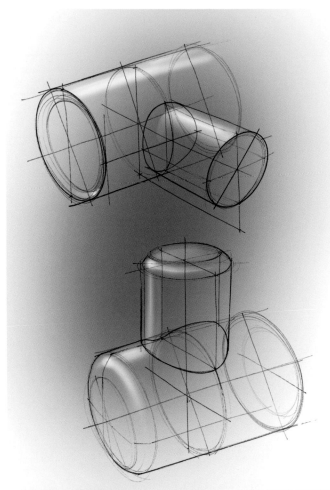

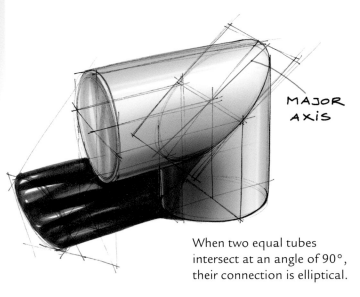

MAJOR AXIS

When two equal tubes intersect at an angle of 90°, their connection is elliptical.

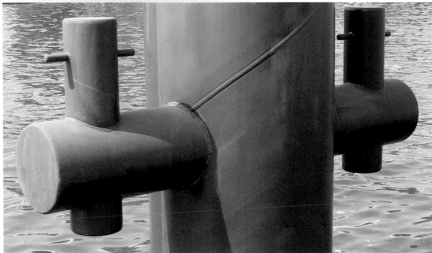

Horizontal and vertical cross sections of the smaller cylinder are projected onto the bigger one, resulting in the height and width of the connection.

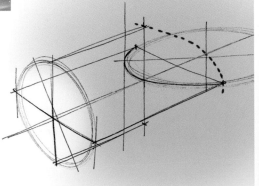

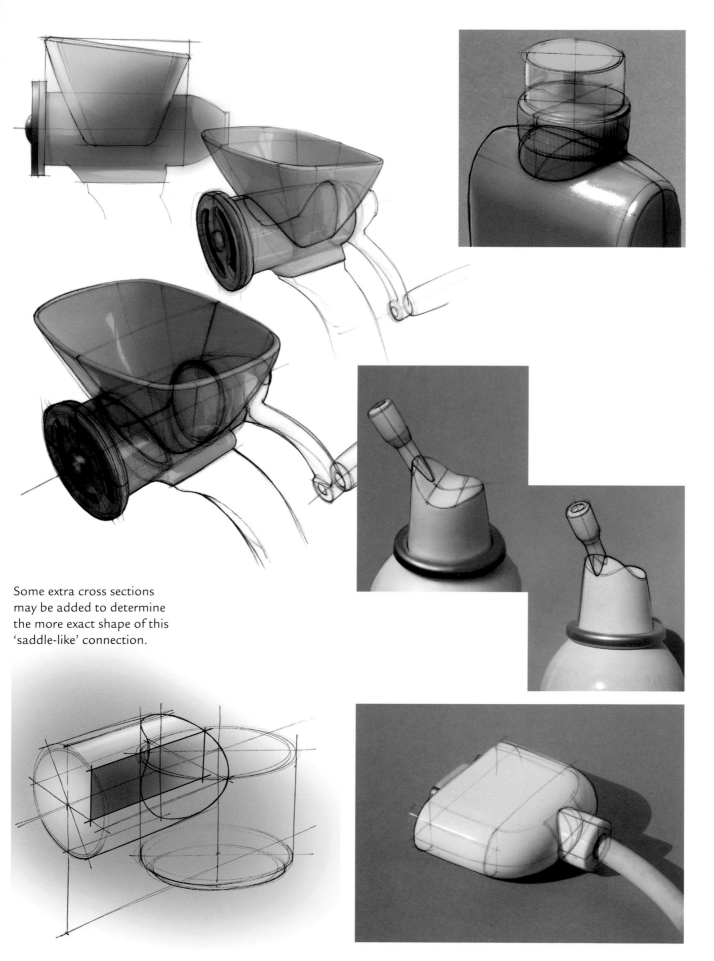

Some extra cross sections
may be added to determine
the more exact shape of this
'saddle-like' connection.

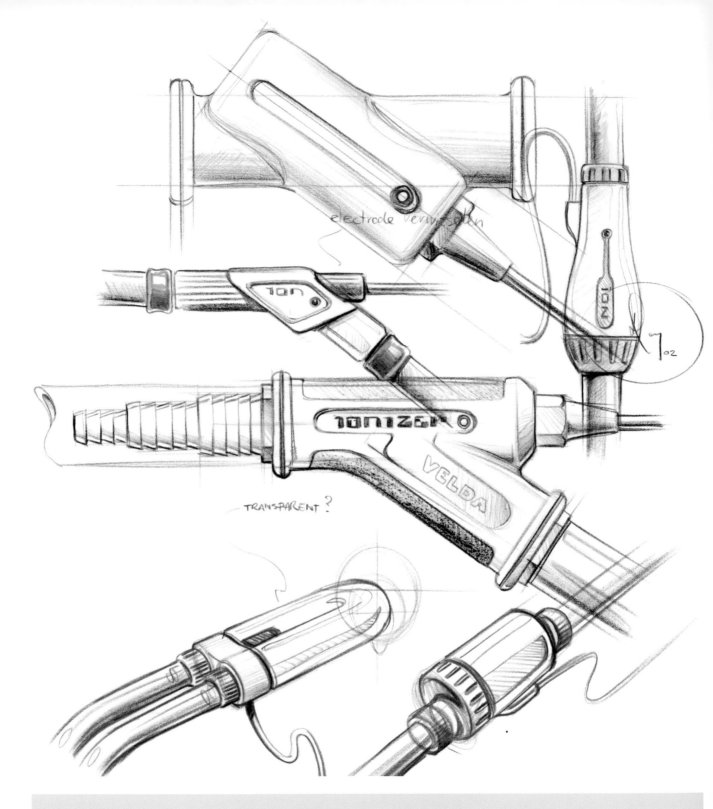

electrode vernissen

ION

IONIZER

VELDA

TRANSPARENT?

WAACS

In 2002, Velda introduced the I-Tronic to permanently eliminate the algae problem that many pond owners suffer from. Not with destructive chemicals, but with a microprocessor-controlled electronic core that generates electric pulses and emits positive copper ions. These ions are the natural extinguishers of both fibrous and slimy algae.

Side view drawings with shading provide a quick spatial impression of a possible solution. In this case, a more simple representation of complex tube joints. A combination of shaded side view drawings

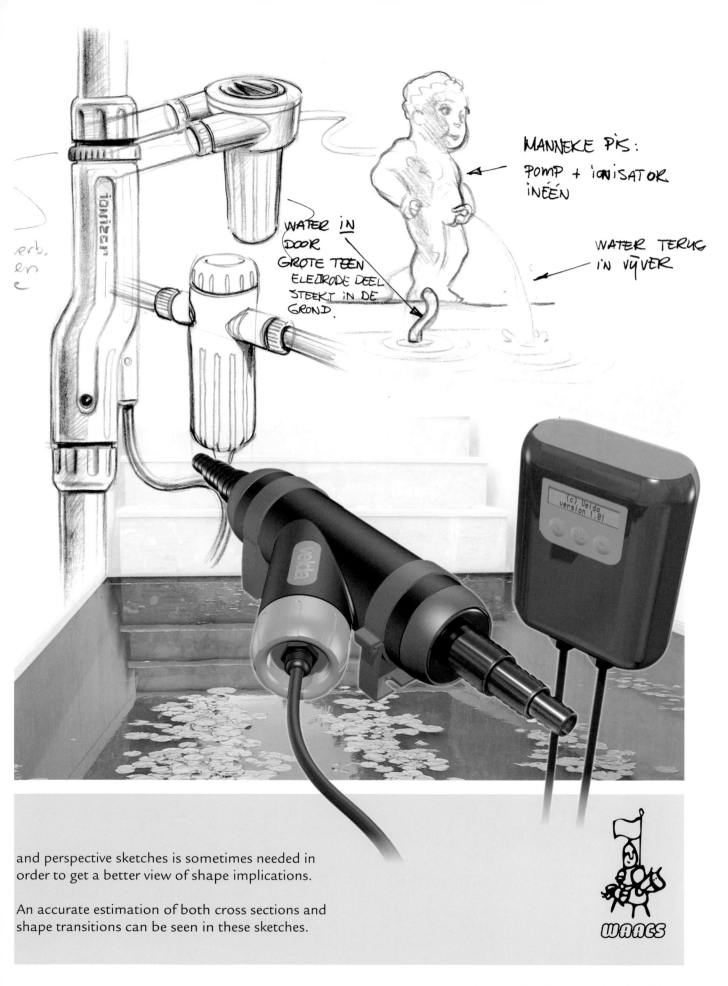

MANNEKE PIS:
POMP + IGNISATOR
INÉÉN

WATER TERUG
IN VIJVER

WATER IN
DOOR
GROTE TEEN
ELEKTRODE DEEL
STEEKT IN DE
GROND.

and perspective sketches is sometimes needed in order to get a better view of shape implications.

An accurate estimation of both cross sections and shape transitions can be seen in these sketches.

Tubes with curvature

Besides straight tubes, there are curved ones.
A specific kind of curved tube is a torus, or donut.
Understanding this shape will provide guidelines
for drawing curved tubes in general. A torus can
be analyzed as a round shape with infinite cross
sections of circles in perspective; their orientation is
perpendicular to the curvature. A quick estimation
is drawn by using only a few strategic ones. Cross-
secting the donut in the direction of the major
and minor axes results in two circles and two lines.
Halfway, the cross section is represented by a 30°
ellipse.

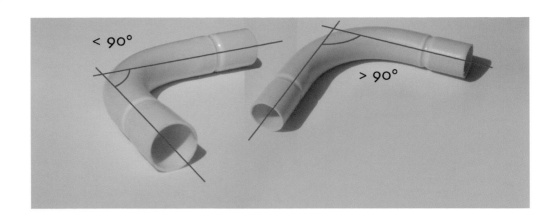

Some examples of 90° curves can be seen here. In certain viewpoints, this curve is drawn at an angle that is < 90°. The fluent ongoing shape is suggested by a specific extended contour line inside the tube, as seen in the torus. To determine this line, connecting similar points (top and outer points) on several cross sections can serve as a reference.

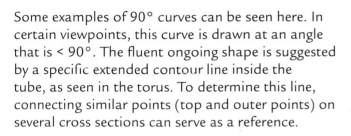

EXTENDED CONTOUR

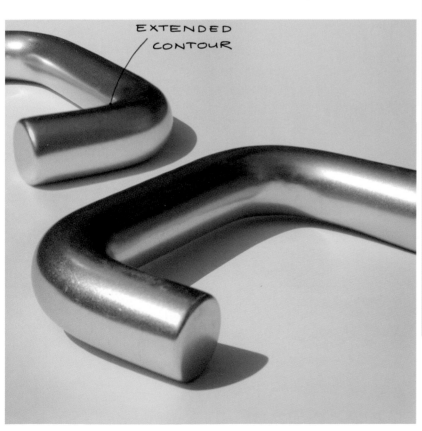

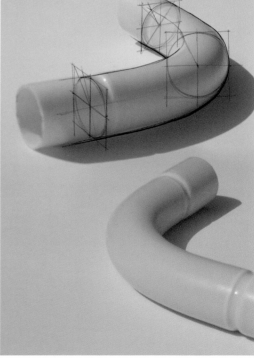

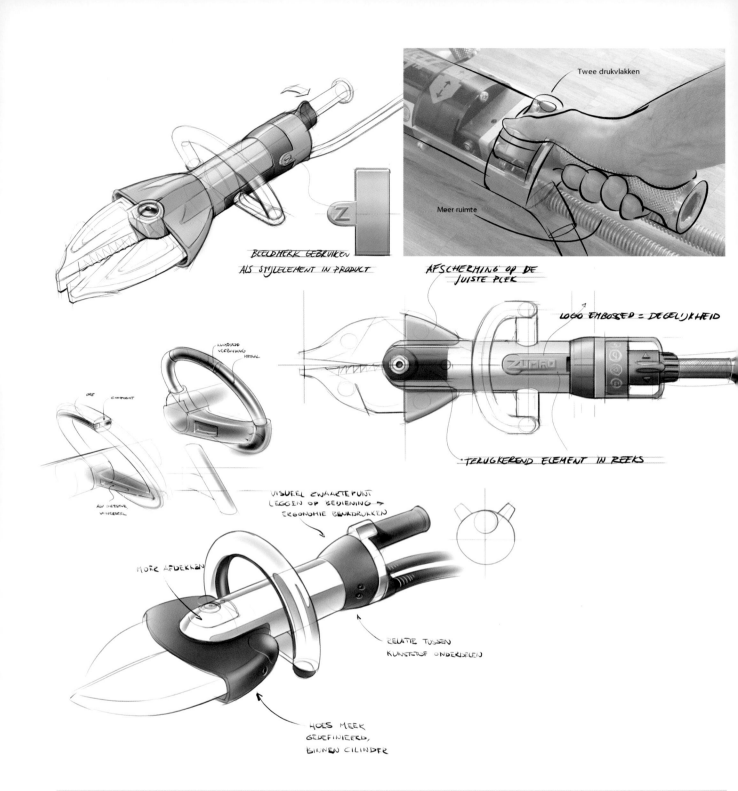

Twee drukvlakken

Meer ruimte

BEELDMERK GEBRUIKEN
ALS STIJLELEMENT IN PRODUCT

AFSCHERMING OP DE
JUISTE PLEK

LOGO EMBOSSED = DEGELIJKHEID

ZUMRO

·TERUGKEREND ELEMENT IN REEKS

VISUEEL ZWAARTEPUNT
LEGGEN OP BEDIENING →
ERGONOMIE BENADRUKKEN

MEER AFDEKKEN

RELATIE TUSSEN
KUNSTSTOF ONDERDELEN

HOES MEER
GEDEFINIEERD,
BINNEN CILINDER

Outlines are sketched over photos of technical
prototypes to determine ergonomic properties.
Important design details are communicated through
combinations of partly detailed visuals and textual
explanations.

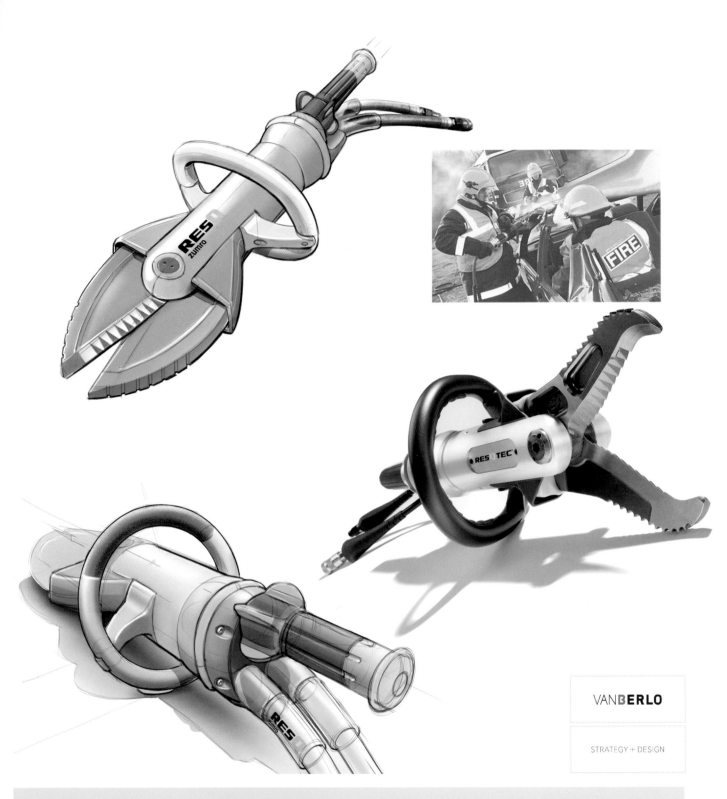

VAN**BERLO**

STRATEGY + DESIGN

Rescue tools are used to free victims from entrapped situations, for instance after car accidents. VanBerlo designed an entirely new range of rescue tools that basically focus on performance and ease of use, rather than on specifications. Special attention was given to mobility and speed of action. Their design has the best weight/performance ratio on the market. A new brand image was developed to communicate these properties.

VanBerlo Strategy + Design

Branding and design of hydraulic rescue tools, for RESQTEC, 2005.
iF Gold Award 2006. Red Dot 'Best of the Best' Award 2006. Dutch Design Award, 2006. Industrial Design Excellence Award (IDEA) Gold 2006.

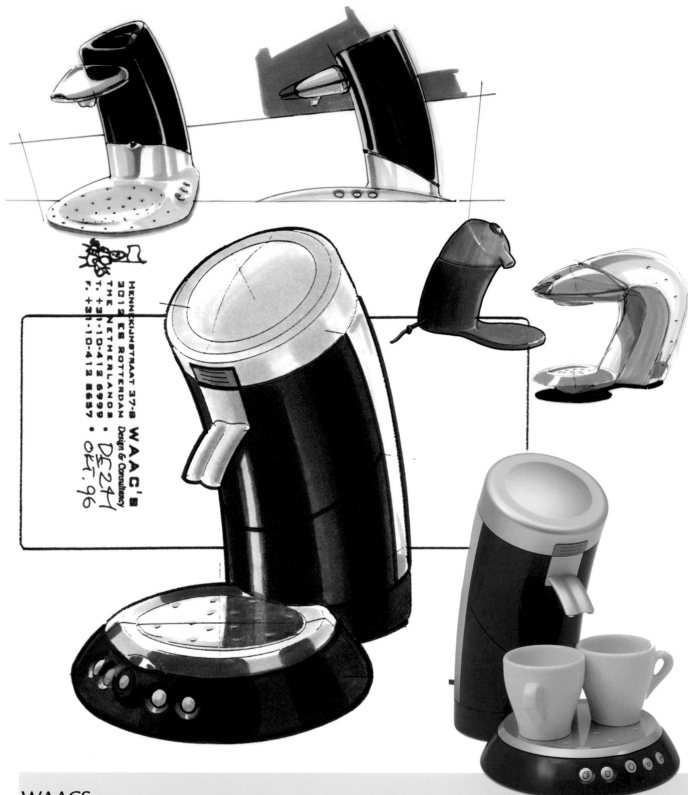

WAACS

Success is a result of passion, and there's no methodology of the heart (thankfully). Every new product begins with a certain motivation. For example, a coffee machine must be designed in order to reinvigorate the consumer market and increase profit margins. The idea phase follows, and this is where passion plays a critical role. WAACS'

passion for the assignment was met with enthusiasm by those responsible for production – namely, Douwe Egberts/Sara Lee and Philips. Shortly after its launch in 2002, it took Europe and the USA by storm, surpassing all expectations. Consumers call it 'Senseo'. They call the frothy brew Senseo, too. That's also passion. Consumer passion.

Rounding

Nearly every industrial product has rounding in its shape. These roundings, which can be related to manufacturing processes or derive from form, have a big impact on the appearance of a product. There are only a few basic roundings – with endless variations, however: from singular rounding in one direction to multiple, curved rounding in different directions.

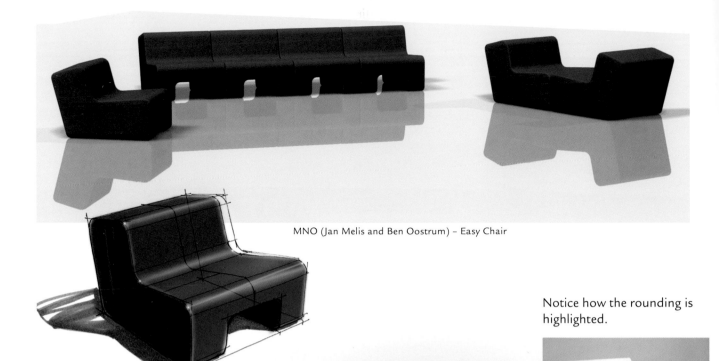

MNO (Jan Melis and Ben Oostrum) – Easy Chair

Notice how the rounding is highlighted.

Singular rounding

An object has 'singular rounding' when its rounding is curved in one direction only. In its simplest form, this will result in extrusion-like shapes. A good way to learn about rounding is to analyze and draw existing shapes. First the objects can be drawn as block shapes, then roundings are 'subtracted'.

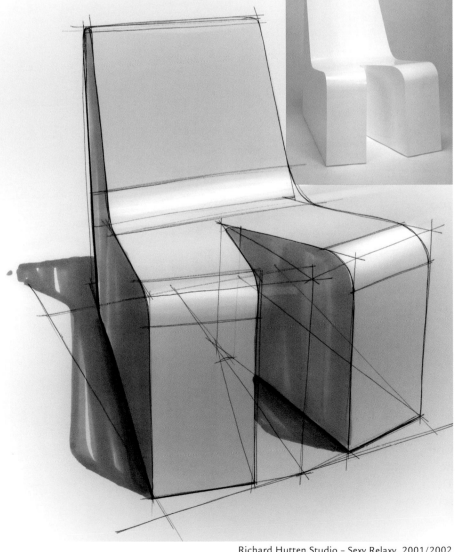

Richard Hutten Studio – Sexy Relaxy, 2001/2002

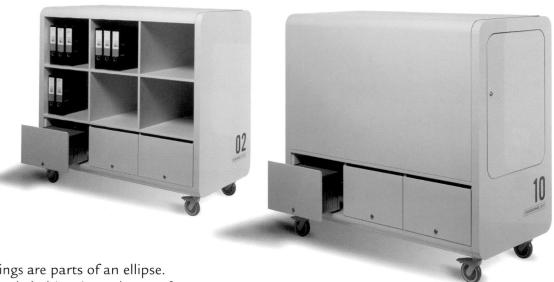

Most basic roundings are parts of an ellipse. As a singularly rounded object is made out of a combination of parts of blocks and cylinders, its shading will be made the same way.

Fabrique – Metal cabinets / Rotterdam Droogdok furniture, part of the interior design of the new office for the development corporation CityPorts Rotterdam, 2005.

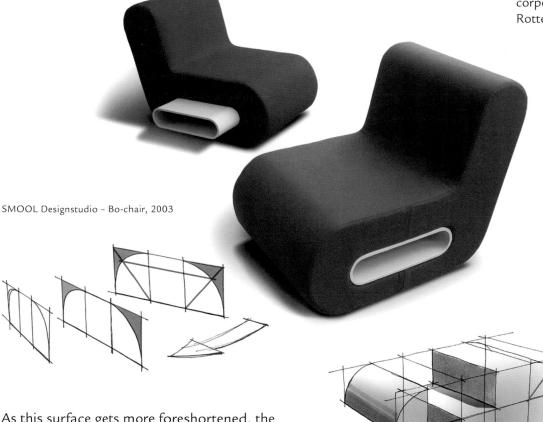

SMOOL Designstudio – Bo-chair, 2003

As this surface gets more foreshortened, the opposed roundings will differ more in shape. Comparing the shapes of the remaining space can help to match curves; these have to feel similar. The section of a curve with the diagonal may also serve as a guide for the opposed rounding.

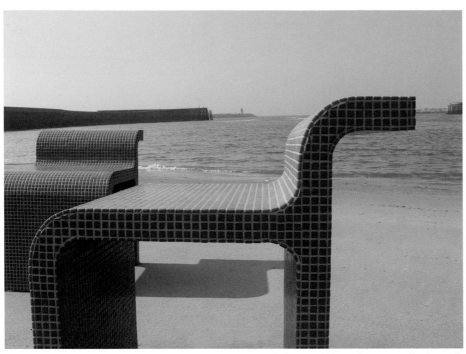

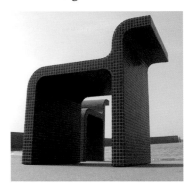

The Pharaoh furniture line can be used both outdoors and indoors. Selected for the Dutch Design Awards 2005.

Design and photography: studioMOM, Alfred van Elk

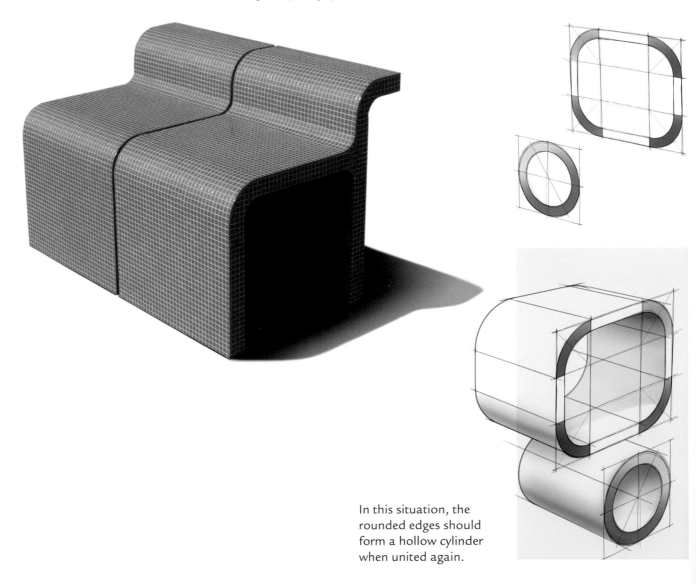

In this situation, the rounded edges should form a hollow cylinder when united again.

Ramin Visch –chair ELI, 2006.
Materials: steel, covered with wool felt.
Photography: Jeroen Musch

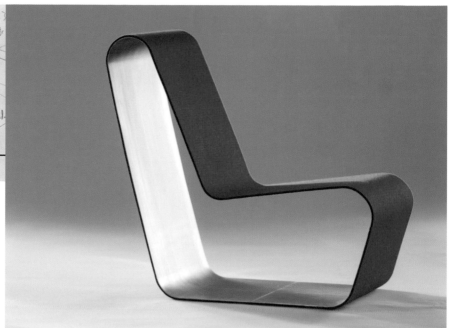

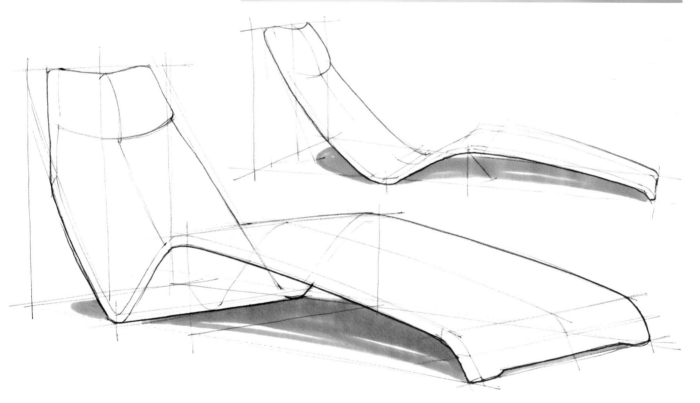

When a rounding is not cylindrical but curved in another way, the use of guiding lines such as a cross section becomes more essential in order to achieve symmetry.

As the cross-sectional surfaces were placed on the ground floor, they were also handy in drawing cast shadow.

Early sketches are used to document the initial idea, and to visualize the first step as to what the shape should look like. After that, various media are used to develop the concept towards materialization, varying from small hand-drawn paper models to more precise Adobe Illustrator try-outs. Employing such a delicate ratio-based principle, the final shape determination was largely done by computer.

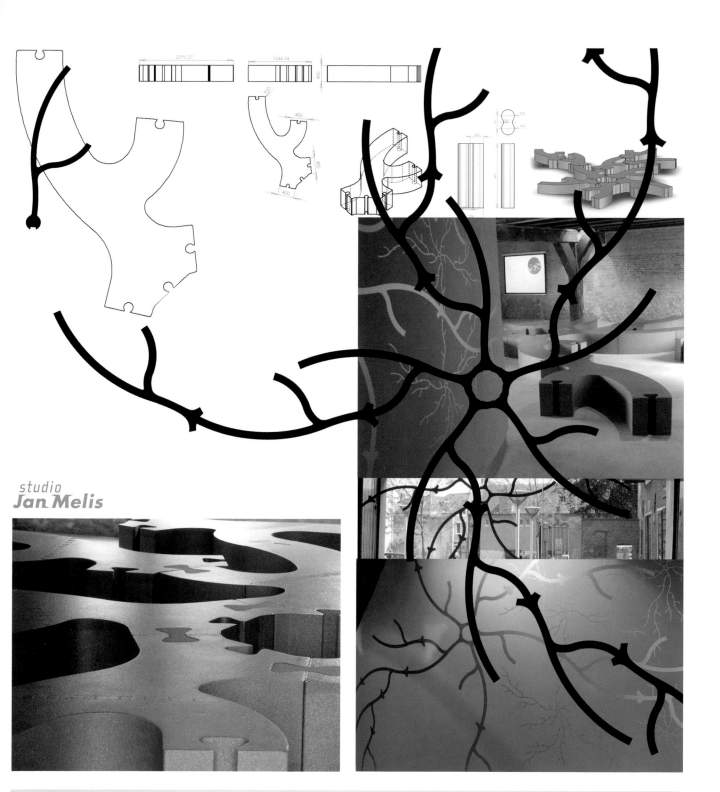

Studio Jan Melis

The Golden Ratio, also known as the divine proportion, is a universal proportion related to beauty that is revealed in nature and in artefacts around us. This phenomenon is used as inspiration to design modular shapes that can be combined in endless ways. During the *Luctor et emergo* exhibition at the CBK Zeeland in Middelburg, it has taken shape as a self-adhesive wall decoration and a modular bench, 2006.

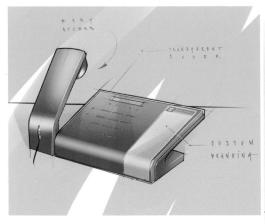

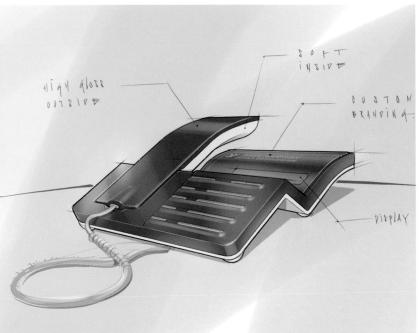

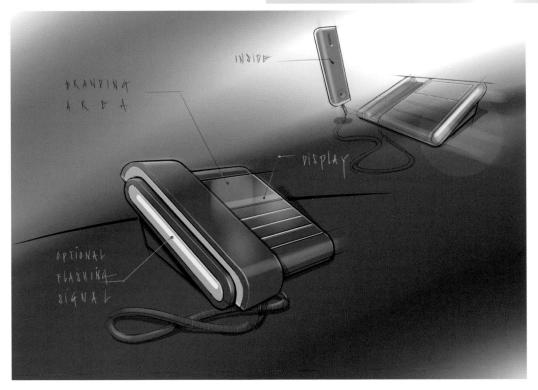

Pilots Product Design

Tabletop phone for Philips, 2005. This on-board telephone was designed for use on American cruise ships being re-furbished. Initial concepts took into account the high quality minimalistic styling of the ships' interiors.

A clear indication of the look and feel can already be seen in these early drawings. The use of text in these drawings helps communicate concepts with overseas clients and interior designers.

Designers: Stanley Sie and Jurriaan Borstlap

116

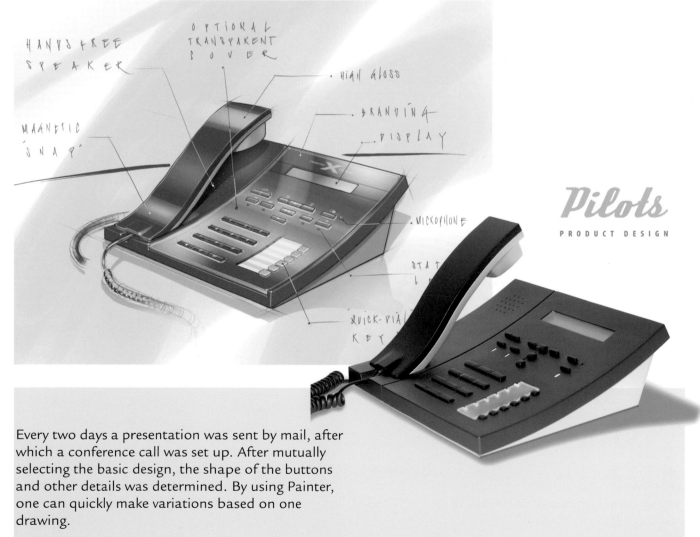

HANDS FREE SPEAKER

OPTIONAL TRANSPARENT COVER

HIGH GLOSS

BRANDING

DISPLAY

MAGNETIC "SNAP"

MICROPHONE

STATE

QUICK-DIAL KEY

Pilots

PRODUCT DESIGN

Every two days a presentation was sent by mail, after which a conference call was set up. After mutually selecting the basic design, the shape of the buttons and other details was determined. By using Painter, one can quickly make variations based on one drawing.

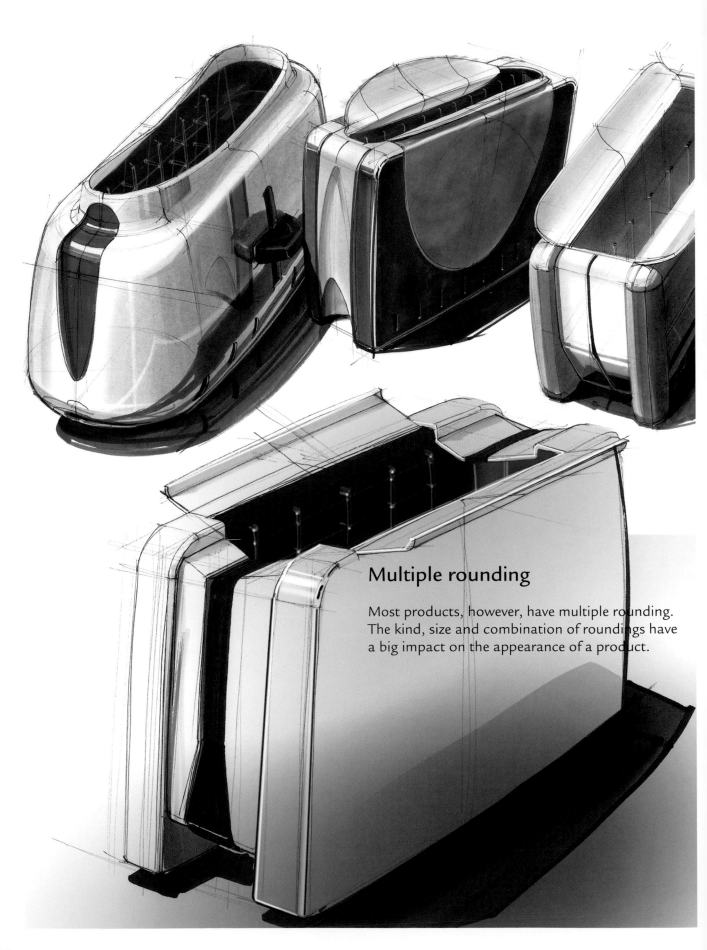

Multiple rounding

Most products, however, have multiple rounding. The kind, size and combination of roundings have a big impact on the appearance of a product.

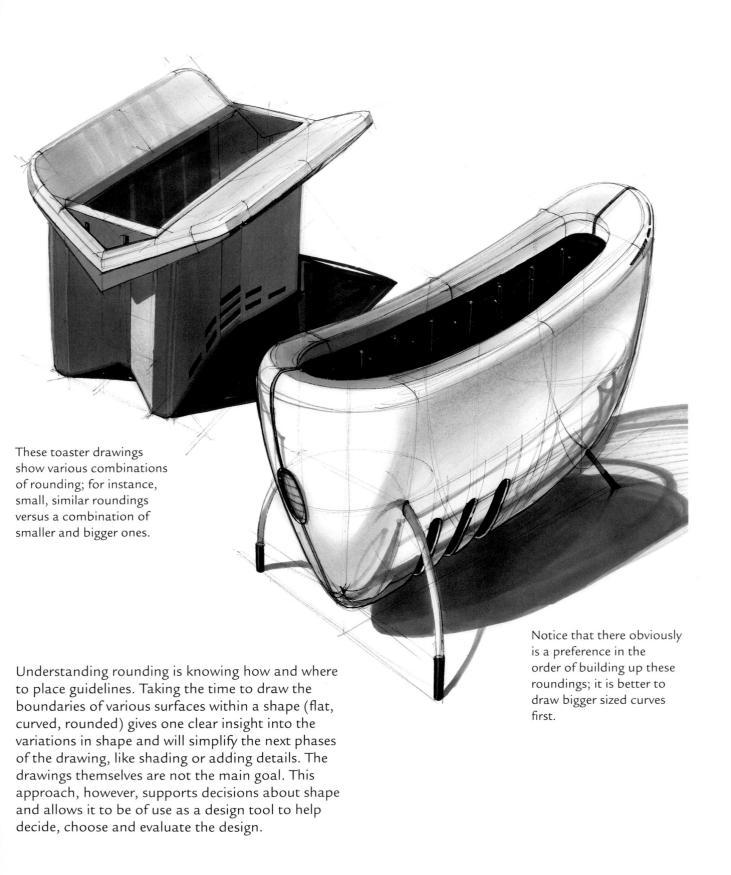

These toaster drawings show various combinations of rounding; for instance, small, similar roundings versus a combination of smaller and bigger ones.

Notice that there obviously is a preference in the order of building up these roundings; it is better to draw bigger sized curves first.

Understanding rounding is knowing how and where to place guidelines. Taking the time to draw the boundaries of various surfaces within a shape (flat, curved, rounded) gives one clear insight into the variations in shape and will simplify the next phases of the drawing, like shading or adding details. The drawings themselves are not the main goal. This approach, however, supports decisions about shape and allows it to be of use as a design tool to help decide, choose and evaluate the design.

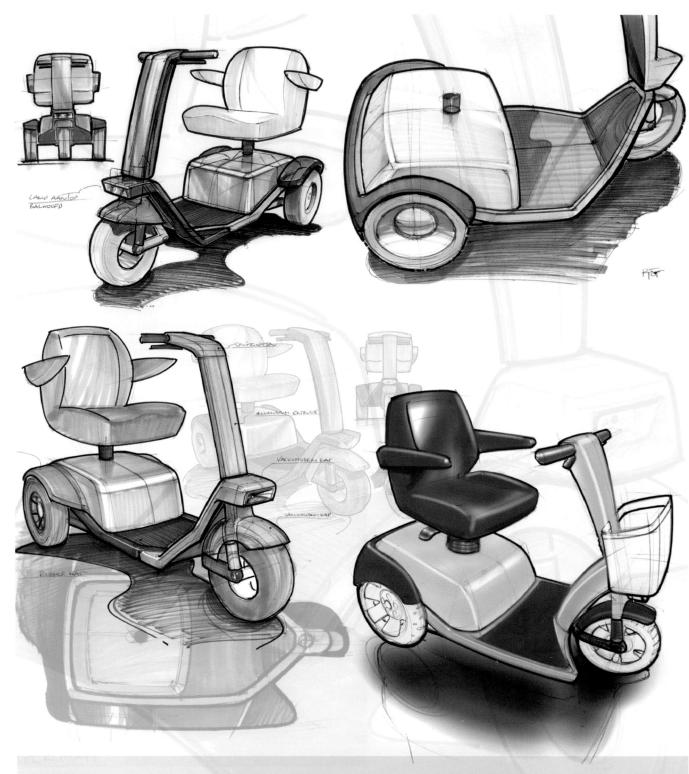

MMID

Logic-M, Ligtvoet Products BV, 2006. In close collaboration with the client, the focus was mainly the overall styling of the electric scooter. The development of the technical, metal parts of the scooter was done by Ligtvoet. The first sketches, the renderings and the mock-ups were made by using different combination of tools, like Painter, Photoshop and Rhino-3D.

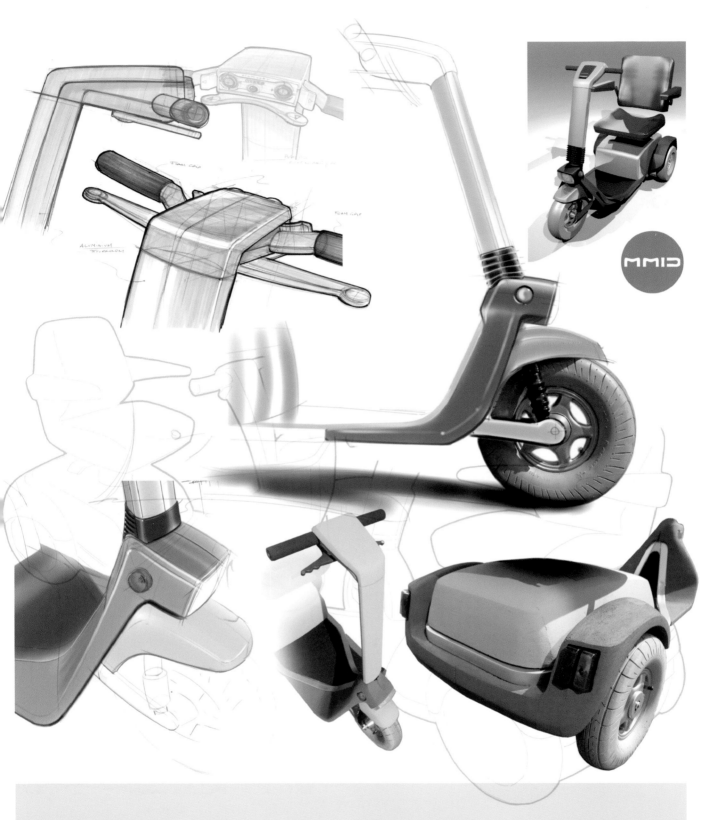

"Different sketching techniques were used during this project. Our first drawings were ballpoint with marker sketches. After that we used the foam mock-up photos for sketching over, and for the detailing of the styling we used the Rhino CAD model as a master to sketch on.

This combination of techniques helps us to give a good impression of the product at any stage and makes us able to fine-tune all styling aspects of

the scooter on different levels. Using the Rhino CAD model also makes it possible to use perspective as you like, in any view you want."

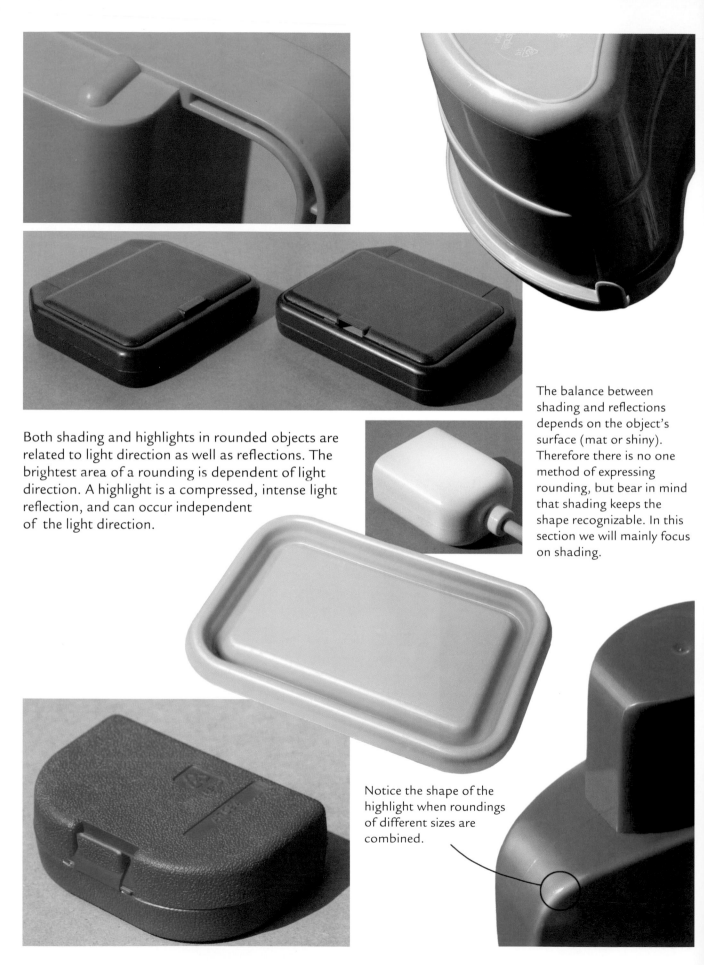

Both shading and highlights in rounded objects are related to light direction as well as reflections. The brightest area of a rounding is dependent of light direction. A highlight is a compressed, intense light reflection, and can occur independent of the light direction.

The balance between shading and reflections depends on the object's surface (mat or shiny). Therefore there is no one method of expressing rounding, but bear in mind that shading keeps the shape recognizable. In this section we will mainly focus on shading.

Notice the shape of the highlight when roundings of different sizes are combined.

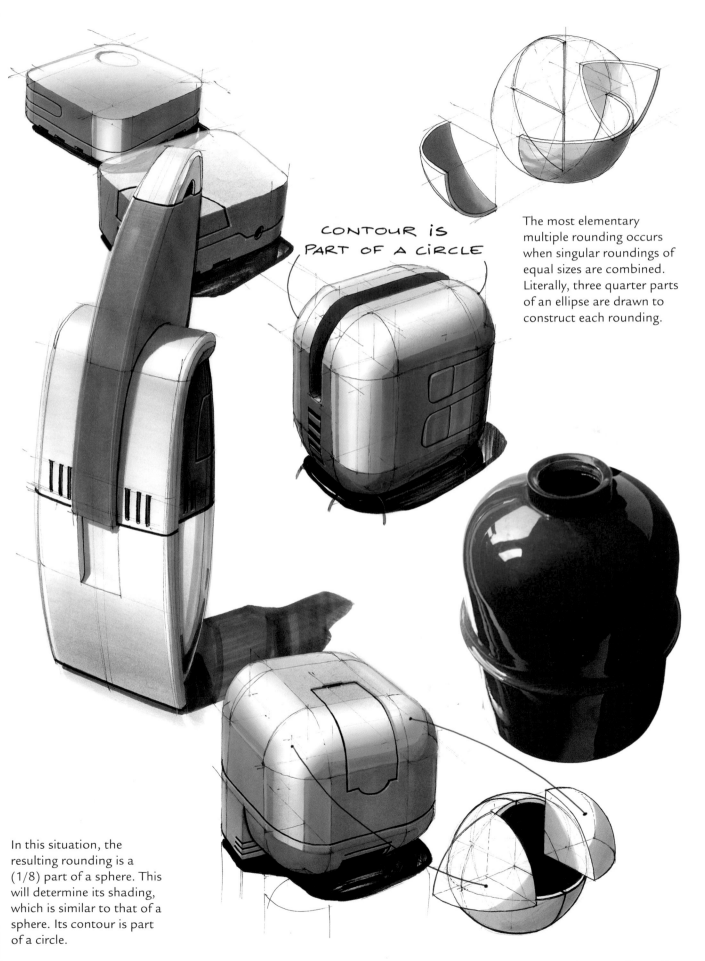

CONTOUR IS PART OF A CIRCLE

The most elementary multiple rounding occurs when singular roundings of equal sizes are combined. Literally, three quarter parts of an ellipse are drawn to construct each rounding.

In this situation, the resulting rounding is a (1/8) part of a sphere. This will determine its shading, which is similar to that of a sphere. Its contour is part of a circle.

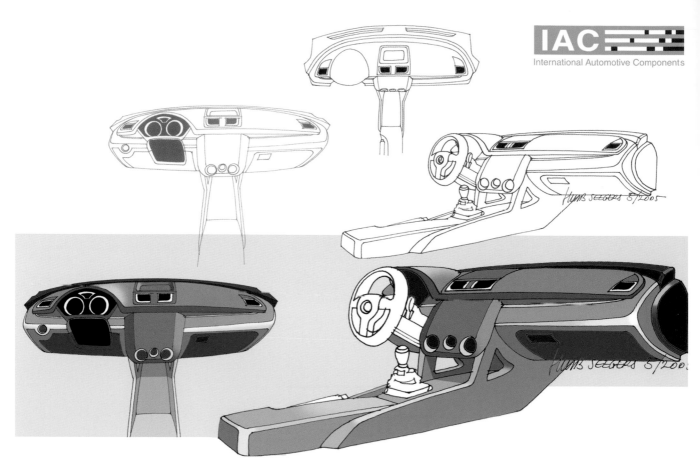

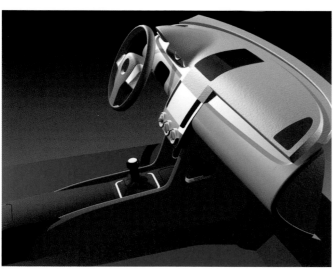

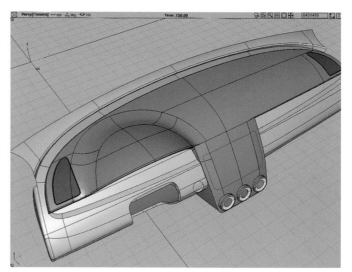

IAC Gruppe, Germany – Huib Seegers

These concept drawings explore dashboard and centre console shapes, which had to tie in with a typical OEM (specifications) styling, and at the same time visualize certain innovative manufacturing processes (2005).

The starting point was pencil sketches that were finalized in a 'cartoon-like' manner with black fineliner on paper, and quickly collared with Photoshop. The next step was 3D concept modelling and rendering in Alias software.

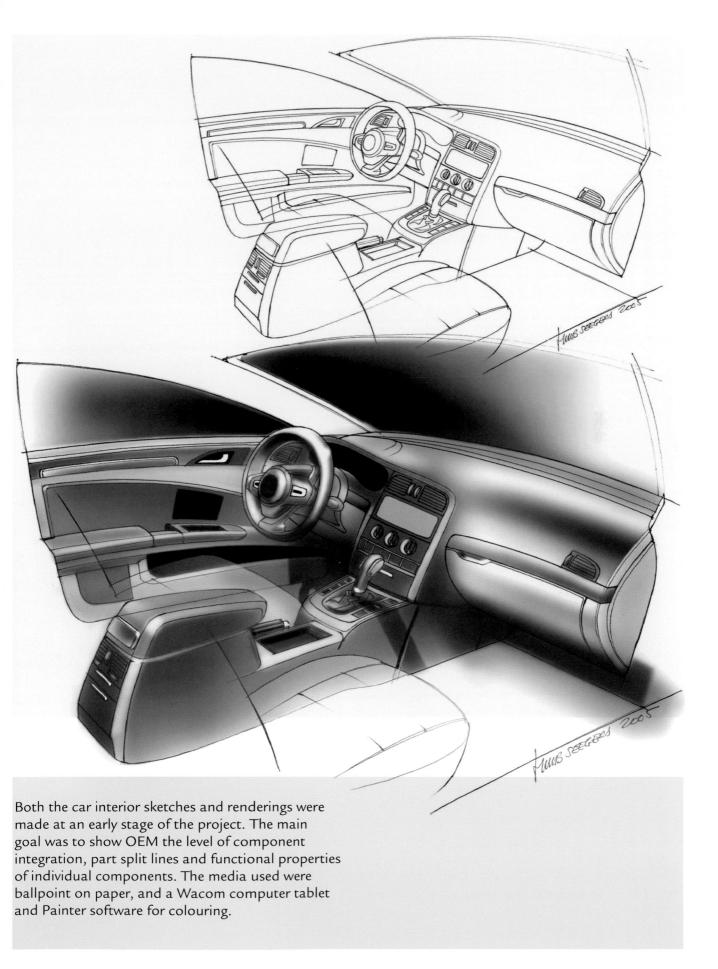

Both the car interior sketches and renderings were
made at an early stage of the project. The main
goal was to show OEM the level of component
integration, part split lines and functional properties
of individual components. The media used were
ballpoint on paper, and a Wacom computer tablet
and Painter software for colouring.

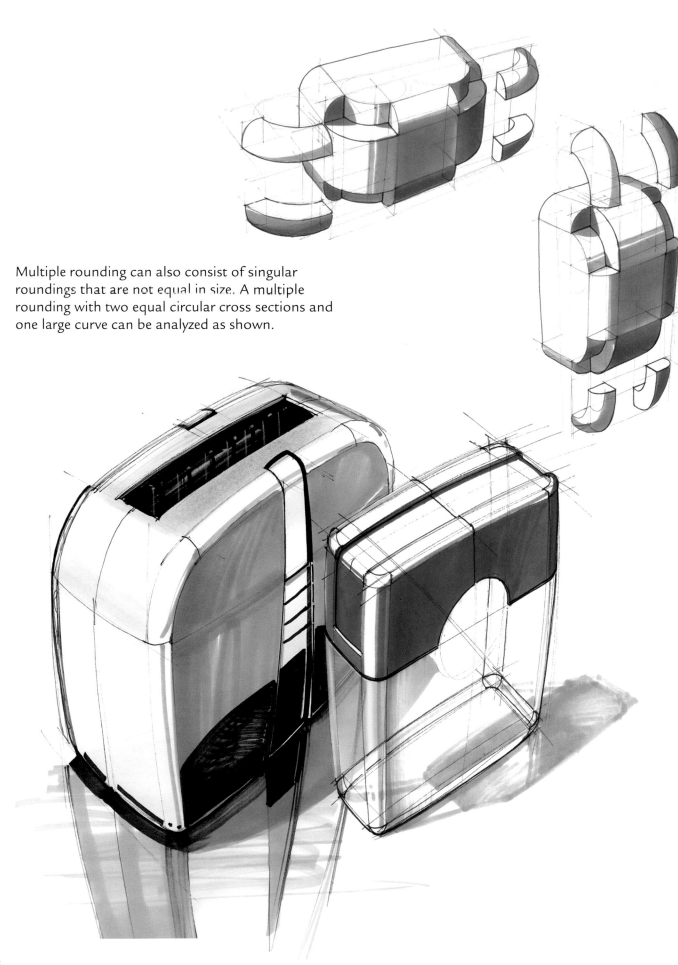

Multiple rounding can also consist of singular roundings that are not equal in size. A multiple rounding with two equal circular cross sections and one large curve can be analyzed as shown.

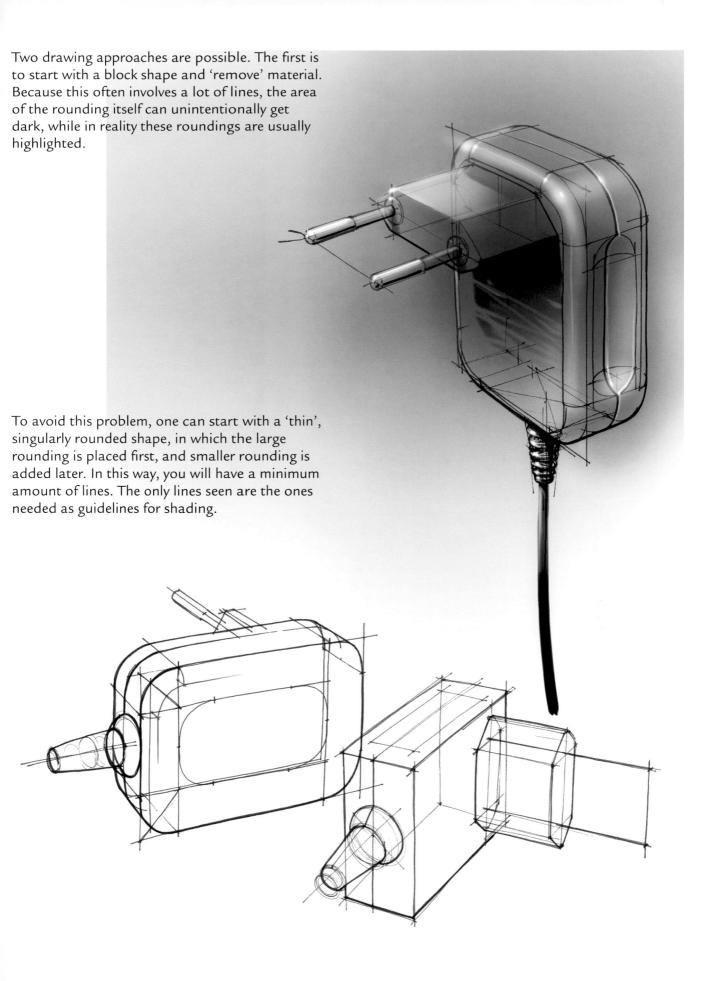

Two drawing approaches are possible. The first is to start with a block shape and 'remove' material. Because this often involves a lot of lines, the area of the rounding itself can unintentionally get dark, while in reality these roundings are usually highlighted.

To avoid this problem, one can start with a 'thin', singularly rounded shape, in which the large rounding is placed first, and smaller rounding is added later. In this way, you will have a minimum amount of lines. The only lines seen are the ones needed as guidelines for shading.

Although these objects differ a lot in shape in comparison to the objects shown earlier, one can still see the same drawing approach as before. The drawings start with a flat surface, on which a large rounding is drawn. Smaller rounding is added later. An occasional cross section is added to emphasize the transformation of the surface. Reinforcement ribs are also helpful in this.

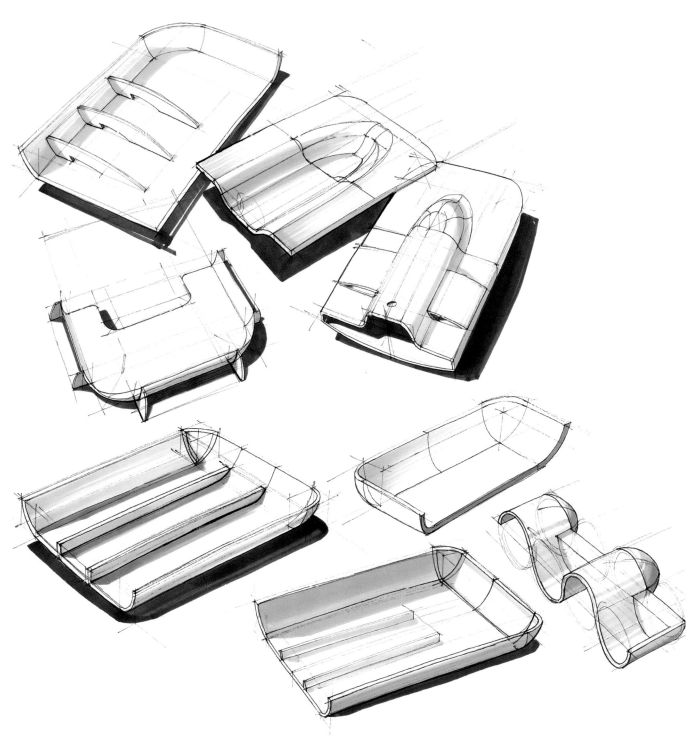

Starting at the surface

When a shape is not clearly spatial or voluminous, but for instance is very flat, approaching it as a volume may not be very efficient. This object is drawn starting with the top surface, at which a slight thickness is added downwards.

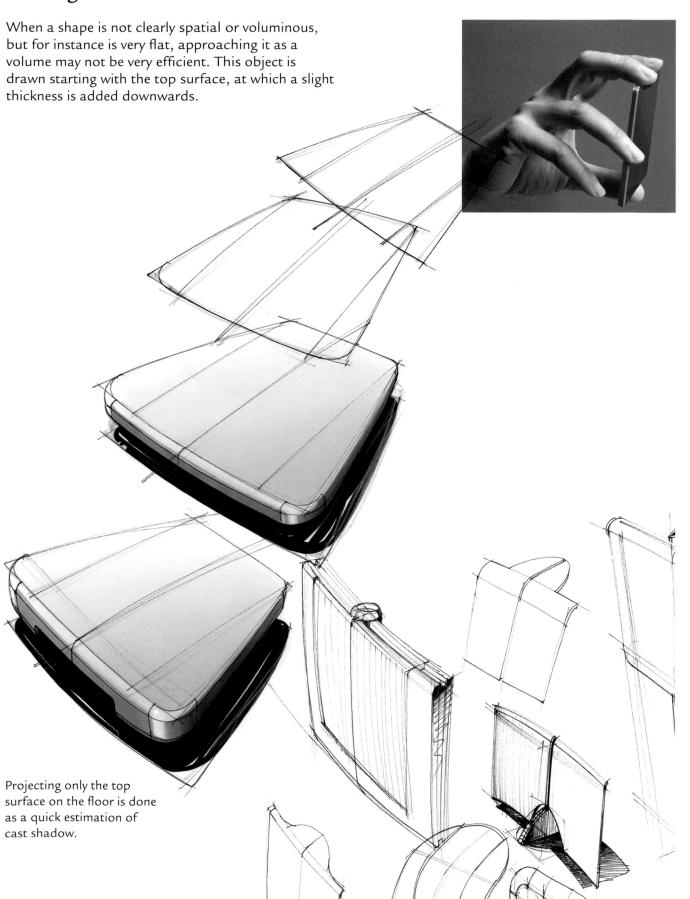

Projecting only the top surface on the floor is done as a quick estimation of cast shadow.

When rounding is relatively small, it will not have to be constructed; it can also be 'suggested' by drawing two lines and keeping the stroke between them brighter. In these examples, the starting point is the top surface, which can be slightly curved. Cross sections or seams that follow the shape over rounding can help indicate or emphasize it.

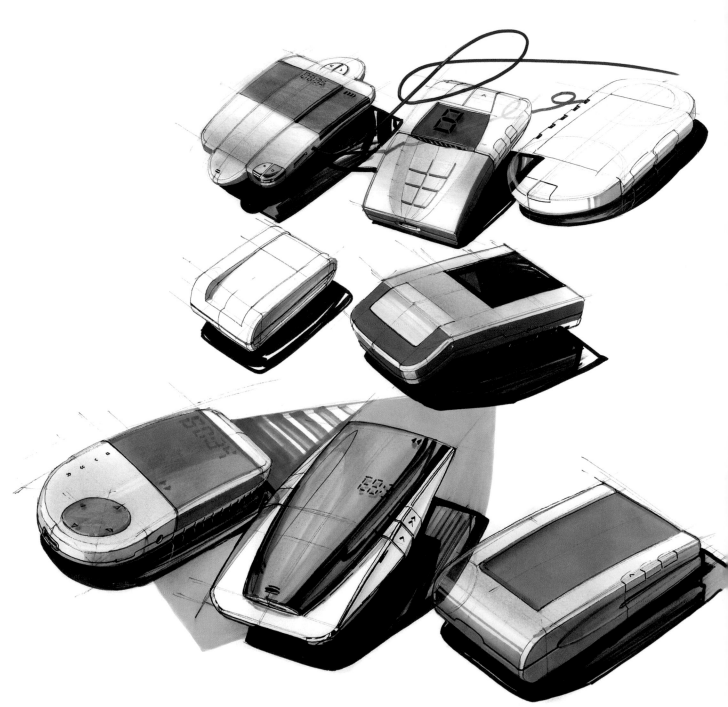

Details are added after colour and shading.

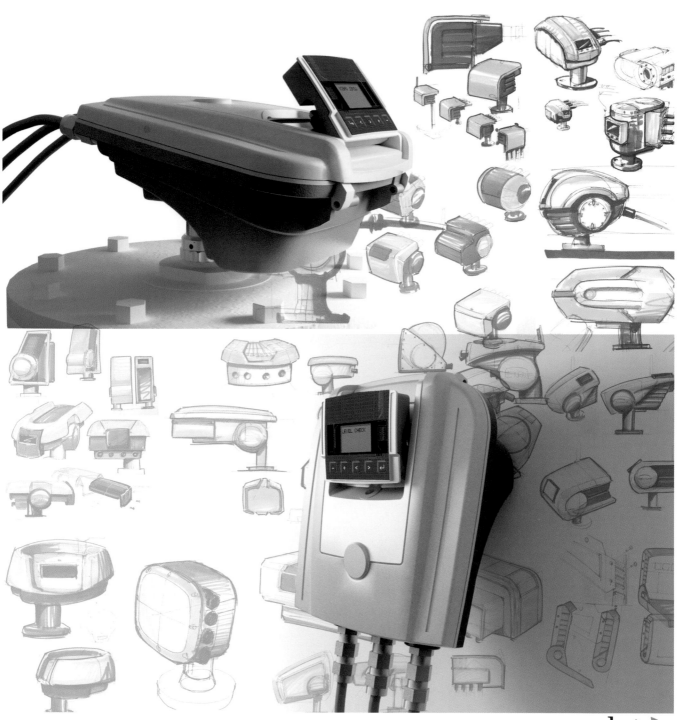

Spark Design Engineering

Explosion-proof level gauges, 2006.
As these measurement devices are used in storage terminals in the oil and gas industry, safety is a key factor. Spark set out to develop the line of gauges so as to enhance and reinforce the client's brand image without concessions to safety or product cost. By defining a set of modular components, a complete portfolio of products can be made using few parts. In a previous project phase, Spark had defined the desired perception of the product and brand positioning. This allowed the designers to make early sketches using the chosen colour scheme. The way in which colour is used can actually drive the styling and shape development of the product.

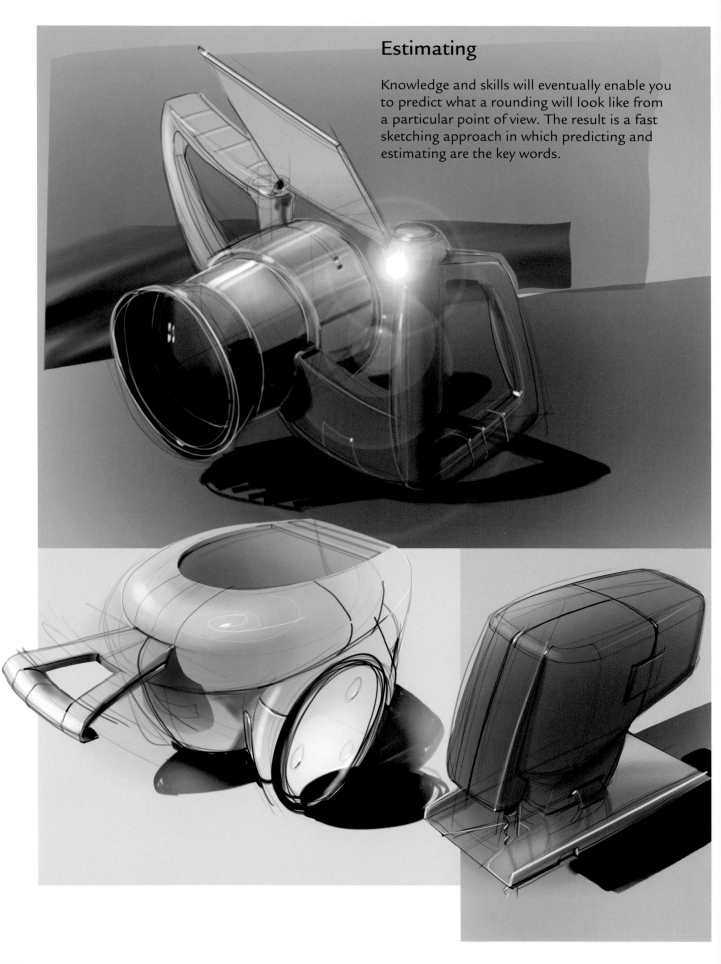

Estimating

Knowledge and skills will eventually enable you to predict what a rounding will look like from a particular point of view. The result is a fast sketching approach in which predicting and estimating are the key words.

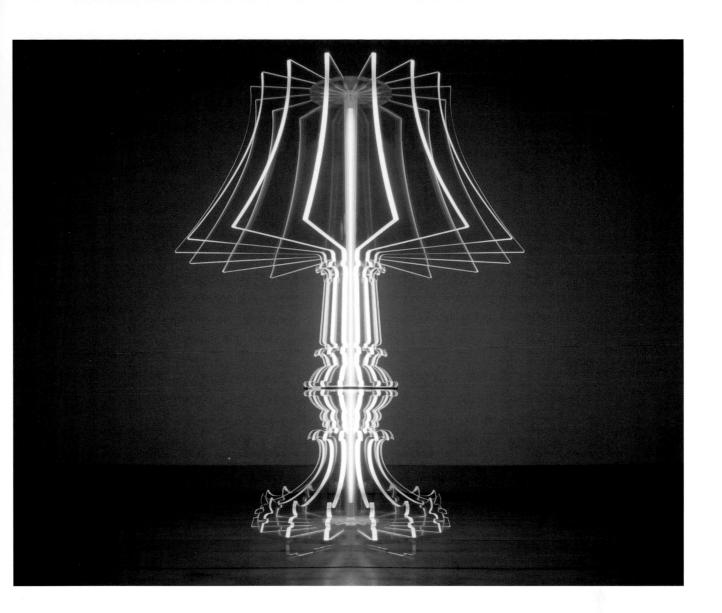

Planes / cross sections

Another approach to spatial drawing is plane-oriented. Up to this point, an object has been regarded as a combination of basic volumes, but it may also be drawn using planes. The most commonly used plane is the cross section. Cross sections are used in 'building up' an object and also in determining shape transitions.

Buro Vormkrijgers – Marie-Louise, 2002

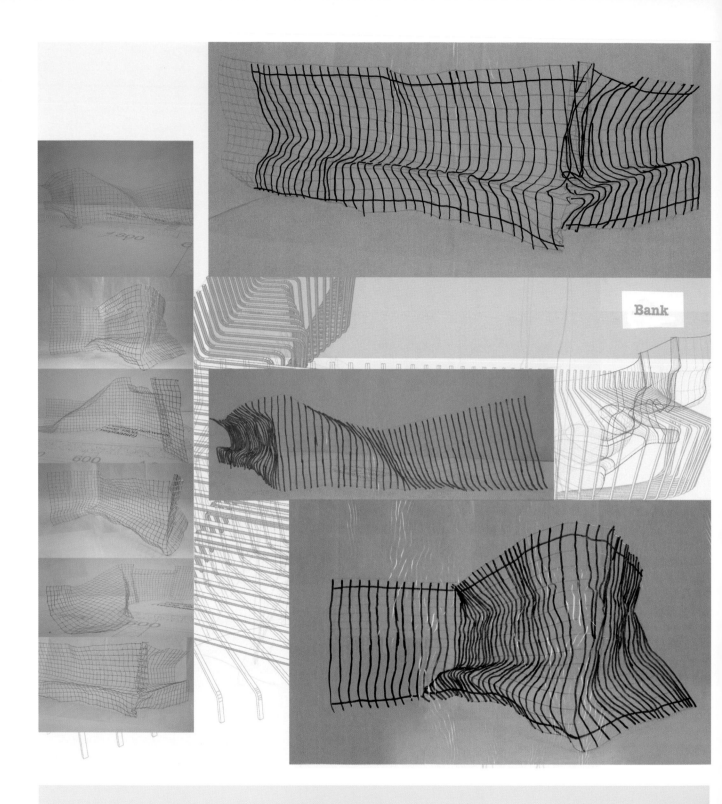

Bank

At the start of the design process, numerous pictures were taken of scale models using industrial wire netting. On several optional pictures, the structure was traced in order to get a clear understanding of the shape transition, and to intensify the original character of the idea. These drawings were used later as a starting point for renderings.

"Usually, (scale) models play an important role in the early stage of our design process."

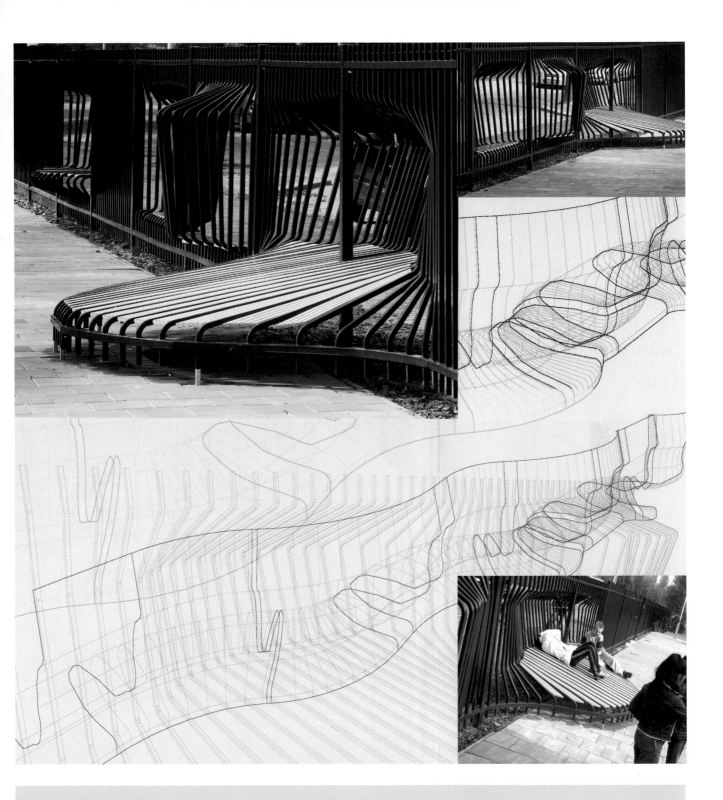

Remy & Veenhuizen ontwerpers

Can a fence become a place to meet, hang out and relax? An impersonal fence at the Noorderlicht primary school in Dordrecht has been transformed into such a meeting area.

The deformation of the existing rigid rhythm into an organic structure has created places to hang out on both sides of the fence. This bent structure is connected at each end to the previously existing industrial Heras fence.

Although the first sketches were drawn freely and the final shape was bound by technical and budget limitations, their resemblance can be clearly seen.

Client: CBK Dordrecht, 2005. Designers: Tejo Remy and René Veenhuizen. Photography: Herbert Wiggerman

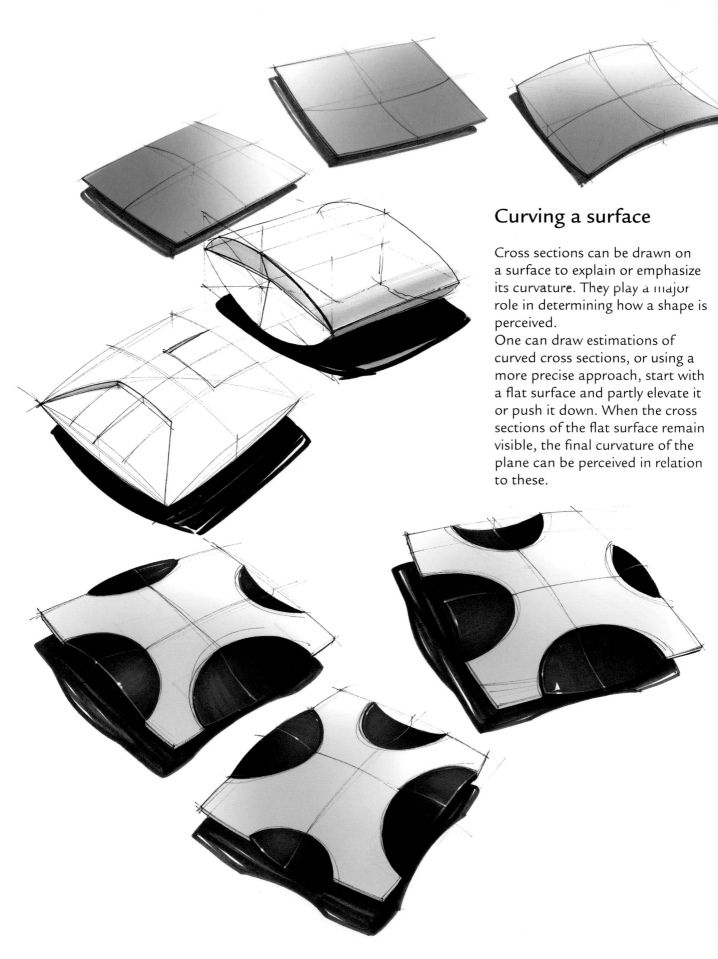

Curving a surface

Cross sections can be drawn on a surface to explain or emphasize its curvature. They play a major role in determining how a shape is perceived.

One can draw estimations of curved cross sections, or using a more precise approach, start with a flat surface and partly elevate it or push it down. When the cross sections of the flat surface remain visible, the final curvature of the plane can be perceived in relation to these.

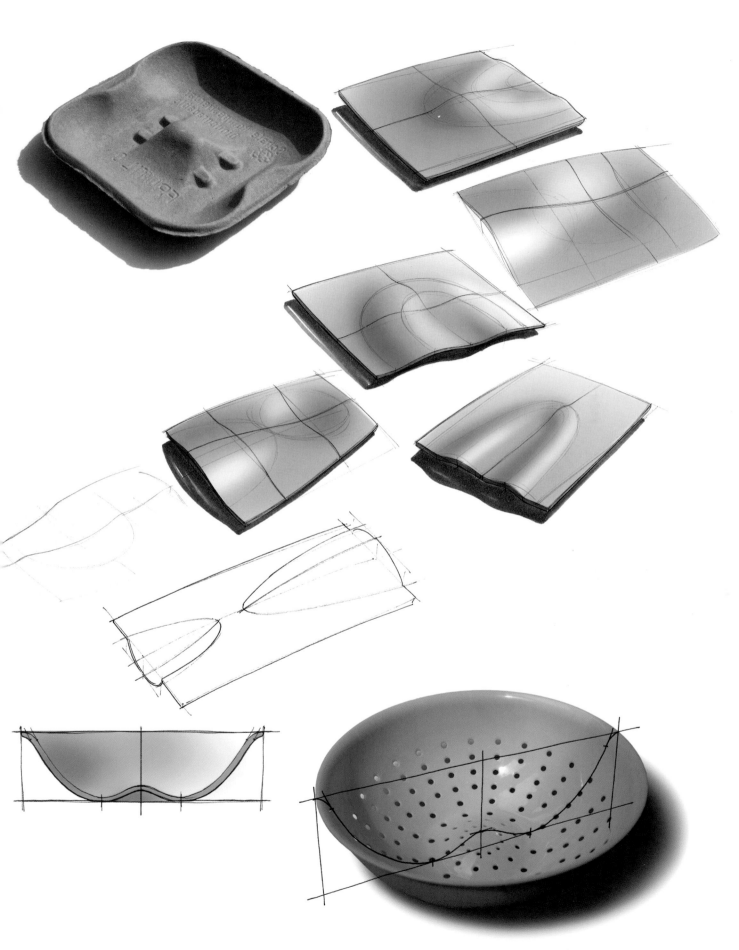

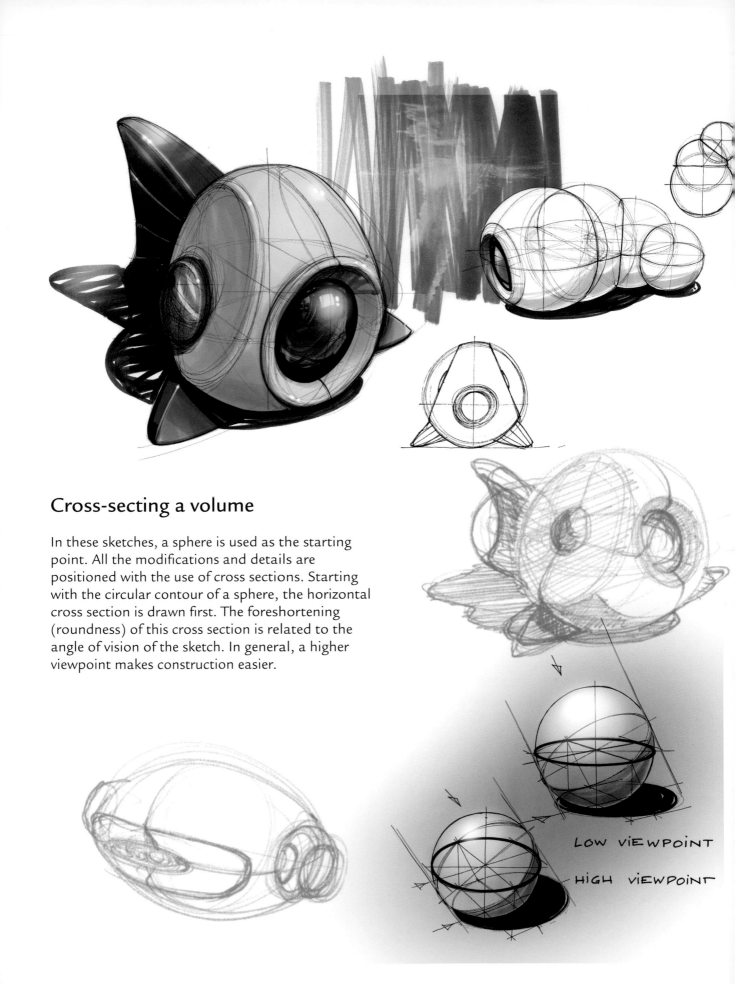

Cross-secting a volume

In these sketches, a sphere is used as the starting point. All the modifications and details are positioned with the use of cross sections. Starting with the circular contour of a sphere, the horizontal cross section is drawn first. The foreshortening (roundness) of this cross section is related to the angle of vision of the sketch. In general, a higher viewpoint makes construction easier.

LOW VIEWPOINT

HIGH VIEWPOINT

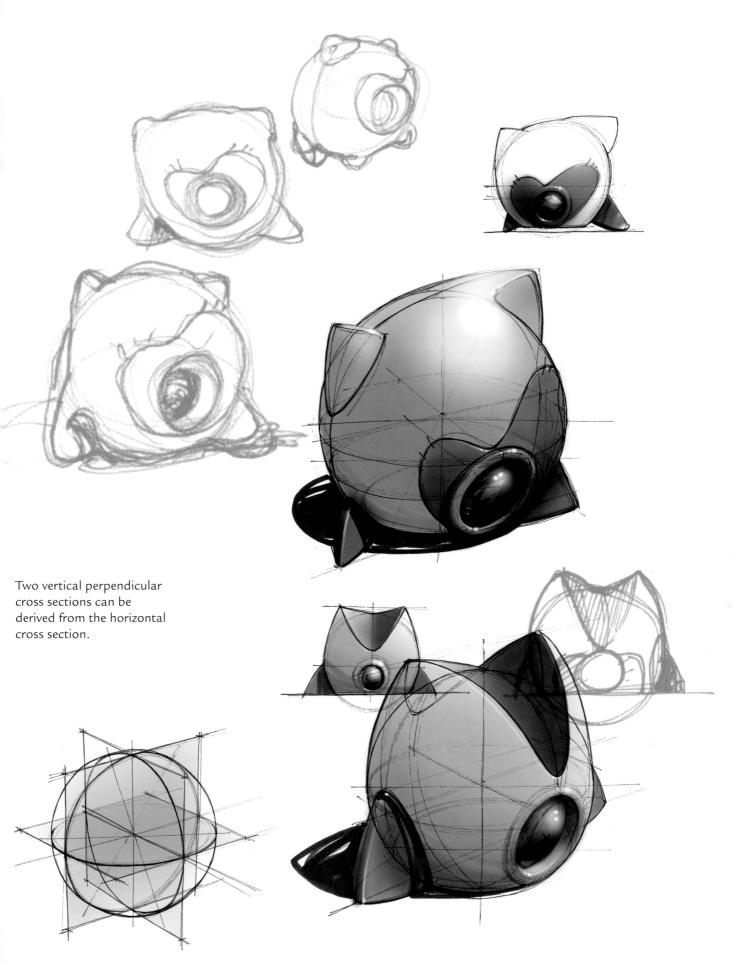

Two vertical perpendicular cross sections can be derived from the horizontal cross section.

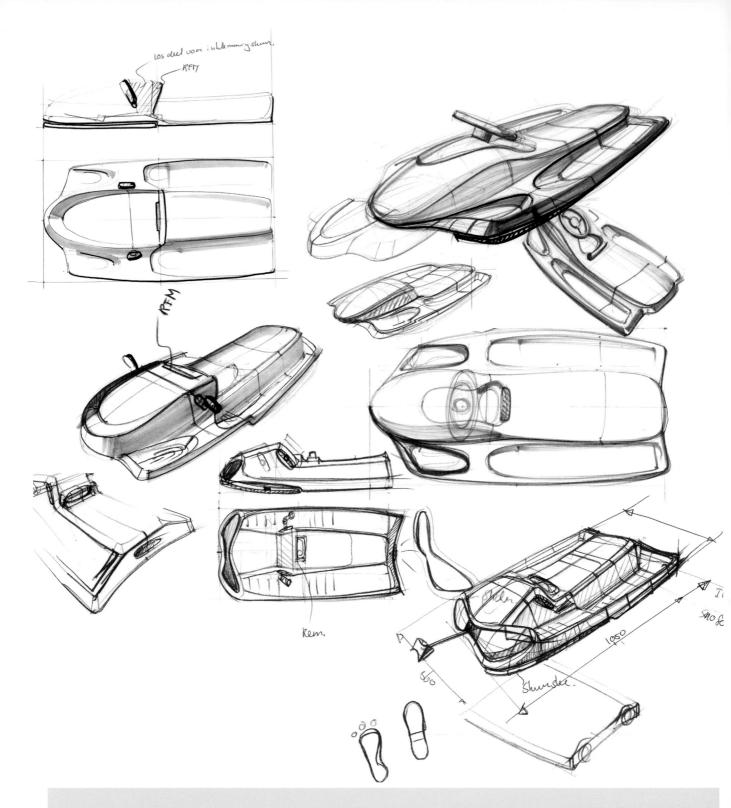

The complexity of the object can already be seen at an early stage.
Due to the complex curvature transitions, cross sections are added to clarify the intended shape and keep it symmetrical.

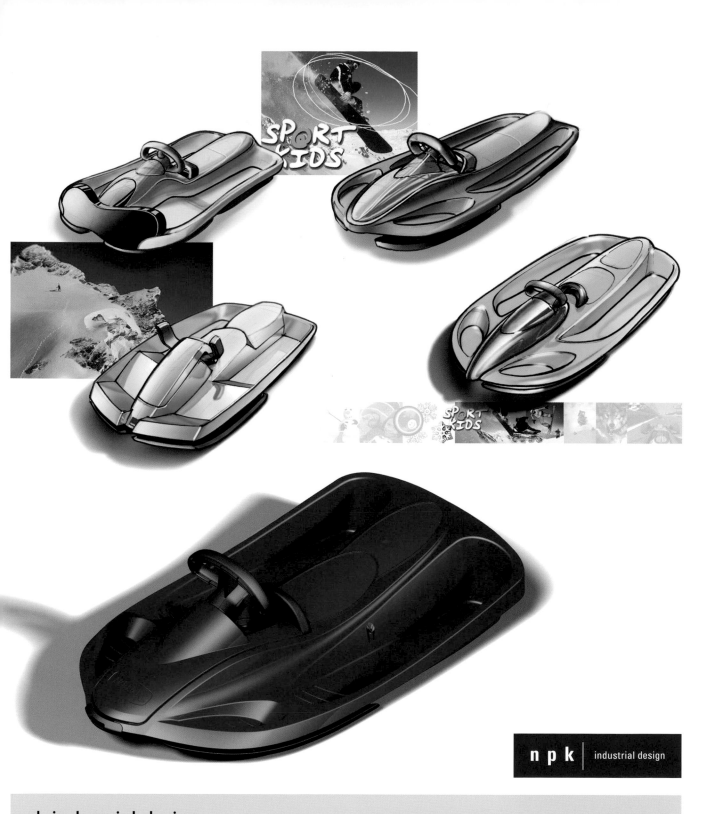

npk industrial design

The Sport Kids family sledge for Hamax (2007) is built for two persons: two kids or one adult and a child. A new feature is the coil that automatically rewinds the pull-rope when it is released. The powerful brake also strengthens the product's construction. It is a simple product, hardly needing assembly. Its compact packaging reduces transport costs. After choosing the concept, complex shape implications in terms of packaging and shipping were done on the computer.

"To make the Cinderella table we used a high-tech method as our new modern 'craft', putting sketches of old furniture into a computer which translated them into digital drawings."

Drawing curved shapes

When cross sections are used in constructing a shape, they should be positioned in a logical manner, which is usually perpendicular. This drawing approach has much in common with the way in which certain computer programs require input for 3D rendering.

Cinderella table – Jeroen Verhoeven, studio DEMAKERSVAN.
Photography: Raoul Kramer

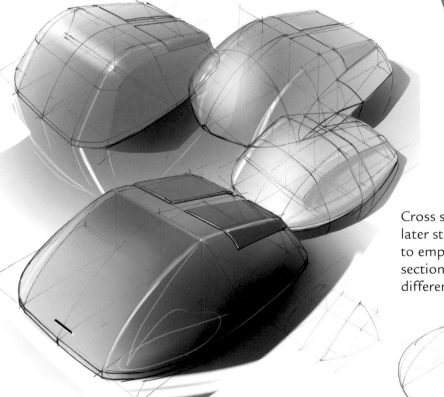

Cross sections can also be drawn at a later stage to explain a shape better or to emphasize an area. This way, cross sections can also be used to explore different curvatures or to optimize shape.

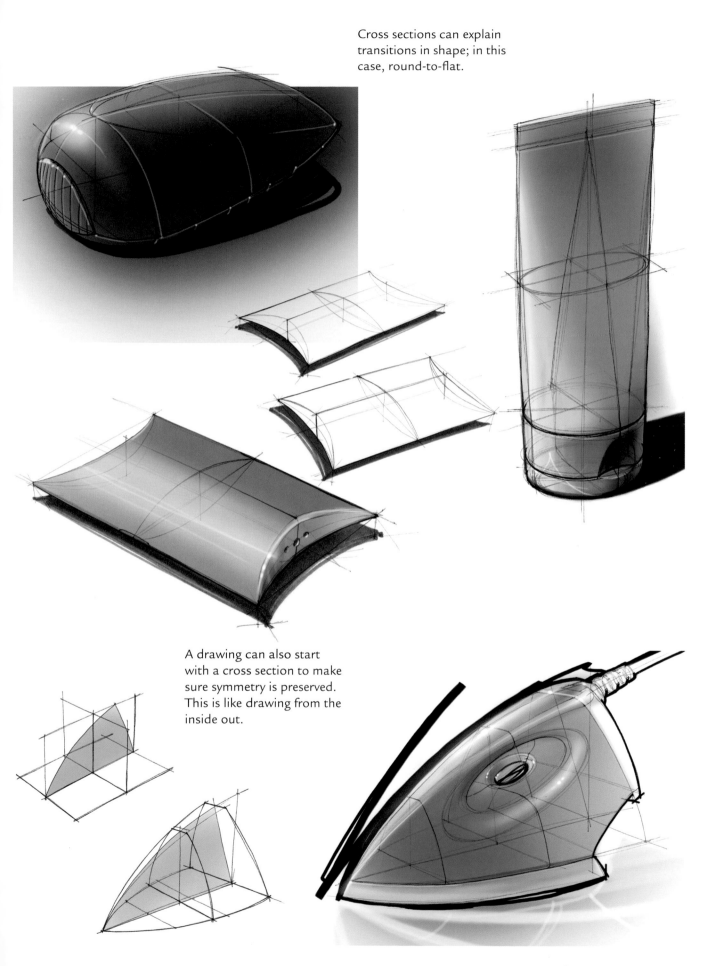

Cross sections can explain transitions in shape; in this case, round-to-flat.

A drawing can also start with a cross section to make sure symmetry is preserved. This is like drawing from the inside out.

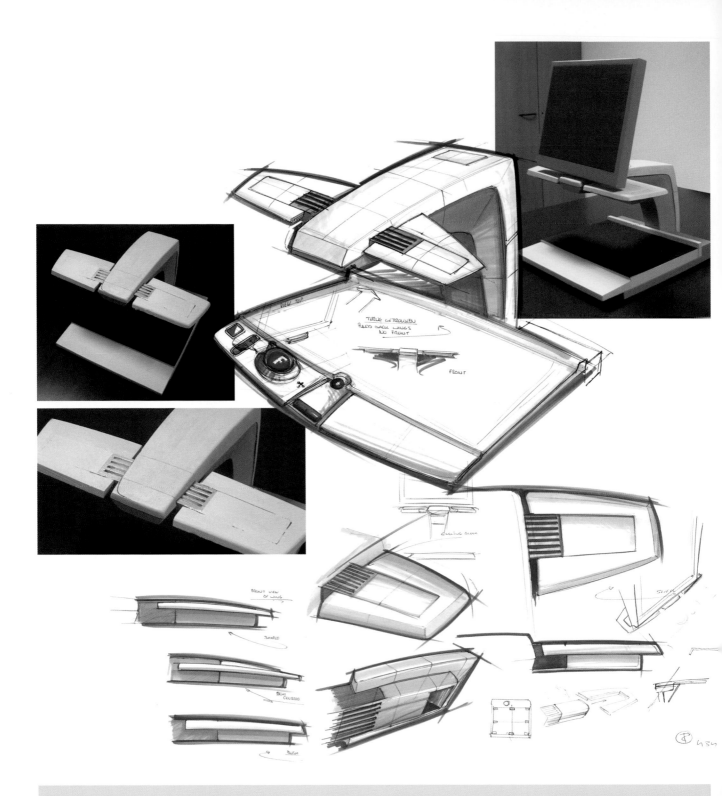

Spark Design Engineering

The Desktop Video Magnifier, 2005, is part of a product range that helps the visually impaired read printed text, see photos, do fine handwork, etc. With the sliding reading table, an object can be put beneath the camera and magnified up to 50 times on the display. Part of the process of creating this product was the development of a new lighting solution. This required, and inspired, a new approach to the product's styling. Using sketches and foam models, Spark investigated the option of adding aluminium parts that add lighting design styling elements, improve heat dissipation from the light sources and visually separate the wings from the camera arm. Cross sections were added to emphasize changes in the shape of the surface.

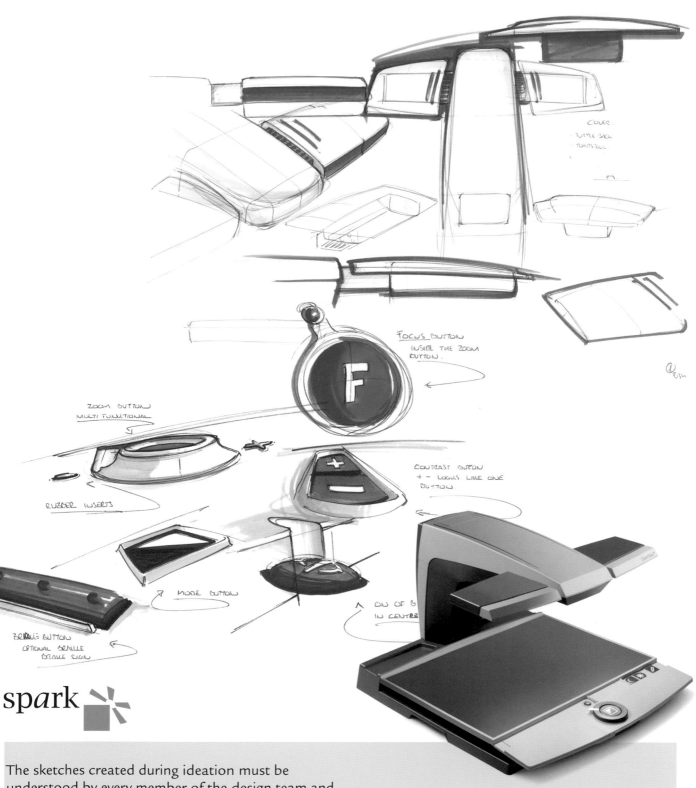

COVER.
· TURTLE BACK
· TOAD STOOL

FOCUS BUTTON
INSIDE THE ZOOM
BUTTON.

ZOOM BUTTON
MULTI FUNCTIONAL

RUBBER INSERTS

CONTRAST BUTTON
+ – LOOKS LIKE ONE
BUTTON

MODE BUTTON

ON OF B
IN CENTRE

BRAILLE BUTTON
OPTIONAL BRAILLE
BRAILLE SIGN

spark

The sketches created during ideation must be understood by every member of the design team and sometimes also must be suitable for interaction with clients. Adding text helps in pointing out technical and form possibilities or requirements. The research on detailing and colour in relation to the poor eyesight of users of the video magnifier is clearly evident in these sketches. User interface solutions have been visualized, taking size, shape, position, movement, graphics and contrast into account.

Estimating

At a more advanced level, one uses fewer
guidelines and makes more estimations.
Sometimes a contour can be 'predicted',
with cross sections being added later to
explain more about the shape.

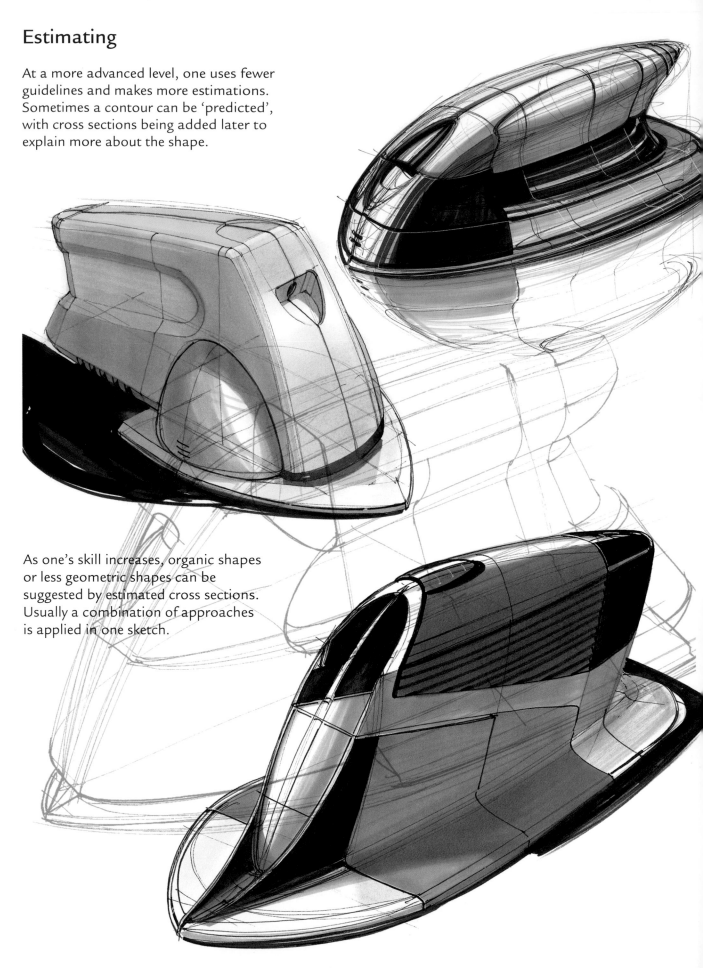

As one's skill increases, organic shapes
or less geometric shapes can be
suggested by estimated cross sections.
Usually a combination of approaches
is applied in one sketch.

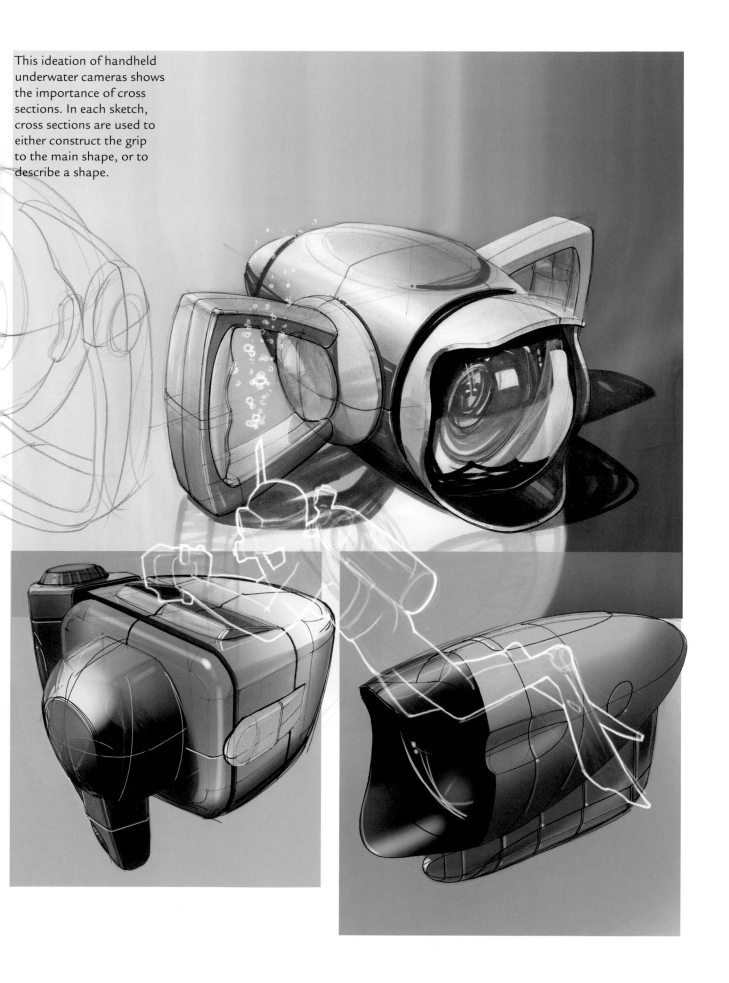

This ideation of handheld underwater cameras shows the importance of cross sections. In each sketch, cross sections are used to either construct the grip to the main shape, or to describe a shape.

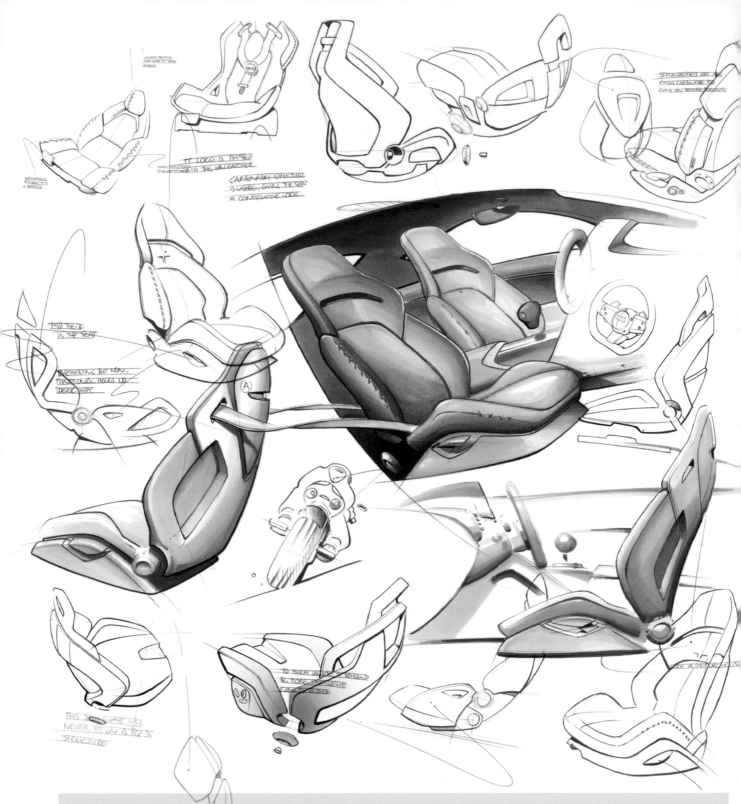

Audi AG, Germany – Wouter Kets

The Audi Le Mans concept was presented in September 2003 at the Frankfurt motor show. The goal of the project was to show the sports potential of the Audi brand. This resulted in a rear engine two-seater sports car with a V10 engine. The car was designed and built within 6 months, fully functional. The car received a lot of positive feedback at the show and in the press; especially the interior was well appreciated by the public.

This prototype was then developed into the production version, the Audi R8 super sports car. The seats in this car are lightweight carbon fibre bucket seats, with the possibility of folding them to gain more luggage space.

Chief designer: Walter de'Silva

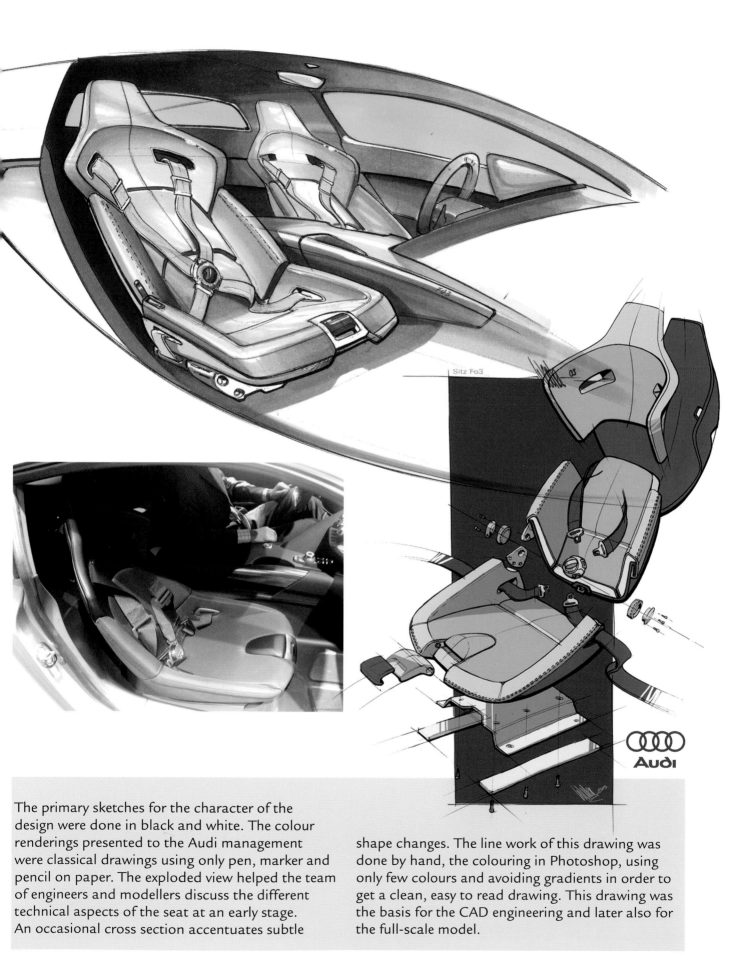

The primary sketches for the character of the design were done in black and white. The colour renderings presented to the Audi management were classical drawings using only pen, marker and pencil on paper. The exploded view helped the team of engineers and modellers discuss the different technical aspects of the seat at an early stage. An occasional cross section accentuates subtle shape changes. The line work of this drawing was done by hand, the colouring in Photoshop, using only few colours and avoiding gradients in order to get a clean, easy to read drawing. This drawing was the basis for the CAD engineering and later also for the full-scale model.

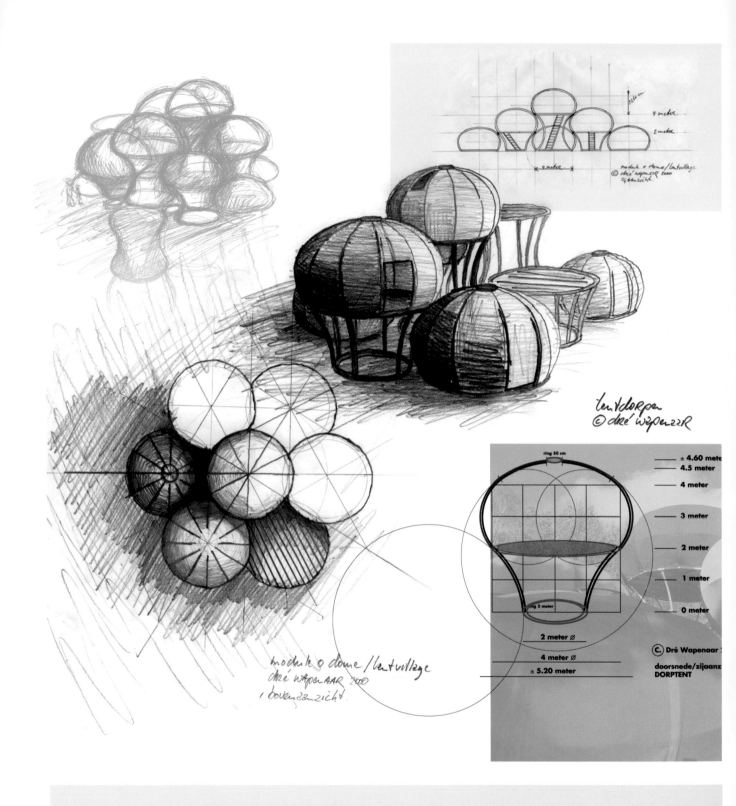

At the start of the design process, pencil sketches on paper were used to explore and visualize the original idea. Later on, sketching was mainly used to research construction possibilities, and solve other pre-construction issues such as size and measurements.

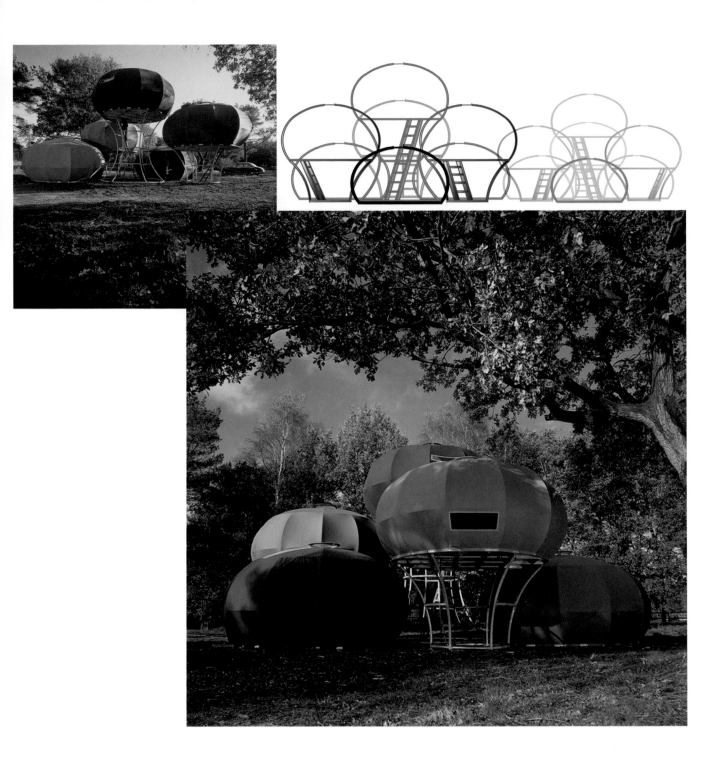

Dré Wapenaar

The TENTVILLAGE (2001) is a sculpture that has been part of art exhibitions. The way in which the individual modules are set together as a village – the arrangement of common and private spaces, the different levels and proximities of the tents – can be done in many different ways, depending on the group of people that are to live in it and the social implications it deals with. All together, the tents present an image of a miniature society and create a situation of encountering.

Photography: Robbert R. Roos

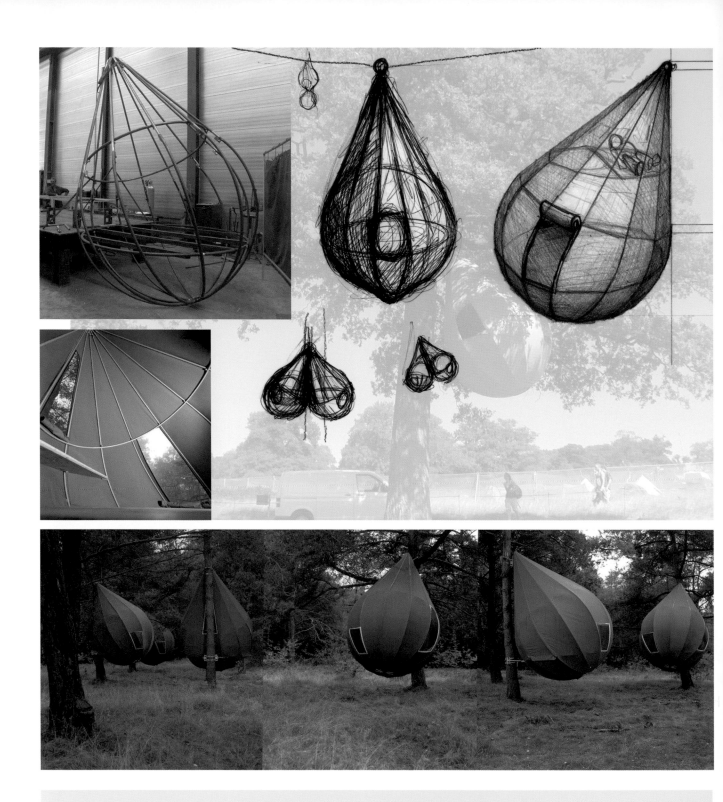

The 'Tree Tents' project is inspired by the residential need of activists who chain themselves to trees to prevent woodland giants from being chopped down. A spin-off of this art project came about when a campsite representative saw the drawings and convinced Wapenaar to sell him several tents. They are entirely handmade, 'low-production'. They provide sleeping room for two adults and two children on the main floor. The character and overall dimensions of the final design are already visible in these sketches.

Photography: Robbert R. Roos

Ideation

Ideation is the forming of ideas or concepts. It is important in creativity, innovation and concept development. A powerful method in creativity is divergent thinking. Generating a large number of drawings and sketches allows people to explore and go beyond conventional ideas so as to create new directions for a design. This interesting way of 'drawing without valuing' is often used in brainstorming sessions. Either with or without clients, positive sharing can create new opportunities: visioning, modifying, exploring and experimenting in relation to trends, technologies or product ranges. This chapter shows several divergent visual thinking processes, 'uncut', used in 'in-house' brainstorming and personal sketchbooks. These examples present a personal way of ideation.

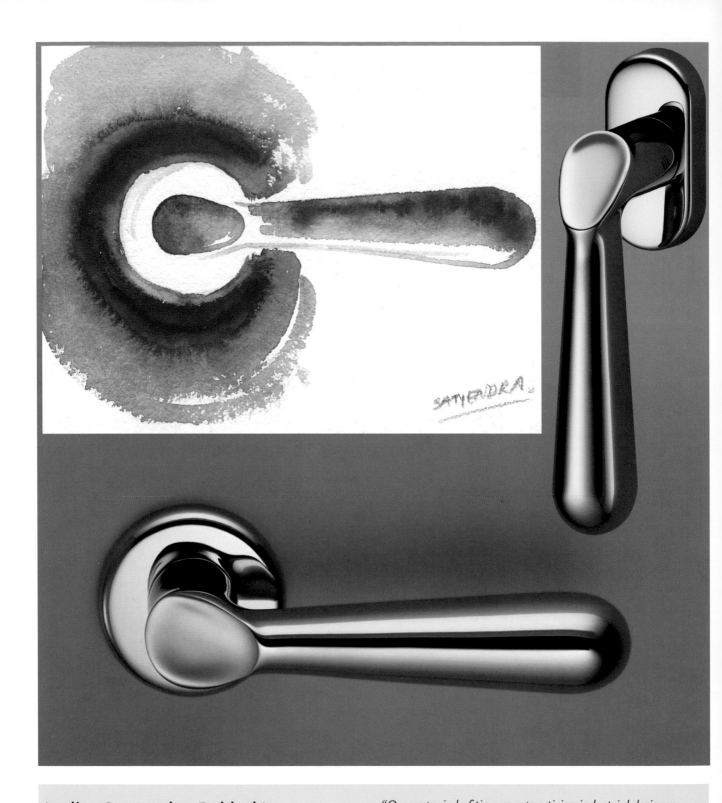

Atelier Satyendra Pakhalé

Amisa, sensorial door
handle in die-cast brass for
Colombo Design S.p.A.,
Italy, 2004.

*"Over a period of time as a practicing industrial designer,
I have cultivated the habit of sketching often with aquarelle
and also with a soft pencil in order to capture that mental
spark, or shall I say creative wave. To capture that thought,
feeling, emotion in the course of the design process, which is
hard to pin down."*

Designer: Satyendra Pakhalé. Photography: Colombo Design S.p.A.

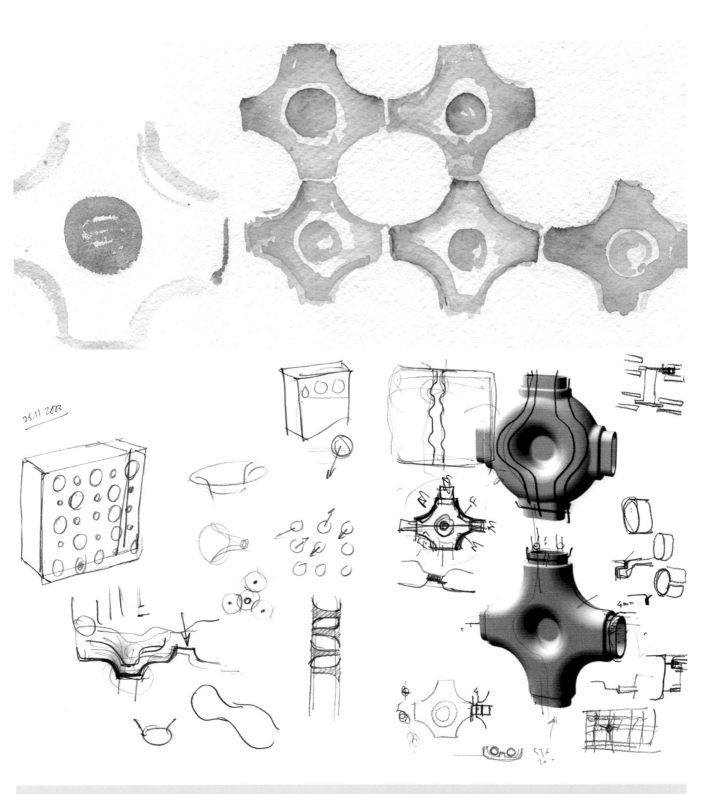

25.11.2003

"For me, thinking/feeling sketches is important; it has to do with the personal way I approach industrial design. To create and develop innovative design solutions and develop new symbology with an ingenious use of materials and their cultural significance, I have evolved my own way of working on industrial design projects. My sketching, drawing and presentation techniques have evolved over a period of time. As my work became international and travelling became a part of the design process,

I cultivated the habit of carrying a sketchbook. Sketching in the transit area while waiting to take the next flight or on board a long distance flight became a habit.

Then I rediscovered the power of aquarelle. Aquarelle is like life; once a stroke is placed one cannot go back. To be able to capture a moment is the most challenging part of aquarelle. I like to exercise that challenge in an industrial design process."

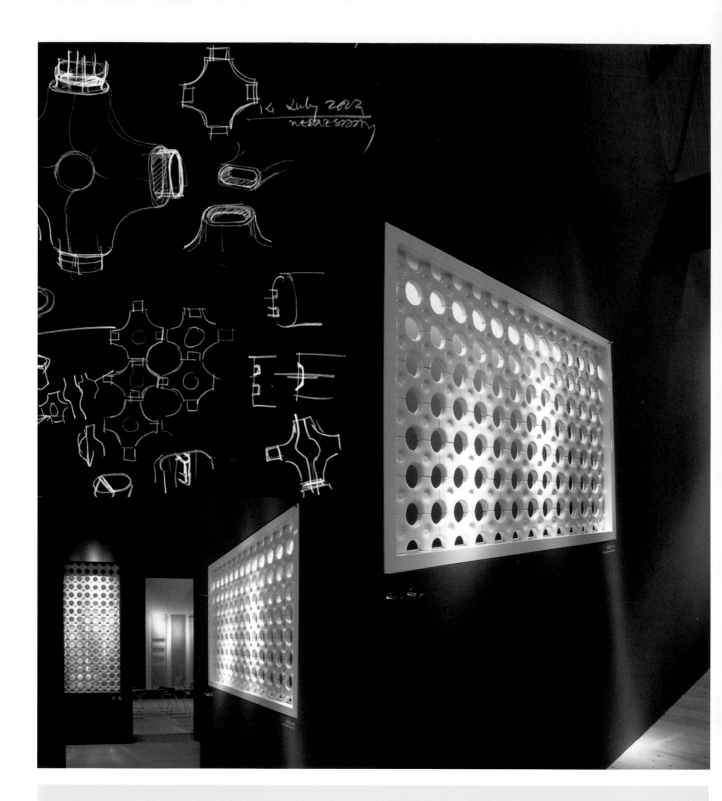

Atelier Satyendra Pakhalé

Add-on Radiator, modular radiator in an electric and hydraulic version, for Tubes Radiatory, Italy, 2004. Describing himself as a 'cultural nomad', Satyendra Pakhalé works in a wide range of disciplines, bringing to his design a set of fresh perspectives and a diversity of strong cultural influences that are particularly relevant in today's society. Pakhalé's design emanates from cultural dialogue, synthesizing new applications of materials and technologies with great ingenuity. He conveys a message through his designs that could be defined as 'universal' and that ranks him among the most influential designers working today.

Designer: Satyendra Pakhalé. Photo: Tubes Radiatory, Italy

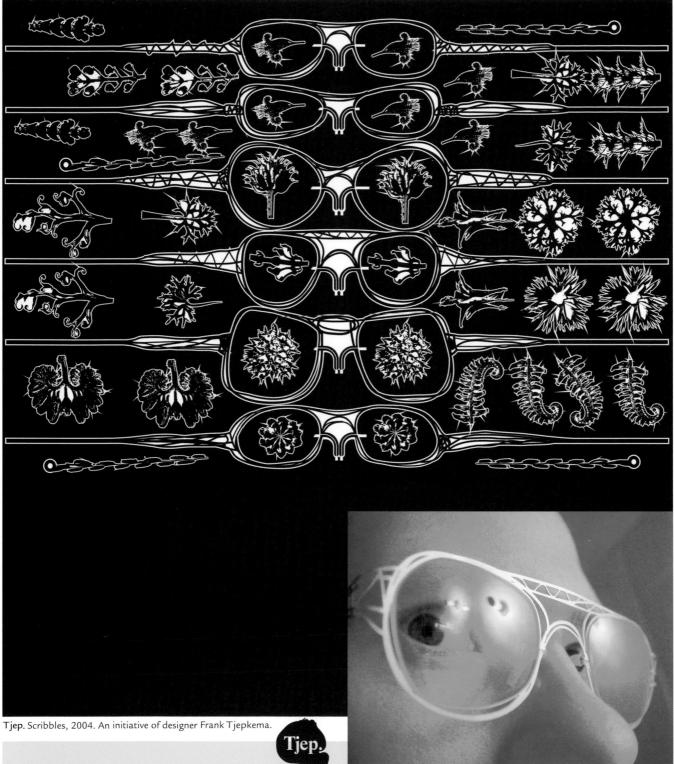

Tjep. Scribbles, 2004. An initiative of designer Frank Tjepkema.

Tjep.

People tend to get seduced by original drawings from the hand of the designer. These scribbles contain the untouched, pure artistic intention of the creator. Architects can put three lines on a piece of paper, and that impression will be sufficient to use as a guideline for the development of complex constructions.

Unfortunately, the spontaneous and uninhibited quality of the first intention always tends to fade out in that process. What if the original scribble were to immediately become the end result, with no abstraction, no alterations due to technical requirements? Tjep. has achieved this true revolution in a first series of glasses called 'Scribbles'. Here's a preview.

Photography: Tjep.

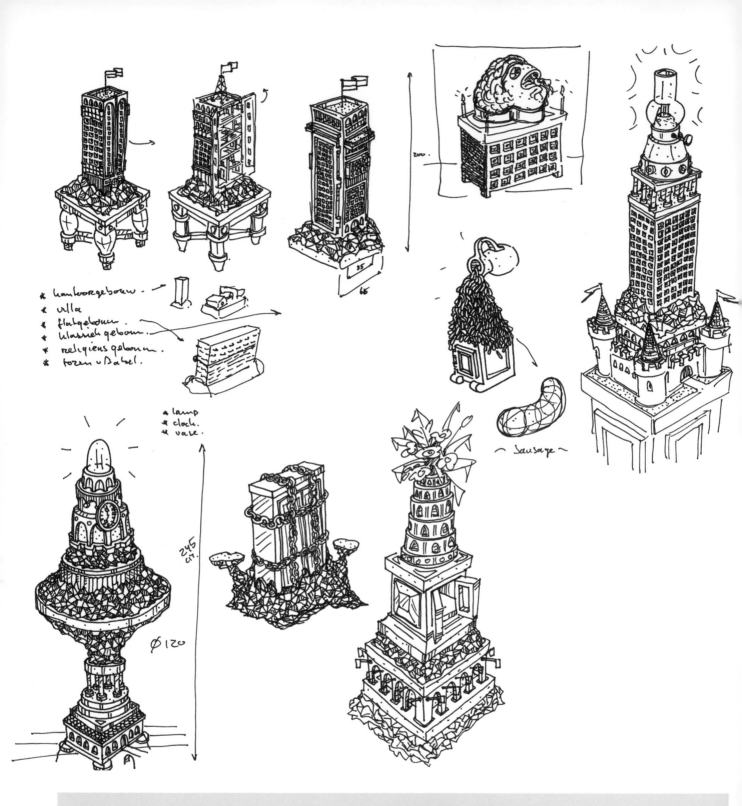

* hankoorgebouw.
* villa
* flatgebouw.
* klassiek gebouw.
* religieus gebouw.
* toren v Babel.

* lamp
* clock.
* vase.

~ Sausage ~

Studio Job

Job Smeets uses drawing as a way of expressing thoughts. This results in thousands of drawings, all on A4 white paper, as an empirical way of exploring. There is no clear start or end to a project; rather, the drawing process is a continuous flow of drawings out of which various projects arise.

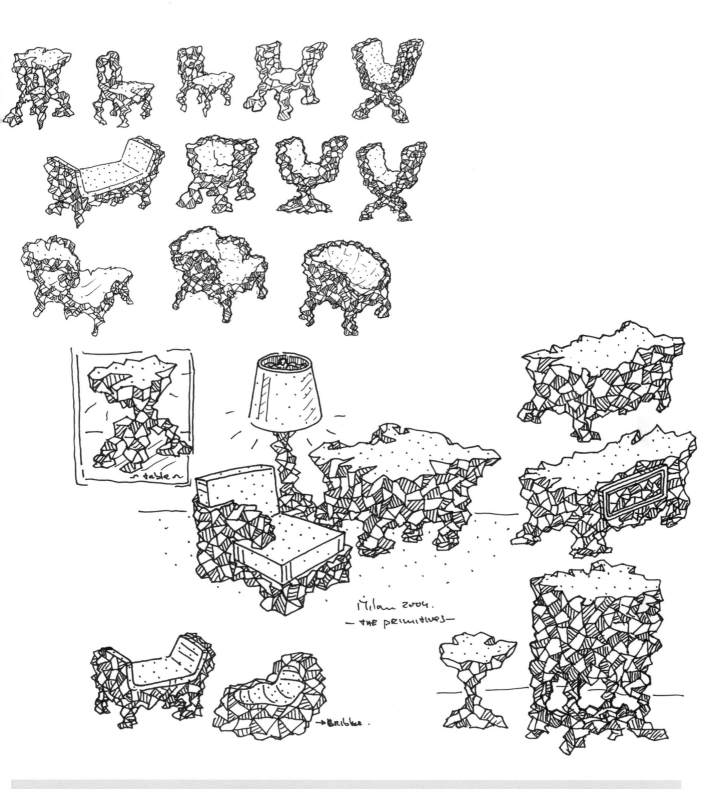

Milan 2004.
— THE PRIMITIVES —

→ Bribble.

"Like a good storyteller who's only getting started, Studio Job (Job Smeets and Nynke Tynagel) adds a new chapter each season to their increasingly grim tale that initially sounded humorous due to its characteristic framework.

Studio Job's infectious, caricatural designs, which are devoid of scale, have caused considerable uproar in the international world of design. Their works of art provide a commentary on usual interpretations about functionality, mass production and style by purposely playing with elements such as unity, autonomy and figuration in their designs." (Sue-an van der Zijpp)

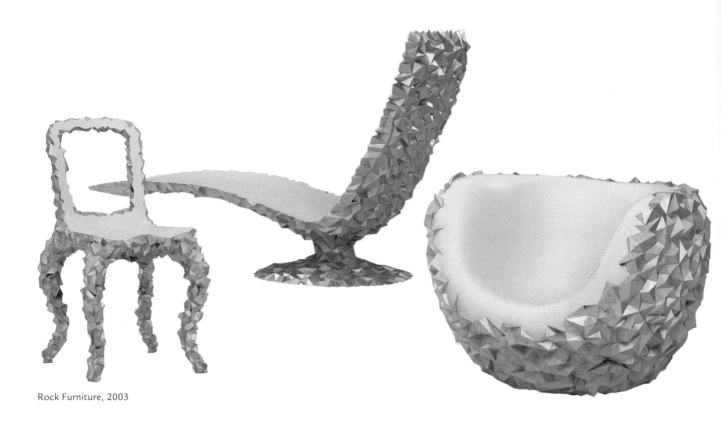

Rock Furniture, 2003

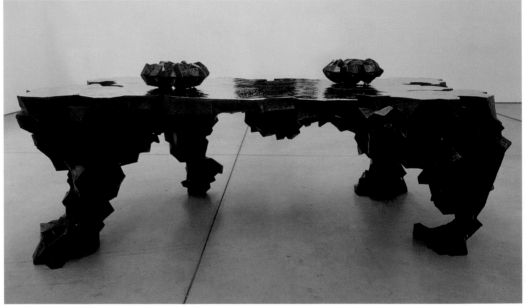

Rock Table, 2002

"Studio Job is well-known for a refined play of visual clues, and elements have been embedded in their work which sometimes seemed to have been restricted to visual arts. Their work balances between design and autonomous art."
(Sue-an van der Zijpp)

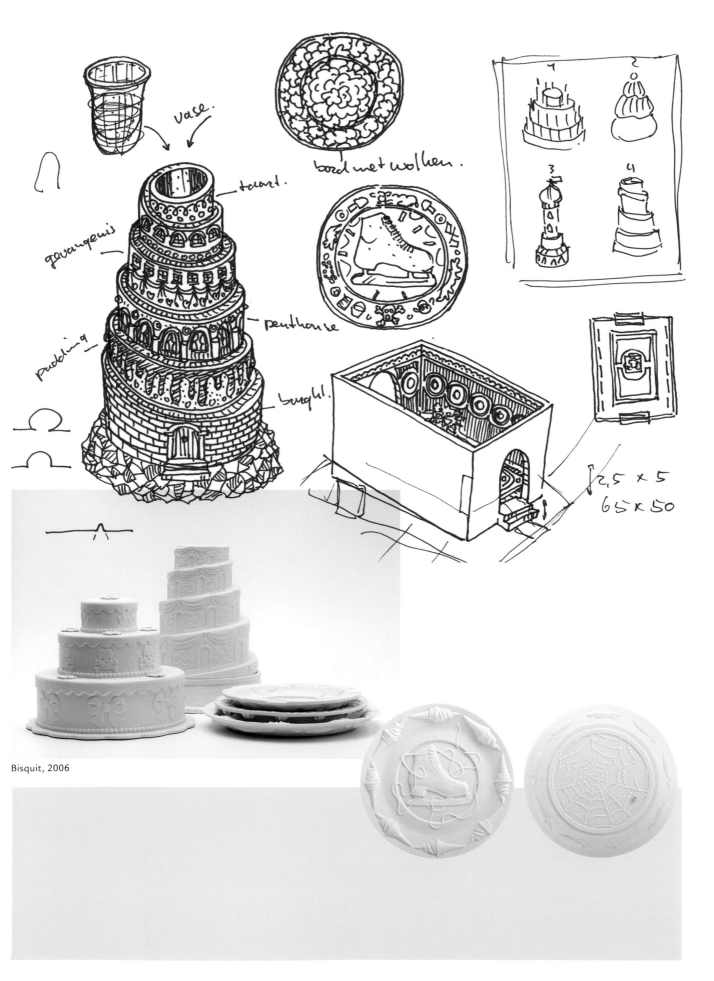

Bisquit, 2006

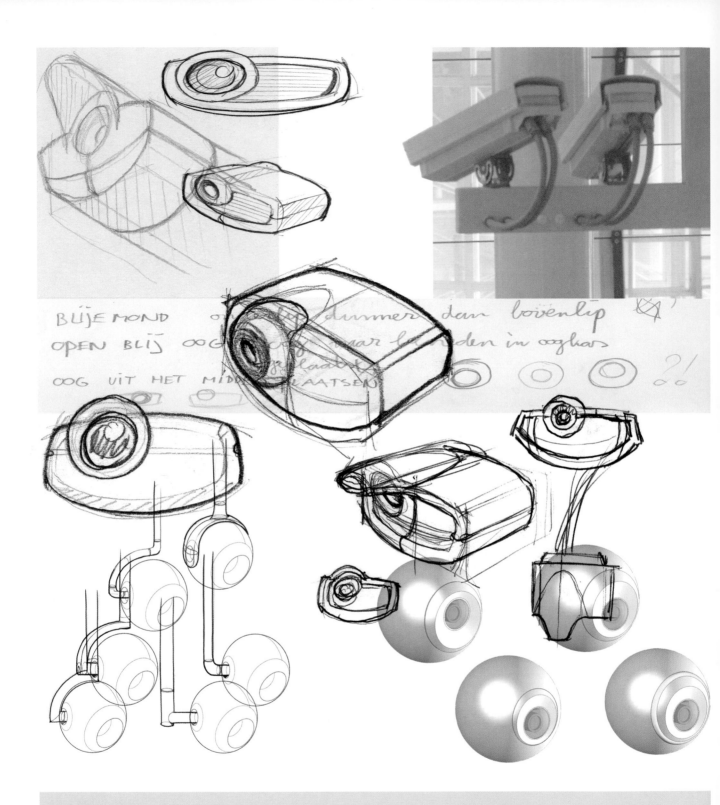

In the preliminary sketches, the resemblance to existing cameras is still quite clear; the evolution towards the new, more friendly, camera can be seen as the drawings become more characteristic or 'animal-like'.

There usually is no one particular moment when handmade sketching is abandoned and only computer renderings are made. Instead, this shift in materials is often done gradually. Sketching on printouts of renderings thus combines comparable and 'form-safe' underlays with free and intuitive expression. Rendering dictates a more rational approach (more distance) and can result in less spontaneous actions, whereas freehand drawing allows quick and suggestive adaptations.

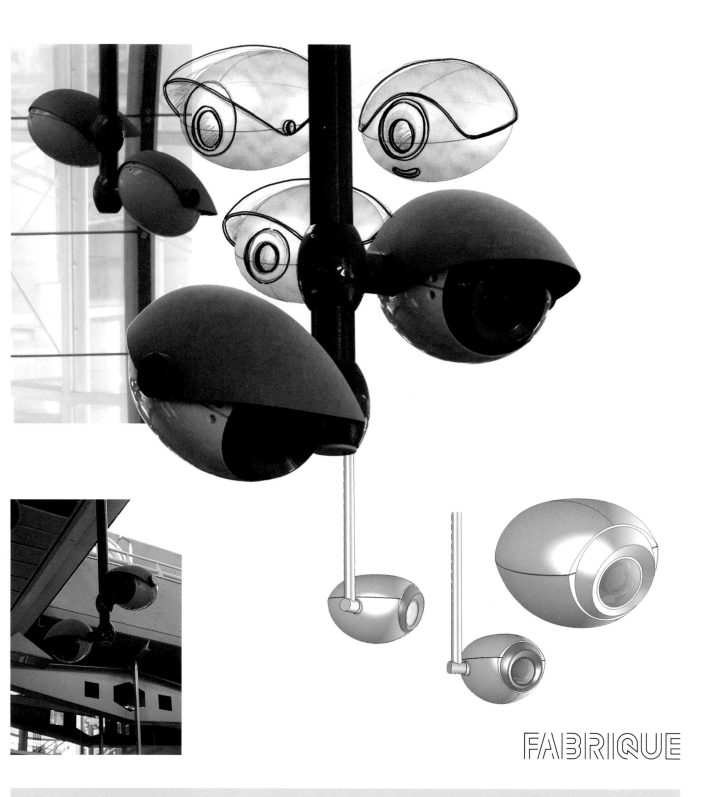

FABRIQUE

Fabrique

Fabrique was commissioned by Hacousto to develop new surveillance cameras for Dutch Railways (NS), which fit in better with the railway's look and take away the 'Big Brother' feel. By giving the cameras a face – almost literally – they now have an affable image: a friendly eye helping to keep watch. The former tangle of cables has been eliminated; the cable is now hidden in the bracket, creating a tidier image. The cameras are highly visible and are placed in 'bunches' for optimum range. Eye-on-you has been nominated for the Dutch Design Awards, 2006.

Designers: Iraas Korver and Erland Bakkers

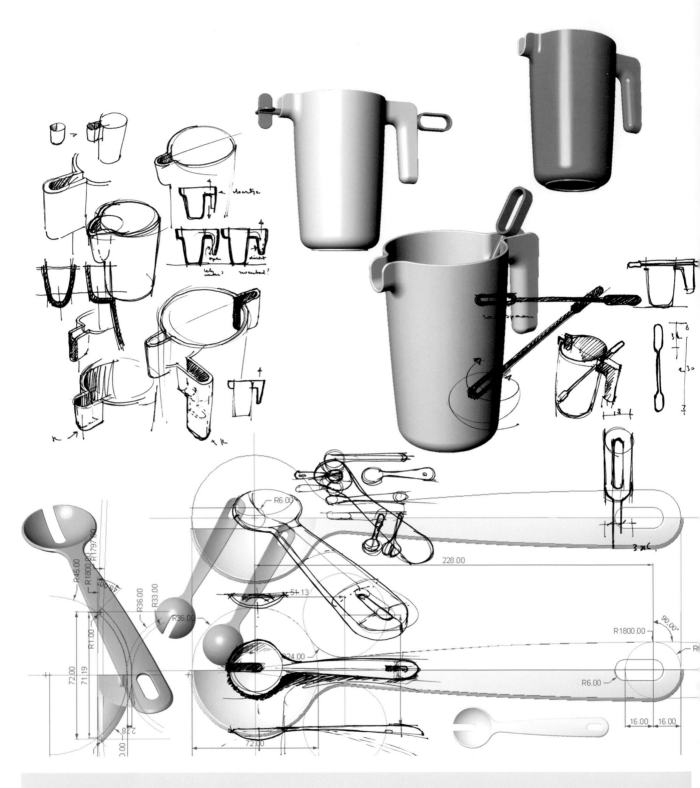

studioMOM

Several accessories for serving and drinking, from the melamine dinnerware collection for Widget, 2006.

"During sketching you react directly to the drawing on the paper, whereas with CAD you execute a designated plan and react to the outcome later. These two ways of visualizing imply different moments of reaction and decision-making."

Designers: studioMOM, Alfred van Elk and Mars Holwerda

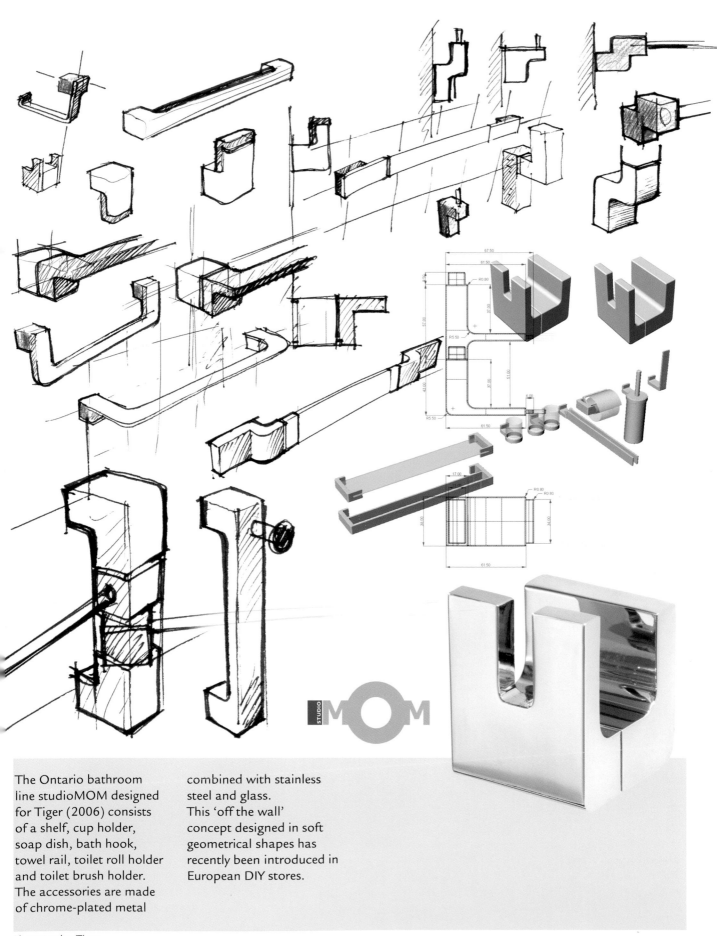

The Ontario bathroom line studioMOM designed for Tiger (2006) consists of a shelf, cup holder, soap dish, bath hook, towel rail, toilet roll holder and toilet brush holder. The accessories are made of chrome-plated metal combined with stainless steel and glass. This 'off the wall' concept designed in soft geometrical shapes has recently been introduced in European DIY stores.

Photography: Tiger

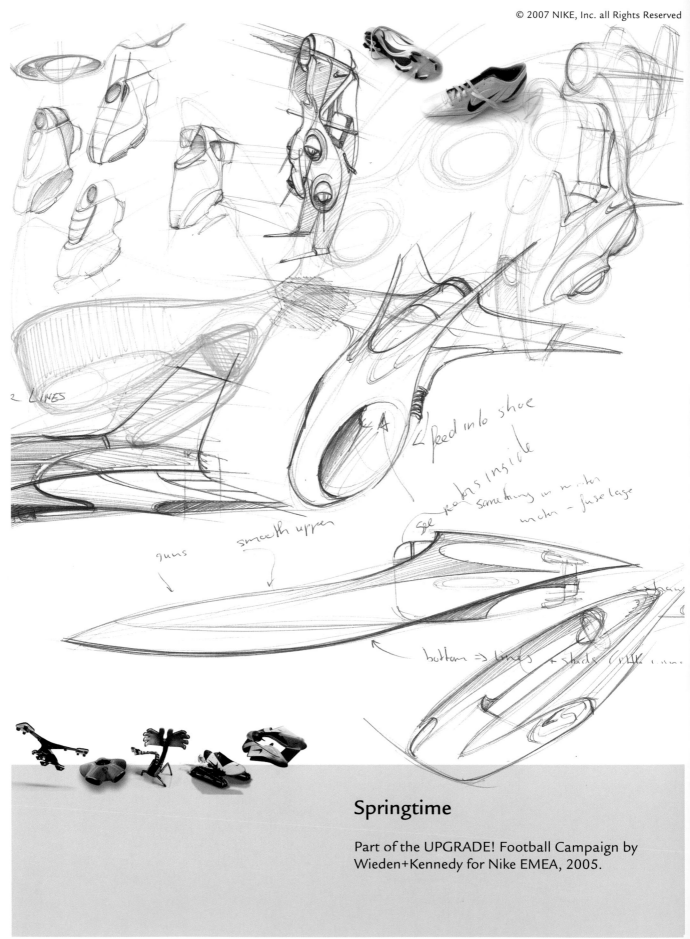

2 LINES

guns

smooth upper

feed into shoe

see marks inside

something in motor

motor — fuselage

bottom => lines + shade

Springtime

Part of the UPGRADE! Football Campaign by
Wieden+Kennedy for Nike EMEA, 2005.

Designer: Michiel Knoppert; Computer rendering: Michiel van Iperen; Photography: Paul D. Scott

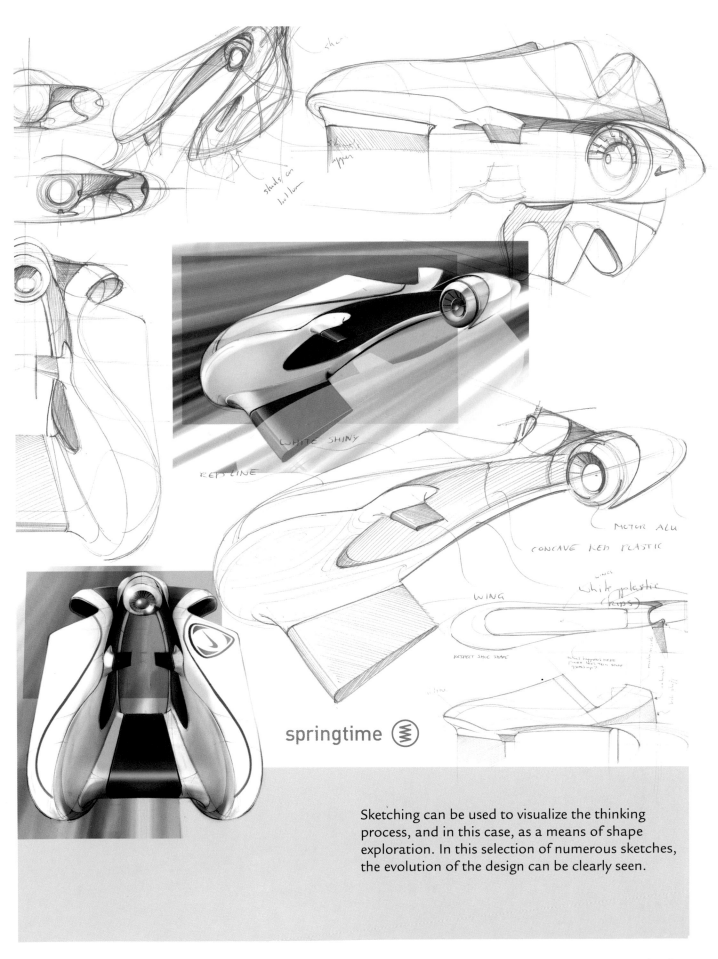

springtime

Sketching can be used to visualize the thinking process, and in this case, as a means of shape exploration. In this selection of numerous sketches, the evolution of the design can be clearly seen.

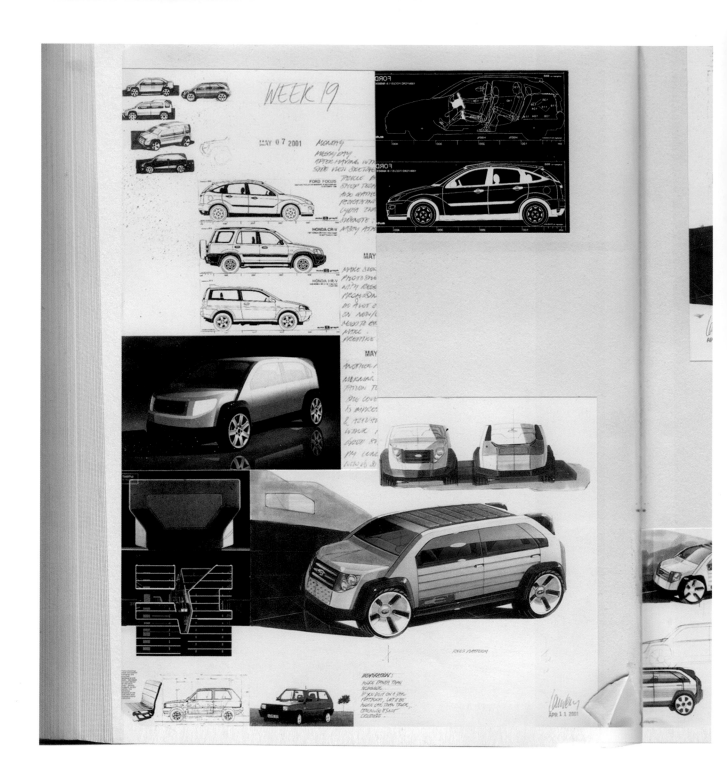

WEEK 19

MAY 07 2001

Ford Motor Company, USA – Laurens van den Acker

The Model U 2003 concept car is seen as the Model T Ford of the 21st century, equipped with upgradeable technologies and powered by the world's first supercharged hybrid hydrogen powertrain with electric transmission. Modularity and ongoing upgrades provide an array of individual adaptations. Model U features pre-crash sensing, adaptive front headlights and an advanced night vision system to help the driver avoid accidents before they occur.

Photography: Ford Motor Company, USA

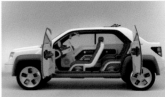

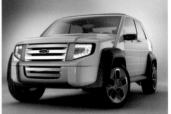

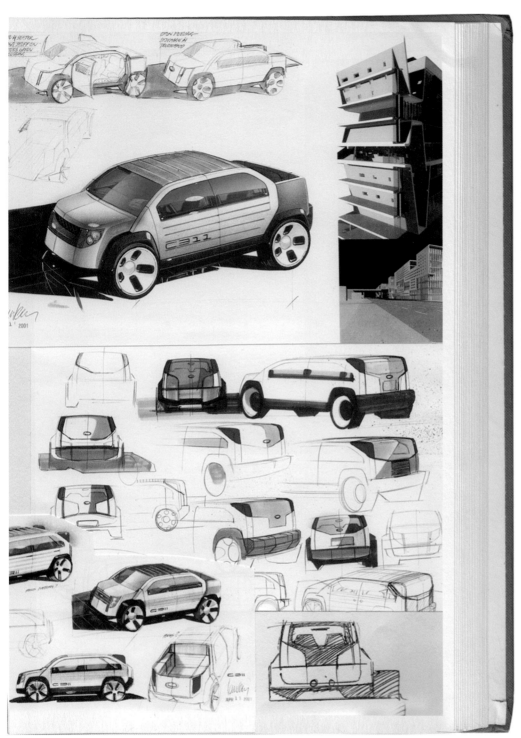

"This project was very exciting for us," says Laurens van den Acker, chief designer for the Model U. "To embody the spirit of the Model T, we had to design an extremely ingenious car that could grow with your needs and meet an incredible packaging challenge. Model U doesn't compromise interior space for the occupants or cargo despite the storage space needed for the hydrogen tanks and the hybrid powertrain."

A combination of inspirations: pictures of cars to emphasis certain aspects and evaluating sketches are glued together to explore and map design directions. Two pages out of the designer's sketchbook show progress in week 19. Notice that at this stage the layout of the taillights and headlights is already visible.

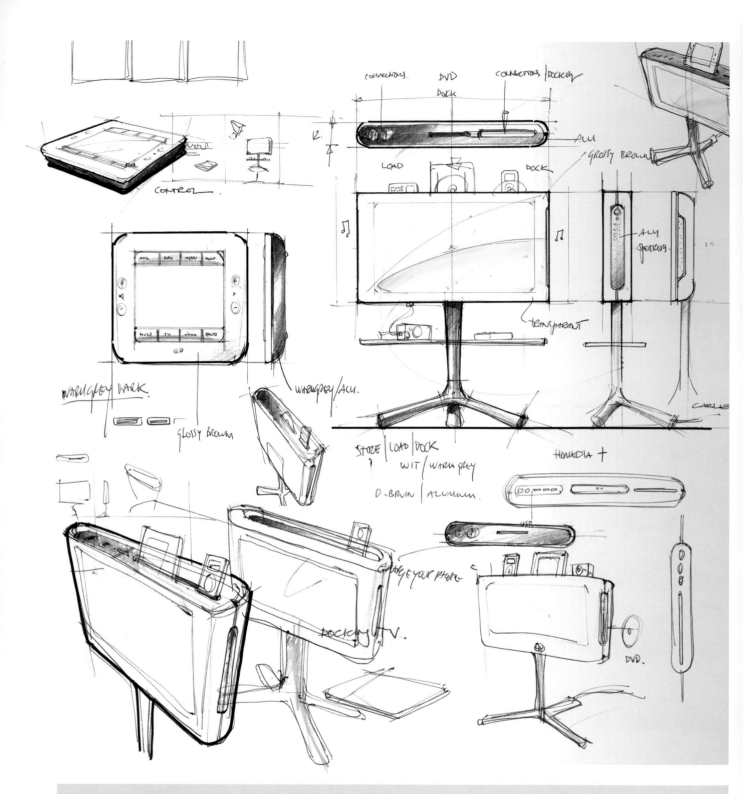

Each design process starts with exploring possibilities through handmade sketches. The final design is modelled in SolidWorks, and rendered in Cinema 4D.

"I generally make a deliberate choice in advance on how to communicate a design to a client."

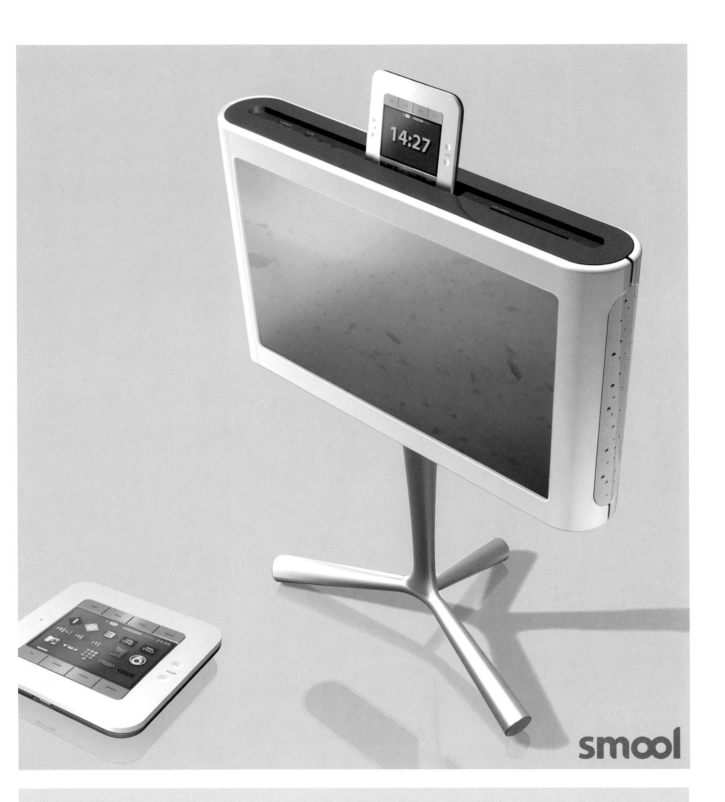

SMOOL Designstudio

This multimedia TV also is part of the series of redesigned existing products with which Robert Bronwasser showcases his design vision. Here, all multimedia functionality has been integrated in a user-friendly design, adjusted to the consumer's interior. Items/5, Sept/Oct. 2006

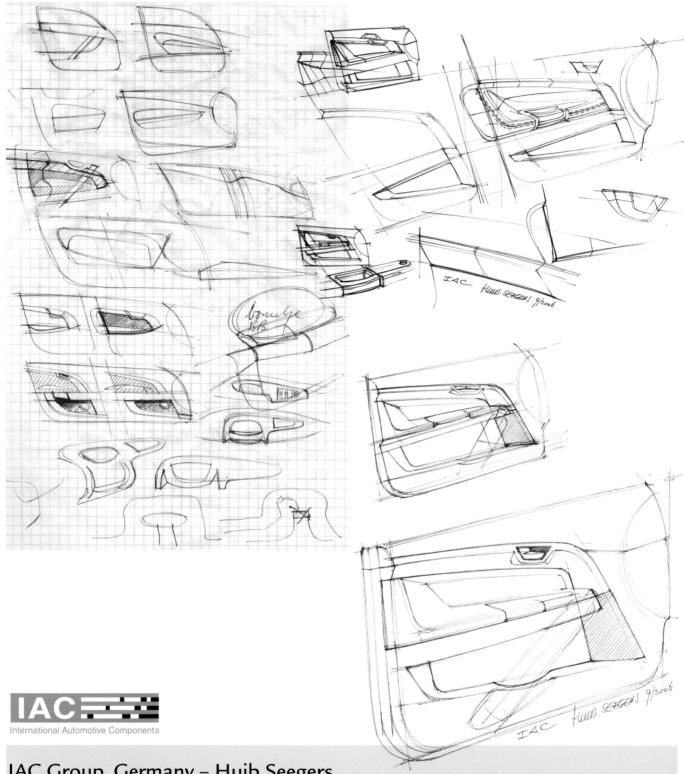

International Automotive Components

IAC Group, Germany – Huib Seegers

Sketches out of one of Huib Seegers's sketchbooks for IAC exploring shapes of a door panel, researching probable flowing curves, 2006. In the next stage, drawings were much more precise and in perspective, looking at possible incompatibilities between armrest and door handle and remaining stowage space for roadmaps and bottles.

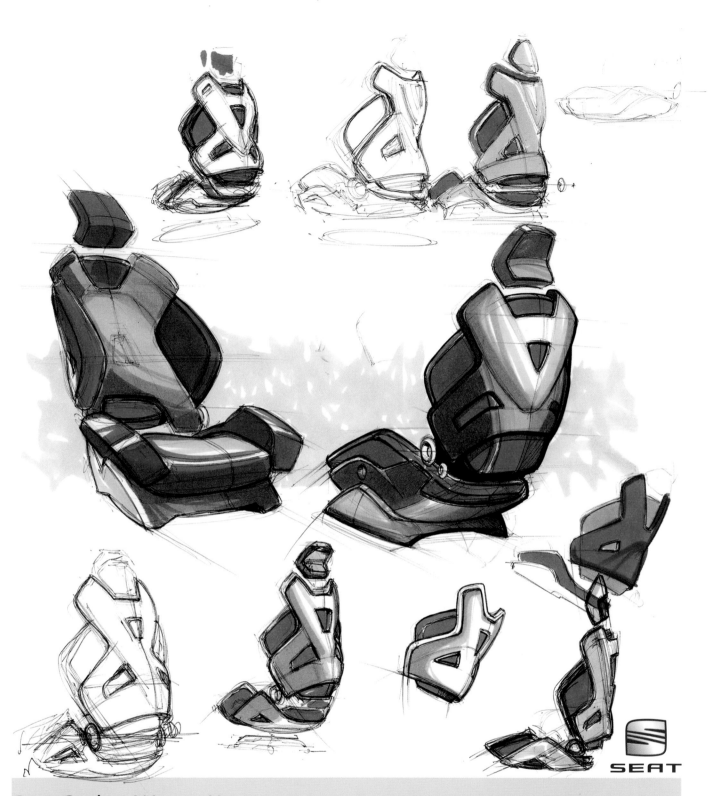

Seat, Spain – Wouter Kets

Quick explorative drawings for a seat design for the Seat Leon Prototype, 2005. Quick sketches of different viewpoints are set up in pen; interesting sketches serve as an underlay for the next sketches, thereby improving the design. The main cross sections are drawn in for symmetry and to make the

drawing easier to read. Finally, marker is added to emphasize potential designs. At a later stage, such drawings are used as the start of tape-drawings and a CAD model. Normally this level of detailing and materializing is good enough to communicate first ideas within the design team and design management.

Chief designer: Luca Casarini

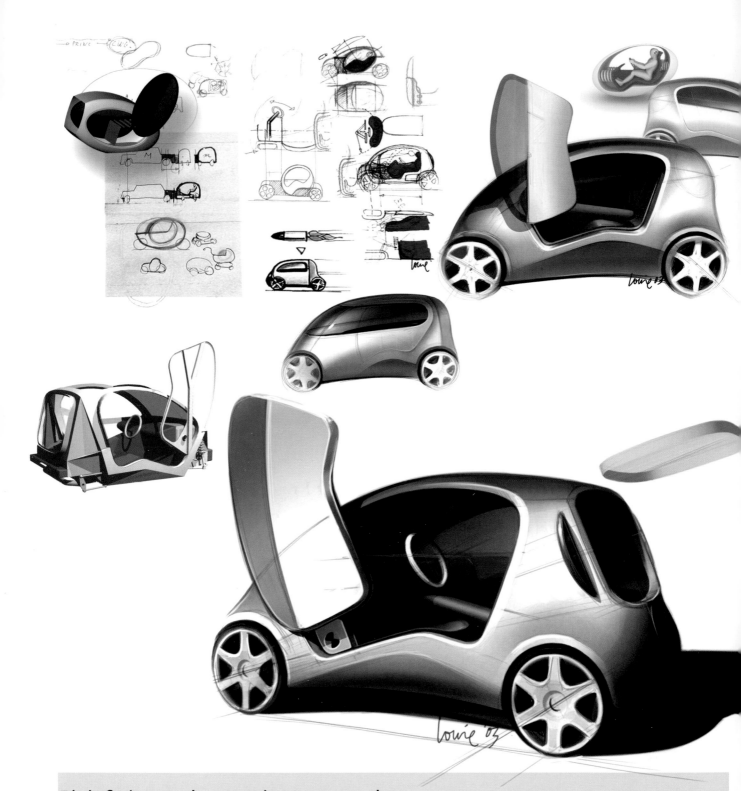

Pininfarina, Italy – Lowie Vermeersch

At the Paris Motor Show of 2004, Pininfarina Nido, a safety research prototype, was presented in a world preview and won the Most Beautiful Car of the Year award in the Prototype and Concept Car category. The Nido project is based on the study, design and prototyping of new solutions that involve structural aspects and the design of a small two-seater car. The possible use of available space between the inner and outer shell is explored with the goal of increasing both internal safety, which affects the occupants directly, and external safety, designed to limit any damage to pedestrians in the event of a collision.

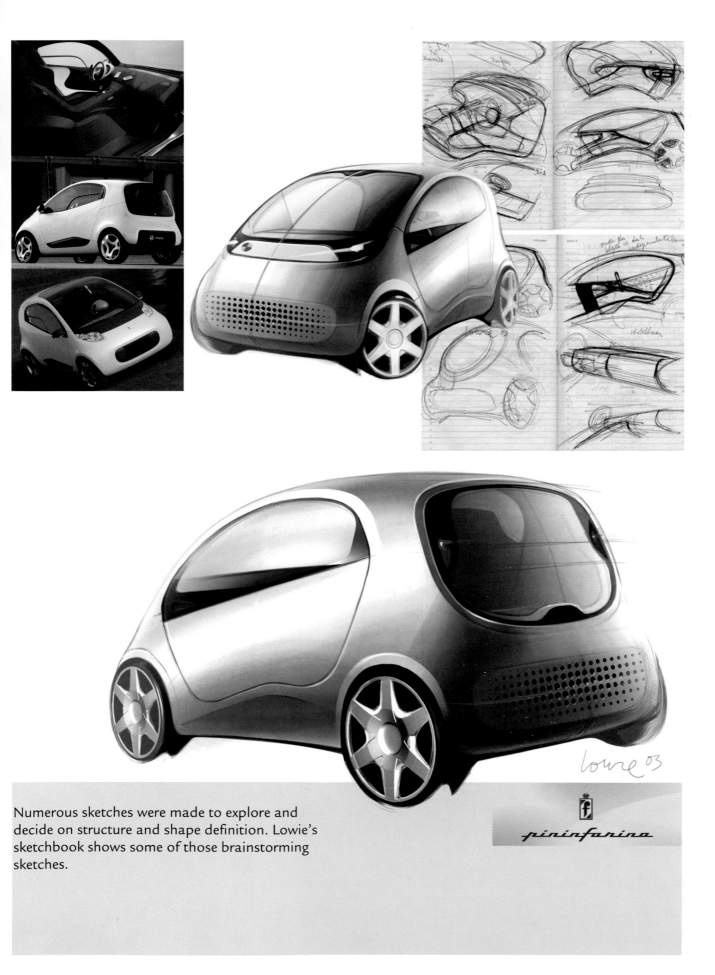

Numerous sketches were made to explore and decide on structure and shape definition. Lowie's sketchbook shows some of those brainstorming sketches.

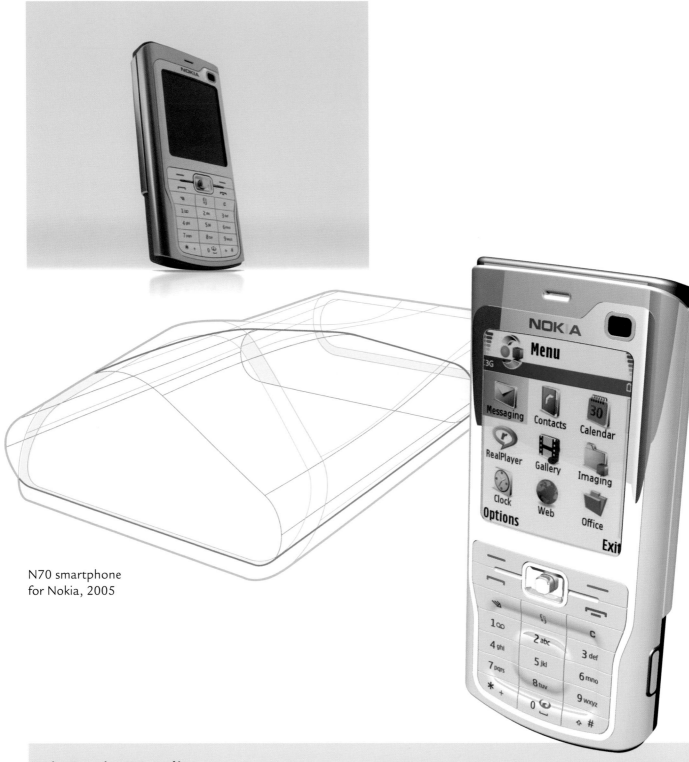

N70 smartphone
for Nokia, 2005

Feiz Design Studio

Working in close collaboration with Nokia design, the objective of this project was to create a distinct identity and character for a family of mobile multimedia products. This activity led to final products such as the N70 and N80 smartphones. The formal language of these products is based on a sculptural approach, which is highly controlled (a transition between a soft triangular form into a flat lozenge shape). This form is both reflective of the technology inside and the human outside, creating a form which cradles and complements the hand. Careful attention has been paid to the choice of materials, such as the stainless steel front panels creating a qualitative and distinct image.

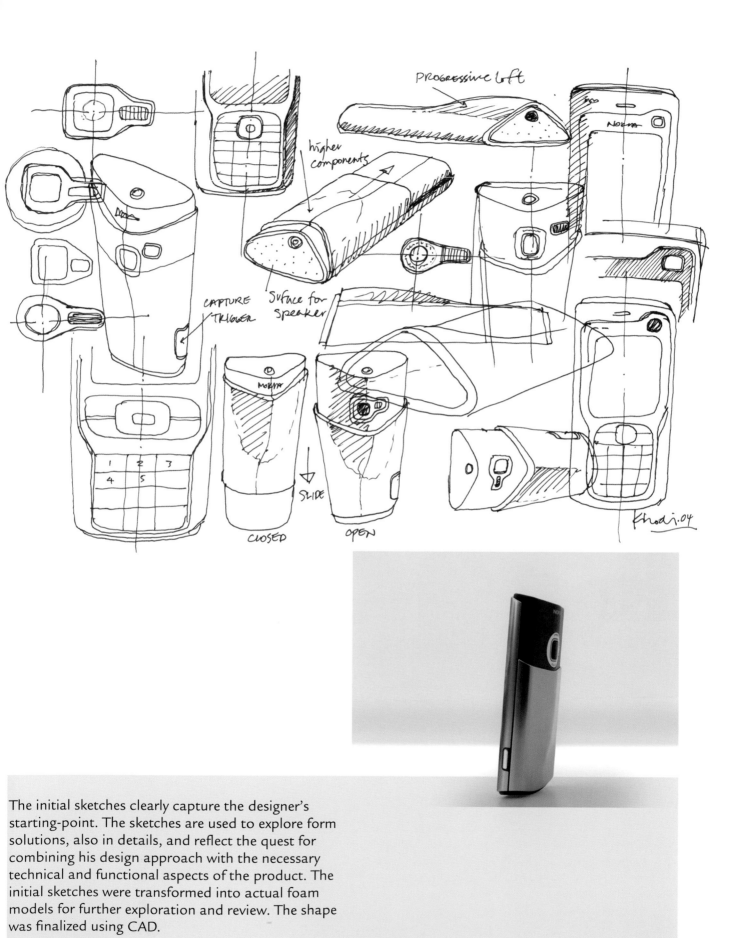

The initial sketches clearly capture the designer's starting-point. The sketches are used to explore form solutions, also in details, and reflect the quest for combining his design approach with the necessary technical and functional aspects of the product. The initial sketches were transformed into actual foam models for further exploration and review. The shape was finalized using CAD.

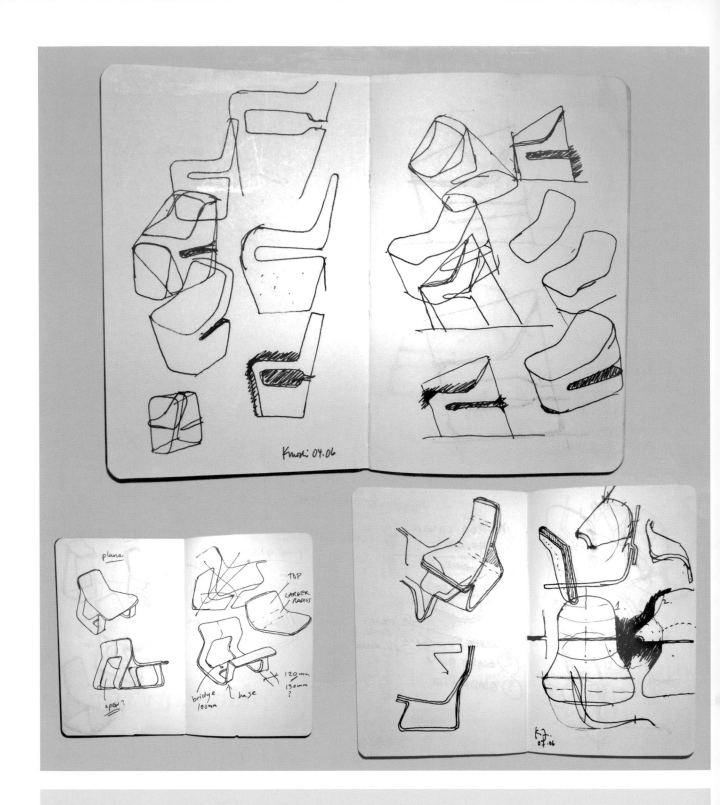

Khodi Feiz

"Like most designers, I also keep a small sketchbook with me at all times to jot down my ideas wherever they may come.... I use sketching more or less as an iterative thinking process which I can later translate into three dimensions. Sketches are generated to explore the formal qualities of my design. With me, they are very seldom used as a presentation tool; they don't need to look sleek or polished, only explorative and in turn communicative. Sketching is not precious to me, it is just a recording of a thought process."

Explanatory drawings

In addition to ideation and presentation, drawings can also be used to 'explain' to others. This has resulted in specific kinds of drawings like exploded views and side view drawings, especially in communicating specific technical information. We have already seen a crossover between presentation and technical drawing in the chapter on side view. In general, a more schematic way of drawing is applied in explanatory drawings. That way, pure information can be isolated for clarity. Archetype or icon-like drawings can ensure neutral or non-judgmental communication. Several drawings together can form a storyline, like a visual script, a manual or a storyboard.

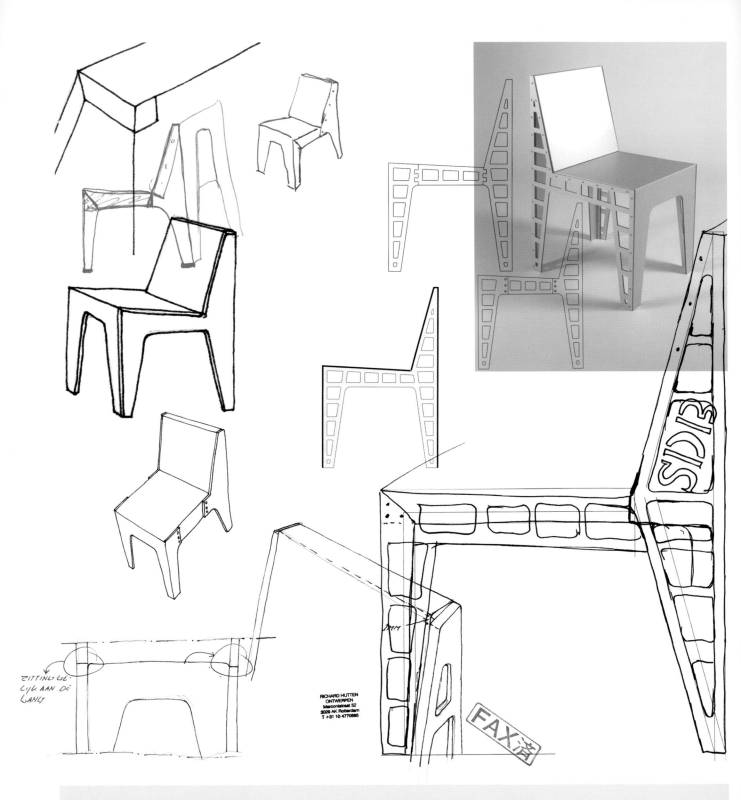

Richard Hutten Studio

The 'One of a Kind' project originally started out to pay homage to the Dutch architect Gerrit Rietveld, who in 1942 constructed a chair out of one sheet of aluminium, which became a great classic. The 'One of a Kind' chair is made of Alucarbon©. Later on other, related, designs also came about, and in 2000 this collection became known under the brand name 'Hidden'. After the initial sketch that embodies the basic product idea, the drawings are used, for example, to visualize the basic implications of different technical solutions and as a way to communicate with engineering.

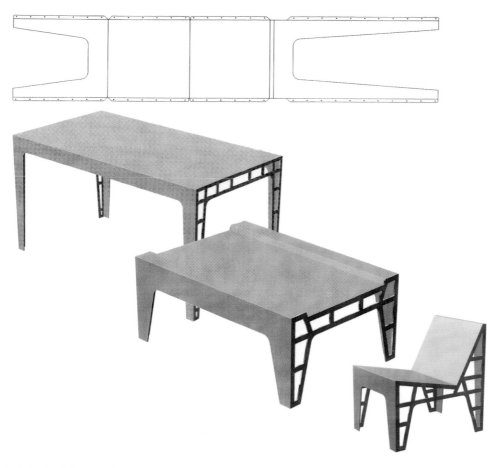

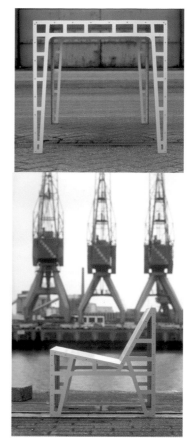

Final shape optimization is done by computer and a 1:1 model. The 'One of a Kind' project eventually resulted in six objects: a chair, table, dining table and chair, cabinet and 'stow chest'.

Photography: Richard Hutten Studio. Computer rendering: Brenno Visser

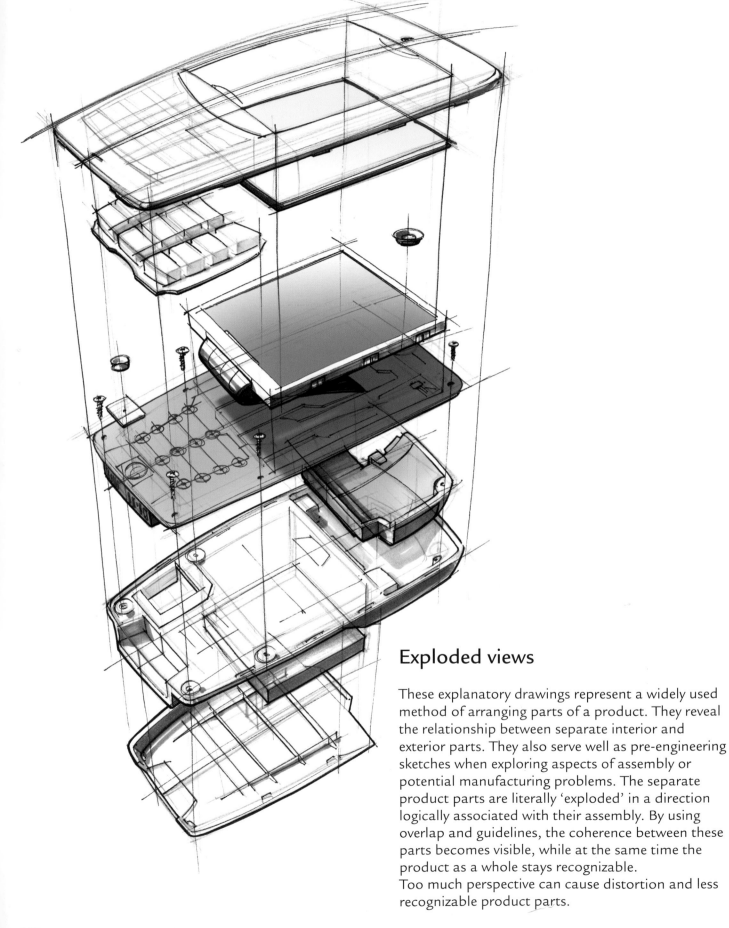

Exploded views

These explanatory drawings represent a widely used method of arranging parts of a product. They reveal the relationship between separate interior and exterior parts. They also serve well as pre-engineering sketches when exploring aspects of assembly or potential manufacturing problems. The separate product parts are literally 'exploded' in a direction logically associated with their assembly. By using overlap and guidelines, the coherence between these parts becomes visible, while at the same time the product as a whole stays recognizable.

Too much perspective can cause distortion and less recognizable product parts.

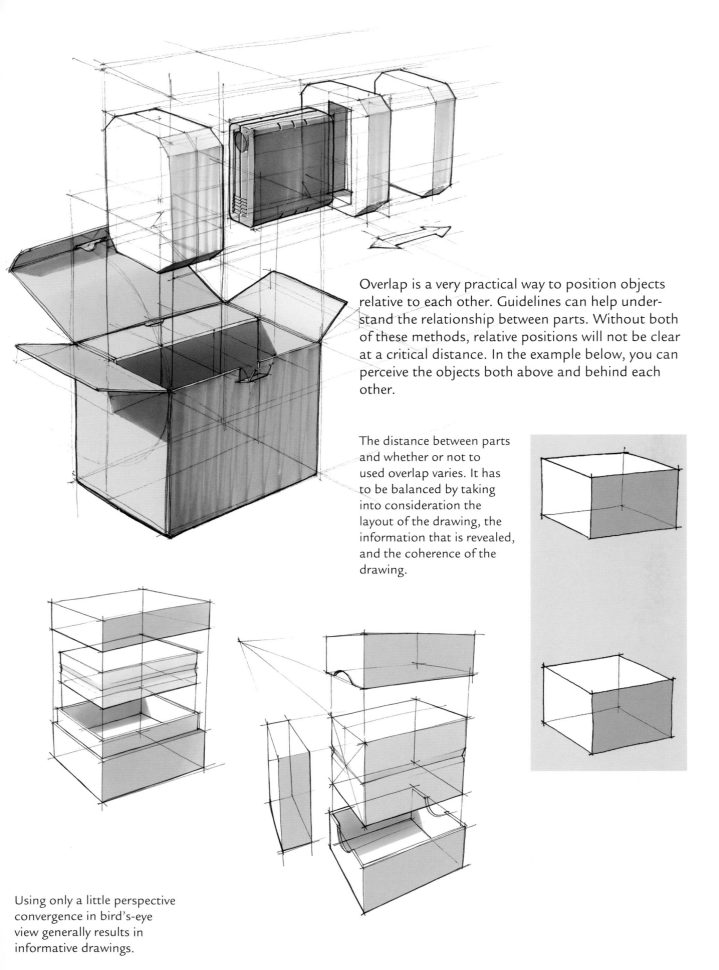

Overlap is a very practical way to position objects relative to each other. Guidelines can help understand the relationship between parts. Without both of these methods, relative positions will not be clear at a critical distance. In the example below, you can perceive the objects both above and behind each other.

The distance between parts and whether or not to used overlap varies. It has to be balanced by taking into consideration the layout of the drawing, the information that is revealed, and the coherence of the drawing.

Using only a little perspective convergence in bird's-eye view generally results in informative drawings.

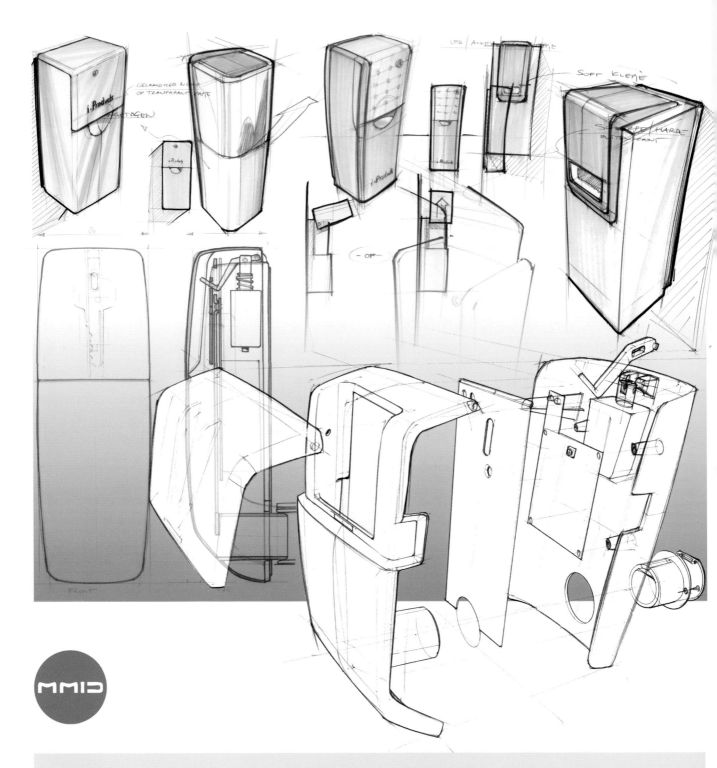

MMID

"For i-Products, we completely developed the KeyFree system from the first sketches until the end product, 2006. This system hangs on a door and in an emergency it can release a key from a distance, using a mobile phone. We paid special attention to easily hanging the key and releasing it without errors. A semi-transparent lid was designed in order to show the key and the battery LED inside."

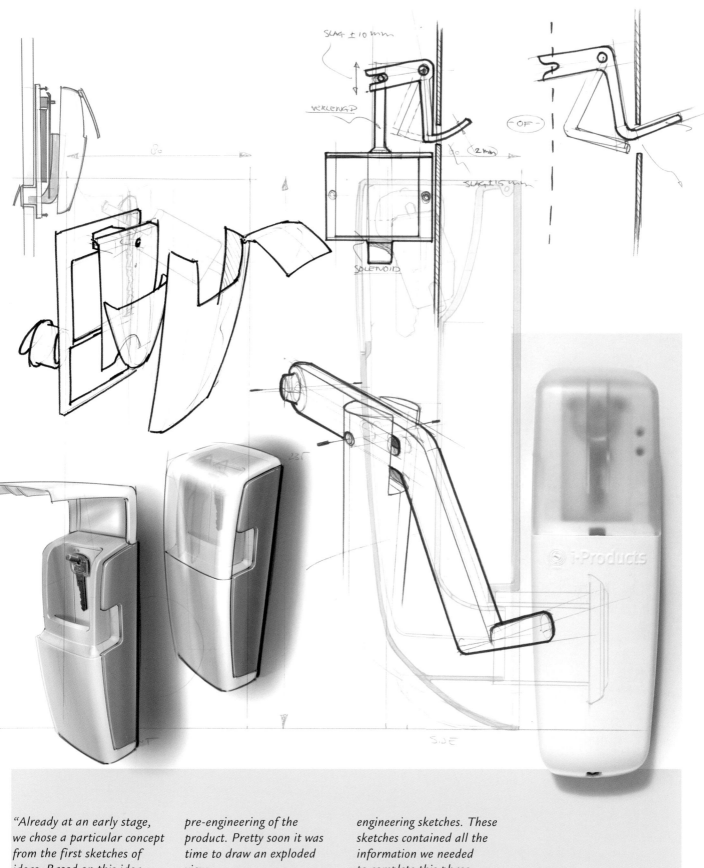

Labels within the drawing: SLAG ± 10 mm, VERLENGD, 2 mm, SLAG ± 15 mm, SOLENOID, -OF-, SIDE, i-Products

"Already at an early stage, we chose a particular concept from the first sketches of ideas. Based on this idea sketch, we made a few concept sketches to define the styling as well as the pre-engineering of the product. Pretty soon it was time to draw an exploded view.
To communicate our technical idea behind the concept, we drew pre-engineering sketches. These sketches contained all the information we needed to complete this phase before we could start the engineering in CAD."

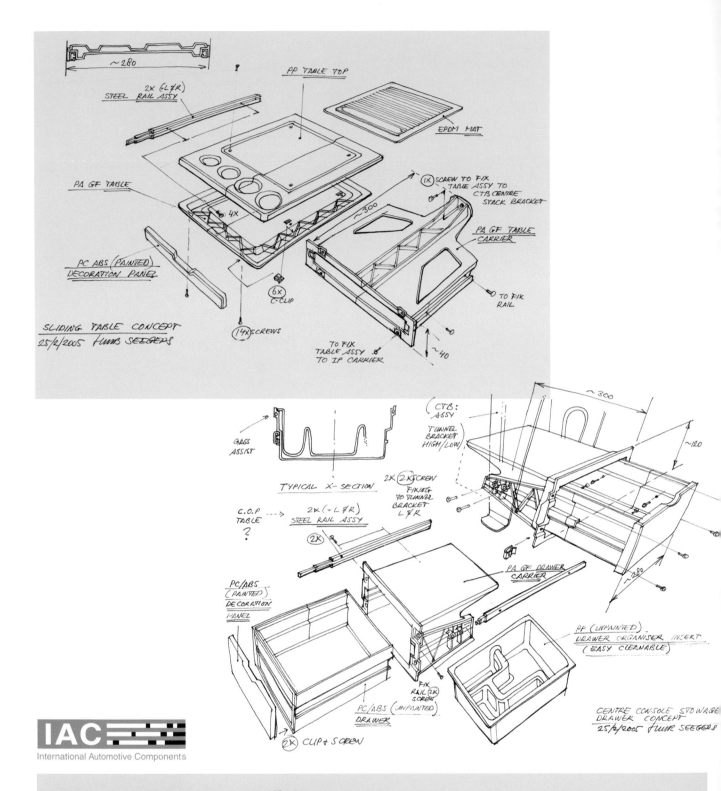

SLIDING TABLE CONCEPT
25/2/2005 Huib Seegers

~280

PP TABLE TOP

2X (L&R)
STEEL RAIL ASSY

PA GF TABLE

EPDM MAT

PC ABS (PAINTED)
DECORATION PANEL

1X SCREW TO FIX
TABLE ASSY TO
CTB CENTRE
STACK BRACKET

~300

PA GF TABLE
CARRIER

4X

6X
C-CLIP

14X SCREWS

TO FIX
RAIL

TO FIX
TABLE ASSY
TO IP CARRIER

~40

GLASS
ASSIST

TYPICAL X-SECTION

2X 2X SCREW
FIXING
TO TUNNEL
BRACKET
L&R

CTB:
ASSY:
TUNNEL
BRACKET
HIGH/LOW

~300

~120

C.O.P
TABLE
?

2X (-L&R)
STEEL RAIL ASSY

2X

PA GF DRAWER
CARRIER

~280

PC/ABS
(PAINTED)
DECORATION
PANEL

PP (UNPAINTED)
DRAWER ORGANISER INSERT
(EASY CLEANABLE)

PC/ABS (UNPAINTED)
DRAWER

FIX
RAIL (2X)
SCREW

CENTRE CONSOLE STOWAGE
DRAWER CONCEPT
25/2/2005 Huib Seegers

2X CLIP & SCREW

IAC Group, Germany – Huib Seegers

These examples of exploded views show a sliding table concept and a centre console stowage concept for a truck instrument panel application,

2005. A typical use for these sketches is to give cost estimators input on the concept, to enable them to make a first quote.

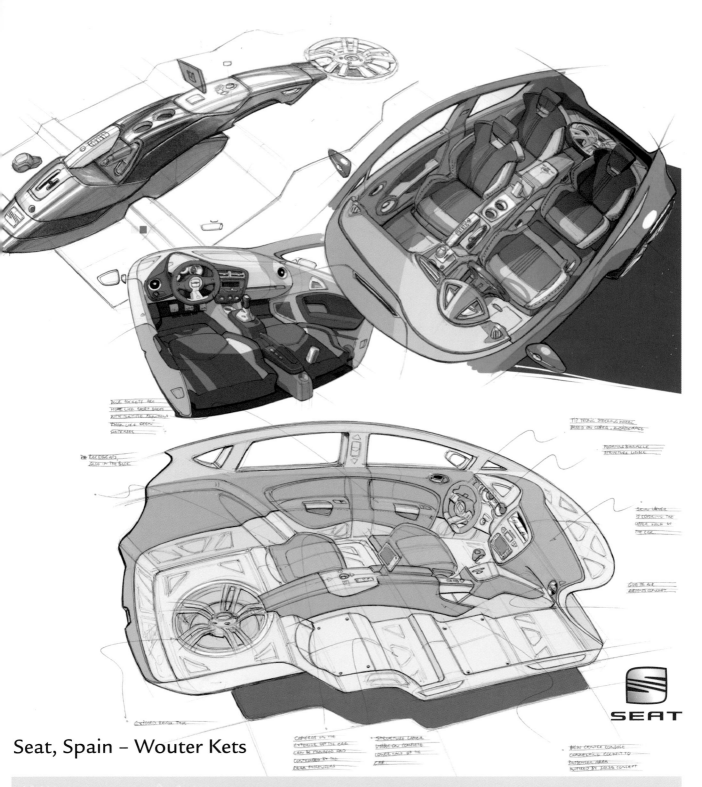

Seat, Spain – Wouter Kets

The Seat Leon Prototype was presented in 2005 at the Geneva motor show. The goal of the project was to whet the public's appetite for the Leon production car, which was introduced a few months later. The project was done in a short time-span with a limited budget.

The drawings for this project served mainly to communicate ideas within the team. Detailed design solutions were directly made in the full-size model. The challenge in these drawings is to find a suitable perspective and viewpoint for an enclosed and complex space, visualizing both overview and specific shape information. This is supported by leaving out parts of the car, the so-called cut-away.

The pen drawings were scanned in and collared in Photoshop. The shadows were put into gray tones on one layer. Then each colour was added in a separate layer so that different colour and trim solutions could be easily explored.

Chief designer: Luca Casarini

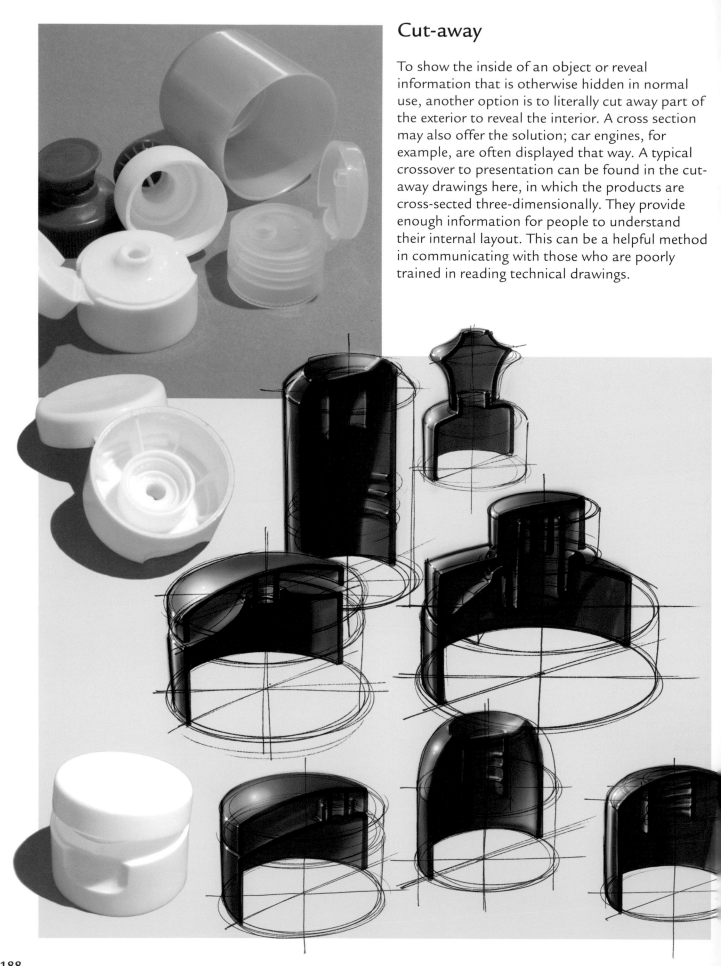

Cut-away

To show the inside of an object or reveal information that is otherwise hidden in normal use, another option is to literally cut away part of the exterior to reveal the interior. A cross section may also offer the solution; car engines, for example, are often displayed that way. A typical crossover to presentation can be found in the cut-away drawings here, in which the products are cross-sected three-dimensionally. They provide enough information for people to understand their internal layout. This can be a helpful method in communicating with those who are poorly trained in reading technical drawings.

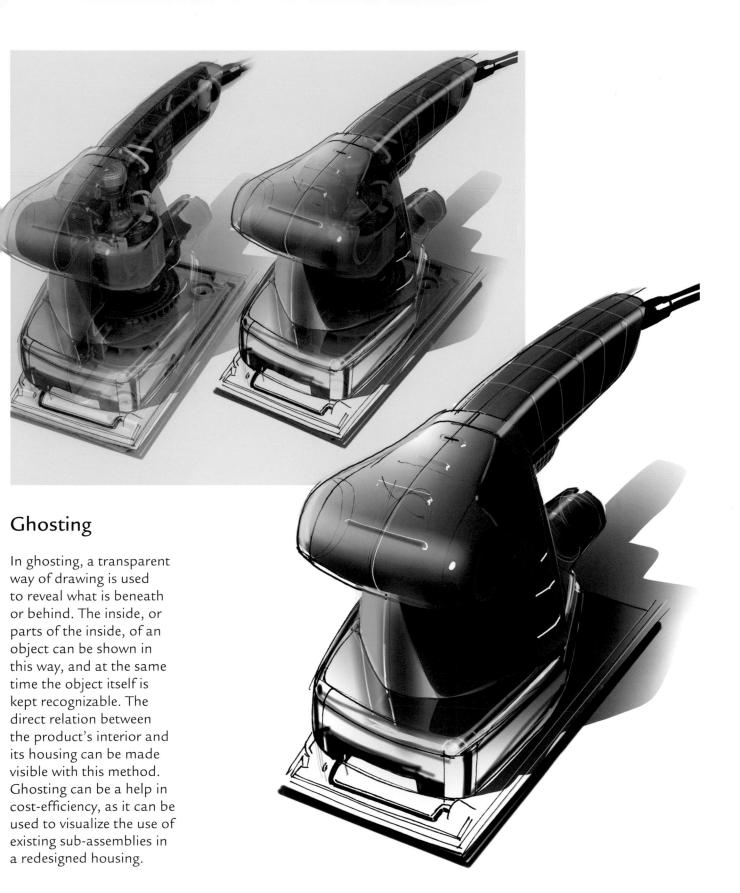

Ghosting

In ghosting, a transparent way of drawing is used to reveal what is beneath or behind. The inside, or parts of the inside, of an object can be shown in this way, and at the same time the object itself is kept recognizable. The direct relation between the product's interior and its housing can be made visible with this method. Ghosting can be a help in cost-efficiency, as it can be used to visualize the use of existing sub-assemblies in a redesigned housing.

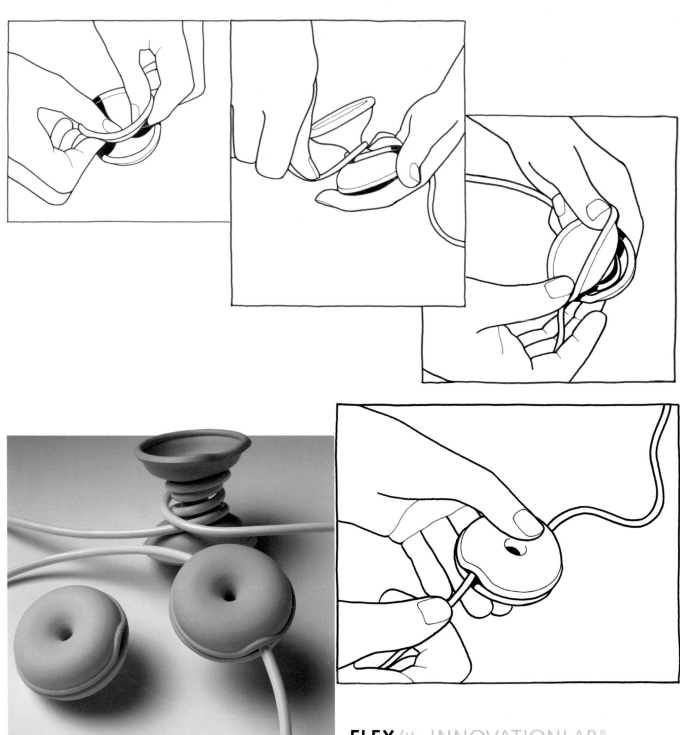

FLEX/theINNOVATIONLAB®

Cable Turtle for Cleverline, 1997, solves the problem of excess electrical wires in a surprisingly simple way. The product is now part of the MOMA collection in New York.

A reduced way of drawing was necessary to explain the working principle of the new product. Without a prototype to convince the client, drawings had to do the job.

Photography: Marcel Loermans

Instructional drawings

There are two kinds of instructional drawings. The first consists of a sequence of similar drawings, and is widely seen in assembly instructions for products such as furniture that come in parts and have to be assembled. In the other kind of instructional drawing, different kinds of drawings are grouped. These are often seen in general user manuals for products – such as how to install your computer.

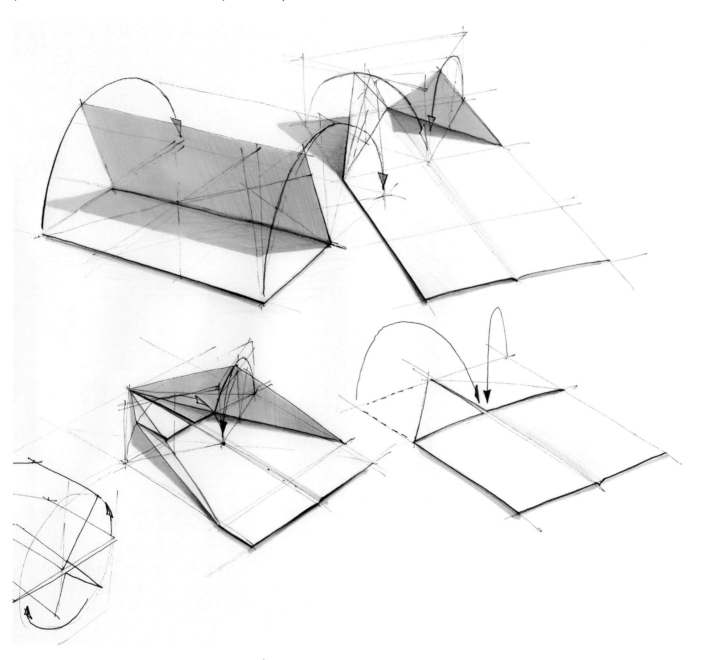

Studies about manuals and the consumer's understanding of them show that cultural background matters, and that international visual language has to be used. Handling instructions usually require more than one drawing. Studying the sequence of actions will determine the number and type of drawings needed. The aim is to pass on information as logically and plainly as possible. To do so here, for example, arrows are used to indicate the folding actions.

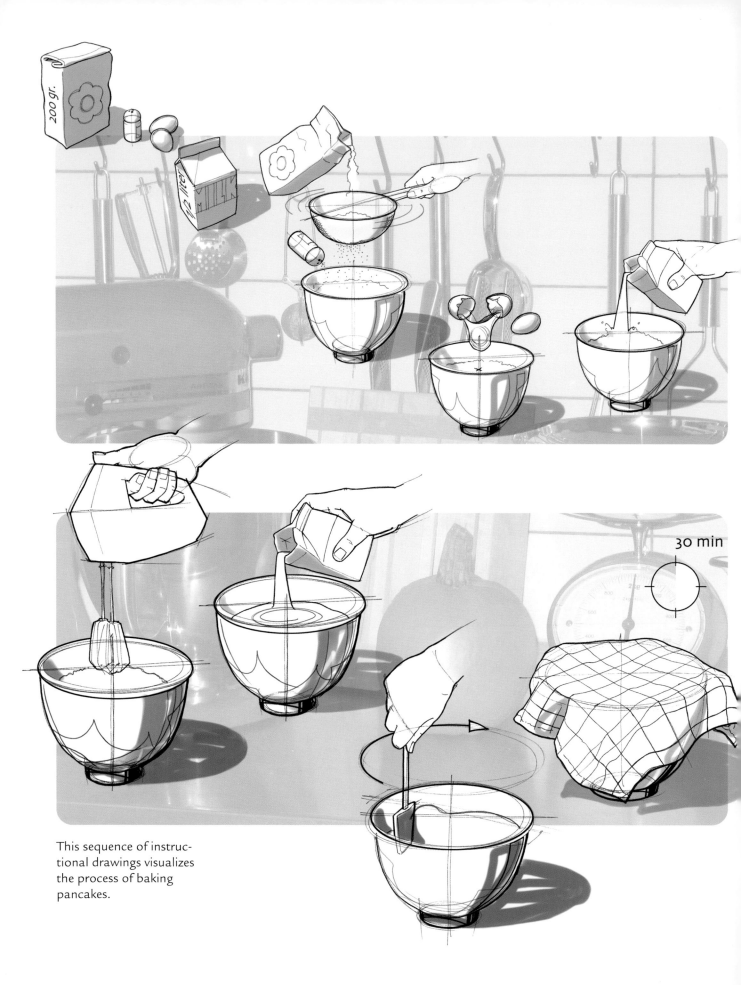

This sequence of instructional drawings visualizes the process of baking pancakes.

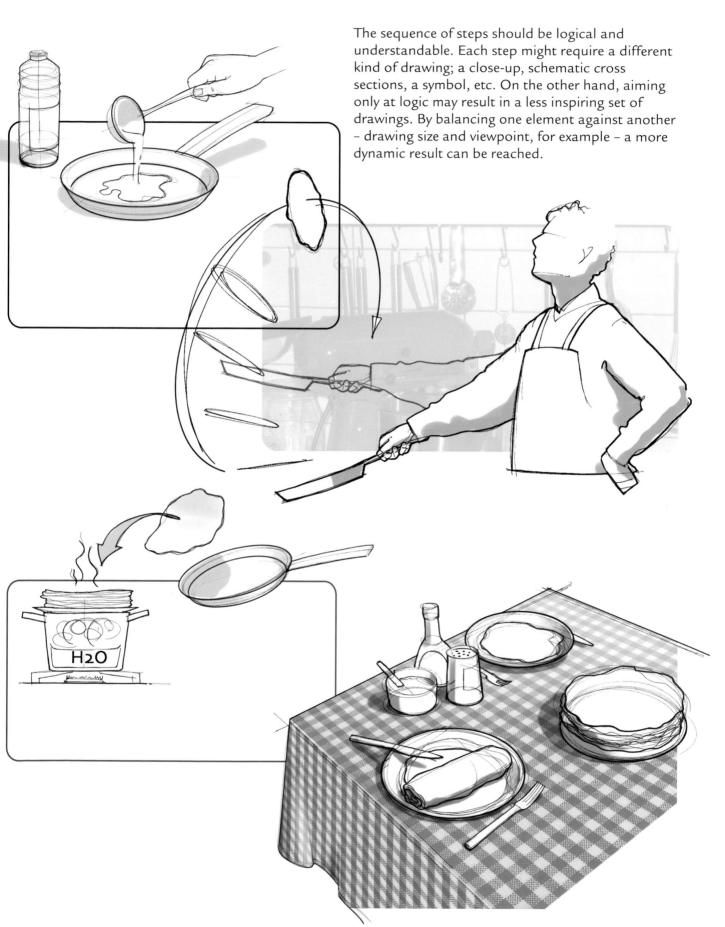

The sequence of steps should be logical and understandable. Each step might require a different kind of drawing; a close-up, schematic cross sections, a symbol, etc. On the other hand, aiming only at logic may result in a less inspiring set of drawings. By balancing one element against another – drawing size and viewpoint, for example – a more dynamic result can be reached.

H2O

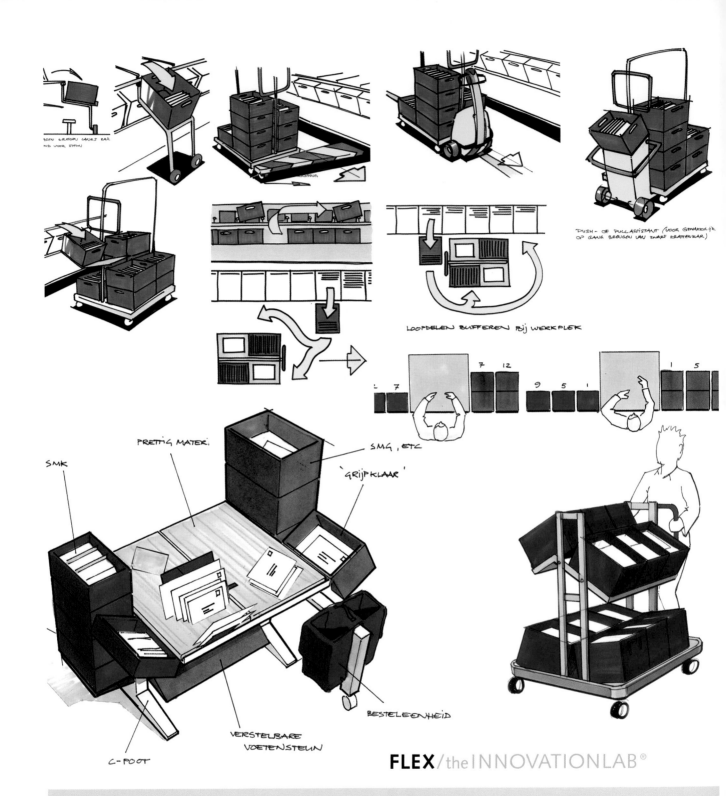

SMK

PRETTIG MATER.

SMG, ETC

'GRIJPKLAAR'

BESTELEENHEID

VERSTELBARE VOETENSTEUN

C-POOT

LOOPDELEN BUFFEREN BIJ WERKPLEK

PUSH- OF PULL ASSISTANT (VOOR GEMAKKELIJK OP GANG BRENGEN VAN ZWARE KRATTENKAR)

FLEX/theINNOVATIONLAB®

At the start of the project, the complex situation was analyzed and mapped in numerous drawings. This overview helped to split up the situation in several smaller design areas covering the process handling, routing, workplaces and object/tools. The simple yet clear drawings helped the designers and the client get a grip on the enormous complexity of the process and all its details.

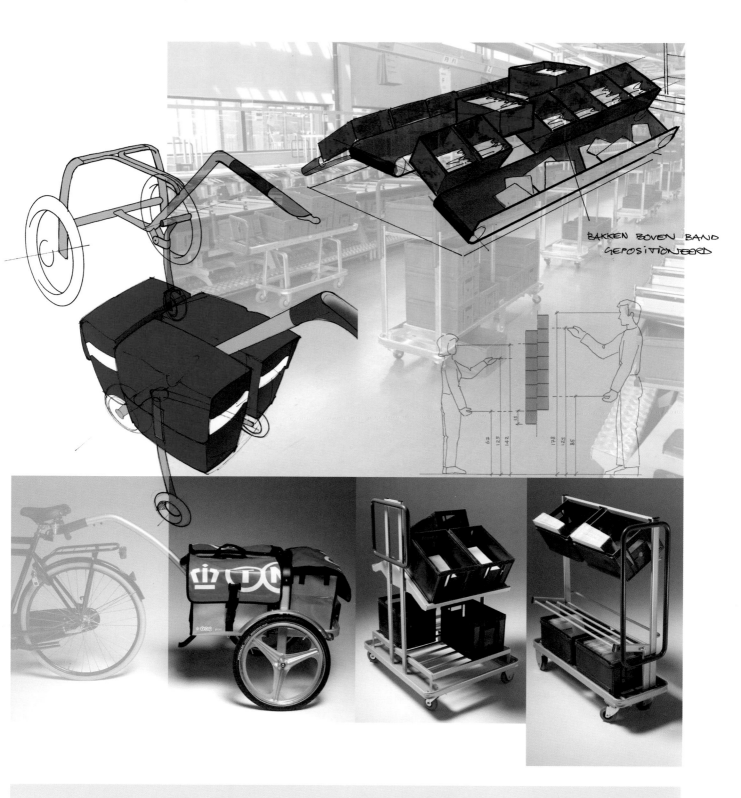

BAKKEN BOVEN BAND GEPOSITIONEERD

Mail handling systems, 2004–2006. FLEX was involved in the development of aids to improve and optimize the process of collecting, sorting and delivering mail for the Dutch mail company TNT. The first results were the trolleys for the temporary storage and collection of crates with sorted mail. Later a whole range of items followed, including the postal carrier used by postmen to deliver mail both on foot and by bike.

Photography: Marcel Loermans

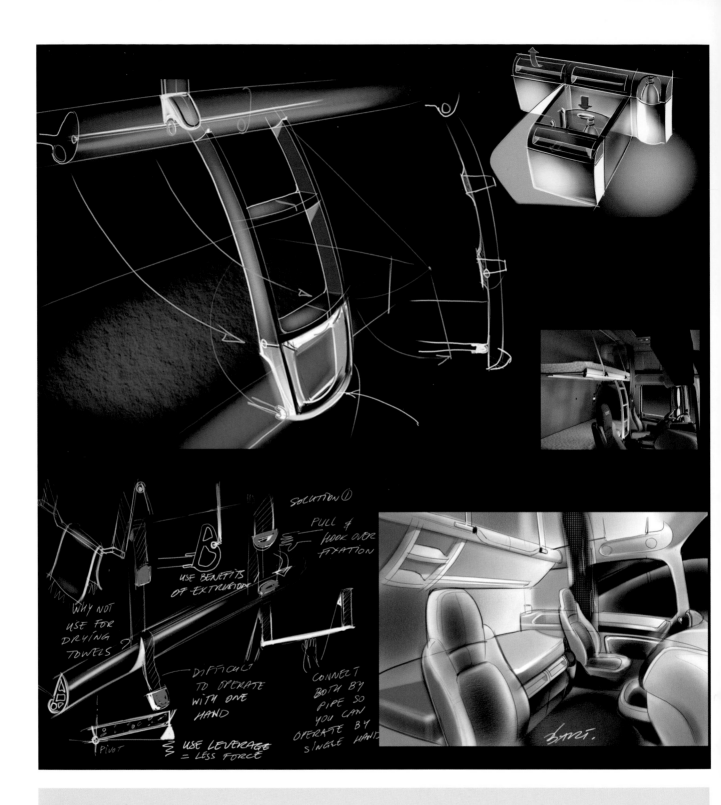

DAF Trucks NV

Easy Lift System for the upper bed of the XF105, 2006. Guidelines with arrows can be helpful in showing how the lightweight steps are positioned. The cross section at the end of the bar explains the shape of the proposal for an aluminium extrusion. Drawings were scanned and inverted in Photoshop, so that the initial black lines became white. After that the colour and the blue lines were added. The slide-out storage boxes under the lower bed are within easy reach of the driver. A bottle holder is also part of the design, so as to create ample storage space inside the truck without compromising the freedom to move around.

Designer: Bart van Lotringen

Surface and textures

Material expression can have great impact on a drawing. A drawing of a product will become more realistic if surface properties such as reflections, gloss or texture are shown. Knowledge of light and shading is necessary, and can now be combined. The intention is not to draw photo-realistically, but to gain knowledge of characteristics so that a material can be 'suggested', which in turn could support decision-making in a design process.

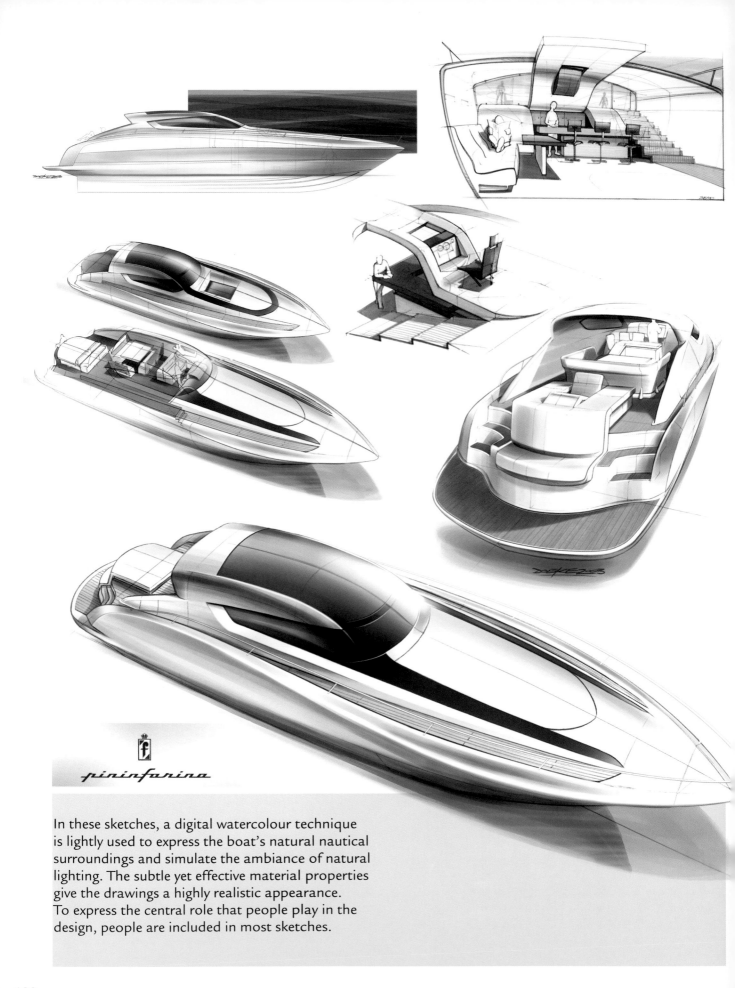

pininfarina

In these sketches, a digital watercolour technique is lightly used to express the boat's natural nautical surroundings and simulate the ambiance of natural lighting. The subtle yet effective material properties give the drawings a highly realistic appearance. To express the central role that people play in the design, people are included in most sketches.

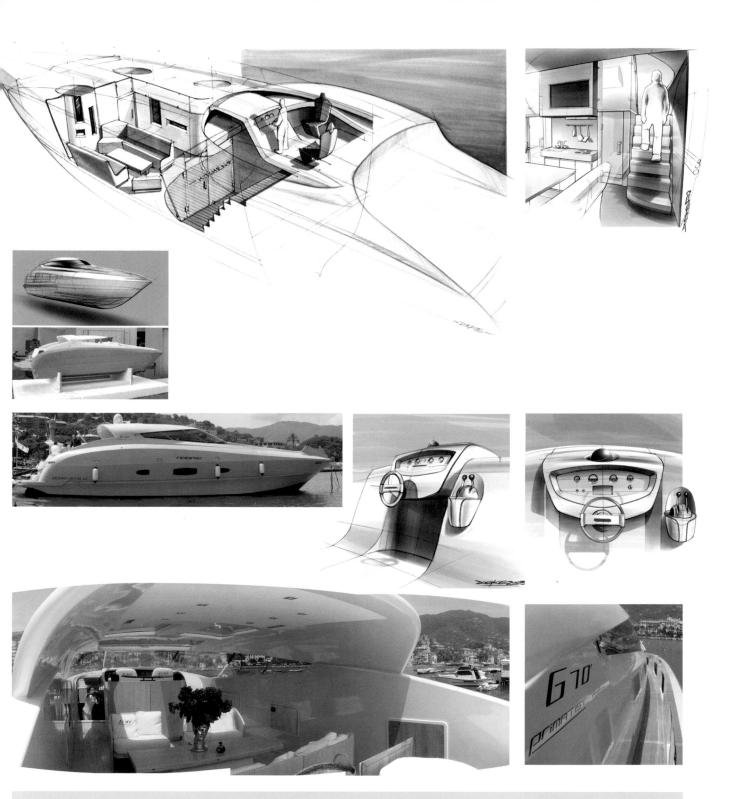

Pininfarina, Italy – Doeke de Walle

Leisure speedboat for Primatist.
The objective of the design is to create a strong connection between the interior and the environment by opening up the entrance of the cabin to let in more natural light and create a vista from inside to outside. The sketches give clear information about shape and proportions and also strongly express the ambiance aimed at in this design. Notice the clever choice of standpoints to express information about spaces, sections, routing, sightlines and lighting.

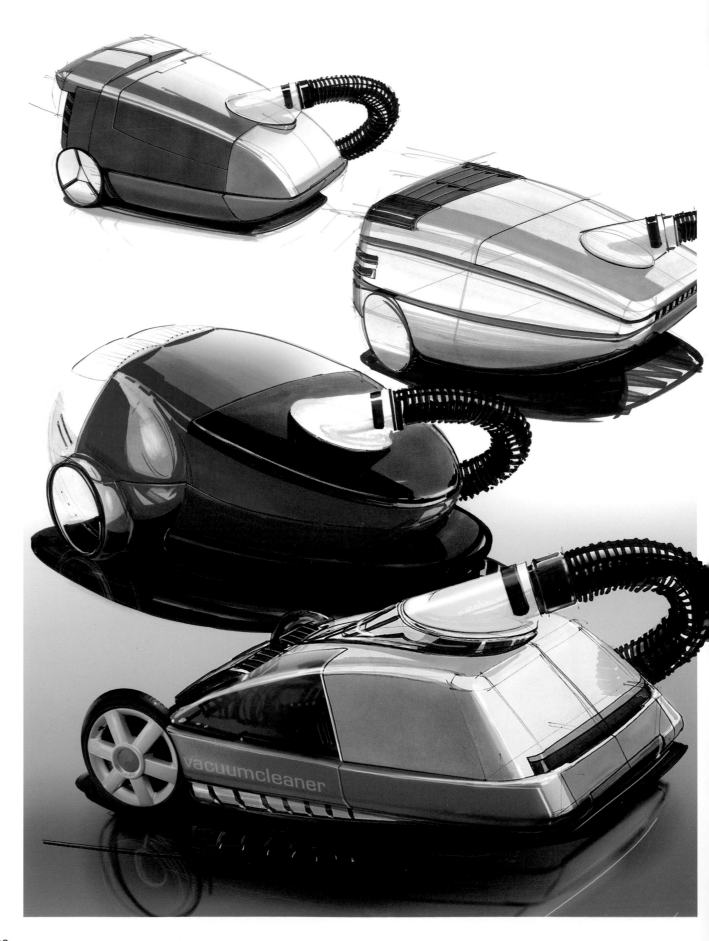

Reflections

Material effects can be simplified and exaggerated in drawings to make a clear statement with strong impact. In these sketches, reflections are not 'constructed', but approximated, and a similarity can be seen in treatment of the top surface. The end result is not photorealistic, but aims at expressing the characteristics of the material. The reflections of close surroundings, such as the cast shadow, the hose and its connector, are combined with an 'abstract' reflection of the general surroundings, all aimed at creating high contrast.

Guidelines for reflections

Reflections can be seen in a mirror, in chromium, and also in shiny surfaces. Their colour, however, is different in each situation. In a mirror, the colour of an object's reflection resembles the colour of the object; a blue object appears blue in the mirror. The overall contrast of the reflection is slightly less than that of the object.

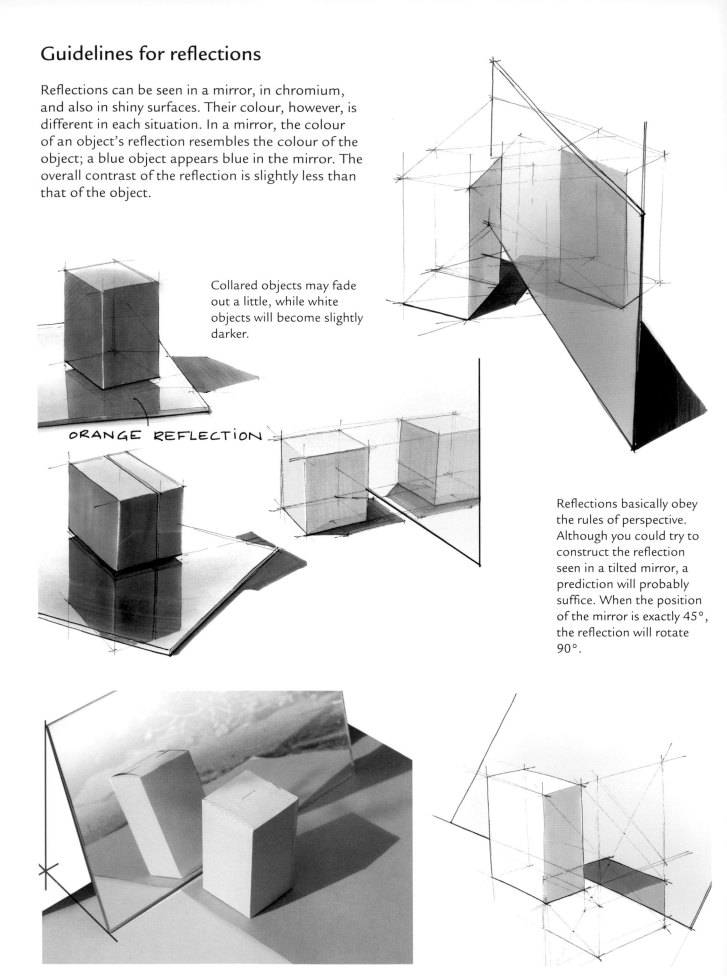

Collared objects may fade out a little, while white objects will become slightly darker.

ORANGE REFLECTION

Reflections basically obey the rules of perspective. Although you could try to construct the reflection seen in a tilted mirror, a prediction will probably suffice. When the position of the mirror is exactly 45°, the reflection will rotate 90°.

In glossy material, the colour of reflections is a mixture of the shiny surface and the object's colour. Reflected in a collared shiny surface, a blue object does not appear blue; it tends to shift towards the colour of the shiny surface.

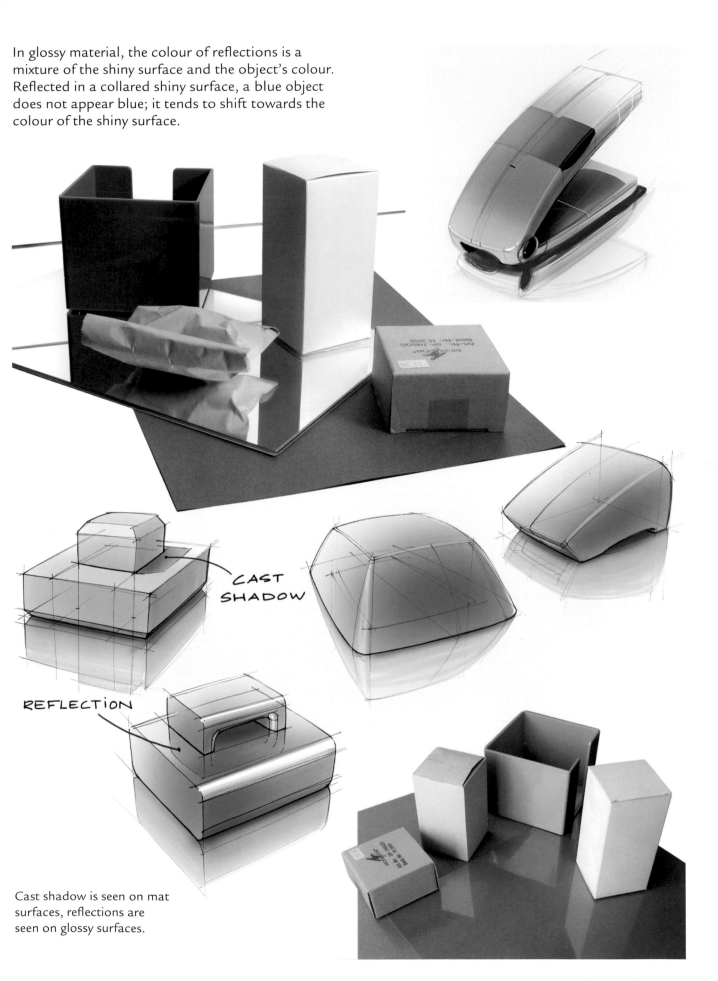

CAST SHADOW

REFLECTION

Cast shadow is seen on mat surfaces, reflections are seen on glossy surfaces.

Glossy

On extremely glossy materials, reflections will have the colour of the shiny material itself. In reality there will always be a mixture of reflection and cast shadow visible. To emphasize the glossy appearance in a drawing, cast shadow is usually left out, and the collared reflections of the surroundings are exaggerated. As a result, much more contrast is seen in comparison to mat materials.

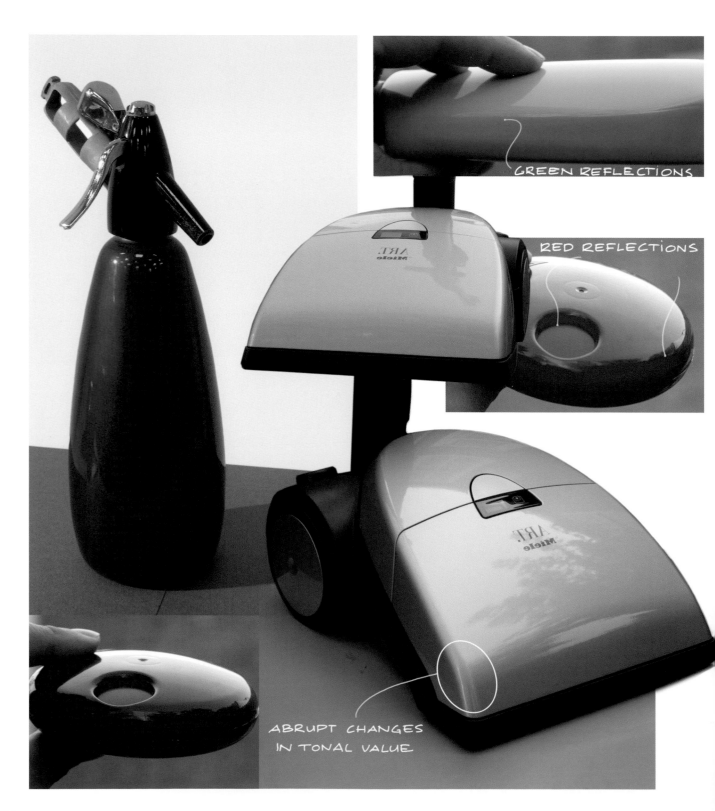

GREEN REFLECTIONS

RED REFLECTIONS

ABRUPT CHANGES
IN TONAL VALUE

Mat

These materials are expressed largely through colour and shading only, and do not reflect their surroundings. Soft transitions and modest highlights can be seen in their shading.

TRANSITION

CAST SHADOW

MODEST HIGHLIGHTS

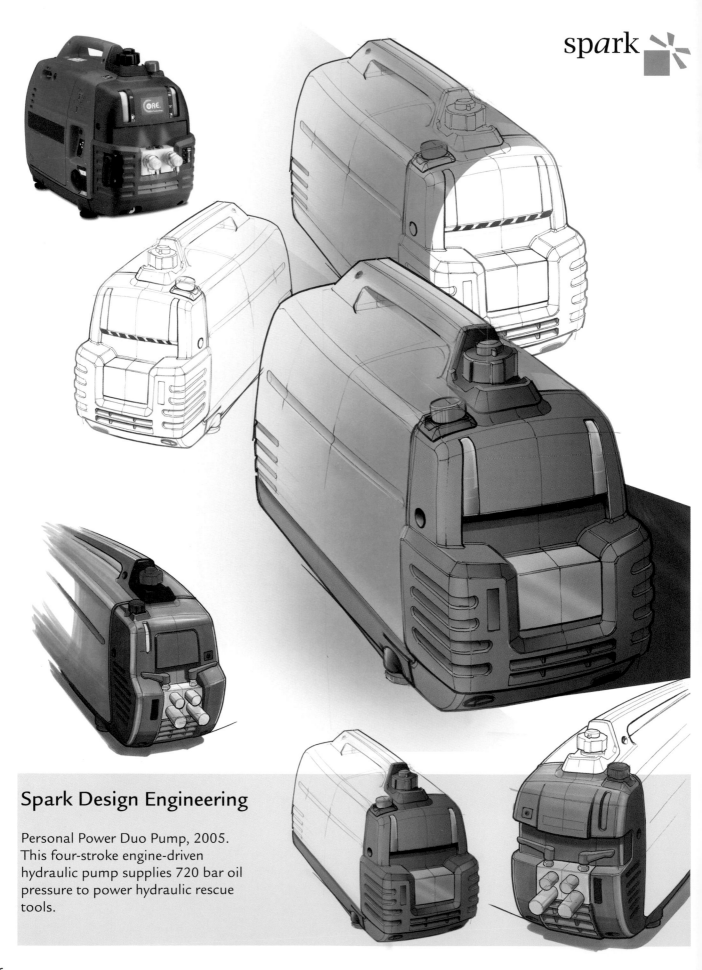

spark

Spark Design Engineering

Personal Power Duo Pump, 2005. This four-stroke engine-driven hydraulic pump supplies 720 bar oil pressure to power hydraulic rescue tools.

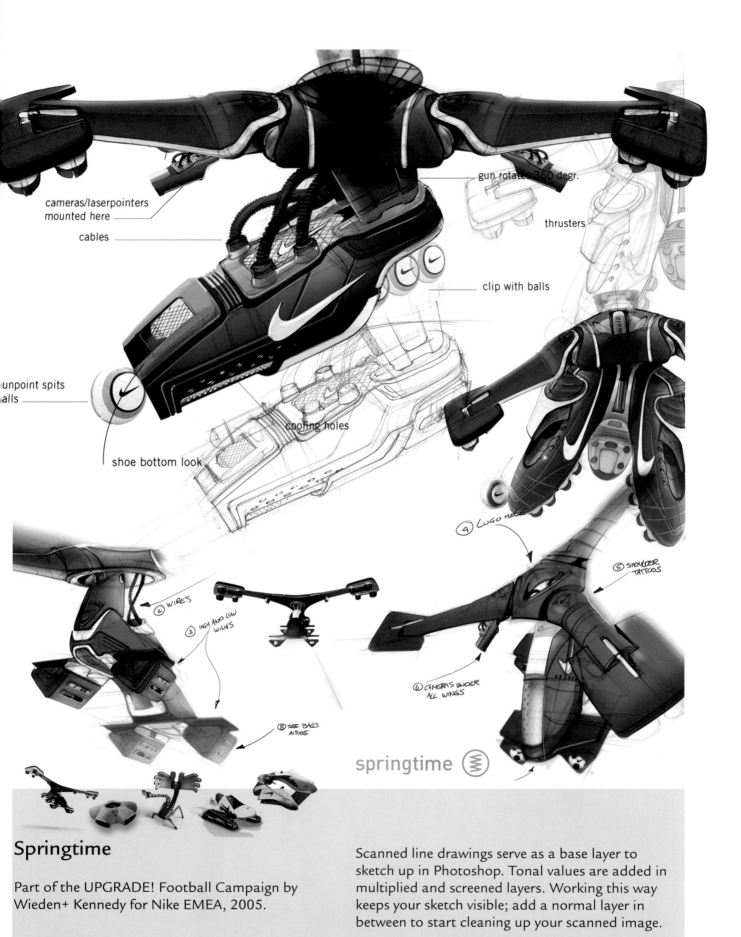

cameras/laserpointers mounted here

cables

gun rotates 360 degr.

thrusters

clip with balls

gunpoint spits balls

shoe bottom look

cooling holes

② WIRES

③ HIGH AND LOW WINGS

④ LOGO HERE

⑤ SHOULDER TATTOOS

⑥ CAMERAS UNDER ALL WINGS

⑧ SEE BALLS INSIDE

springtime

Springtime

Part of the UPGRADE! Football Campaign by Wieden+ Kennedy for Nike EMEA, 2005.

Scanned line drawings serve as a base layer to sketch up in Photoshop. Tonal values are added in multiplied and screened layers. Working this way keeps your sketch visible; add a normal layer in between to start cleaning up your scanned image.

Designer: Michiel Knoppert; Computer rendering: Michiel van Iperen

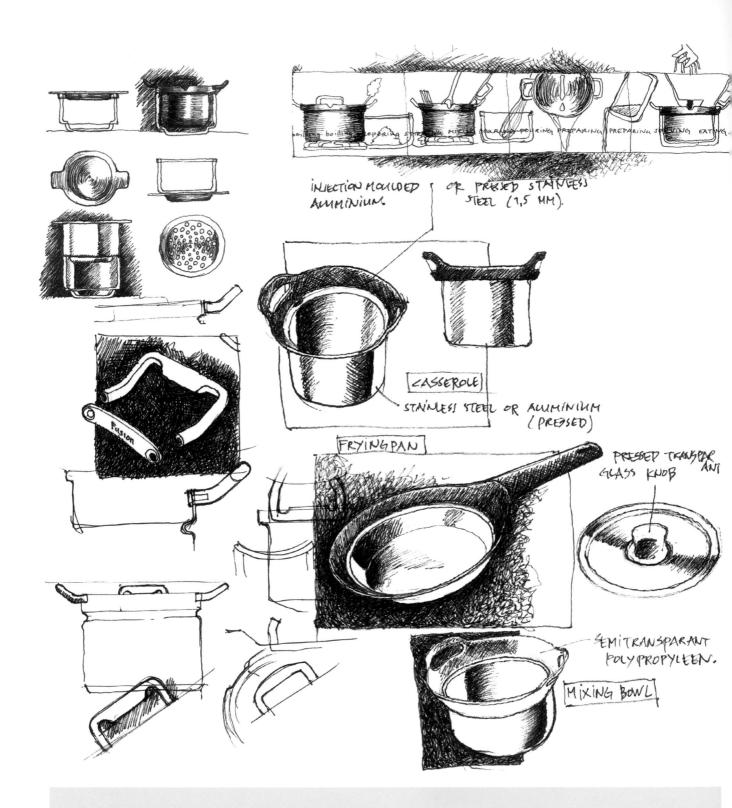

INJECTION MOULDED ALUMINIUM.

OR PRESSED STAINLESS STEEL (1,5 MM).

CASSEROLE

STAINLESS STEEL OR ALUMINIUM (PRESSED)

FRYINGPAN

PRESSED TRANSPARANT GLASS KNOB

SEMITRANSPARANT POLYPROPYLEEN.

MIXING BOWL

Fusion

Material expression can already be seen in these pen sketches done at an early stage of the design. This helps in making a better choice between different concepts. Drawings are also used as a means of exploring different design solutions and their impact on the final shape of the pans.

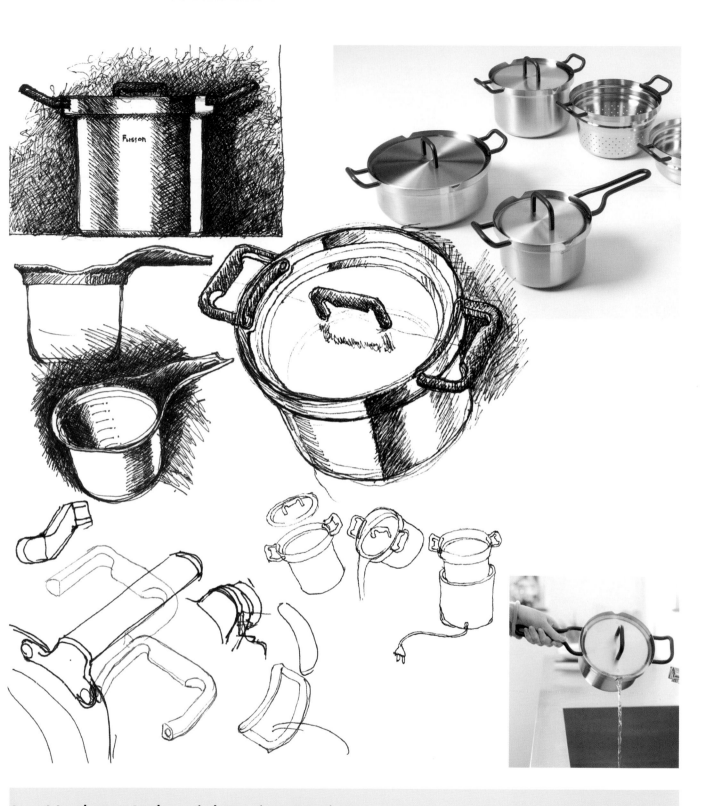

Jan Hoekstra Industrial Design Services

Cookware for Royal VKB. Stainless steel cookware
with black stained handles. A smart locking system
on the handles in combination with the lid allows
you to strain water without holding onto the lid.
Design Plus Award 2002, Red Dot Award 2003,
Grand Prix de l'Arte 2004, Collection M&O 2006.

Photography: Marcel Loermans

Chromium

This material has hardly any colour of its own, but mainly consists of reflections. It behaves in this respect like a mirror. These reflections can have very big contrast. A combination of black and white is often used in drawing, together with a little cobalt blue and ochre, referring to reflected sky and earth. In the case of the toaster, you can see the start of the rounding by the deformity of the reflections. These deformities can also be seen in the drawing above.

In curved or cylindrical shapes, reflections of the general surroundings are compressed and appear 'stripy' in the longitudinal direction of the rounding. Reflections of the near surroundings, on the other hand, are more prominent, and their shape is unique in each situation.

Even simple surroundings can result in complex reflections. It is effective to create a clear and simple environment whose reflections support the shape of the object.

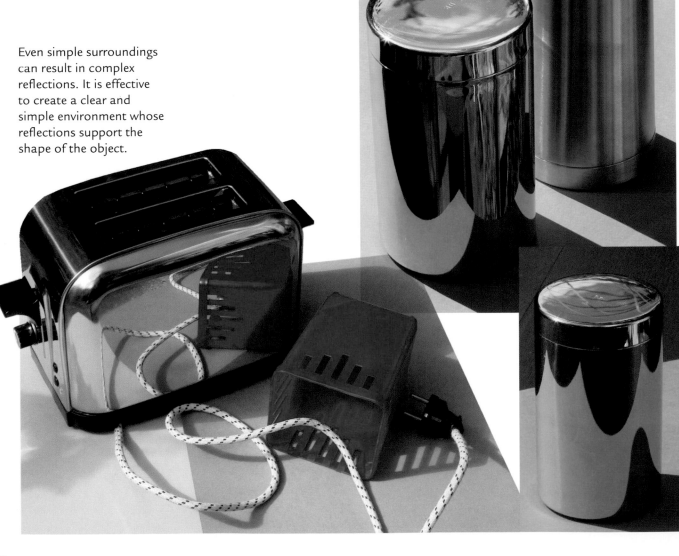

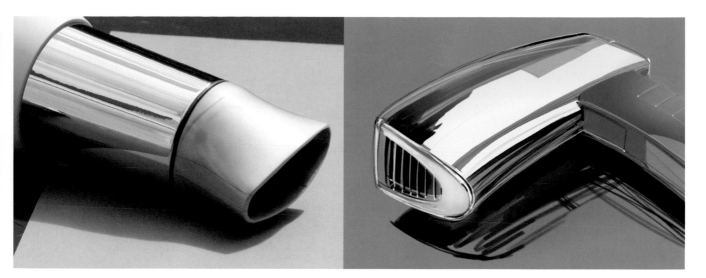

Compared to standing cylinders, horizontally oriented cylinders will reflect only part of their nearby surroundings, and a large portion of the bright sky, for instance. Because of this, they have a much brighter appearance than vertical cylinders.

Contrasting black and white is needed to express the shiny metal surface. This will stand out more if the drawing is placed in a collared environment. Several reflections are suggested intuitively, aiming at a realistic character of the material, rather than a realism of the reflections themselves.

In the brightest area of the cylinder, the blue colour of the reflected sky can be seen.
Notice the two kinds of reflections. The refection of a square surface in a cylinder results in a typical shape, as will the reflection of the cast shadow.

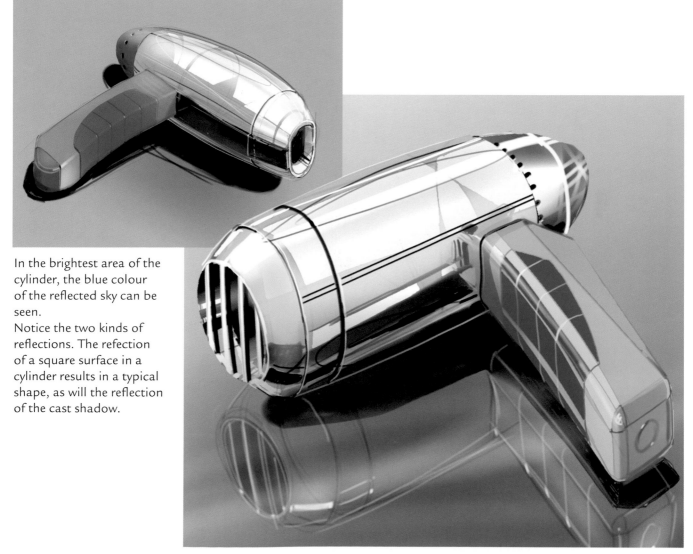

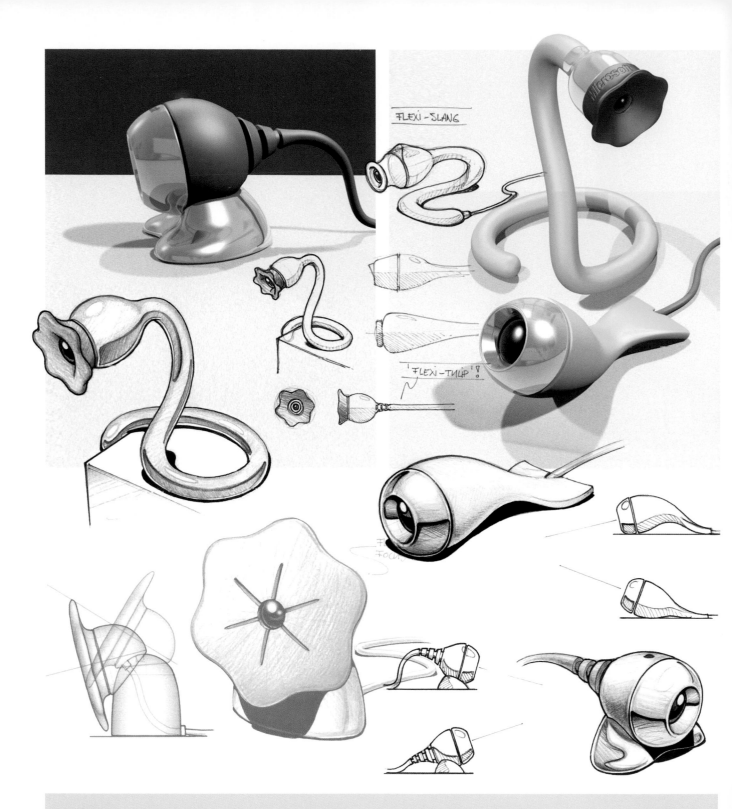

FLEXI-SLANG

'FLEXI-TULIP'

WAACS

Raw emotion. You're born with it. So are products. They either have it, or they don't. And most don't. Microsoft Corporation, Redmond, approached WAACS in 1999, lured by the smell of raw emotion. Since that time, they have conceived a number of hardware and software projects. These concept sketches for a family of 3 PC web cams are similar enough to read as a family and dissimilar enough to exemplify the three different markets. Each one is reminiscent of a small pet.

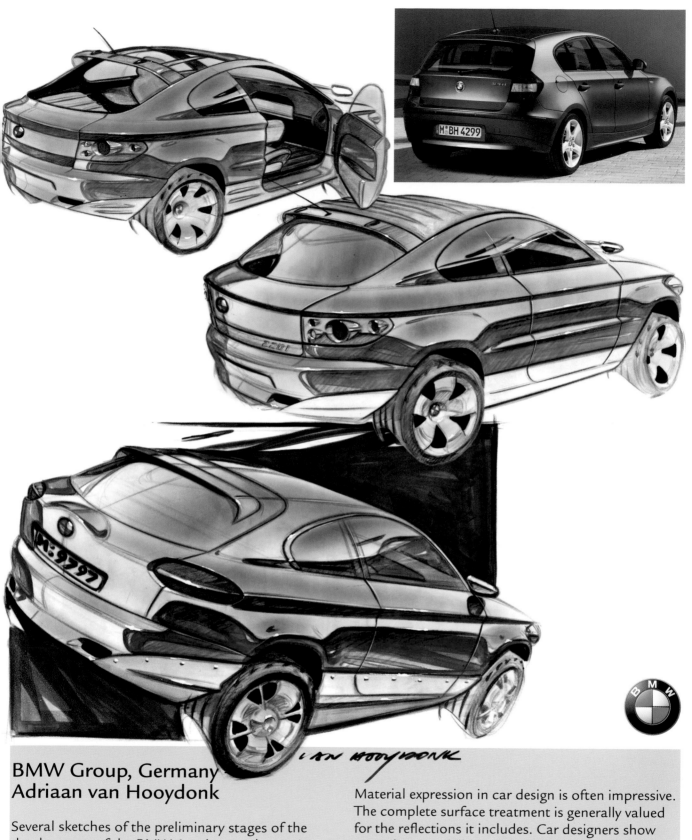

BMW Group, Germany
Adriaan van Hooydonk

Several sketches of the preliminary stages of the
development of the BMW-1 series are shown. In
addition to other design proposals, a full-scale
model was made out of Van Hooydonk's sketches.
Chris Chapman was responsible for the final design.

Material expression in car design is often impressive.
The complete surface treatment is generally valued
for the reflections it includes. Car designers show
great drawing skill in applying these reflections in
their proposals. In these examples, marker and
pastel are used on Vellum, adding highlights with
white paint.

Glass

This material has three major characteristics. Besides its obvious transparency, reflection and distortion also play a role. Where light is reflected, the material will be less transparent. As there is always a slight reflection of soft light, any surroundings seen through glass will always appear more faint.

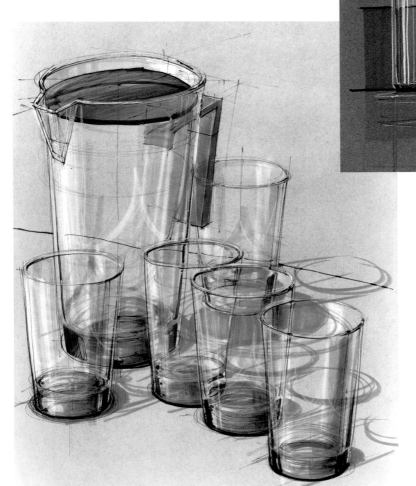

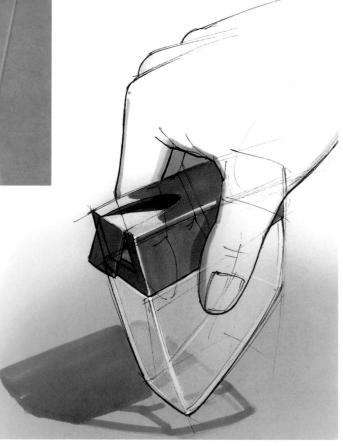

Distortion is especially seen through curved or cylindrical glass objects, especially near the contour. Glass is also less transparent near this edge. In the thicker parts of transparent material, dark reflections can be seen in addition to the white ones.

To express the see-through material of this product, a collared abstract environment is chosen so that highlights will stand out. Cast shadow seen through the material appears lighter.

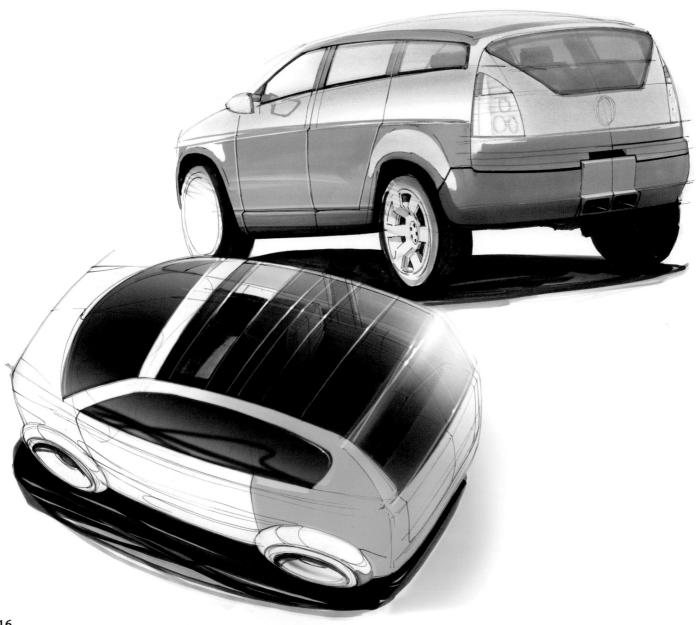

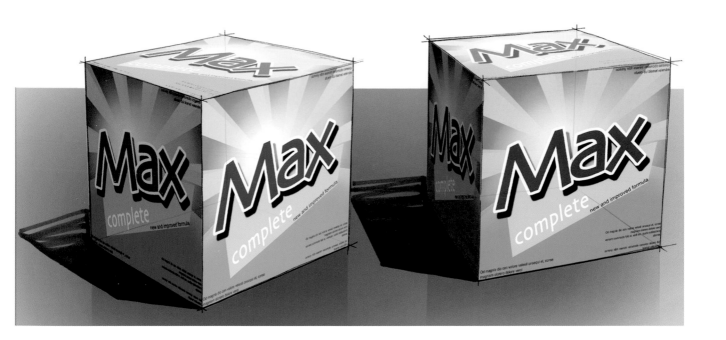

Textures and graphics

A surface can have a certain texture. If you take a close look, a lot of textures are like the tread of a car tire, made out of grooves and ridges, which may be suggested by using black and white lines only. Either drawn by hand, digitally generated or rendered in 3D, these textures have to take into account the linear and aerial perspective of the drawing, as well as light conditions.

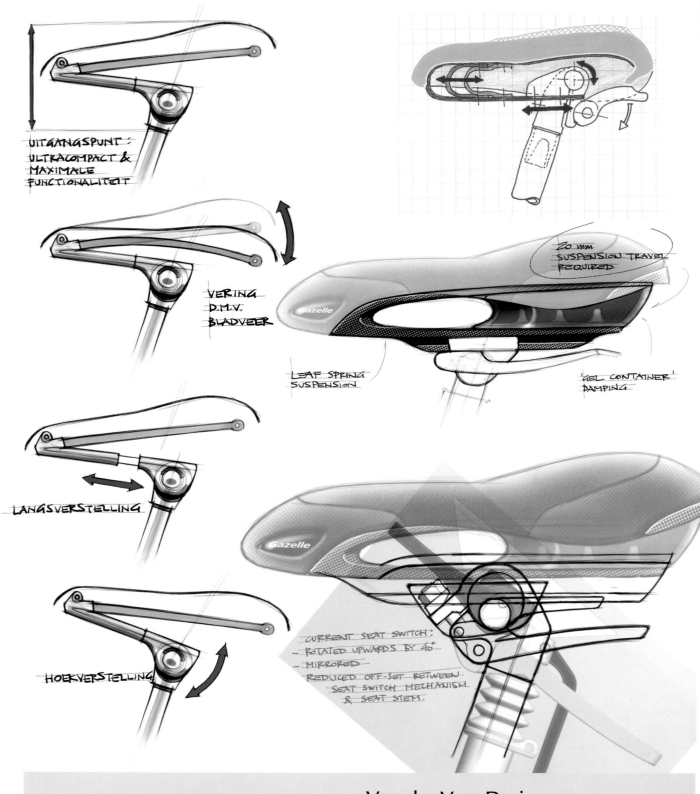

UITGANGSPUNT
ULTRACOMPACT &
MAXIMALE
FUNCTIONALITEIT

VERING
D.M.V.
BLADVEER

LEAF SPRING
SUSPENSION

GEL CONTAINER
DAMPING

20 mm
SUSPENSION TRAVEL
REQUIRED

LANGSVERSTELLING

HOEKVERSTELLING

CURRENT SEAT SWITCH:
- ROTATED UPWARDS BY 40°
- MIRRORED
- REDUCED OFF-SET BETWEEN
 SEAT SWITCH MECHANISM
 & SEAT STEM.

Van der Veer Designers

Gazelle Comfort Seat, 2006.
One of Gazelle's main brand identity cues is 'cycling comfort'. Seat adjustment and suspension are completely integrated into the design. The Comfort Seat will be mounted on Gazelle's Gold Line Series.

Client: Gazelle. Designers: Rik de Reuver, Albert Nieuwenhuis

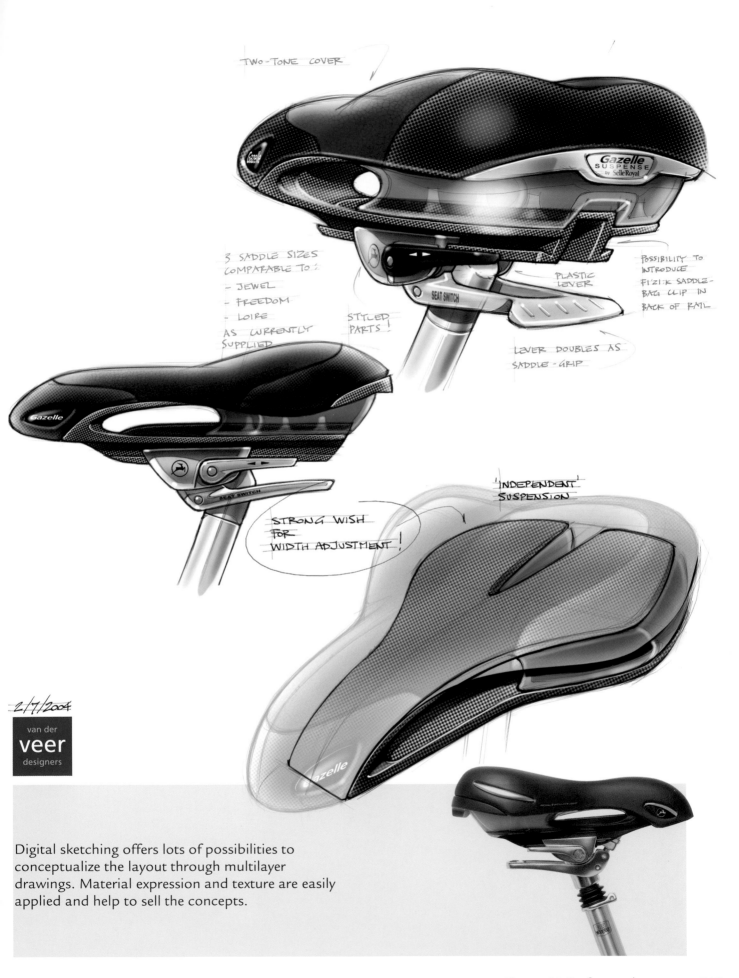

TWO-TONE COVER

Gazelle
SUSPENSE
by Selle Royal

3 SADDLE SIZES
COMPARABLE TO :
– JEWEL
– FREEDOM
– LOIRE
AS CURRENTLY
SUPPLIED

STYLED
PARTS !

POSSIBILITY TO
INTRODUCE
FI'ZI:K SADDLE-
BAG CLIP IN
BACK OF RAIL

PLASTIC
LEVER

SEAT SWITCH

LEVER DOUBLES AS
SADDLE - GRIP

Gazelle

SEAT SWITCH

STRONG WISH
FOR
WIDTH ADJUSTMENT !

INDEPENDENT
SUSPENSION

2/7/2004

van der
veer
designers

Gazelle

Digital sketching offers lots of possibilities to
conceptualize the layout through multilayer
drawings. Material expression and texture are easily
applied and help to sell the concepts.

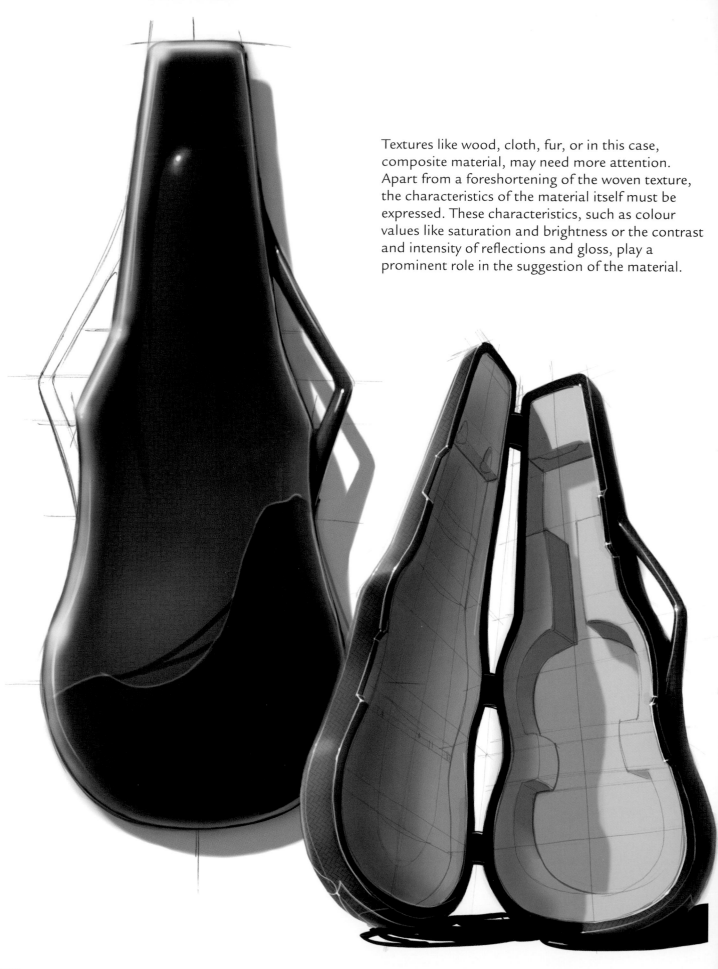

Textures like wood, cloth, fur, or in this case,
composite material, may need more attention.
Apart from a foreshortening of the woven texture,
the characteristics of the material itself must be
expressed. These characteristics, such as colour
values like saturation and brightness or the contrast
and intensity of reflections and gloss, play a
prominent role in the suggestion of the material.

Emitting light

For something to emit light, the light source needs to be perceived as the brightest area in the picture or drawing. In order to be seen, an object must be lit. Pictures or drawings of light sources have to be carefully balanced in terms of light sources and light intensity.

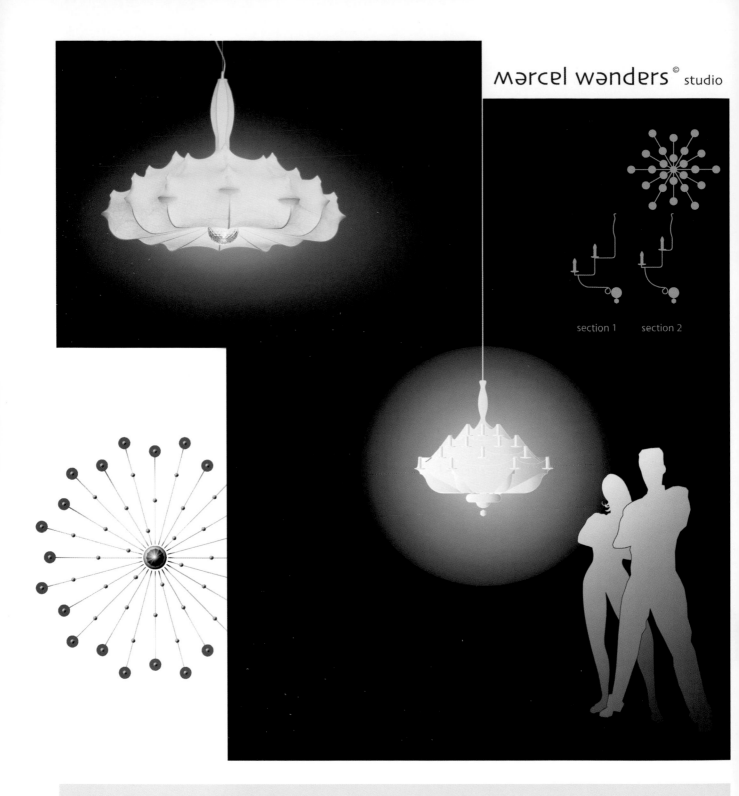

section 1 section 2

Marcel Wanders Studio

"Amongst all the lists, there is a list of the 10 best lamps in the world. The 'cocoon' lamp that Achille Castiglioni designed in the early 60s must be on that list. I call Achille my uncle because he was always there when I was taking my first steps as a designer and I feel we are family. He was there when I was kicked out of design school after a year, and when I made my first wooden 'rocking' lamp which burned my room down.

I have always been so much inspired by the man who gave identity to what we call 'the untouchable lightness'. And sometimes, still, he taps me on the shoulder; and when I turn my head... and think a little...I smile...I take a new fresh piece of paper and try again to fill the shadow of his light. Today I have made my own cocoon lamp and hope he forgives me, as I have named it 'Zeppelin'."
Zeppelin, for Flos, S.p.A., 2005.

Designer: Marcel Wanders. Photography: Flos S.p.A., Italy

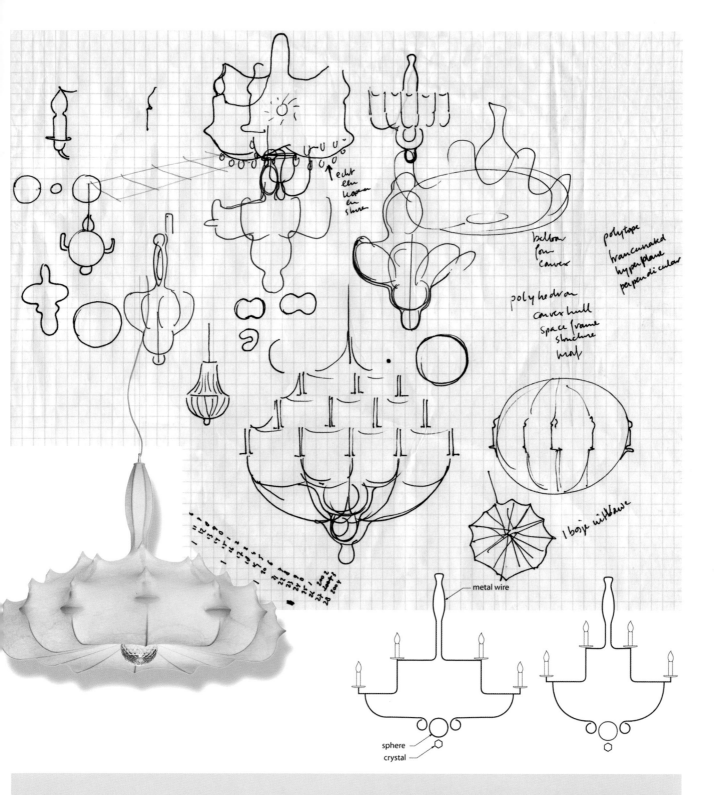

A brief exploration of shape can be seen in the initial drawings. In later sketches, the object's shape becomes more final and the idea becomes clearer in terms of form. The initial sketches, however, have already started to capture the character of the final shape.

When light is cast upon a surface, its intensity obviously fades out as it gets further away from the light source.

Emitting bright light

There are various kinds of light sources. In perceiving them, and in drawing them, there are basically just a few situations. A great distinction can be made between whether or not the light is cast onto something. Besides that, light intensity and the colour of the light is important. To optimize the suggestion of emitting light, a lamp can be placed in a black surrounding.

Biodomestic, 2001. Winner of the European Design Competition, 'Lights of the future'

The porcelain becomes deformed during manufacturing, which results in uniquely shaped objects.

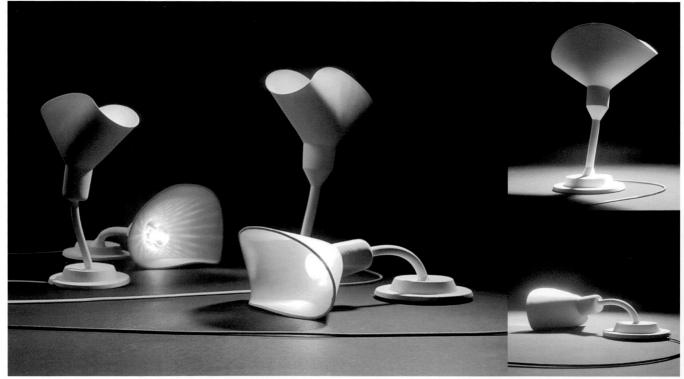

Spineless lamps by Studio Frederik Roijé, 2003

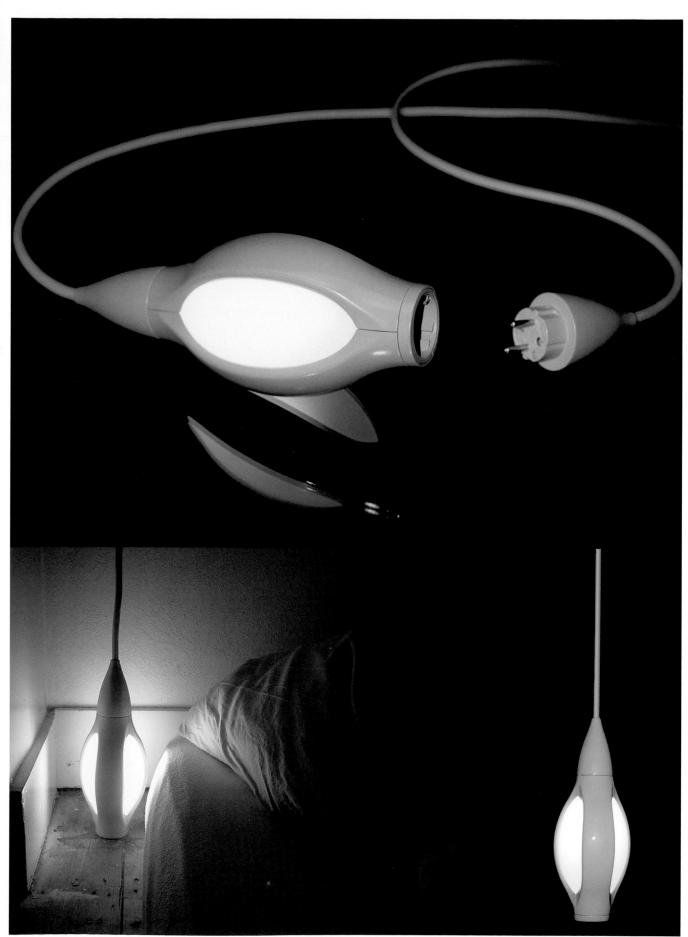

Design and Photography: Hugo Timmermans and Willem van der Sluis: Customr

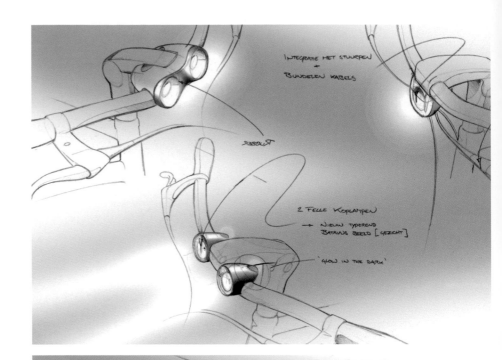

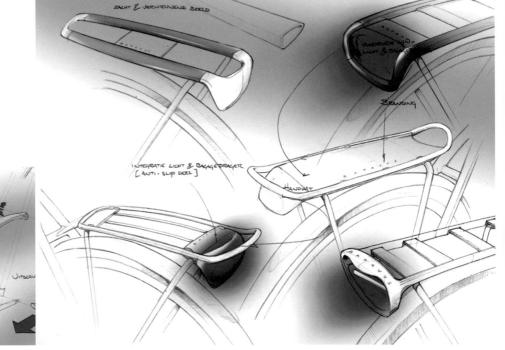

FLEX/theINNOVATIONLAB®

Regular bike for Batavus, 2002. Part of the assignment was to develop new bike accessories, like lamps and luggage carriers.

The suggestion of an object emitting light is achieved by making it the brightest area in the drawing. First you have to darken the area around the object with the airbrush tool. For the rear light we used a bright, saturated red.

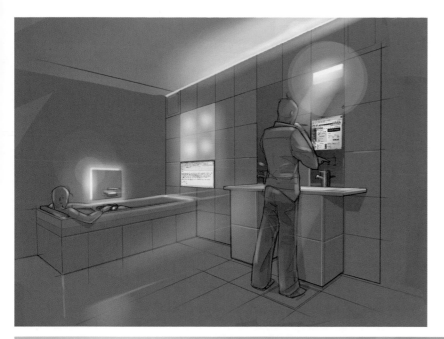

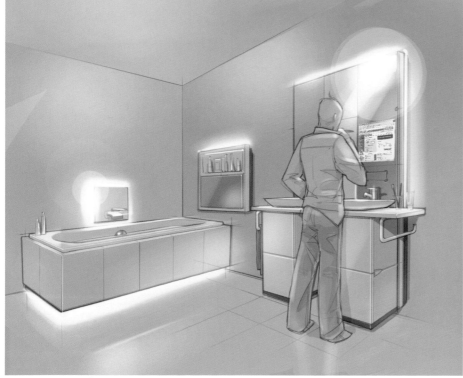

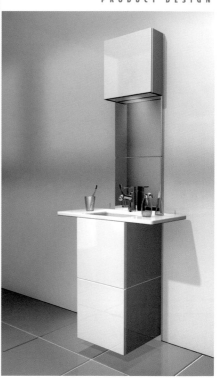

Pilots Product Design

Future bathroom concept for Vitra Bathrooms, 2004. A study on integrating electronics in the bathroom for health and comfort resulted in several product directions, such as a modular tile system with integrated cable space, internet connectivity and mood lighting.

The use of Painter as a digital sketching tool is an excellent way to build up a presentation. First we showed clear concepts, then we introduced people, then the mood lighting (animated in a dark bathroom), then we turned on the right music and after that a video and an internet browser appeared on the wall.

Designers: Stanley Sie and Hans de Gooijer

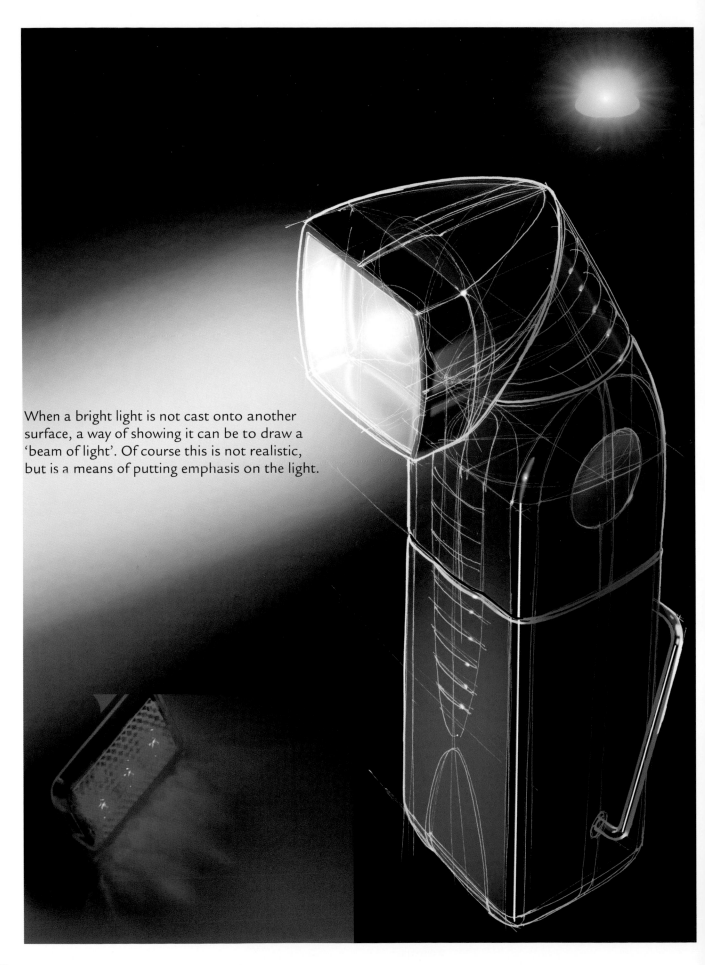

When a bright light is not cast onto another surface, a way of showing it can be to draw a 'beam of light'. Of course this is not realistic, but is a means of putting emphasis on the light.

Emitting soft light

Backlights and indication lights should also appear as bright areas. Richly saturated bright colours are best for displaying collared light. The most effect is gained when the light is surrounded by a darker and less colourful area, for example grey.

Notice that normal light has hardly any colour.

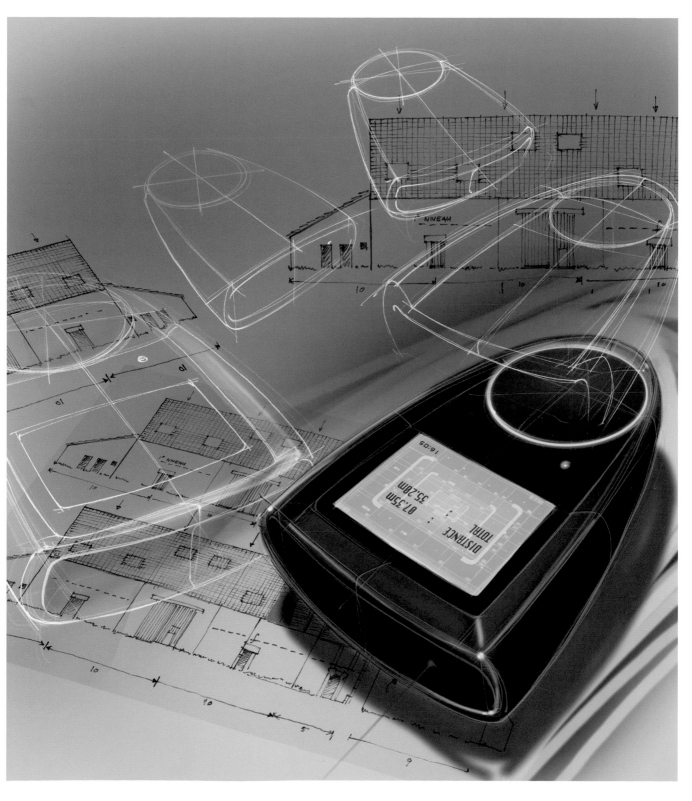

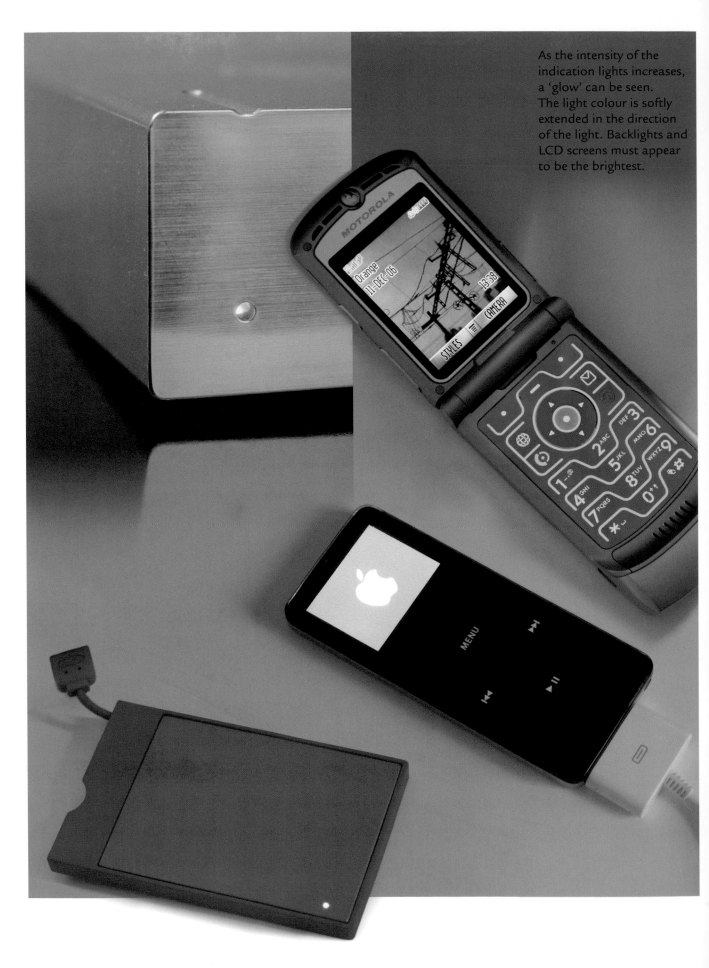

As the intensity of the indication lights increases, a 'glow' can be seen. The light colour is softly extended in the direction of the light. Backlights and LCD screens must appear to be the brightest.

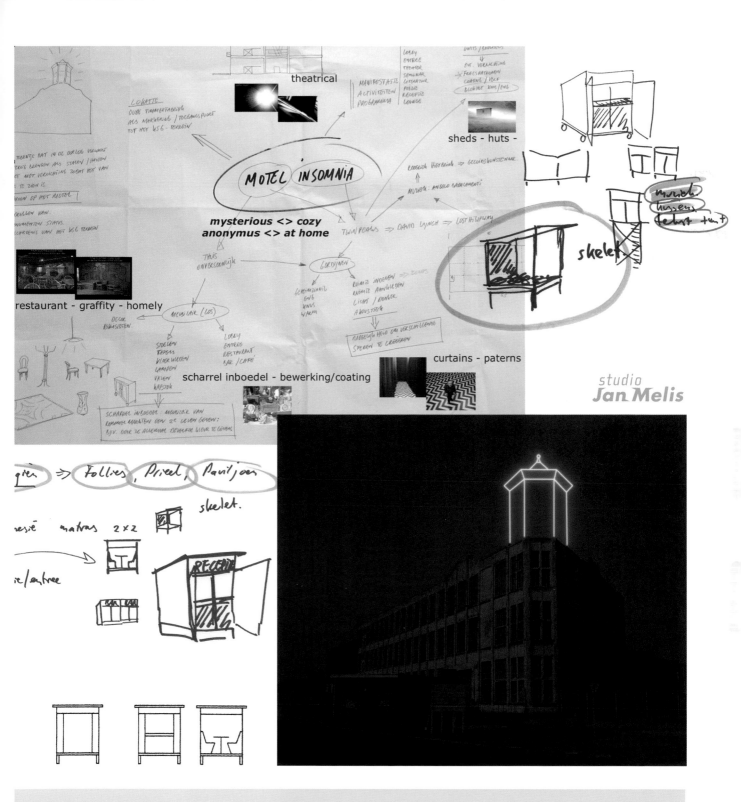

Studio Jan Melis

Small drawings, words and reference pictures were used for 'mind mapping' and to give direction. The former carpenter's factory on the KSG terrain in Vlissingen is a potential location for a hotel, according to the master plan of Rotterdam-based architects VHP. 'Motel Insomnia' (2007) investigates the potential of this monumental building and its surroundings as a cultural hotspot. Studio Jan Melis was commissioned to make both an exterior and interior design.

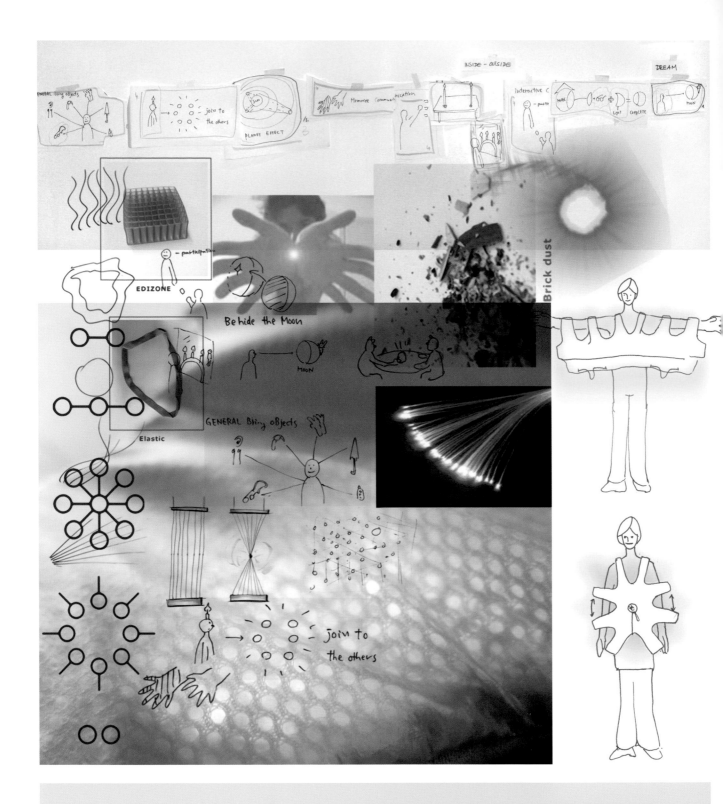

In what is referred to as 'Sketching Knowledge', participants exchanged their knowledge and perception of light, and little sketches were made of that. A story could then be created using words and pictures. During the process, many small sketches were drawn and grouped together to create new typologies and visualize solutions and proposals.

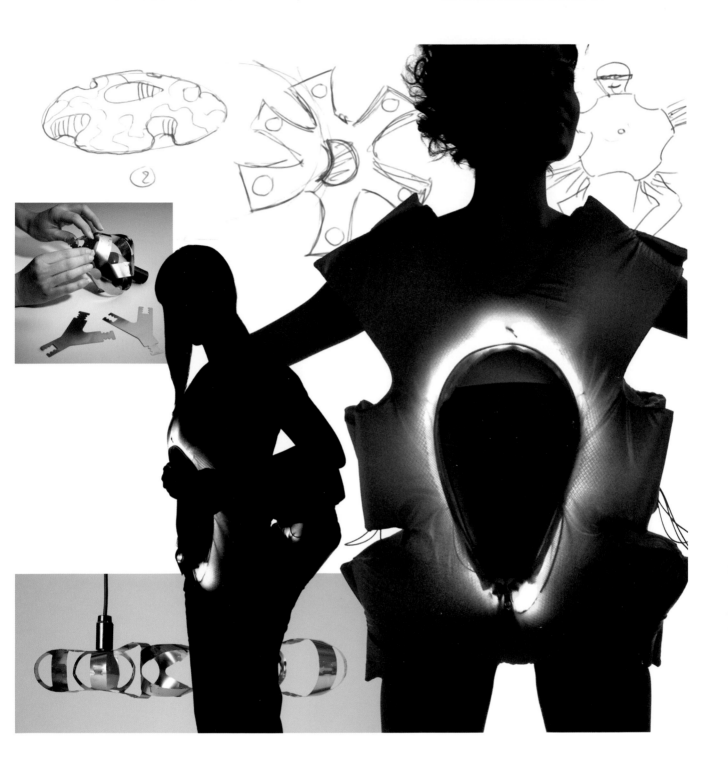

Studio Jacob de Baan, in cooperation with Ken Yokomizo

Big Moon Bad (in cooperation with OptilLED, 2006); a collection of lamps and wearable objects. The project relates both to interior design and fashion design.

Product photography: Crisp photography. Model photography: Lorenzo Barassi

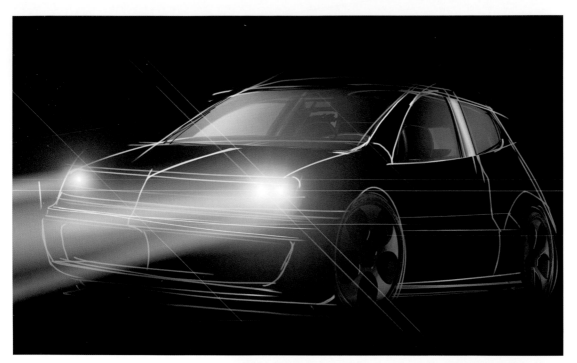

The effect of emitting
light can also be quickly
achieved by inverting a line
drawing originally made
in black lines on white
background.

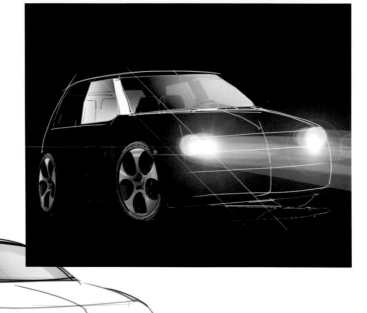

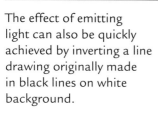

Context

Drawings can be made for various reasons and used in various situations of communication, such as ideation, brainstorming or explanatory drawings. Another situation arises when presenting or pitching an idea, especially to people from outside the design field like management, consumers, or sponsors. Involving them requires special kinds of drawings. These often show not only the product itself, but also its implications in real life, to make the product idea more understandable or convincing.

Products are related to people, and a drawing will become more lively or understandable if the product is placed in its user context - for example, by adding a person for scale and explanation or by combining it with photos. Another consideration is that ideas suggested with more realism look more definite or convincing.

Roman Photo – Compañia de Teatro Gran Reyneta at the Oerol Festival, Terschelling 2006

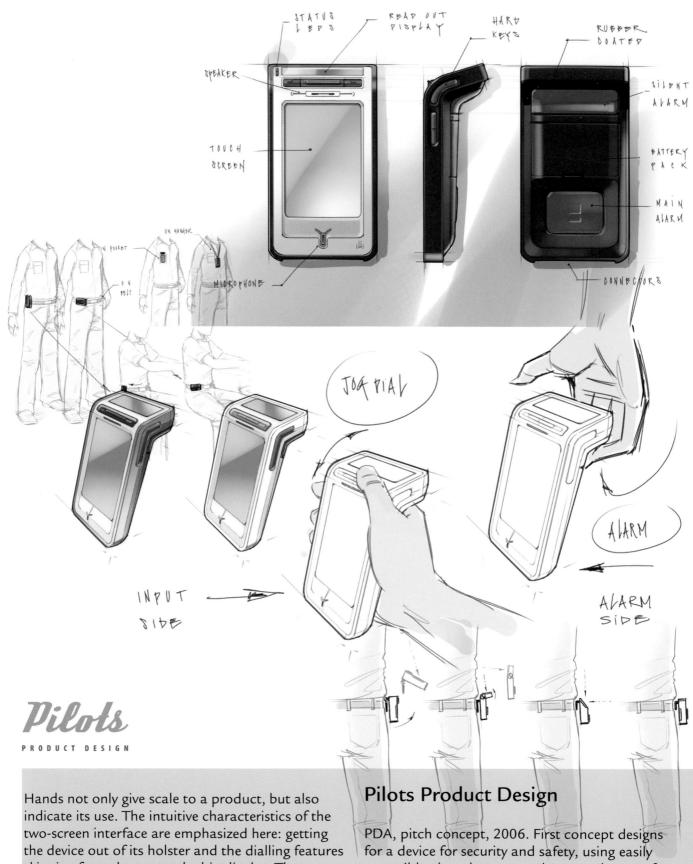

STATUS LEDS

READ OUT DISPLAY

HARD KEYS

RUBBER COATED

SPEAKER

SILENT ALARM

TOUCH SCREEN

BATTERY PACK

MAIN ALARM

IN POCKET

ON HANGER

ON BELT

MICROPHONE

CONNECTORS

JOG DIAL

ALARM

INPUT SIDE

ALARM SIDE

Pilots

PRODUCT DESIGN

Hands not only give scale to a product, but also indicate its use. The intuitive characteristics of the two-screen interface are emphasized here: getting the device out of its holster and the dialling features skipping from the top to the big display. The underlays with people were used to express various positions of the holster.

Pilots Product Design

PDA, pitch concept, 2006. First concept designs for a device for security and safety, using easily accessible alarm buttons and a second screen for incoming messages.

Designers: Stanley Sie and Hans de Gooijer

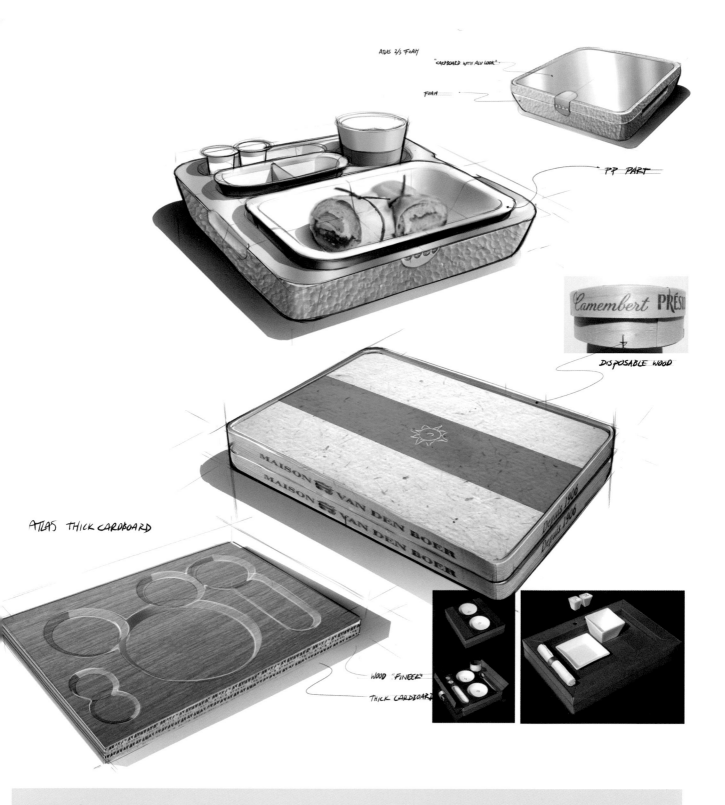

ATLAS 2/3 FOAM

"CARDBOARD WITH ALU LOOK"

FOAM

PP PART

Camembert PRÉSI

DISPOSABLE WOOD

ATLAS THICK CARDBOARD

MAISON VAN DEN BOER

Depuis 1906

WOOD "FINEER"

THICK CARDBOARD

VanBerlo Strategy +Design

Disposable in-flight meal boxes for Helios Food Service Solutions, 2005. Meal boxes and trays are customized for different airlines (e.g. Air France business class).

Line sketches are set up directly in Painter. Pictures, graphic elements and textures are then added in Painter or Photoshop. This gives the sketches a more rendered, definite character. It is also a quick and efficient way to convey a certain look & feel.

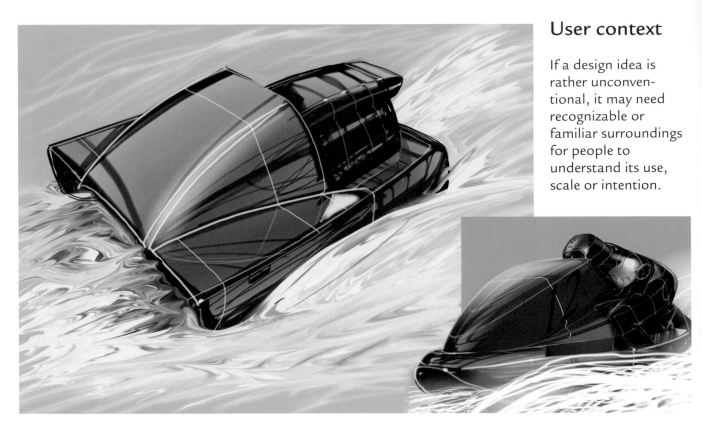

If a design idea is rather unconventional, it may need recognizable or familiar surroundings for people to understand its use, scale or intention.

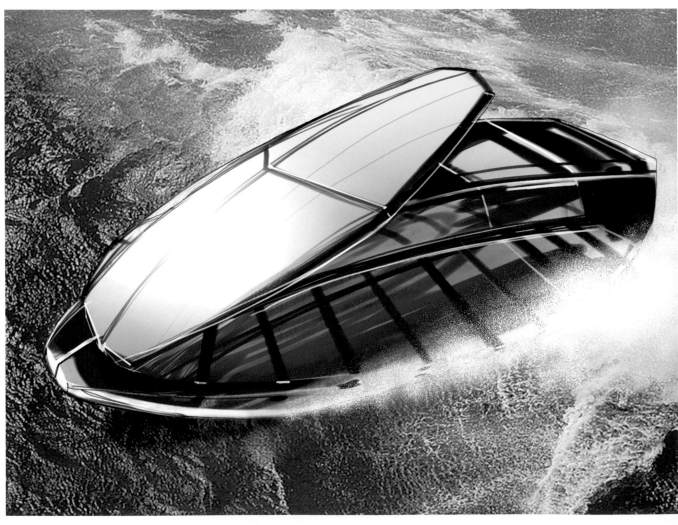

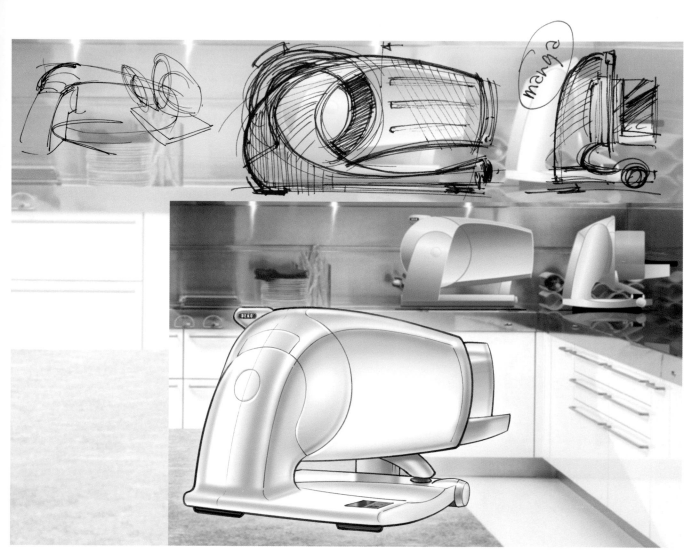

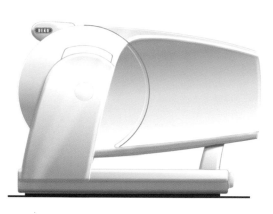

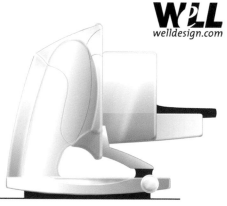

WeLL
welldesign.com

WeLL Design

WeLL Design developed a new generation of meat slicers for De Koningh Food Equipment, formerly Berkel Produktie Rotterdam, following upon the 834, which has been on the market for over 50 years. Quality, Hygiene and Craft were key issues in designing the aluminium and stainless steel housing. Hygiene especially is a critical issue in market acceptance; the fluent integration of the engine housing creates and expresses easy cleaning. In addition to the straight feed slicer (visualized here), we designed a gravity feed slicer.

The 3D drawing started out on paper, and was scanned and airbrushed in Photoshop. The side views were set up in Illustrator and finished in Painter. The views are suggestively blended in an environment.

Designers: Gianni Orsini and Thamar Verhaar

Blending in part of an object

Generally recognizable surroundings or archetypal objects can serve as scale elements. In these drawings, the underlay of the existing car works both ways. It gives the designer a basis for proportion and speeds up the drawing process. And when the wheel hubs remain untouched, they again serve as scale elements and give the brainstorming sketches a more realistic impact. There are various advantages to adding a realistic element of scale. As the idea becomes clearer, it may support design decisions. When used in presentation, it can involve the viewer. By adding this realism, the feel of a drawing can change from 'a thought' into a more credible or convincing product.

Using layer blending options offers various ways of getting picture and drawing 'to match better' in terms of colour and contrast. This line drawing was set up on paper and scanned. Shading gradients done by hand, using a very large brush and little opacity, will in most cases result in a more natural look than using a standard gradient tool.

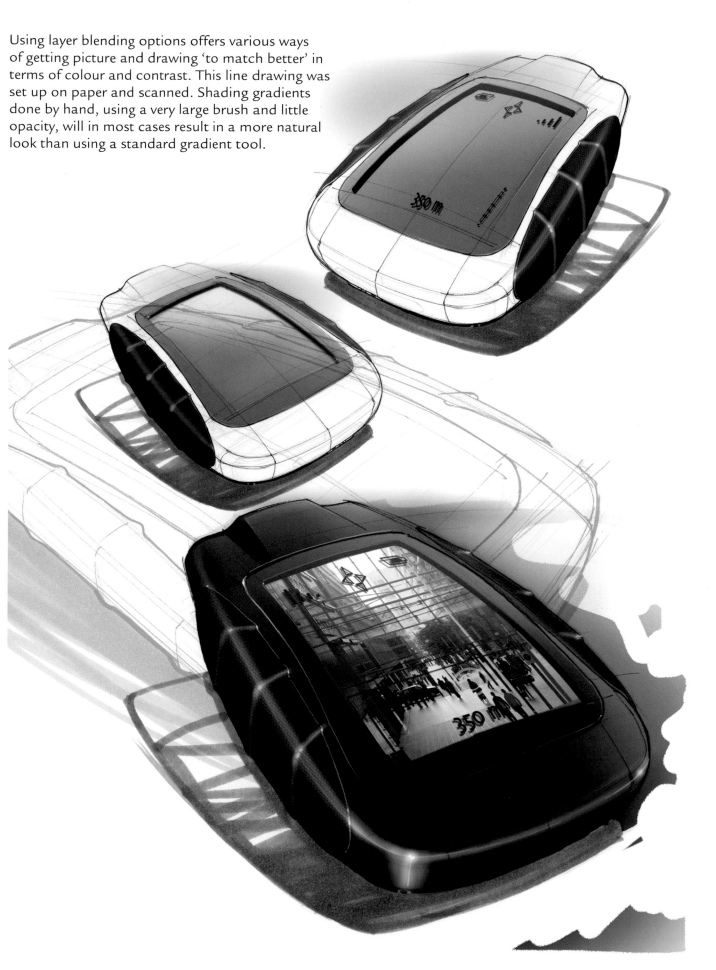

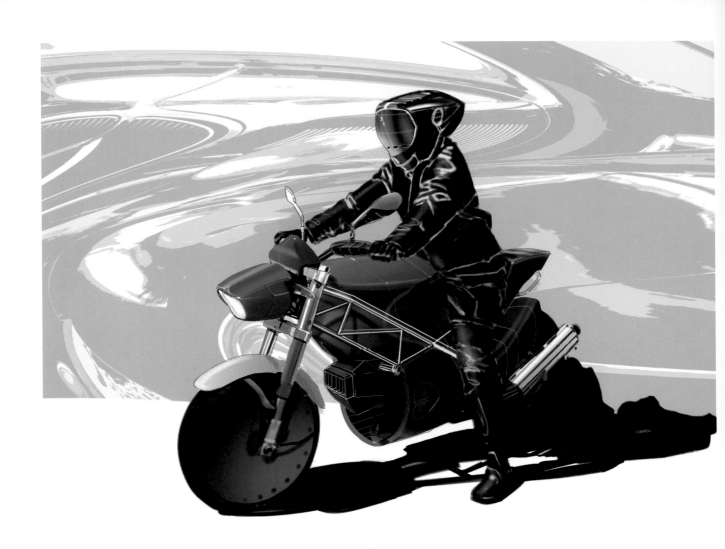

Combining pictures and drawing

The use of images is an efficient way of introducing ambiance or style elements to a sketch. In some situations, the context of the product in terms of mood and ambiance may even be as important as the appearance of the product itself.

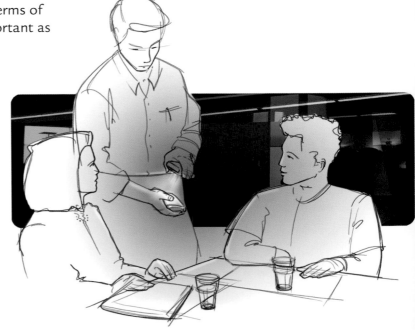

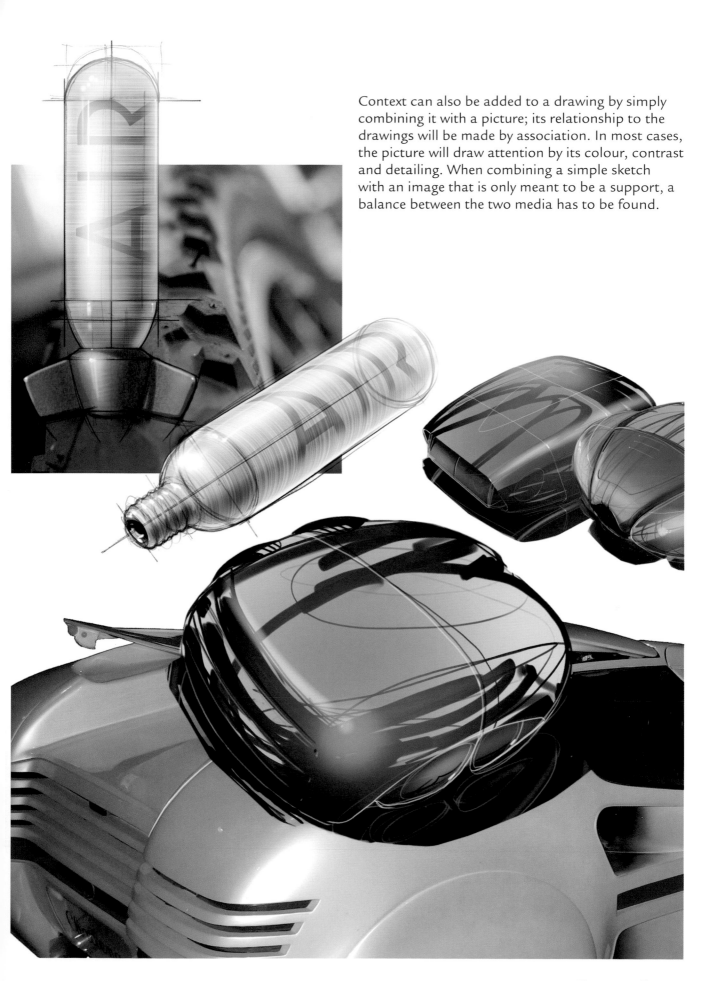

Context can also be added to a drawing by simply combining it with a picture; its relationship to the drawings will be made by association. In most cases, the picture will draw attention by its colour, contrast and detailing. When combining a simple sketch with an image that is only meant to be a support, a balance between the two media has to be found.

Hands

Hands can be introduced in drawings of products for several reasons. Drawings like this can be used to explain the use of the product, its scale, or its relation to human hands. The drawing of a hand can sometimes be the starting point for a designer, to suggest a possible way of use.

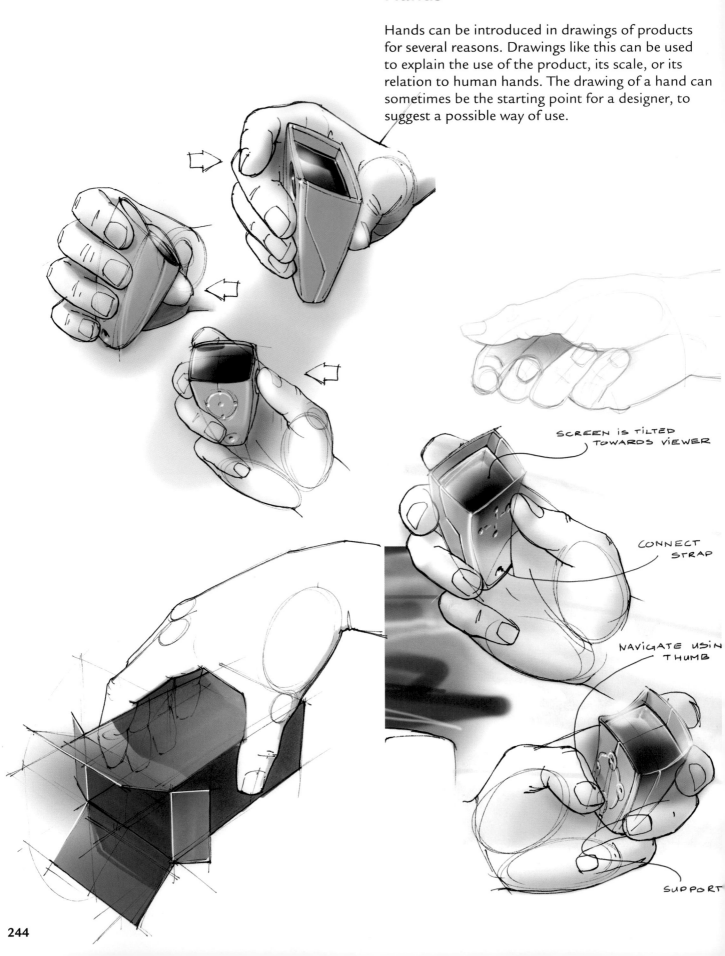

SCREEN IS TILTED TOWARDS VIEWER

CONNECT STRAP

NAVIGATE USIN THUMB

SUPPORT

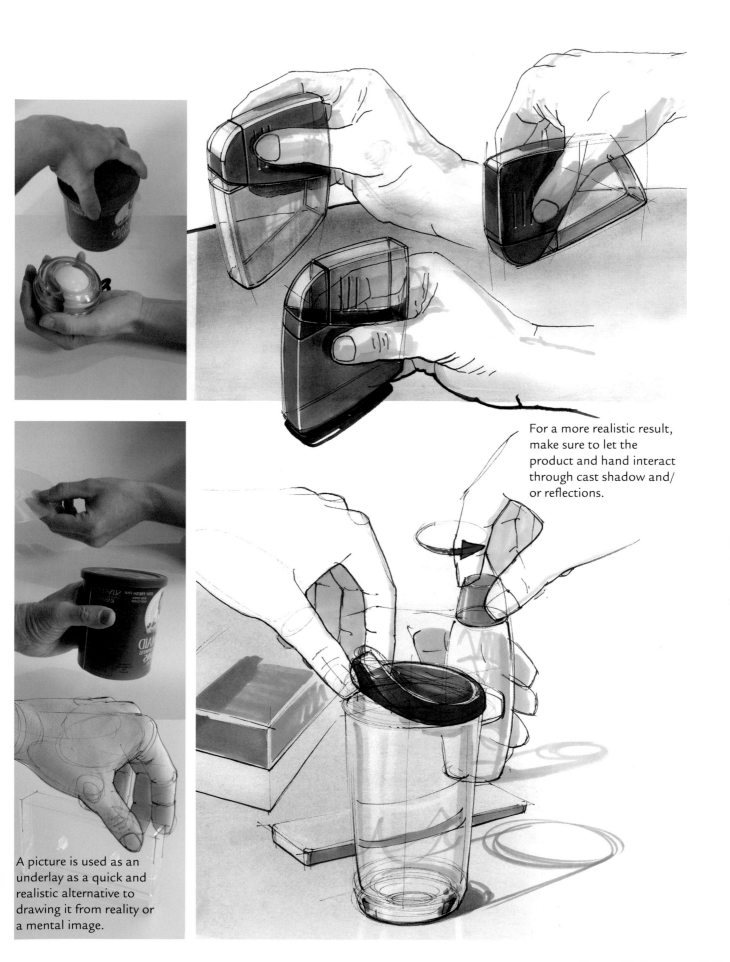

For a more realistic result, make sure to let the product and hand interact through cast shadow and/ or reflections.

A picture is used as an underlay as a quick and realistic alternative to drawing it from reality or a mental image.

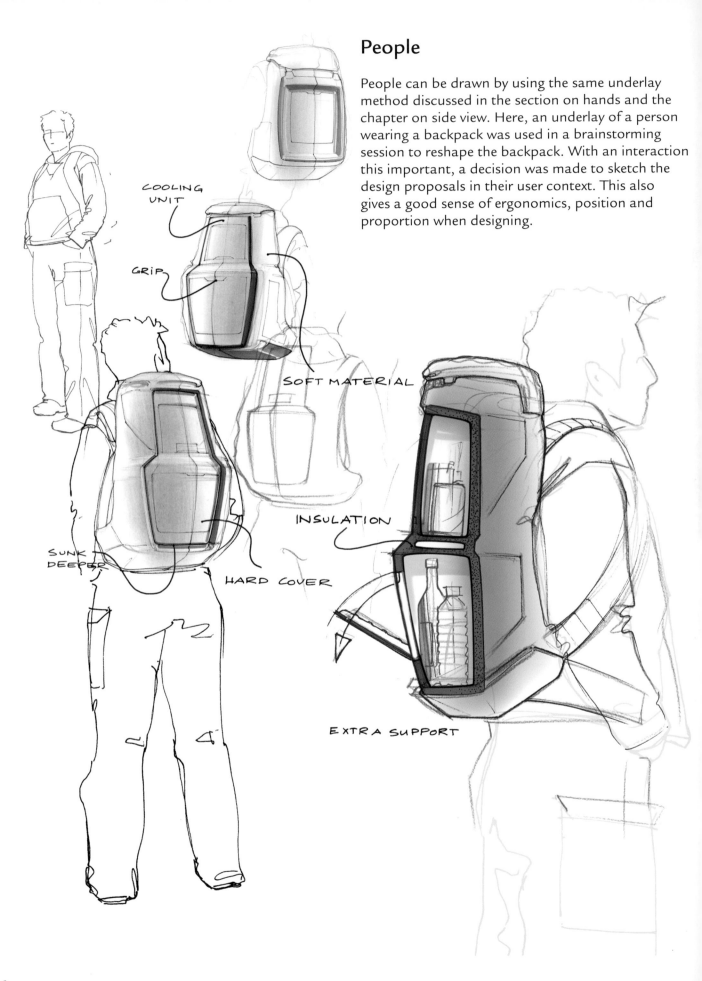

People

People can be drawn by using the same underlay method discussed in the section on hands and the chapter on side view. Here, an underlay of a person wearing a backpack was used in a brainstorming session to reshape the backpack. With an interaction this important, a decision was made to sketch the design proposals in their user context. This also gives a good sense of ergonomics, position and proportion when designing.

COOLING UNIT

GRIP

SOFT MATERIAL

INSULATION

SUNK DEEPER

HARD COVER

EXTRA SUPPORT

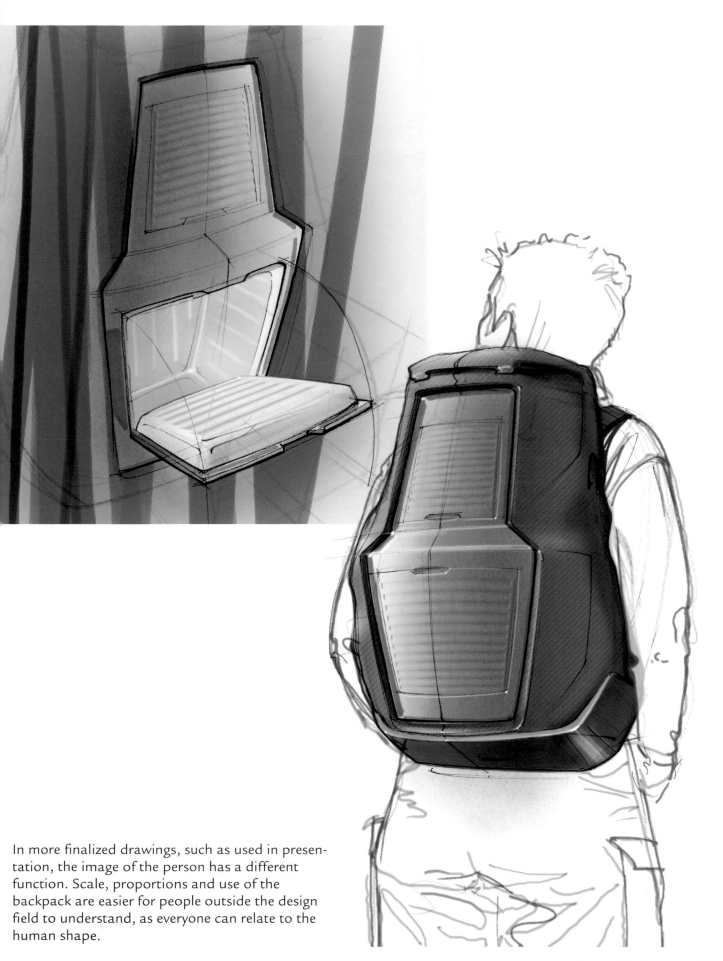

In more finalized drawings, such as used in presentation, the image of the person has a different function. Scale, proportions and use of the backpack are easier for people outside the design field to understand, as everyone can relate to the human shape.

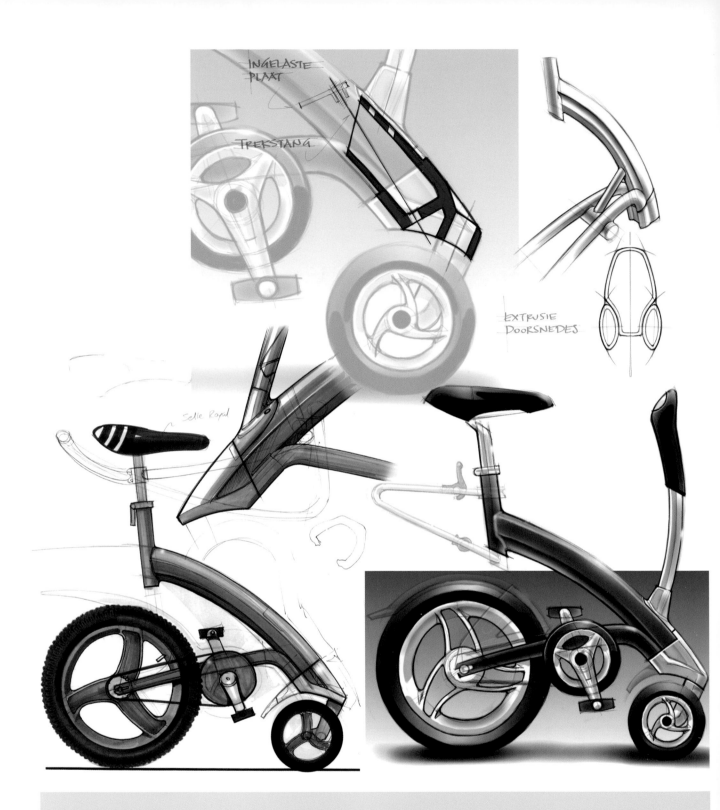

Bikes (and bike-related products like the SQRL) are often sketched in 2D views. Perspective sketches should never be forgotten, though. What especially helps to communicate the goals of the project are suggestive sketches of the product in use. By using digital sketching techniques, one can easily benefit from multilayer functionality.

The result of the sketch phase was an elegant bow-form frame, with a cast-aluminium nose. Removing the stick reveals a clean frame.

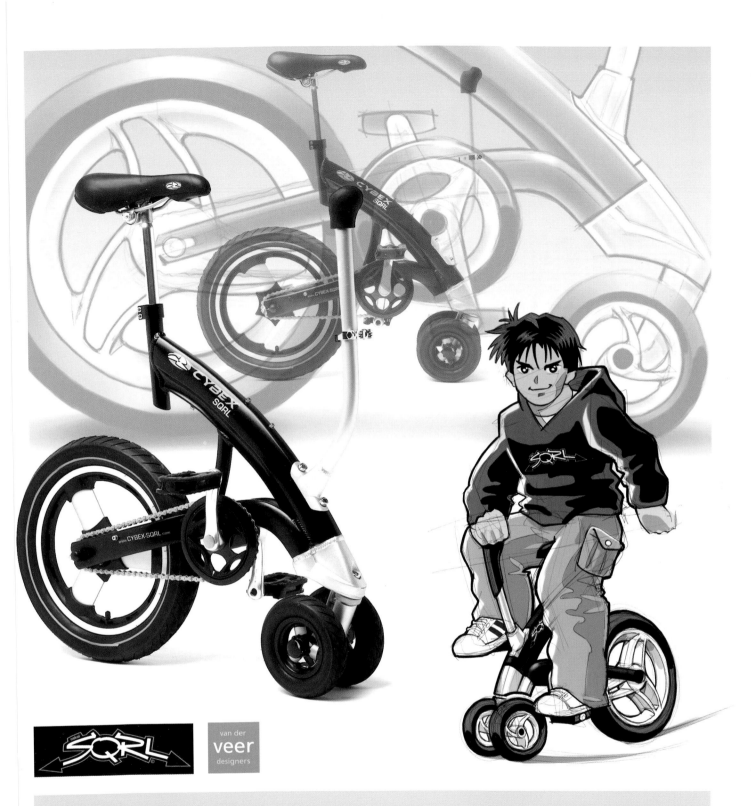

Van der Veer Designers

SQRL, 2006. The SQRL is an extremely manoeuvrable urban toy, targeted at 'kids' of eight years and older. Handling is done by transferring your weight. The twin front wheel swivels to make the turns. The stick can be used for balancing and support.

Client: Nakoi. Designers: Peter van der Veer, Rik de Reuver, Joep Trappenburg, Michiel Henning, in collaboration with Dick Quint

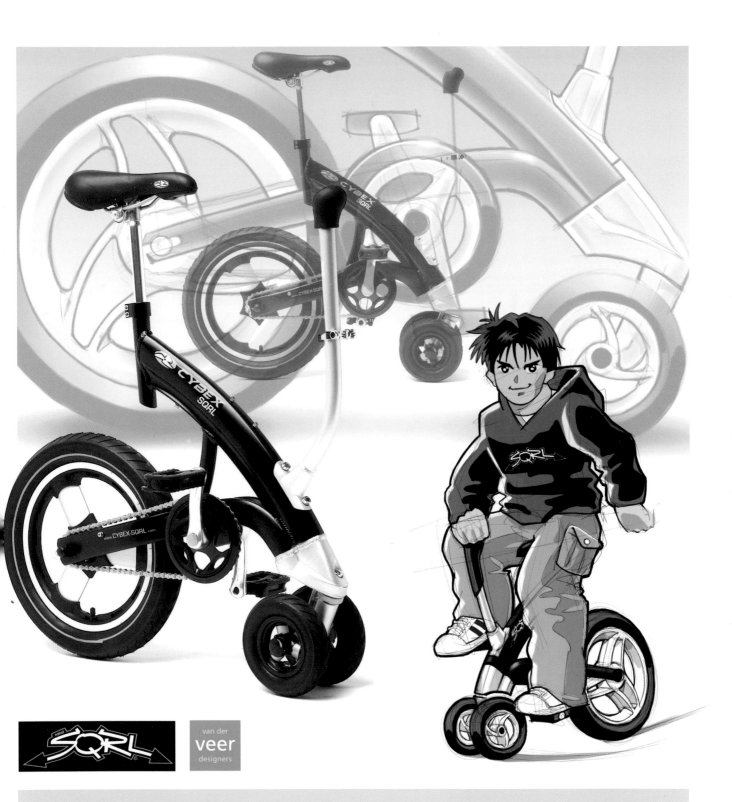

Van der Veer Designers

SQRL, 2006. The SQRL is an extremely manoeu-
vrable urban toy, targeted at 'kids' of eight years and
older. Handling is done by transferring your weight.
The twin front wheel swivels to make the turns. The
stick can be used for balancing and support.

Client: Nakoi. Designers: Peter van der Veer, Rik de Reuver, Joep Trappenburg, Michiel Henning, in collaboration with Dick Quint

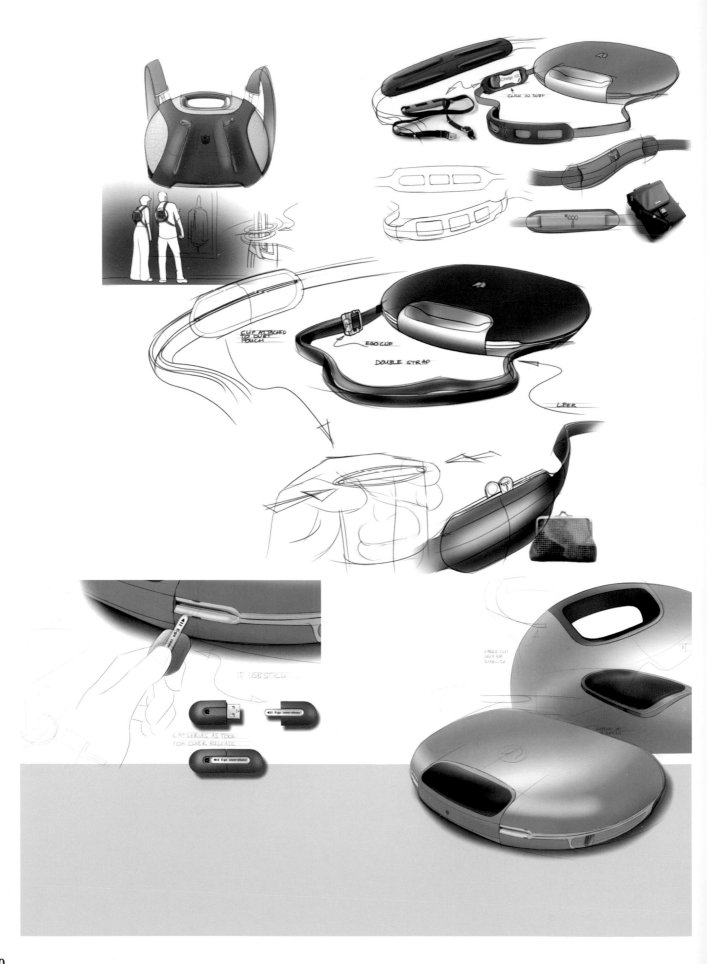

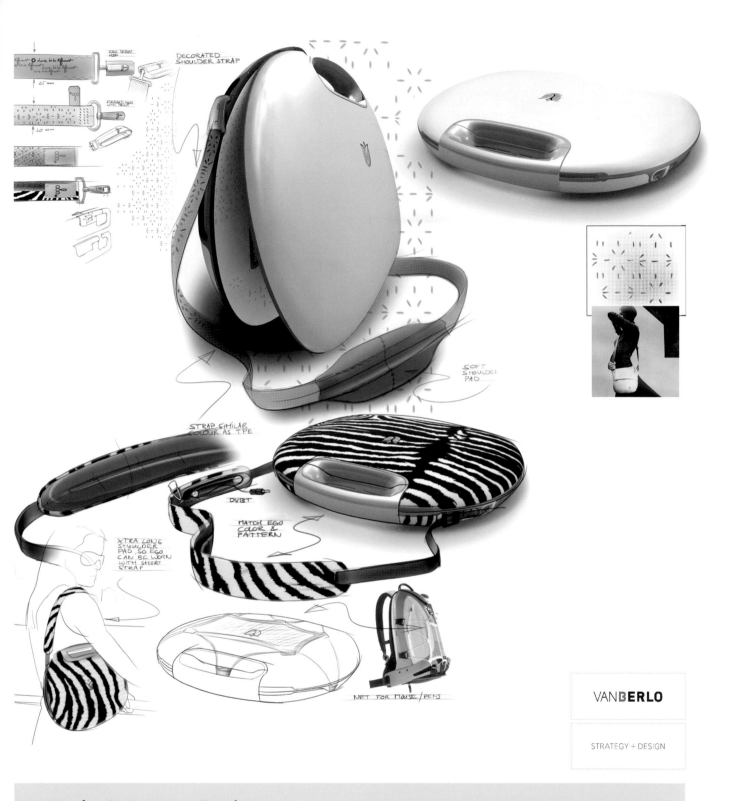

DECORATED SHOULDER STRAP

SOFT SHOULDER PAD

STRAP SIMILAR COLOUR AS TPE

DVBT

MATCH EGO COLOR & PATTERN

XTRA LONG SHOULDER PAD, SO EGO CAN BE WORN WITH SHORT STRAP

NET FOR MOUSE / PENS

VAN**B**ERLO

STRATEGY + DESIGN

VanBerlo Strategy + Design

Ego notebook for Ego Lifestyle BV, 2006.
This high-end luxury lifestyle notebook can be personalized with different skins, and is wearable like a personal handbag. During various stages of the design, mixes of different media were used to generate and communicate ideas.

Computer rendering and traditional drawing techniques are combined to generate ideas, and to efficiently communicate both technical and emotional aspects of the design.
Strong imagery is needed to introduce this new kind of laptop computer and puts it in its lifestyle context.

Bibliography

Eissen, Koos, Erik van Kuijk, and Peter de Wolf. *Product presentatietekenen*. Delft, the Netherlands: Delftse Universitaire Pers, 1984.

Gill, Robert W. *Rendering with pen and ink*. London: Thames and Hudson Ltd, reprinted 1979.

IDSA (Industrial Designers Society of America). *Design Secrets: Products*. Gloucester, USA: Rockport Publishers Inc, 2001.

IDSA (Industrial Designers Society of America), Lynn Haller and Cheryl Dangel Cullen. *Design Secrets: Products 2*. Gloucester, USA: Rockport Publishers Inc, 2001.

Fitoussi, Brigitte, and Aaron Betsky. *Richard Hutten – Works in Use*. Oostkamp, Belgium: Stichting Kunstboek Oostkamp, 2006.

Gerritsen, Frans. *Evolution in Color*. West Chester, Pennsylvania, USA: Schiffer Publishing, 1988.

Van Hinte, Ed. *Richard Hutten*. Rotterdam: 010 Publishers, 2002.

Itten, Johannes. *The Art of Color*. Hoboken, USA: John Wiley and Sons, 1974; also as a version in Dutch, Baarn, the Netherlands: Cantecleer, 2000.

Krol, Aad and Timo de Rijk. *Jaarboek Nederlandse Vormgeving 05*. Rotterdam: Episode Publishers, 2005.

Lauwen, Ton. De Nederlandse Designprijzen 2006 (The Dutch Design Awards, 2006). Catalogue. Eindhoven: 2006.

Lidwell, William, Kritina Holden, and Jill Butler. *Universal Principles of Design*. Gloucester, USA: Rockport Publishers Inc, 2003.

Mijksenaar, Paul and Piet Westendorp. *OPEN HERE*. New York: Joost Elfers Books, 1999.

Olofsson, Erik and Klara Sjölén. *Design Sketching*. Sundsvall, Sweden: KEEOS Design Books, 2005.

Ramakers, Renny, and Gijs Bakker. *Droog Design: spirit of the nineties*. Rotterdam: 010 Publishers, 1998.

Shimizu, Yoshihru. *Quick & Easy Solutions to Marker Techniques*. Tokyo, Japan: Graphic-Sha Publishing co., Ltd., 1995.

Sue-an van der Zijpp. *Brave New Work* London. Curator contemporary art Groninger Museum, The Netherlands, 2003.

Sue-an van der Zijpp. *The eternal beauty*. Curator contemporary art Groninger Museum, The Netherlands, 2004.

Magazines:
Auto & Design, Torino, Italy
Items, Amsterdam

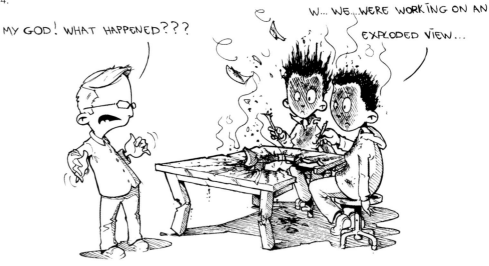

Credits designers

Adidas AG, Herzogenaurach, Germany
www.adidas.com
designer: Sonny Lim
Football Footwear 2001 – 2006

AUDI AG, Ingolstadt, Germany
www.audi.com
project: Audi LeMans seats, 2003
designer: Wouter Kets
chief designer: Walter de'Silva
photography: Audi Design
project: Audi R8 interior, 2006
designer: Ivo van Hulten
chief designer: Walter de'Silva

Studio Jacob de Baan, Amsterdam,
in cooperation with Ken Yokomizo, Milan, Italy
www.jacobdebaan.com
www.yokomizoken.com
project: Big Moon Bad (in cooperation with OptiLED),
2006
product photography: Crisp Photography
model photography: Lorenzo Barassi

VanBerlo Strategy + Design, Eindhoven
www.vanberlo.nl
project: hydraulic rescue tools for RESQTEC, 2005
designers: VanBerlo design team
photography: VanBerlo
awarded: iF Gold Award 2006 / Red Dot 'Best of the
Best' Award 2006 / Dutch Design Award, 2006 /
Industrial Design Excellence Award (IDEA) Gold 2006
project: Disposable in-flight meal boxes for Helios
Food Service Solutions, 2005
designers: VanBerlo design team
project: Ego notebook for Ego Lifestyle BV, 2006
design: VanBerlo design team
photography: VanBerlo

BMW Group, Munich, Germany
www.bmwgroup.com
project: concept sketches
designer: Adriaan van Hooydonk
lead designer: Chris Chapman
photography: BMW Group
projects: / BMW Z-9 concept car / concept sketch
6-series
designer: Adriaan van Hooydonk
photography: BMW Group

DAF Trucks NV, Eindhoven
www.daftrucks.com
project: DAF XF105 truck exterior, 2006
designers: Bart van Lotringen, Rik de Reuver
awarded: 'International Truck of the Year 2007'
project: DAF XF105 / CF / LF truck interior, 2006.
designers: Bart van Lotringen, Rik de Reuver, Gerard
Baten
photography: DAF Trucks
project: DAF XF105 Truck Easy Lift System, 2006
designer: Bart van Lotringen
photography: DAF Trucks

Fabrique, Delft
www.fabrique.nl
project: Eye-on-you for Hacousto/Dutch Railways
(NS), 2006
designers: Iraas Korver and Erland Bakkers
photography: Fabrique
photo: Rotterdam Droogdok furniture, 2005
designers: Emiel Rijshouwer and Jeroen van Erp
photography: Bob Goedewaagen

Feiz Design Studio, Amsterdam
www.feizdesign.com
project: N70 Smartphone for Nokia, 2005
designers: Khodi Feiz in collaboration with Nokia
Design
photography/rendering: Feiz Design Studio
project: personal sketchbook
designer: Khodi Feiz

FLEX/theINNOVATIONLAB, Delft
www.flex.nl
project: portable hard disk for Freecom, 2004
photography: Marcel Loermans, The Hague
project: mail handling systems for TNT, 2004-2006
photography: Marcel Loermans
project: Cable Turtle for Cleverline, 1997
photography: Marcel Loermans
project: regular bike for Batavus, 2002

Ford Motor Company, Dearborn, USA
www.ford.com
project: Ford Bronco concept car, 2004
designer: Laurens van den Acker
chief designer: Joe Baker
project: Ford Model U concept car, 2003
designer: Laurens van den Acker
project: Ford Model U Tires in cooperation with
Goodyear, 2003
designer: Laurens van den Acker
photography: Ford Motor Company, USA

Guerrilla Games, Amsterdam
www.guerrilla-games.com
project: Killzone2 for SonyPlaystation3 (work in
progress)
designers: Roland IJzermans and Miguel Angel
Martínez

Jan Hoekstra Industrial Design Services, Rotterdam
www.janhoekstra.com
project: cookware for Royal VKB, 2000
awarded: Design Plus Award 2002, Red Dot Award
2003, Grand Prix de l'Arte 2004
photography: Marcel Loermans
photos: Mix and Measure for Royal VKB, 2005
photography: Marcel Loermans

Richard Hutten Studio, Rotterdam
www.richardhutten.com
project: part of the Hidden Collection, 2000
designer: Richard Hutten
computer renderings: Brenno Visser
photography: Richard Hutten Studio
photo: Sexy relaxy, 2001/2002
Design and photography: Richard Hutten Studio

IAC Group GmbH, Krefeld, Germany
www.iacgroup.com
project: Dashboard and centre console, 2005/door
panel concept sketches, 2006/centre console stowage
concept, 2005
designer: Huib Seegers

Studio Job, Antwerp, Belgium.
www.studiojob.nl
projects: Rock Furniture, 2004/Rock Table, 2004/
Biscuit, 2006
designers: Job Smeets and Nynke Tynagel
photography: Studio Job

Studio Jan Melis, Rotterdam
www.janmelis.nl
project: Motel Insomnia, 2007
project: Luctor et Emergo exhibition for CBK Zeeland,
2006
photography: Studio Jan Melis
rendering: Easy chair
Design and rendering: MNO (Jan Melis and Ben
Oostrum)
boo | ben oostrum ontwerpt, Rotterdam www.
boontwerpt.nl

MMID, Delft.
www.mmid.nl
project: Logic-M Electrical Scooter for Ligtvoet
Products BV, 2006
photography: MMID
project: KeyFree System for i-Products, 2006
photography: MMID

studioMOM
www.studiomom.nl
project: dinnerware collection for Widget, 2006
designers: studioMOM, Alfred van Elk and Mars
Holwerda
photography: Widget
project: Ontario bathroom line for Tiger, 2006
designers: studioMOM, Alfred van Elk and Mars
Holwerda
photography: Tiger
photo: Pharaoh furniture line, 2005
awarded: selected for the Dutch Design Awards 2005
design and photography: studioMOM, Alfred van Elk
industrial design, www.alfredvanelk.com

npk industrial design bv, Leiden
www.npk.nl
project: Two Speed Impact Drill for Skill, 2006
project: Sport Kids family sledge for Hamax, 2007

Pilots Product Design, Amsterdam
www.pilots.nl
project: Tabletop phone for Philips, 2005
designers: Stanley Sie and Jurriaan Borstlap
project: PDA concept, 2006
designers: Stanley Sie and Hans de Gooijer
project: bathroom concept for Vitra Bathrooms, 2004
designers: Stanley Sie and Hans de Gooijer

Pininfarina S.p.A., Torino, Italy
www.pininfarina.com
project: Nido concept car, 2004
designer: Lowie Vermeersch
photography: Pininfarina S.p.A.
awarded: 'Most Beautiful Car of the Year'
project: Primatist G70 Leisure speed boat for
Primatist.
designer: Doeke de Walle
photography: Pininfarina S.p.a.

Remy & Veenhuizen ontwerpers, Utrecht
www.remyveenhuizen.nl
project: Meeting Fence for CBK Dordrecht, 2005
designers: Tejo Remy and René Veenhuizen
photography: Herbert Wiggerman
photos: Bench, part of the interior of VROM canteen
in The Hague, 2002
photography: Mels van Zutphen

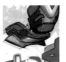

Atelier Satyendra Pakhalé, Amsterdam
www.satyendra-pakhale.com
project: Amisa, sensorial door handle for Colombo
Design SPA, Italy, 2004
designer: Satyendra Pakhalé
photography: Colombo Design SPA
project: Add-on Radiator, for Tubes Radiatori, Italy,
2004
designer: Satyendra Pakhalé
photography: Tubes Radiatori, Italy

SEAT, Martorell, Spain
www.seat.com
project: Seat Leon prototype concept, interior and
seats, 2005
designer: Wouter Kets
chief designer: Luca Casarini

SMOOL Designstudio, Amsterdam
www.smool.nl
project: multimedia TV concept, 2006
designer: Robert Bronwasser
project: mobile phone concept, 2006
designer: Robert Bronwasser
photo: Bo-chair, 2003
design and photography: SMOOL Designstudio

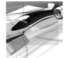

Spark Design Engineering, Rotterdam
www.sparkdesign.nl
project: explosion-proof level gauges, 2006
project: Desktop Video Magnifier, 2005
project: Personal Power Duo Pump, 2005
photography: Spark Design Engineering

Springtime, Amsterdam
www.springtime.nl
Client: Wieden+Kennedy
project: UPGRADE! Football Campaign for Nike
EMEA, 2005
designer: Michiel Knoppert
computer rendering: Michiel van Iperen
photography: Paul D. Scott

Tjep., Amsterdam
www.tjep.com
project: Scribbles, 2004
designer: Frank Tjepkema
photography: Tjep

Van der Veer Designers, Geldermalsen
www.vanderveerdesigners.nl
project: Comfort Seat for Gazelle, 2006
designers: Rik de Reuver, Albert Nieuwenhuis
photography: Van der Veer Designers
project: SQRL, for Nakoi, 2006
designers: Peter van der Veer, Rik de Reuver, Joep
Trappenburg, Michiel Henning, in collaboration
with Dick Quint
photography: Van der Veer Designers

WAACS, Rotterdam
www.waacs.nl
project: Senseo coffee machine, for Douwe Egberts/
Sara Lee and Philips, 2002
photography: WAACS
project: I-Tronic for Velda, 2002
project: webcam concepts for Microsoft Corporation,
1999
project: 'Screen Sketching Foil', column by Joost
Alferink for VrijNederland, 2006

Marcel Wanders Studio, Amsterdam
www.marcelwanders.com
project: Zeppelin Lamp for Flos S.p.a., 2005
designer: Marcel Wanders
photography: Flos S.p.a., Italy

Dré Wapenaar, Rotterdam
www.drewapenaar.nl
projects: Treetents, 1998 and Tentvillage, 2001
designer: Dré Wapenaar
photography: Robbert R. Roos

WeLL Design, Utrecht
www.welldesign.com
project: hairdryer product line for Princess, 2005
designers: Gianni Orsini and Mathis Heller
product photography: Princess
project: espresso machine series for Etna Vending
Technologies, 2004
designers: Gianni Orsini and Mathis Heller
project: meat slicer product line for De Koningh Food
Equipment, 2004-2007
designers: Gianni Orsini and Thamar Verhaar

*The publishers/authors have done their very best to give due
right to all images presented in this book. We ask anyone
entitled to such rights to contact the publishers.*

Photo acknowledgments

photo and renderings: Biodomestic, 2001
winner of the European Design Competition 'Lights of the future'
design and photography: Hugo Timmermans and Willem van der Sluis:
Customr
www.customr.com
photo: Leaning Mirror, 1998
design: Hugo Timmermans, Amsterdam. www.optic.nl
photography: Marcel Loermans

photo: The Carbon Copy
design and photography: Studio Bertjan Pot, Schiedam. www.bertjanpot.nl

photo: Cinderella table
studio DEMAKERSVAN, Rotterdam
www.demakersvan.com
design: Jeroen Verhoeven
photography: Raoul Kramer

photo: Dutchtub
design: Floris Schoonderbeek
Dutchtub, Arnhem. www.dutchtub.com
photography: Dutchtub USA / product photography: Steven van Kooijk

photo and drawing: chair ELI, 2006
design: Studio Ramin Visch, Amsterdam
www.raminvisch.com
photography: Jeroen Musch

photo: Functional Bathroom Tiles / Functional Kitchen Tiles, 1997-2001
designers: Erik Jan Kwakkel, Arnhem. www.erikjankwakkel.com
Arnout Visser, Arnhem. www.arnoutvisser.com
Peter van der Jagt, Amsterdam photography: Erik Jan Kwakkel

photo: Honda BF 90 outboard engine
Honda Nederland B.V. www.honda.nl

photo: KitchenAid Ultra Power Plus Handmixer
design: KitchenAid
photography: Whirlpool Corporation

photo: Marie-Louise, 2002 Buro Vormkrijgers, Eindhoven
www.burovormkrijgers.nl
design: Sander Mulder & Dave Keune
photography: Sander Mulder

photo: Shady Lace, 2003
design and photography prototype: Studio Chris Kabel, Rotterdam.
www.chriskabel.com
outdoor photograph: Daniel Klapsing

photos: Spineless Lamps, 2003 / Two of a kind, 2004
design and photography: Studio Frederik Roijé, Amsterdam/Duivendrecht.
www.roije.com

photos: trainticket, page 69 / 2 rolls of toiletpaper, page 77 / moorings,
page 100 / Cd boxes, page 85
photography: Yvonne van den Herik

all other photos: the authors

cartoons: Jan Selen
JAM visueel denken, Amsterdam,
www.visueeldenken.com